T0251912

GAME PHYSICS ENGINE DEVELOPMENT

GAME PHYSICS ENGINE DEVELOPMENT

How to Build a Robust Commercial-Grade Physics Engine for your Game

Second Edition

IAN MILLINGTON

CRC Press
Taylor & Francis Group
Boca Raton London New York

CRC Press is an imprint of the
Taylor & Francis Group, an **informa** business

CRC Press
Taylor & Francis Group
6000 Broken Sound Parkway NW, Suite 300
Boca Raton, FL 33487-2742

First issued in hardback 2017

© 2010 by Taylor & Francis Group, LLC
CRC Press is an imprint of Taylor & Francis Group, an Informa business

No claim to original U.S. Government works

ISBN 13: 978-1-138-40312-3 (hbk)
ISBN 13: 978-0-12-381976-5 (pbk)

This book contains information obtained from authentic and highly regarded sources. Reasonable efforts have been made to publish reliable data and information, but the author and publisher cannot assume responsibility for the validity of all materials or the consequences of their use. The authors and publishers have attempted to trace the copyright holders of all material reproduced in this publication and apologize to copyright holders if permission to publish in this form has not been obtained. If any copyright material has not been acknowledged please write and let us know so we may rectify in any future reprint.

Except as permitted under U.S. Copyright Law, no part of this book may be reprinted, reproduced, transmitted, or utilized in any form by any electronic, mechanical, or other means, now known or hereafter invented, including photocopying, microfilming, and recording, or in any information storage or retrieval system, without written permission from the publishers.

For permission to photocopy or use material electronically from this work, please access www.copyright.com (http://www.copyright.com/) or contact the Copyright Clearance Center, Inc. (CCC), 222 Rosewood Drive, Danvers, MA 01923, 978-750-8400. CCC is a not-for-profit organization that provides licenses and registration for a variety of users. For organizations that have been granted a photocopy license by the CCC, a separate system of payment has been arranged.

Trademark Notice: Product or corporate names may be trademarks or registered trademarks, and are used only for identification and explanation without intent to infringe.

Visit the Taylor & Francis Web site at
http://www.taylorandfrancis.com

and the CRC Press Web site at
http://www.crcpress.com

For Richard

CONTENTS

CHAPTER
10 LAWS OF MOTION FOR RIGID BODIES

PART V CONTACT PHYSICS 333

CHAPTER 14 COLLISION RESOLUTION 335

LIST OF FIGURES

PREFACE TO THE SECOND EDITION

This second edition of the text is designed to extend and improve upon the first edition. There is a broad selection of minor changes and corrections that have been made throughout the book. A lot of these are due to the dilliegent attention of scores of readers who sent suggestions and corrections. Thank you for your comments and ideas.

There are three new features of this edition that were consistently requested by readers of the first edition:

1. The chapter on fine-grained or narrow-phase collision detection from the first edition was designed to make it as easy as possible to get some kind of collision detection running. Collision detection is at least as complex as physical simulation, and there are other books that analyze it in considerable detail. The feedback has been that it would be worth looking at an algorithm that is generally useful in detail, rather than skirting several options. In this edition, therefore, I have rewritten the collision detection chapter to focus on the general-purpose separating axis test algorithm. This is used as the collision detection system in a number of commercial middleware products, and many more in-house technologies.

2. Many readers gave me feedback that they wanted to use their physics engines to build 2D as well as 3D games. This is particularly important as the 2D games scene has undergone a renaissance with the rapid growth of casual and mobile games. I have added a chapter that details the steps needed to build a 2D physics engine on the basis of the 3D code that comprises the majority of this book. I have decided to present the content this way because the feedback I get indicates that the majority of the readers are interested in coding for 3D games, and although 2D physics is simpler, having the grounding in 3D is still important to make sensible decisions as you code. If you are only interested in 2D physics, I would still encourage you to follow through the 3D code, referring forward to Chapter 18 where you implement a chunk of the algorithm.

3. Because the book was designed to lead novice physics programmers through to a complete engine, it has been picked up and adopted for use in many games

development courses at universities around the world. The feedback I have received from instructors encouraged me to provide more resources for structured learning alongside the main text. This edition is therefore packaged in a cheaper, softcover format, so that it is more affordable as a text in a college course. It includes a glossary of terms, making it useful as a reference during lectures or to decode other resources. The chapters that introduce new content have a set of exercises at the end. These exercises can be used by anyone to sharpen their understanding, but they are also designed to be assigned by instructors. Answers can be obtained directly from the author. Unlike some resources on physics, the exercises are designed not to be purely mathematical: some are experimental, while some require small implementations. Finally, each part of this book ends with a series of graded projects that can be used by students as short-term assignments or larger thesis projects. The thesis projects all involve implementing a physics-based game using the techniques in this book.

I hope you'll find this edition of the book useful, and will enjoy building your physics engine with its help. I'm always keen to get feedback on the book, including both corrections and suggestions for future editions. Feel free to email me at `idmillington@googlemail.com` with your opinions or observations.

PREFACE TO THE FIRST EDITION

When I started writing games, in the 8-bit bedroom coding boom of the 1980s, the low budgets and short turnaround times of writing games encouraged innovation and experimentation. This in turn led to some great games (and, it has to be said, a whole heap of unplayable rubbish—let no one tell you games were better back then!).

There were two games I remember being particularly inspired by, and both used realistic physics as a core of their game play. The first was Thrust, written by Jeremy Smith and originally published for the UK's BBC Micro range of home computers.

Based on the arcade game Gravitar, an ivy-leaf–shaped ship navigates through underground caverns under the influence of a 2D physical simulation. The aim is to steal a heavy fuel pod, which is then connected to the ship via a cable. The relatively simple inertial model of the spaceship then becomes a wonderfully complex inter-action of two heavy objects. The game play was certainly challenging, but had that one-more-time feel that marks a classic game.

The second game was Exile, written by Peter Irvin and Jeremy Smith[1] (again). This is perhaps the most innovative and impressive game that I have ever seen, fea-turing techniques beyond physics such as emergent game play, open world levels, and procedural content creation that were a decade or more ahead of their time.

Exile's physics extends to every object in the game. Ammunition follows ballistic trajectories, you can throw grenades, which explode sending nearby objects flying, you can carry a heavy object to weigh you down in a strong up-draft, and you float pleasingly in water. Exile must qualify for the first complete physics engine in a game.

With Exile released in 1988, I feel that I am a relative newcomer to the physics coding party. I started writing game physics in 1999, creating an engine for modeling cars in a driving game. What I thought was a month's project turned into something of an albatross.

I ran headlong into every physics problem imaginable, from stiff-suspension springs that sent my car spiraling off to infinity, to wheels that wobbled at high speed, from friction that moved objects around of its own accord, to hard surfaces that

1. Sadly, Jeremy died in an accident in 1992, but Peter is currently developing an iPhone version of Exile.

looked like they were made of soft rubber. I tried a whole gamut of approaches, from impulses to Jacobians, from reduced coordinates to faked physics. It was a learning curve unlike anything before or since in my game coding career.

While I was merrily missing my deadlines (driving physics gave way to third person shooters) and my company examined every middleware physics system we could find, I learned a lot about the pitfalls and benefits of various approaches. The code I wrote, and often abandoned, proved to be useful over the intervening years as it got dusted off and repurposed. I have built several physics engines based on that experience, and customized them for many applications, and I think I have a good sense of how to get the best effects from the simplest approach.

We have entered a phase where physics simulation is a commodity in game development. Almost every game needs physics simulation, and every major development company will have an in-house library, or license one of the major middleware solutions. Physics, despite being more common than ever before, is still somewhat of a black box. The physics developers do their stuff, and the rest of the team relies on the results.

Most of the information and literature on game physics assumes a level of mathematical and physical sophistication that is uncommon. Other references might give you all the physical information, but no architecture for how to apply it. And still others contain misinformation and advice that will sting you. Physics engines are complicated beasts, and there is a universe of optimizations and refinements out there, most still waiting to be explored. But before you can wrangle with implementing variations on LCP solvers or pivot algorithms, you need to understand the basics, and have a working body of code to experiment with.

This book is grounded in the first few years of painful experimentation I went through. I wanted this book to be a starting point, to be the book I needed 12 years ago. I want it to take you from zero to a working physics engine in one logical and understandable story. It is just the first step on a much longer road, but it is a sure and dependable step, and a step in the right direction.

Acknowledgments

My quest to create robust game physics, although difficult, would have been impossible without the contributions of a handful of skilled code writers and mathematicians who published papers and articles, and who gave SIGGRAPH presentations and released source code. Although there are many more, I am thinking particularly of Chris Hecker, Andrew Watkin, and David Barraf. Their early contributions were the lifeline that those of us who followed needed.

I would like to thank the hard work and dilligence of the technical review team on this book, both the first edition team—Dave Eberly, Philip J. Schneider, Dr. Jonathan Purdy, and Eitan Grinspun—and Matt Smith, who reviewed the second edition material with great patience and attention to detail: Thank you for your valuable contributions that helped improve the book's quality, readability, and usefulness. As always, the quality of the book owes a great deal to these people, but any remaining shortcomings are my own.

Unlike my first book, which was written during "gardening leave" after selling my previous business, this text and its second edition were written while working full-time building the R&D consultancy partnership I still work with. I therefore want to thank my wife, Mel, who has now suffered my late nights over two editions of this book.

I first played a copy of Thrust loaned to me by my school friend Richard, who went on to become my best friend and the best man at my wedding. Each day at school we would compare our achievements, scores, and the level we had reached. I have such fond memories of those days. In the last week of writing this second edition, Richard died suddenly. He leaves a huge lacuna in my life. This second edition is dedicated to his memory.

About the Author

Ian Millington consults on game technologies and research and development, including artificial intelligence, real-time simulation, and physics, through his company, the R'n'D Guy. Previously he founded Mindlatthe Ltd., the largest specialist AI middleware company in computer games, working on a huge range of game genres and technologies. He has an extensive background in AI, including doctoral research in complexity theory and natural computing. He has published academic and professional papers and articles on topics ranging from paleontology to hypertext.

INTRODUCTION

Physics is a hot topic in computer games. No self-respecting action game can get by without a good physics engine, and the trend has recently spread through other genres, including strategy games and puzzles. This growth has been largely fueled by middleware companies offering high-powered physics simulation. Most high-profile games now feature commercial physics engines.

But commercial packages come at a high price, and for a huge range of developers building a custom physics solution can be better, as it can be cheaper, provide more control, and be more flexible. Unfortunately, physics is a topic shrouded in mystery, mathematics, and horror stories.

When I came to build a general physics engine in 2000, I found that there was almost no good information available, almost no code to work from, and lots of contradictory advice. I struggled through and built a commercial engine, and learned a huge amount in the process. Over the last 10 years I've applied my own engine and other commercial physics systems to a range of real games. Almost a decade of effort and experience is contained in this book.

There are other books, websites, and articles on game physics, much of it quite excellent. But there is still almost no reliable information on building a physics engine from scratch—a complete simulation technology that can be used in game after game. This book aims to step you through the creation of a physics engine. It goes through a sample physics engine (provided on the CD), as well as giving you insight into the design decisions that were made in its construction. You can use the engine as is, use it as a base for further experimentation, or make various design decisions and create your own system under the guidance that this book provides.

Copyright © 2010, Elsevier Inc. All rights reserved.
DOI: 10.1016/B978-0-12-381976-5.00001-2

1.1 WHAT IS GAME PHYSICS?

Physics is a huge discipline, and academic physics has hundreds of subfields. Each describes some aspect of the physical world, from the way light works to the nuclear reactions inside a star.

Lots of these areas of physics might be useful in games. We could use optics, for example, to simulate the way light travels and bounces, and use to make great-looking graphics. This is the way ray tracing works, and (although it is still very slow compared to other approaches) it has been used in several game titles. Although these areas are part of academic physics, they are not part of what we mean by game physics and I won't consider them in this book.

Other bits of physics have a more tenuous connection with games. I cannot think of a use for nuclear physics simulation in a game, unless the nuclear reactions were the whole point of the game play.

When we talk about physics in a game, we really mean classical mechanics, that is, the laws that govern how large objects move under the influence of gravity and other forces. In academic physics these laws have largely been superceded by relativity and quantum mechanics. Almost all of the physics described in this book has long since stopped being an active area of research; all the results we'll be relying on were settled before the turn of the twentieth century.

In games, classical mechanics is used to give game objects the feel of being solid things, with mass, inertia, bounce, and buoyancy.

Game physics has been around almost since the first games were written. It was first seen in the way particles move: the ballistics of bullets, sparks, fireworks, smoke, and explosions. Physics simulation has also been used to create flight simulators for nearly three decades. Next came automotive physics, with ever-increasing sophistication of tire, suspension, and engine models.

As processing power became available, we saw crates that could be moved around or stacked, and walls that could be destroyed and crumble into their constituent blocks. This is rigid-body physics, which rapidly expanded to include softer objects: clothes, flags, and rope. Then came the rise of the ragdoll: a physical simulation of the human skeleton that allows more realistic trips, falls, and death throes. And recently we've seen a lot of effort focused on simulating fluid flow: water, fire, and smoke.

In this book we'll cover a representative sample of physics tasks. With a gradually more comprehensive technology suite, our physics engine will support particle effects, flight simulation, car physics, crates, destructible objects, cloth, and ragdolls, along with many other effects.

1.2 WHAT IS A PHYSICS ENGINE?

Although physics in games is more than 30 years old, there has been a distinct change in recent years in the way that physics is implemented. Originally, each effect was programmed for its own sake, creating a game with only the physics needed for that

title. If a game needed arrows to follow trajectories, then the equation of the trajectory could be programmed into the game. It would be useless for simulating anything but the trajectory of arrows, but it would be perfect for that.

This is fine for simple simulations, where the amount of code is small and the scope of the physics is quite limited. As we'll see, a basic particle system can be programmed in only a hundred lines or so of code. But directly implementing phyical behavior becomes a difficult task as the complexity increases.

In the original Half-Life game, for example, you can push crates around, but the physics code isn't quite right, and the way crates move looks odd. The difficulty of getting physics to look good, combined with the need for almost the same effects in game after game encouraged developers to look for general solutions that could be reused.

Resuable technology needs to be quite general: a ballistics simulator that will only deal with arrows can have the behavior of arrows hard coded into it. If the same code needs to cope with bullets too, then the software needs to abstract away from particular projectiles and simulate the general physics that they all have in common. This is what we call a physics engine: a common piece of code that knows about physics in general, but isn't programmed with the specifics of each game.

This leaves us with a gap. If we have special code for simulating an arrow, then we need nothing else in order to simulate an arrow. If we have a general physics engine for simulating any projectile, and we want to simulate an arrow, we also need to tell the engine the characteristics of the thing we are simulating. We need the physical properties of arrows, or bullets, or crates, and so on.

This is an important distinction. The physics engine is basically a big calculator: it does the mathematics needed to simulate physics. But it doesn't know what needs to be simulated. In addition to the engine we also need game-specific data that represents the objects in our level.

Although we'll look at the kind of data we need throughout this book, I won't focus on how the data gets into the game. In a commercial game, there will likely be some kind of level-editing tool that allows level designers to place crates, flags, ragdolls, or aeroplanes to set their weight, the way they move through the air, their buoyancy, and so on. For a physics engine driving a flight simulator, the data may have to be acquired from real aircraft capabilities. For simpler games, it may be hardcoded somewhere in the source code.

The physics engine we'll be developing throughout this book needs gradually more and more data to drive it. I'll cover in depth what kind of data this is, and reasonable values it can take, but for our purposes we will assume this data can be provided to the engine. It is beyond the scope of the book to consider the tool chain that you will use to author these properties for the specific objects in your game.

1.2.1 ADVANTAGES OF A PHYSICS ENGINE

There are two compelling advantages for using a physics engine in your games. First, there is the time savings. If you intend to use physics effects in more than one game

(and you'll probably be using them in most of your games from now on), then putting the effort into creating a physics engine now pays off when you can simply import it into each new project. A lightweight, general-purpose physics system, of the kind we develop in this book, doesn't have to be difficult to program either. A couple of thousand lines of code will set you up for most of the game effects you need.

The second reason is quality. You will most likely be including more and more physical effects in your game as time goes on. You could implement each of these as you need it, such as building a cloth simulator for capes and flags, and a water simulator for floating boxes, and a separate particle engine. Each might work perfectly, but you would have a very hard time combining their effects. When the character with a flowing cloak comes to stand in the water, how will her clothes behave? If they keep blowing in the wind even when underwater, then the illusion is spoiled.

A physics engine provides you with the ability to have effects interact in believable ways. Remember the moveable crates in Half-Life 1? They formed the basis of only one or two puzzles in the game. When it came to Half-Life 2, crate physics was replaced by a full physics engine. This opens up all kinds of new opportunities. The pieces of a shattered crate float on water, objects can be stacked and used as moveable shields, and so on.

It's not easy to create a physics engine to cope with water, wind, and clothes, but it's much easier than trying to take three separate ad-hoc chunks of code and make them look good together in all situations.

1.2.2 WEAKNESSES OF A PHYSICS ENGINE

This isn't to say that a physics engine is a panacea. There are reasons that you might not want to use a full physics engine in your game.

The most common reason is speed. A general-purpose physics engine is quite processor-intensive. Because it has to be general, it can make no assumptions about the kinds of objects it is simulating. When you are working with a very simple game environment, this generality can mean wasted processing power. This isn't an issue on modern consoles or the PC, but on handheld devices such as phones and PDAs, it can be significant. You could create a pool game using a full physics engine on a PC, but the same game on a mobile phone would run faster with some specialized pool physics.

The need to provide the engine with data can also be a serious issue. In a game that I worked on we needed no physics other than flags waving in the wind. We could have used a commercial physics engine (one was available to the developer), but the developer would need to have calculated the properties of each flag, its mass, springiness, and so on. This data would then need to be fed into the physics engine to get it to simulate the flags.

There was no suitable level-design tool that could be easily extended to provide this data, so instead we created a special bit of code just for flag simulation, the characteristics of flags were hardcoded in the software, and the designer needed to do

nothing special to support it. We avoided using a physics engine because special-case code was more convenient.

A final reason to avoid physics engines is scope. If you are a one-person hobbyist working on your game in the evenings, then developing a complete physics solution might take your time away from improving other aspects of your game, such as the graphics or game play. Or worse, it might distract you from finishing, releasing, and promoting your game. On the other hand, even amateur games need to compete with commercial titles for attention, and top-quality physics is a must for a top-quality title of any kind.

1.3 APPROACHES TO PHYSICS ENGINES

There are several different approaches to building a physics engine. From the very simple (and wrong) to the cutting-edge physics engines of top middleware companies. Creating a usable engine means balancing the complexity of the programming task with the sophistication of the effects you need to simulate.

There are a few broad distinctions we can make to categorize different approaches.

1.3.1 TYPES OF OBJECTS

The first distinction is between engines that simulate full rigid bodies or so-called "mass aggregate" engines. Rigid-body engines treat objects as a whole, and work out the way they move and rotate. A crate is a single object, and can be simulated as a whole. Mass aggregate engines treat objects as if they were made up of lots of little masses. A box might be simulated as if it were made up of eight masses, one at each corner, connected by rods.

Mass aggregate engines are easier to program because they don't need to understand rotations. A large amount of effort is needed to support rotations, and it forms a sizable chunk of this book. Mass aggregate engines treat each mass as if it were located at a single point, and the equations of motion can be expressed purely in terms of linear motion. The whole object rotates naturally as a result of the connections between masses.

Because it is very difficult to make things truly rigid in a physics engine, it is difficult to make really firm objects in a mass aggregate system. Our eight-mass crate will have a certain degree of flex in it. To avoid this being visible to the player, extra code is needed to reconstruct the rigid box from the slightly springy set of masses. While the basic mass aggregate system is very simple to program, these extra checks and corrections are more hit and miss, and very quickly the engine becomes a mess of fixes and ugly code.

Fortunately, we can extend a mass aggregate engine into a full rigid-body system, simply by adding rotations. In this book, we will develop a mass aggregate physics engine on the way to a full rigid-body physics engine. Because we are heading for a

more robust engine, I won't spend the time creating the correction code for springy aggregates.

1.3.2 Contact Resolution

The second distinction involves the way in which touching objects are processed. As we'll see in this book, a lot of the difficulty in writing a rigid-body physics engine is simulating contacts—locations where two objects touch or are connected. This includes objects resting on the floor, objects connected together, and, to some extent, collisions.

One approach is to handle these contacts one by one, making sure each works well on its own. This is called the "iterative" approach and it has the advantage of speed. Each contact is fast to resolve, and with only a few tens of contacts, the whole set can be resolved quickly. It has the downside that one contact can affect another, and sometimes these interactions can be significant. This is the easiest approach to implement, and can form the basics of more complex methods. It is the technique we will use in the engine in this book.

A more physically realistic way is to calculate the exact interaction between different contacts and calculate an overall set of effects to apply to all objects at the same time. This is called a "Jacobian-based" approach,[1] but it is very time consuming. The mathematics needed to process the Jacobian is very complex, and solving the equations can involve millions of calculations. In some cases there is simply no valid answer and the developer needs to add special code to fall back on when the equations can't be solved. Most physics middleware packages and several open-source physics engines use this approach, and each has its own techniques for solving the equations and dealing with inconsistencies.

A third option is to calculate a set of equations based on the contacts and constraints between objects. Rather than use Newton's laws of motion, we can create our own set of laws for the specific configuration of objects we are dealing with. These equations will change from frame to frame, and most of the effort for the physics engine goes into creating them (even though solving them is no picnic either). This is called a "reduced coordinate" approach. Some physics systems have been created with this approach, and it is the most common one used in engineering software to achieve really accurate simulation. Unfortunately, it is very slow, and isn't very useful in games, where speed and believability are more important than accuracy.

We'll return to the Jacobian and reduced coordinate approaches in Chapter 20, after we've looked at the physics involved in the first approach.

1.3.3 Impulses and Forces

The third distinction is in how the engine actually resolves contacts. This takes a little explaining, so bear with me.

1. The "Jacobian" itself is a way of mathematically representing the effects of one contact on another.

When a book rests on a table, the table is pushing the book upwards with a force equal to the gravity pulling it down. If there were no force from the table to the book, then the book would sink into the table. This force is constantly pushing up on the book as long as the book is there. The speed of the book doesn't change.

Contrast this with the way a ball bounces on the ground. The ball collides with the ground, and the ground pushes back on the ball, accelerating the ball upward until it bounces back off the floor with an upward velocity. This change in velocity is caused by a force, but the force acts for such a small fraction of a second that it is easier to think of it as simply a change in velocity. This is called an *impulse*.

Some physics engines use forces for resting contacts and impulses for collisions. This is relatively complex, because it involves treating forces and impulses differently. More commonly physics engines treat everything as a force: impulses are simply forces acting over a very small space of time. This is a "force-based" physics engine and it works in the way the real world does. Unfortunately, the mathematics of forces are more difficult than the mathematics of impulses. Engines that are force-based tend to employ a Jacobian or reduced coordinate approach.

Other engines use impulses for everything: the book on the table is kept there by lots of miniature collisions, rather than a constant force. This is, not surprisingly, called an "impulse-based" physics engine. Each frame of the game, the book receives a little collision that keeps it on the surface of the table until the next frame. If the frame rate slows down dramatically, things lying on surfaces can appear to vibrate. Under most circumstances, however, it is indistinguishable from a forced-based approach. This is the approach we will use in this book, as it is easy to implement, and has the advantage of being very flexible and adaptable. It has been used in several middleware packages, in a large number of the in-house physics systems I have seen, and has been proven in many commercial titles.

1.3.4 WHAT WE'RE BUILDING

In this book I will cover in depth the creation of a rigid-body, iterative, impulse-based physics engine that I call Cyclone. The engine has been written specifically for this book, although it is broadly based on a commercial physics engine I was involved with writing a few years ago.

I am confident that the impulsed-based approach is best for developing a simple, robust, and understandable engine for a wide range of game styles, and for using as a basis for adding more complex and exotic features. It can be used as a foundation for experimenting with other approaches: I've used the skeleton structure to implement a Jacobian force-based engine, for example.

As we move through the book, I will give pointers for various approaches, and Chapter 20 will provide some background to techniques for extending the engine to take advantage of more complex simulation algorithms. While we won't cover other approaches in the same depth, the engine is an excellent starting point for any kind of game physics. You will need to understand the content of this book to be able to create a more exotic system.

1.4 THE MATHEMATICS OF PHYSICS ENGINES

Creating a physics engine involves a lot of mathematics. If you're the kind of person who feels nervous working with math, then you may find some bits hard going. I've tried throughout the book to step through the mathematical background slowly, but unfortunately there's no way to avoid the mathematics entirely.

If you have difficulty following the mathematics, don't worry: you can still use the accompanying source code for the corresponding section. While it is better to understand all of the engine in case you need to tweak or modify it, you can still implement and use it quite successfully without such understanding.

As a quick reference, the mathematical equations and formulas in the book are brought together in Appendix C, for easy location when programming.

If you are an experienced game developer, then chances are you will know a fair amount of 3D mathematics, including vectors, matrices, and linear algebra. If you are relatively new to games, then these topics may be beyond your comfort zone.

In this book I will assume you know some mathematics, and I will cover the rest. If I assume something that you aren't comfortable with, then it would be worthwhile to find a reference book, or look for a web tutorial before proceeding, so that you can stay with the flow of the text.

1.4.1 THE MATH YOU NEED TO KNOW

I'm going to assume that every potential physics developer knows some mathematics.

The most important thing to be comfortable with is algebraic notation. I will introduce new concepts directly in notation, and if you flick through this book you will see many formulas written into the text.

I'll assume you are happy to read an expression such as:

$$x = \frac{4}{t} \sin \theta^2$$

and are able to understand that x, t, and θ are variables, and how to combine them to get a result.

I will also assume you know some basic algebra. You should be able to understand that, if the formula above is correct, then

$$t = \frac{4}{x} \sin \theta^2$$

These kinds of algebraic manipulations will pop up throughout the book without explanation.

Finally, I'll assume you are familiar with trigonometry and coordinate geometry: sines, cosines, tangents, their relationship to the right-angled triangles, and to two-dimensional geometry in general.

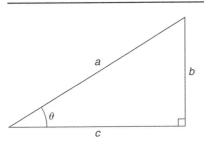

FIGURE 1.1 Trigonometry and coordinate geometry.

In particular, you should know that if we have the triangle shown in Figure 1.1, then these formulas hold:

$$b = a \sin \theta$$

$$c = a \cos \theta$$

$$b = c \tan \theta$$

Especially when a is of length 1, we will use these results tens of times in the book without further discussion.

1.4.2 THE MATH WE'LL REVIEW

Because the experience of developers varies so much, I will not assume you are familiar with three-dimensional mathematics to the same extent. This isn't taught in high schools and is often quite specialized to computer graphics. If you are a long-standing game developer, then you will be able to skip through these reviews as they arise.

We will cover the way that vectors work in the next chapter, including the way a three-dimensional coordinate system relates to the 2D mathematics of high school geometry. I will review the way that vectors can be combined, including the scalar and vector product, and their relationship to positions and directions in three dimensions.

We will also review matrices. Matrices are used both to transform vectors, representing movement in space, or to change other matrices from one set of coordinates into another. We will also see matrices called *tensors* at a couple of points, which have different uses but the same structure. We will review the mathematics of matrices, including matrix multiplication, the transformation of vectors, and matrix inversion.

These topics are fundamental to any kind of 3D programming, and are used extensively in graphics development, and in many AI algorithms too. I assume that most readers will be at least a little familiar with them, and there are comprehensive books available that cover them in great depth.

Each of these topics is reviewed lightly once in the book, but afterwards I'll assume that you are happy to see the results used directly. They are the bread and butter topics for physics development, so it would be inconvenient to step through them each time they arise.

If you find later sections difficult, rereading the reviews is worthwhile, as well as finding a more comprehensive reference to linear algebra or computer graphics, and teaching yourself how they work.

1.4.3 THE MATH I'LL INTRODUCE

Finally, there is a good deal of mathematics that you may not have discovered unless you have done some physics programming in the past. This is the content I'll try not to assume you know, and cover in more depth.

At the most well-known end of the spectrum this includes quaternions, a vector-like structure that represents the orientation of an object in 3D space. We will take some time to understand why such a strange structure is needed, and how it can be manipulated, converted into a matrix, combined with other quaternions, and affected by rotations.

We will also need to cover vector calculus, or the way vectors change with time and through space. Most of the book requires only simple calculus—numerical integration and first-order differentiation. The more complex physics approaches of Chapter 20 get considerably more exotic, including both partial differentials and differential operators. Fortunately, we will have completely built the physics engine by this point, so the content is purely optional.

Finally, we will cover a few more advanced topics in matrix manipulation. In particular, resolving contacts in the engine development involves changing the coordinates of existing transform matrices. This kind of manipulation is rarely needed in graphics development, so it will be covered in some depth in the relevant section.

1.5 THE SOURCE CODE IN THE BOOK

Throughout the book the source code from the Cyclone physics engine is given in the text. The complete engine is available on the accompanying website, but repeating the code in the text has allowed me to comment more fully on how it works.

The latest Cyclone source, including errata and new features, is available at its own site, http://www.procyclone.com. It is also hosted on Google's open-source code website at: http://code.google.com/p/game-libraries/. Check the site from time to time for the latest release of the package.

In each section of the book, we will cover the mathematics or concepts needed, and then view them in practice in code. I'd encourage you to try to follow the equations or algorithms in the code, and find how it has been implemented.

I have used an object-oriented design for the source code, and always tried to err on the side of clarity. The code is contained within a cyclone namespace, and its layout is designed to make naming clashes unlikely.

I have used C++ throughout the code. This is still the most common programming language used for game development worldwide. I'm aware, however, that over the last few years, C++ has become less exclusive. With the advent of a wide range of gaming platforms and coding environments, it is no longer C++ or nothing. I know of readers of the first edition who implemented the engine in languages ranging from Microsoft's C# and Apple's Objective-C, through Adobe's Actionscript for Flash, to high-level dynamic languages such as Javascript and Python. I have therefore revised and extended Chapter 19 in this edition, which discusses implementation for a range of languages.

There are many parts of the engine that can be optimized, or rewritten, to take advantage of mathematics hardware on consoles, graphics cards, and some PC processors. If you need to eke out every ounce of speed from the engine, you will find that you need to optimize some of the code to make it less clear and more efficient. Chances are, however, it will be perfectly usable as is. It has a strong similarity to code I have used in real game development projects, that has proved to be easily fast enough to cope with reasonably complex physics tasks.

There are a number of demonstration programs in the source code, and I will use them as case studies in the course of the book. The demonstrations were created to show off physics rather than graphics, so I've tried to use the simplest graphics output possible. The source code is based on the GLUT toolkit, which wraps OpenGL in a platform-independent way. The graphics tend to be as simple as possible, as in calling GLUT's built-in commands for drawing cubes, spheres, and other primitives. This selection doesn't betray any bias on my part and you should be able to transfer the physics so that it works with whatever rendering platform you are using.

The license for your use of the source code is the MIT license. It is designed to allow it to be used in your own projects, but it is not copyright-free. Please read through the software license accompanying the source code for more details.

It is my hope that although the source code will provide a foundation, you'll implement your own physics system as we go. I make decisions throughout this book about my implementation, and chances are that you'll make different decisions at least some of the time. My aim is to give you enough information to understand the decision, and to go a different route if you want to.

1.6 How the Book Is Structured

We will build our physics engine in stages, starting with the simplest engine that is useful and adding new functionality until we have a system capable of running the physics in your game.

The book is split into six sections:

- In Particle Physics, we look at building our initial physics engine, including the basic vector mathematics and the laws of motion for particles.

- The Mass Aggregate Physics section turns the particle physics engine into one capable of simulating any kind of object by connecting masses together with springs and rods.

- In Rigid-Body Physics, rotation and the added complexity of rotational forces are introduced. Overall, the physics engine we end up with is less powerful than the mass aggregate system we started with, but is useful in its own right and as a basis for the final stage.

- The Collision Detection section takes a detour from building engines to look at how the collisions and contacts are generated. A basic collision detection system is built, allowing us to look at general techniques.

- The Contact Physics section is the final stage of our engine, adding collisions and resting contacts to the engine and allowing us to apply the result to almost any game.

- Finally, in Horizons we look beyond the engine we have built. In Chapter 20 we examine means of extending the engine to take advantage of other approaches, without providing the detailed step-by-step source code to do so.

As we begin each part, the content will be quite theoretical, and it can be sometimes difficult to immediately see the kinds of physical effects that the technology supports. At the end of each part, there is a chapter with the payoff, showing ways in which our new functionality may be used in a game. As we go through the book we start with engines controlling fireworks and bullets, and end up with ragdolls and cars.

1.6.1 EXERCISES AND PROJECTS

At the end of most chapters, particularly those that introduce new technical content, there is a set of exercises. These are designed to solidify the new concepts introduced in that chapter and to allow you to think about other implications of what you've learned. The chapter exercises are typically quite narrow and focused.

At the end of each part of the book, I've included some additional exercises and project suggestions. These are designed to be broader and bring together the content of that part into something practical. I've split this content into further exercises, mini-projects, and game projects.

The mini-projects are typically implementation challenges. They are suitable as an exercise over a week or two, or as a homework assignment in a course on game physics. I've tried to indicate the difficulty of these projects using a three-star system. One star is a project that should be relatively simple and accessible for all. I've reserved one star for projects that tweak the code in fairly predictable or minor ways, or that merely apply it to a new scenario. Three stars indicates a problem that requires novel thinking,

or modifications to the core algorithms or mathematics beyond what is introduced in the chapter. It should be suitable for readers who really want to stretch themselves.

The game projects give suggestions for how to use the physics engine developed so far in a complete game, showing off the physics as much as possible. These projects will take longer, and can be used as an end-of-semester project, or as inspiration for a complete game.

For all the projects in this book there is no right or wrong answer: you decide how much or how little you want to develop the physics. I hope they will provide a framework for applying the content of the book. One of the challenges of learning a whole new area, like game physics, is seeing how to apply it as you go, without having to learn everything there is to know before you start.

PART I

Particle Physics

2

THE MATHEMATICS OF PARTICLES

Before we look at simulating the physics of particles, this chapter reviews 3D mathematics. In particular, it looks at vector mathematics and vector calculus, the fundamental building blocks on which all our physics code will be built. I'll avoid some of the harder topics that we'll only need later. Matrices and quaternions, for example, will not be needed until Chapter 9, so I'll postpone reviewing them until that point.

2.1 VECTORS

Most of the mathematics we are taught at school deals with single numbers, such as a number to represent how many apples we have, or the time it takes for a train to make a journey, or the numerical representation of a fraction. We can write algebraic equations that tell us the value of one number in terms of others. If $x = y^2$ and $y = 3$, then we know $x = 9$. This kind of single number on its own is called a scalar value. One particular scalar value is a number chosen from the whole range of possible numbers.

Scalar values have properties that we are very familiar with: they can be added, multiplied, raised to powers, and so on. The rules for carrying out those operations are taught to us from the first day of school.

Vectors have similarities to scalar values. They are also chosen from a whole set of possible vectors, we choose them to represent things, and we define operators that manipulate them according to specific rules.

Copyright © 2010, Elsevier Inc. All rights reserved.
DOI: 10.1016/B978-0-12-381976-5.00002-4

Mathematically, a vector is an element in a set called a *vector space*, a structure that displays certain mathematical properties for addition and multiplication. There are many different kinds of vector spaces with wildly different properties, but for our purposes the only vector spaces we're interested in are regular (called Euclidean) 2D and 3D space. In this case the vectors we choose can represent features of that space, such as position, speed and direction of movement, acceleration, and so on.

Because vectors have a range of operations (addition, multiplication, etc.), we can write them in algebraic equations: $x = 2y$, for example, where x and y are vectors (and the number 2 is just a scalar value). Over the course of this chapter, we'll look at these operations and how they work, building up our ability to do math with vectors.

Vectors can be thought of as abstract values, but we're interested in coding them, so we'll need a concrete representation. In this book we will represent a vector as an ordered list of scalar values. This will allow us to define our operations on the vector in terms of how its constituent scale values are manipulated. So if y is a vector (let's say it contains the numbers 2 and 3), and $x = 2y$, then x will also be a vector of two numbers, in this case 4 and 6.

Vectors can undergo some of the same mathematical operations as scalars, including multiplication, addition, and subtraction. Some of these work in a slightly different way to scalar values, and some operations that make sense for scalars (such as division) aren't defined for vectors.

Note that when I talk about vectors in this book, I am referring only to this mathematical structure. Many programming languages have a vector data structure that is some kind of growable array. The name comes from the same source (a set of values, rather than just one), but that's where the similarities stop. On the few occasions in this book where I need to refer to a growable array, I will call it that, to keep the name "vector" reserved for the mathematical concept. Few languages have a built-in vector class to represent the kind of vector we are interested in, so we'll create one as we go.

One convenient application of vectors is to represent locations in space. Figure 2.1 shows two locations in 3D space. The position can be represented by three coordinate values, one for the distance from a fixed origin point along each of three axes at right angles to one another. This is called a Cartesian coordinate system, named for the mathematician and philosopher Rene Descartes who invented it. There are other ways of specifying coordinates, but we will use Cartesian coordinates throughout the book.

We group the three coordinates together into a vector, written as

$$a = \begin{bmatrix} x \\ y \\ z \end{bmatrix}$$

where x, y, and z are the coordinate values along the X, Y, and Z axes. Note the a notation. This indicates that a is a vector; we will use this notation throughout the book to make it easy to discriminate between vector and scalar values.

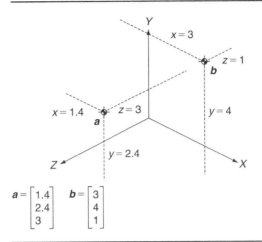

FIGURE 2.1 3D coordinates.

Every vector specifies a unique position in space, and every position in space has only one corresponding vector. We will use only vectors to represent positions in space.

We can begin to implement a class to represent vectors. I have called this class Vector3 to clearly separate it from any other Vector class in your programming language (seeing the name Vector on its own is particularly confusing for Java programmers).

```
──────── Excerpt from file include/cyclone/core.h ────────
namespace cyclone {
    /**
     * Holds a vector in three dimensions. Four data members are
       allocated
     * to ensure alignment in an array.
    class Vector3
    {
    public:
        /** Holds the value along the x axis. */
        real x;

        /** Holds the value along the y axis. */
        real y;

        /** Holds the value along the z axis. */
        real z;
```

```
    private:
        /** Padding to ensure four word alignment. */
        real pad;

    public:
        /** The default constructor creates a zero vector. */
        Vector3() : x(0), y(0), z(0) {}

        /**
         * The explicit constructor creates a vector with the given
         * components.
         */
        Vector3(const real x, const real y, const real z)
            : x(x), y(y), z(z) {}
        /** Flips all the components of the vector. */
        void invert()
        {
            x = -x;
            y = -y;
            x = -z;
        }
    };
```

```
────────────────── Excerpt from file include/cyclone/precision.h ──────────────
namespace cyclone {
    /**
     * Defines a real number precision. Cyclone can be compiled in
     * single- or double-precision versions. By default, single
     * precision is provided.
     */
    typedef float real;
}
```

There are a few things to note about this source code.

- All the code is contained within the cyclone namespace, as promised in the first chapter. This makes it easier to organize code written in C++, and in particular it makes sure that names from several libraries will not clash. Wrapping all the code samples in the namespace declaration is a waste of time, however, so in the remaining exerpts in this book, I will not show the namespace explicitly.

- Also to avoid clashing names, I have placed the header files in the directory include/cyclone/, with the intention of having the include/ directory on the

include path for a compiler (see your compiler's documentation for how to achive this). This means that to include a header we will use an include of the format:

```
#include <cyclone/core.h>
```

or

```
#include "cyclone/core.h"
```

I find this to be a useful way of ensuring that the compiler knows which header to bring in, especially with large projects that are using multiple libraries, several of which may have the same name for multiple header files (I have at least four `math.h` headers that I use regularly in different libraries, which is part of my motivation for putting our mathematics code in a header called `core.h`).

■ I have used `real` rather than `float` to reserve the storage for my vector components. The real data type is a `typedef`, contained in its own file (`precision.h`). I've done this to allow the engine to be rapidly compiled in different precisions. In most of the work I've done, `float` precision is fine, but it can be a huge pain to dig through all the code if you find you need to change to `double` precision later. You may have to do this if you end up with numerical rounding problems that won't go away (they are particularly painful if you have objects with a wide range of different masses in the simulation). By consistently using the `real` data type, we can easily change the precision of the entire engine by changing the type definition once. We will add to this file additional definitions for functions (such as `sqrt`) that come in both `float` and `double` forms.

■ I've added an extra piece of data into the vector structure, called `pad`. This isn't part of the mathematics of vectors, and is purely there for performance. On many machines, four floating-point values sit more cleanly in memory than three (memory is optimized for sets of four words), so noticeable speed-ups can be achieved by adding this padding.

Your physics engine shouldn't rely on the existence of this extra value for any of its functionality. If you are programming for a machine that you know is highly memory limited, and doesn't optimize in sets of four words, then you can remove `pad` safely.

2.1.1 THE HANDEDNESS OF SPACE

If you are an experienced game developer you will have spied a contentious assumption in Figure 2.1. The figure shows the three axes arranged in a right-handed coordinate system.

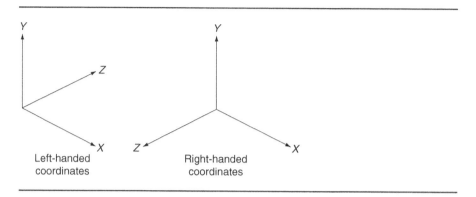

FIGURE 2.2 Left- and right-handed axes.

There are two different ways that we can arrange three axes at right angles to one another: in a left-handed way or a right-handed way,[1] as shown in Figure 2.2.

You can tell which is which using your hands: make a gun shape with your hand, thumb and extended forefinger at right angles to one another. Then, keeping your ring finger and pinky curled up, extend your middle finger so that it is at right angles to the first two. If you label your fingers with the axes in order (thumb is X, forefinger Y, and middle finger Z), then you have a complete set of axes, whether right- or left-handed.

Some people prefer to think of this in terms of the direction that a screw is turned, but I find making axes with my hands much simpler.

Game engines, rendering toolkits, and modeling software use either left- or right-handed axes. There is no dependable standard. DirectX favors a left-handed coordinate system, while OpenGL favors a right-handed system. XBox 360, being DirectX based, is left-handed, Wii, being rather OpenGL-like, is right-handed, and PlayStation's sample code is right-handed, although most developers create their own rendering code. On any platform you can actually use either one with a bit more effort (this is how cross-platform game engines use a consistent system on every platform). For a detailed explanation of various systems and converting between them, see Eberly [2003].

There are relatively few places where it matters which system we use, as it certainly doesn't change the physics code in any way. I have (fairly arbitrarily) chosen right-handed coordinates throughout this book. Because the demonstration code is designed to work with OpenGL, this makes things slightly easier.

If you are working on a DirectX-only project and are keen to stay with a left-handed system, then you'll need to make the occasional adjustment in the code. I'll try to indicate places where this is the case.

1. Strictly speaking, this handedness is called "chirality," and each alternative is a "enantiomorph," although those terms are rarely if ever used in game development.

2.1.2 VECTORS AND DIRECTIONS

In the previous section, I said that vectors represent quantities in 2D or 3D space. The most obvious quantity they represent is a position. Just as importantly, a vector can represent the change in position. Figure 2.3 shows an object that has moved in space from position a_0 to a_1. We can write down the change in position as a vector where each component of the vector is the change along each axis. So,

$$a = \begin{bmatrix} \Delta x \\ \Delta y \\ \Delta z \end{bmatrix}$$

where Δx is the change in the position along the X axis from a_0 to a_1, given by

$$\Delta x = x_1 - x_0$$

where x_0 is the X coordinate of a_0 and x_1 is the X coordinate of a_1, and similarly for Δy and Δz.

Position and change in position are really two sides of the same coin. We can think of any position as a change of position from the origin (written as **0**, where each component of the vector is zero) to the target location.

If we think in terms of the geometry of a vector being a movement from the origin to a point in space, then many of the mathematical operations we'll meet in this chapter have obvious and intuitive geometric interpretations. Vector addition, subtraction, multiplication by a scalar, and different vector products, can all be understood

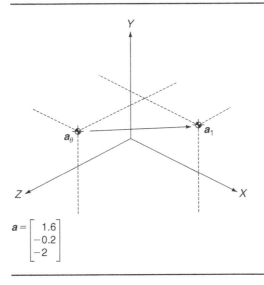

$$a = \begin{bmatrix} 1.6 \\ -0.2 \\ -2 \end{bmatrix}$$

FIGURE 2.3 A vector as a movement in space.

in terms of how these changes in position relate. When drawn as in Figure 2.3, the visual representation of an operation is often much more intuitive than its list of coordinates. We'll consider this for each operation we meet.

A change in position, given as a vector, can be split into two elements:

$$a = dn \qquad [2.1]$$

where d is the straight-line distance of the change (called the "magnitude" of the vector), and n is the direction of the change. The vector n represents a change, whose straight-line distance is always 1, in the same direction as the vector a. The vector n is often called the "unit vector," since its magnitude is always 1.

We can find d using the 3D version of Pythagoras's theorem, which has the formula,

$$d = |a| = \sqrt{x^2 + y^2 + z^2}$$

where x, y, and z are the three components of the vector and $|a|$ is the magnitude of a vector.

We can use Equation 2.1 to find n:

$$\widehat{a} = n = \frac{1}{d}\,a \qquad [2.2]$$

where \widehat{a} is a common (but not universal) notation for the unit vector in the direction of a. The equation is sometimes written as:

$$\widehat{a} = \frac{a}{|a|}$$

The process of finding just the direction n from a vector is called "normalizing," and the result of decomposing a vector into its two components is sometimes called the normal form of the vector (i.e., dn is the normal form of a in the above equations). This decomposition will be a common requirement in our code.

We can add functions to find the magnitude of the vector and its direction, and to perform a normalization:

```
──────────────── Excerpt from file include/cyclone/core.h ────────────────
class Vector3
{
    // ... Other Vector3 code as before ...
    /** Gets the magnitude of this vector. */
    real magnitude() const
    {
        return real_sqrt(x*x+y*y+z*z);
    }

    /** Gets the squared magnitude of this vector. */
    real squareMagnitude() const
    {
```

```
        return x*x+y*y+z*z;
    }
    /** Turns a non-zero vector into a vector of unit length. */
    void normalize()
    {
        real l = magnitude();
        if (l > 0)
        {
            (*this) *= ((real)1)/l;
        }
    }
};
```

Note that I've also added a function to calculate the square of the magnitude of a vector. This is a faster process, because it avoids the call to sqrt which can be slow on some machines. In some cases, we don't need the exact magnitude; for example, we may just need to compare two magnitudes to see which is greater. In these cases the square of the magnitude will do and we can omit the square root. For this reason it is common to see a squared magnitude function in a vector implementation.

2.1.3 SCALAR AND VECTOR MULTIPLICATION

In the normalization equations, I have assumed that we can multiply a scalar $(1/d)$ by a vector. This is our first vector operation, which is a simple process given by:

$$ka = k \begin{bmatrix} x \\ y \\ z \end{bmatrix} = \begin{bmatrix} kx \\ ky \\ kz \end{bmatrix}$$

In other words, we multiply a vector by a scalar by multiplying all the components of the vector by the scalar.

To divide a vector by a scalar, we make use of the fact that

$$a \div b = a \times \frac{1}{b}$$

so

$$\frac{a}{k} = \frac{1}{k} a$$

which is how we arrived at the normalization Equation 2.2 from Equation 2.1.

This formula also lets us define the additive inverse of a vector:

$$-a = -1 \times a = \begin{bmatrix} -x \\ -y \\ -z \end{bmatrix}$$

We can overload the multiplication operator `*=` in C++ to support these operations, with the following code in the `Vector3` class.

```
─────── Excerpt from file include/cyclone/core.h ───────
class Vector3
{
    // ... Other Vector3 code as before ...
    /** Multiplies this vector by the given scalar. */
    void operator*=(const real value)
    {
        x *= value;
        y *= value;
        z *= value;
    }

    /** Returns a copy of this vector scaled the given value. */
    Vector3 operator*(const real value) const
    {
        return Vector3(x*value, y*value, z*value);
    }
};
```

Geometrically, multiplication of a vector by a scalar changes the length of the vector. This is shown in Figure 2.4.

The direction of the vector doesn't change. If a vector has a length of k, we can write it in normal form as

$$a = dn$$

Then multiplication by a scalar gives

$$ka = kdn$$

The resulting vector is in the same direction, but now has a length of kd.

$x2 =$

FIGURE 2.4 The geometry of scalar-vector multiplication.

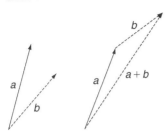

FIGURE 2.5 The geometry of vector addition.

2.1.4 VECTOR ADDITION AND SUBTRACTION

Geometrically, adding two vectors together is equivalent to placing them end to end. The result is the vector from the origin of the first to the end of the second, shown in Figure 2.5. Similarly, subtracting one vector from another places the vectors end to end, but the vector being subtracted is placed so that its tip touches the end of the first. In other words, to subtract vector b from vector a, we first go forward along a, then go backward along b.

In code it is very easy to add vectors or subtract them. For two vectors a and b, their sum is given by

$$a + b = \begin{bmatrix} a_x \\ a_y \\ a_z \end{bmatrix} + \begin{bmatrix} b_x \\ b_y \\ b_z \end{bmatrix} = \begin{bmatrix} a_x + b_x \\ a_y + b_y \\ a_z + b_z \end{bmatrix}$$

where a_x, a_y, and a_z are the x, y, and z components of the vector a. We will normally use this notation for the components of a vector, rather than x, y, and z. This avoids confusion when dealing with more than one vector.

Vector addition is achieved by adding the components of the two vectors together. This can be implemented using the + operator in C++.

```
────────── Excerpt from file include/cyclone/core.h ──────────
class Vector3
{
    // ... Other Vector3 code as before ...
    /** Adds the given vector to this. */
    void operator+=(const Vector3& v)
    {
        x += v.x;
        y += v.y;
```

```
        z += v.z;
    }

    /** Returns the value of the given vector added to this. */
    Vector3 operator+(const Vector3& v) const
    {
        return Vector3(x+v.x, y+v.y, z+v.z);
    }
};
```

In the same way, vector subtraction is also performed by subtracting the components of each vector:

$$\boldsymbol{a} - \boldsymbol{b} = \begin{bmatrix} a_x \\ a_y \\ a_z \end{bmatrix} - \begin{bmatrix} b_x \\ b_y \\ b_z \end{bmatrix} = \begin{bmatrix} a_x - b_x \\ a_y - b_y \\ a_z - b_z \end{bmatrix}$$

which is implemented in the same way as addition.

─── **Excerpt from file include/cyclone/core.h** ───

```
class Vector3
{
    // ... Other Vector3 code as before ...
    /** Subtracts the given vector from this. */
    void operator-=(const Vector3& v)
    {
        x -= v.x;
        y -= v.y;
        z -= v.z;
    }

    /**
     * Returns the value of the given vector subtracted from this.
     */
    Vector3 operator-(const Vector3& v) const
    {
        return Vector3(x-v.x, y-v.y, z-v.z);
    }
};
```

A final version of addition, which is useful, combines both addition and scaling of a vector. We simply merge the two processes into a single function, allowing us to

add a scaled vector to another vector:

$$\boldsymbol{a} + c\boldsymbol{b} = \begin{bmatrix} a_x \\ a_y \\ a_z \end{bmatrix} + c \begin{bmatrix} b_x \\ b_y \\ b_z \end{bmatrix} = \begin{bmatrix} a_x + cb_x \\ a_y + cb_y \\ a_z + cb_z \end{bmatrix}$$

We could do this in two steps with the functions above, but having it in one place is convenient.

```
                        Excerpt from file include/cyclone/core.h
class Vector3
{
    // ... Other Vector3 code as before ...
    /**
     * Adds the given vector to this, scaled by the given amount.
     */
    void addScaledVector(const Vector3& vector, real scale)
    {
        x += vector.x * scale;
        y += vector.y * scale;
        z += vector.z * scale;
    }
};
```

2.1.5 MULTIPLYING VECTORS

Seeing how easy it is to add and subtract vectors may lull you into a false sense of security. When we come to multiply two vectors, things get considerably more complicated. There are several ways of multiplying two vectors together, and whenever we produce a formula involving vector multiplication we will have to specify which type of multiplication to use.

In algebra for scalar values, there is only one kind of multiplication. We write this in various ways, either with no symbol at all (ab), with a dot ($a \cdot b$), or with a multiplication symbol ($a \times b$).

With vectors these three notations have different meanings, and we have to be more precise. Using no symbol usually denotes a type of multiplication that we will not need to cover (the vector direct product; see a good mathematical encyclopedia for information). I will not write \boldsymbol{ab} in this book. The two other notations that we will encounter are called the *scalar product* ($\boldsymbol{a} \cdot \boldsymbol{b}$) and the *vector product* ($\boldsymbol{a} \times \boldsymbol{b}$). First, however, we'll meet a fourth way of multiplying vectors that uses none of these symbols.

2.1.6 THE COMPONENT PRODUCT

The most obvious product is the least useful: the component product, written in this book as ∘ (it does not have a universal standard symbol the way the other products do). It is used in several places in the physics engine, but despite being quite obvious, it is rarely mentioned in books on vector mathematics. This is because it doesn't have a simple geometric interpretation—if the two vectors being multiplied together represent positions, then it isn't clear geometrically how their component product is related to their locations. This isn't true of the other types of product, as we'll see.

The component product is formed in the same way as vector addition and subtraction, by multiplying each component of the vector together.

$$
\boldsymbol{a} \circ \boldsymbol{b} = \begin{bmatrix} a_x \\ a_y \\ a_z \end{bmatrix} \circ \begin{bmatrix} b_x \\ b_y \\ b_z \end{bmatrix} = \begin{bmatrix} a_x b_x \\ a_y b_y \\ a_z b_z \end{bmatrix}
$$

Note that the end result of the component product is another vector. This is exactly the same as for vector addition and subtraction, and for multiplication by a scalar: all end up with a vector as a result.

Because it is not commonly used, we will implement the component product as a method rather than an overloaded operator. We will reserve overloading the * operator for the next type of product. The method implementation looks like the following:

```
                    ——— Excerpt from file include/cyclone/core.h ———
class Vector3
{
    // ... Other Vector3 code as before ...
    /**
     * Calculates and returns a component-wise product of this
     * vector with the given vector.
     */
    Vector3 componentProduct(const Vector3 &vector) const
    {
        return Vector3(x * vector.x, y * vector.y, z * vector.z);
    }

    /**
     * Performs a component-wise product with the given vector and
     * sets this vector to its result.
     */
    void componentProductUpdate(const Vector3 &vector)
    {
        x *= vector.x;
```

```
            y *= vector.y;
            z *= vector.z;
        }
    };
```

2.1.7 THE SCALAR PRODUCT

By far the most common product of two vectors is called the *scalar product*. It is different from any of our previous vector operations because its result is not a vector, but rather a single scalar value (hence its name). It is written using a dot symbol, as in *a · b*, and so is often called the *dot product*. For reasons beyond the scope of this book, it is also more mathematically called the *inner product*, a term I will not use again.

The dot product is calculated with the following formula:

$$\boldsymbol{a} \cdot \boldsymbol{b} = \begin{bmatrix} a_x \\ a_y \\ a_z \end{bmatrix} \cdot \begin{bmatrix} b_x \\ b_y \\ b_z \end{bmatrix} = a_x b_x + a_y b_y + a_z b_z \qquad [2.3]$$

In my vector class, I have used the multiplication operator * to represent the dot product (it looks quite like a dot, after all). We could overload the dot operator, but in most C-based languages it controls access to data within an object, and so overloading it is either illegal or a dangerous thing to do.

The scalar product methods have the following form:

─────────── Excerpt from file include/cyclone/core.h ───────────

```
class Vector3
{
    // ... Other Vector3 code as before ...
    /**
     * Calculates and returns the scalar product of this vector
     * with the given vector.
     */
    real scalarProduct(const Vector3 &vector) const
    {
        return x*vector.x + y*vector.y + z*vector.z;
    }

    /**
     * Calculates and returns the scalar product of this vector
     * with the given vector.
     */
    real operator *(const Vector3 &vector) const
```

```
    {
        return x*vector.x + y*vector.y + z*vector.z;
    }
};
```

Note that there is no in-place version of the operator (i.e., no *= operator). This is because the result is a scalar value, and in most languages an instance of a class can't change which class it belongs to—the vector can't become a scalar.

I have also added a full method version, `scalarProduct`, in case you are more comfortable writing things longhand rather than remembering the slightly odd behavior of the * operator.

The Trigonometry of the Scalar Product

There is an important result for scalar products that is not obvious from the formula above. It relates the scalar product to the length of the two vectors and the angle between them:

$$\boldsymbol{a} \cdot \boldsymbol{b} = a_x b_x + a_y b_y + a_z b_z = |\boldsymbol{a}||\boldsymbol{b}| \cos \theta \qquad [2.4]$$

where θ is the angle between the two vectors.

So if we have two normalized vectors, $\widehat{\boldsymbol{a}}$ and $\widehat{\boldsymbol{b}}$, then the angle between them is given by Equation 2.4 as:

$$\theta = \cos^{-1}(\widehat{\boldsymbol{a}} \cdot \widehat{\boldsymbol{b}})$$

These must be normalized vectors here. If a and b are just regular vectors, then the angle would be given by:

$$\theta = \cos^{-1}\left(\frac{\widehat{\boldsymbol{a}} \cdot \widehat{\boldsymbol{b}}}{|\boldsymbol{a}||\boldsymbol{b}|}\right)$$

You should be able to convince yourself that Equations 2.3 and 2.4 are equivalent by using the Pythagoras theorem, and constructing a right-angled triangle where each vector is the hypotenuse.

The Geometry of the Scalar Product

The scalar product arises time and again in physics programming. In most cases it is used because it allows us to calculate the magnitude of one vector in the direction of another.

Figure 2.6 shows vectors in two dimensions (for simplicity's sake, there is no difference in three dimensions). Note that vector $\widehat{\boldsymbol{a}}$ has unit length. Vector \boldsymbol{b} is almost at right angles to $\widehat{\boldsymbol{a}}$, so most of its length points away and only a small component is in the direction of $\widehat{\boldsymbol{a}}$. Its component is shown, and despite the fact that \boldsymbol{b} is long, its component in the direction of $\widehat{\boldsymbol{a}}$ is small.

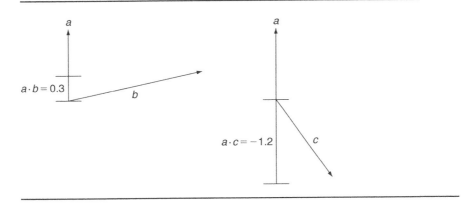

FIGURE 2.6 Geometric interpretation of the scalar product.

Vector **c**, however, is smaller in magnitude, but it is not pointing at right angles to \widehat{a}. Note that it is pointing in almost the opposite direction to \widehat{a}. In this case its component in the direction of \widehat{a} is negative.

We can see this in the scalar products:

$$|\widehat{a}| \equiv 1$$

$$|b| = 2.0$$

$$|c| = 1.5$$

$$\widehat{a} \cdot b = 0.3$$

$$\widehat{a} \cdot b = -1.2$$

If one vector is not normalized, then the size of the scalar product is multiplied by its length (from Equation 2.4). In most cases at least one vector, and often both, will be normalized before performing a scalar product.

When you see scalar products in the physics engines in this book, it will most likely be as part of a calculation that needs to find how much one vector lies in the direction of another.

2.1.8 THE VECTOR PRODUCT

Where the scalar product multiplies two vectors together to give a scalar value, the "vector product" multiplies them to get another vector. In this way it is similar to the component product, but is considerably more common.

The vector product is indicated by a multiplication sign $a \times b$ and so is often called the cross-product. In the same way that the dot product is mathematically called the inner product, the vector product could be called the outer product; as before, I'll avoid using that term.

The vector product is calculated with the formula:

$$\boldsymbol{a} \times \boldsymbol{b} = \begin{bmatrix} a_x \\ a_y \\ a_z \end{bmatrix} \times \begin{bmatrix} b_x \\ b_y \\ b_z \end{bmatrix} = \begin{bmatrix} a_y b_z - a_z b_y \\ a_z b_x - a_x b_z \\ a_x b_y - a_y b_x \end{bmatrix} \qquad [2.5]$$

This is implemented in our vector class in the following way:

```
                    ─── Excerpt from file include/cyclone/core.h ───
class Vector3
{
    // ... Other Vector3 code as before ...
    /**
     * Calculates and returns the vector product of this vector
     * with the given vector.
     */
    Vector3 vectorProduct(const Vector3 &vector) const
    {
        return Vector3(y*vector.z-z*vector.y,
                       z*vector.x-x*vector.z,
                       x*vector.y-y*vector.x);
    }

    /**
     * Updates this vector to be the vector product of its current
     * value and the given vector.
     */
    void operator %=(const Vector3 &vector)
    {
        *this = vectorProduct(vector);
    }

    /**
     * Calculates and returns the vector product of this vector
     * with the given vector.
     */
    Vector3 operator%(const Vector3 &vector) const
    {
        return Vector3(y*vector.z-z*vector.y,
                       z*vector.x-x*vector.z,
                       x*vector.y-y*vector.x);
    }
};
```

To implement this product, I have overloaded the % operator, simply because it looks most like a cross. This operator is usually reserved for modulo division in most languages, so purists may balk at reusing it for something else.

If you are easily offended, you can use the longhand vectorProduct methods instead. Personally, I find the convenience of being able to use operators outweighs any confusion, especially as vectors have no useful notion of division.

The Trigonometry of the Vector Product

Just like the scalar product, the vector product has a trigonometric correspondence. Once again the magnitude of the product is related to the magnitude of its arguments and the angle between them. This time the correspondence is

$$|a \times b| = |a||b|\sin\theta \qquad [2.6]$$

where θ is the angle between the vectors, as before.

This is the same as the scalar product, with the cosine in place of the sine. In fact, we can write

$$|a \times b| = |a||b|\sqrt{1 - (a \cdot b)^2}$$

using the famous trigonometric relationship between cosine and sine,

$$\cos^2\theta + \sin^2\theta = 1$$

We could use Equation 2.6 to calculate the angle between two vectors, just as we did using Equation 2.4 for the scalar product. This would be wasteful, however, since it is much easier to calculate the scalar product than the vector product. So if we need to find the angle (which we rarely do), then using the scalar product would be a faster solution.

Commutativity of the Vector Product

You may have noted in the derivation of the vector product that it is not commutative. In other words, $a \times b \neq b \times a$. This is different from each of the previous products of two vectors, both $a \circ b = b \circ a$ and $a \cdot b = b \cdot a$.

In fact, by comparing the components in Equation 2.5, we can see that

$$a \times b = -b \times a$$

This equivalence will make more sense once we look at the geometrical intepretation of the vector product.

In practice, the noncommutative nature of the vector product means that we need to take care to make sure that the orders of arguments are correct in equations. This is a common error and can manifest itself in the game by objects being sucked into each other, or by bobbing in and out of supposedly solid surfaces.

The Geometry of the Vector Product

Once again, using the scalar product as an example, we can interpret the magnitude of the vector product of a vector and a normalized vector. For a pair of vectors \widehat{a} and b, the *magnitude* of the vector product represents the component of b that is *not* in the direction of \widehat{a}. Again, having a vector a that is not normalized simply gives us a magnitude that is scaled by the length of a. This can be used in some circumstances, but in practice it is a relatively minor result.

Because it is easier to calculate the scalar product than the vector product, if we need to know the component of a vector not in the direction of another vector, we are better performing the scalar product and then using the Pythagoras theorem to give the result,

$$c = \sqrt{1 - s^2}$$

where c is the component of b not in the direction of \widehat{a}, and s is the scalar product $\widehat{a} \cdot b$.

In fact, the vector product is very important geometrically not for its magnitude, but for its *direction*.

In three dimensions, the vector product will point in a direction that is at right angles (i.e., 90°, also called orthogonal) to both of its operands. This is illustrated in Figure 2.7. There are several occasions in this book where it will be convenient to generate a unit vector that is at right angles to other vectors. We can accomplish this easily using the vector product,

$$r = \widehat{a \times b}$$

This interpretation shows us an important feature of the vector product: it is only defined in three dimensions. In two dimensions, there is no possible vector at right angles to two nonparallel vectors. In higher dimensions (which I admit are not very

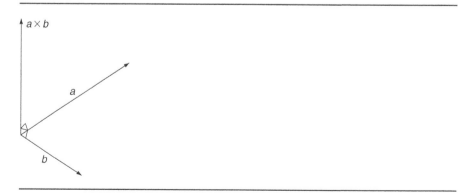

FIGURE 2.7 Geometric interpretation of the vector product.

useful for a game programmer), there are an infinite number of right-angled vectors available. If you are developing a physics engine for a 2D game, you will not have a vector product implementation. The scalar product works for any number of dimensions.

2.1.9 THE ORTHONORMAL BASIS

In some cases we want to construct a triple of mutually orthogonal vectors, where each vector is at right angles to the other two. Typically we want each of the three vectors to be normalized. This kind of triple vector that is both orthogonal and normalized is called an orthonormal basis.

There are a few ways of doing this. The simplest is to use the cross-product to generate the orthogonal vectors.

The process starts with two nonparallel vectors. The first of these two will not have its direction changed at all: call this a. We cannot change its direction during the process, but if it is not normalized, we will change its magnitude. The other vector, b, may not already be at right angles to a, so it may need to have its direction as well as magnitude changed. One constraint on vector b, however, is that it must not be parallel to vector a. If it is parallel, then we cannot find a unique third vector that is at right angles to both a and b—there are an infinite number of such vectors. The third vector, c, is not given at all, as it is determined entirely from the first two.

The algorithm proceeds as follows:

1. Normalize the starting vector a.

2. Find vector c by performing the cross-product $c = a \times b$.

3. If vector c has a zero magnitude, then give up: this means that a and b are parallel.

4. Normalize vector c.

5. Now we need to ensure that a and b are at right angles to one another. We can do this by recalculating b based on a and c using the cross-product, $b = c \times a$ (note the order). The resulting vector b must already be unit length, because both c and a were and we know these are orthogonal.

In code, this algorithm might look like the following:

```
void makeOrthonormalBasis(Vector3 *a, Vector3 *b, Vector3 *c)
{
  a->normalize();
  (*c) = (*a) % (*b);
  if (c.squareMagnitude() == 0.0) return; // Or generate an error.
  c->normalize();
  (*b) = (*c) % (*a);
}
```

This algorithm is a simple way of generating an orthonormal basis from two given axes. When we talk about contact detection and contact resolution later in the book, we will need to create an orthonormal basis, but we'll only have one fixed axis. We'll need to extend this algorithm accordingly.

Note that the construction of an orthonormal basis is a situation where it matters a great deal whether you are working in a left- or right-handed coordinate system. The previous algorithm is designed for right-handed systems. If you need a left-handed coordinate system, then you can simply change the order of the operands for both the cross-products. This will give you a left-handed orthonormal basis.

2.2 CALCULUS

Calculus is a complex field with tendrils that reach into all areas of mathematics. Strictly speaking, "calculus" means any kind of formal mathematical system, but when we talk about "the calculus" we normally mean analysis or the study of the behavior of functions. Real analysis is the most common topic of high school and undergraduate calculus classes, that is, the study of functions that operate on real numbers. We are interested in vector analysis (usually widened to "matrix analysis," of which vectors are just one part). Even this subfield of a subfield is huge, and contains many branches that have filled countless books on their own.

Fortunately for our immediate purpose, we are only interested in a very limited part of the whole picture. We are interested in the way something changes over time such as it might be the position of an object, or the force in a spring or its rotational speed. The quantities we are tracking in this way are mostly vectors (we'll return to the non-vectors later in the book).

There are two ways of understanding changing quantities: we describe the change itself, or we describe the results of the change. If an object is changing position with time, we need to be able to understand how it is changing position (i.e., its speed, the direction it is moving in, whether it is accelerating or slowing), and the effects of the change (i.e., where it will be when we come to render it at the next frame of the game).

These two viewpoints are represented by the differential and integral calculus, respectively. We can look at each in turn.

No code will be provided in this section, as it is intended as a review of the concepts involved. The corresponding code makes up most of the rest of the book, very little of which will make sense unless you grasp the general idea of this section.

2.2.1 DIFFERENTIAL CALCULUS

For our purposes, we can view the differential of a quantity as being the rate that it is changing. In the majority of this book, we are interested in the rate it is changing with respect to time. This is sometimes informally called its "speed," but that term is ambiguous. We will call it by the more specific term, "velocity."

Velocity

Think about the position of an object for a moment. If this represents a moving object, then in the next instance of time, the position of the object will be slightly different.

We can work out the velocity at which the object is moving by looking at the two positions. We could simply wait for a short time to pass, find the position of the object again, and use the formula:

$$v = \frac{p' - p}{\Delta t} = \frac{\Delta p}{\Delta t}$$

where v is the velocity of the object, p' and p are its positions at the first and second measurements (so Δp is the change in position), and Δt is the time that has passed between the two. This would give us the average velocity over the time period.

It wouldn't tell us the exact velocity of the object at any point in time, however. Figure 2.8 shows the position of two objects at different times. Both objects start at the same place, and end at the same place at the same time. Object A travels at a constant velocity, whereas object B stays near its start location for a while, then zooms across the gap very quickly. Clearly they aren't traveling at the same velocity.

If we want to calculate the *exact* velocity of an object, we could reduce the gap between the first and second measurement. As the gap gets smaller we get a more accurate picture of the velocity of the object at one instant in time. If we could make this gap infinitely small, then we would have the exact answer.

In mathematics, this is written using "limit" notation, as in

$$v = \lim_{\Delta t \to 0} \frac{\Delta p}{\Delta t}$$

which simply means that the velocity would be accurately given by the distance traveled divided by the time gap ($\Delta p / \Delta t$), if we could make the gap infinitely small ($\lim_{t \to 0}$). Rather than use this limit notation, this is more commonly written with a lowercase "d" in place of the Δ:

$$v = \lim_{\Delta t \to 0} \frac{\Delta p}{\Delta t} = \frac{dp}{dt}$$

$t = 0$ $t = \frac{1}{2}$ $t = 1$

A

$t = 0$ $t = \frac{1}{2}$ $t = 1$

B

FIGURE 2.8 Same average velocity, different instantaneous velocity.

Because it is so common in mechanics to be talking about the change with respect to time, this is often simplified even further:

$$v = \lim_{\Delta t \to 0} \frac{\Delta p}{\Delta t} = \frac{dp}{dt} = \dot{p}$$

The dot over the p signifies that we're interested in the velocity at which p is changing, that is, its differential with respect to time.

Acceleration

If p is the position of an object and v is its velocity (where $v = \dot{p}$), we can define its acceleration too.

Acceleration is the rate that velocity is changing. If an object is accelerating hard, it is rapidly increasing in velocity. In normal English, we use the word "slowing" to mean the opposite of acceleration, or "braking" if we are talking about an automobile. In physics, the term "acceleration" can mean any change in velocity, either increasing or decreasing velocity. A positive value for acceleration represents speeding up, a zero acceleration means no change in velocity at all, and negative acceleration represents slowing down.

Because acceleration represents the rate that velocity is changing, we can follow the same process to give:

$$a = \lim_{\Delta t \to 0} \frac{\Delta v}{\Delta t} = \frac{dv}{dt}$$

where v in this formula is velocity. And velocity is defined in terms of its own limit, as seen in the previous section.

This is called the second differential: velocity is the first differential of position, and if we differentiate again we get acceleration, so acceleration is the second differential. Mathematicians often write it in this way:

$$a = \frac{dv}{dt} = \frac{d}{dt}\frac{dp}{dt} = \frac{d^2 p}{dt^2}$$

which can be confusing if you're not used to differential notation. Don't worry about how we end up with that particular pattern of squared elements—it isn't important for us; it simply indicates a second differential. Fortunately, we can completely ignore this format altogether and use the dotted form again:

$$a = \frac{d^2 p}{dt^2} = \ddot{p}$$

which is the format we'll use in the remainder of the book.

We could write acceleration in terms of velocity as $a = \dot{v}$ or

$$\frac{dv}{dt}$$

if we wanted to, but this causes problems. As long as I use v for velocity, it's fairly clear what I mean. But if I write \dot{m} or

$$\frac{\mathrm{d}m}{\mathrm{d}t}$$

it would not be obvious whether m is a velocity (and therefore, the whole expression is an acceleration) or a position (making the expression a velocity). To avoid this confusion, it is typical to write acceleration in terms of position only, using the \ddot{x} notation.

We've seen how to find the velocity and acceleration now. We could carry on, and find the rate at which the acceleration is changing. This is called the *jerk* or sometimes the *jolt*, and it can be important for some physical simulations.[2] We could go further and find the rate of change of jerk, and so on.

A side effect of the laws of physics at work in our universe is that these quantities are not connected in the same way as position, velocity, and acceleration. We therefore do not need them in our physics engine. As we shall see in the next chapter, Newton discovered that applying a force to an object changes its acceleration only: to make believable physics involving forces, all we need to track are position, velocity, and acceleration.

In summary, \dot{p}, the velocity of p, is measured at one instant in time, not an average velocity, and \ddot{p} is the acceleration of p, measured in exactly the same way, and it can be negative to indicate slowing down.

Vector Differential Calculus

So far we've looked at differentiation purely in terms of a single scalar quantity. For full 3D physics, we need to deal with vector positions rather than scalars.

Fortunately, the simple calculus we've looked at so far works easily in three dimensions (although you must be careful—as a general rule, most of the equations for one-dimensional calculus that you find in mathematics reference books cannot be used in three dimensions).

If the position of the object is given as a vector in three dimensions, then its rate of change is also represented by a vector. Because a change in the position on one axis doesn't change the position on any other axis, we can treat each axis as if it were its own scalar differential.

The velocity and the acceleration of a vector depends only on the velocity and acceleration of its components, as in

$$\dot{\boldsymbol{a}} = \begin{bmatrix} \dot{a}_x \\ \dot{a}_y \\ \dot{a}_z \end{bmatrix}$$

2. It is particularly important in the design of roller coasters, among other things, because part of the way that humans experience a roller coaster has to do with the patterns of jerk at play.

and similarly,

$$\ddot{a} = \begin{bmatrix} \ddot{a}_x \\ \ddot{a}_y \\ \ddot{a}_z \end{bmatrix}$$

As long as our formulas do not involve the products of vectors, the way we defined vector addition and vector–scalar multiplication earlier in the chapter works perfectly. The upshot of this is that for most of the formulas that involve the differentials of vectors, we don't need any more complex math (or code) than if we were dealing with scalars. We'll see an example of this in the next section.

As soon as we have formulas that involve multiplying vectors together, or that involve matrices, things are no longer as simple. Fortunately, they are rare in this book.

Velocity, Direction, and Speed

Although in everyday English we often use *speed* and *velocity* as synonyms, they have different technical meanings. The velocity of an object, as we've seen, is a vector giving the rate that its position is changing.

The speed of an object is the magnitude of this velocity vector, irrespective of the direction it is moving in. By decomposing the velocity vector, we can get the speed and the direction of movement:

$$\dot{x} = s\widehat{d}$$

where s is the speed of the object, and \widehat{d} is its direction of movement. Using the equations for the magnitude and direction of any vector, the speed is given by

$$s = |\dot{x}|$$

and the direction by

$$\widehat{d} = \frac{\dot{x}}{|\dot{x}|}$$

Both the speed and direction can be calculated from a velocity vector using the `magnitude` and `normalize` methods developed earlier in the chapter; they do not need additional code.

The speed of an object is rarely needed in game physics development; it has an application in calculating aerodynamic drag but little else. Both the speed and the direction of movement are often used by an animation engine to work out what animation to play as a character moves. This is less common for physically controlled characters.

This is largely a terminology issue, and the main point is to get into the habit of calling velocity by its name.

2.2.2 INTEGRAL CALCULUS

In mathematics, integration is the opposite of differentiation. If we differentiate something and then integrate it, we get back to where we started.

In the same way that we obtained velocity from the position using differentiation, we go the other way in integration. If we know the velocity, then we integrate to work out the position at some point in the future. If we know the acceleration, we can find the velocity at any point in time.

In physics engines, the term "integration" refers to updating the position and velocity of each object in each frame. The chunk of code that performs this operation is called the *integrator*.

Although integration in mathematics is an even more complex process than differentiation, in game development it can be very simple. If we know that an object is moving with a constant velocity (i.e., no acceleration), and we know this velocity along with how much time has passed, we can update the position of the object using the formula:

$$p' = p + \dot{p}t \qquad [2.7]$$

where \dot{p} is the constant velocity of the object over the whole time interval.

This is the integral of the velocity—an equation that gives us the position. In the same way, we could update the object's velocity in terms of its acceleration using the formula:

$$\dot{p}' = \dot{p} + \ddot{p}t \qquad [2.8]$$

Equation 2.7 only works for an object that is not accelerating.

Rather than finding the position by the first integral of the velocity, we could find it as the second integral of the acceleration (just as acceleration was the second derivative of the position). This would give us an update equation of

$$p' = p + \dot{p}t + \ddot{p}\frac{t^2}{2} \qquad [2.9]$$

where \dot{p} is the velocity of the object at the start of the time interval, and \ddot{p} is the constant acceleration over the entire time.

Describing how these equations are arrived at is beyond the scope of this book; any introductory calculus book will derive them from first principles.

Just as Equation 2.7 assumes a constant velocity, Equation 2.9 assumes a constant acceleration. We could generate further equations to cope with changing accelerations. As we will see in the next chapter, however, even 2.9 isn't needed. When it comes to updating the position, we can make do with the assumption that there is no acceleration.

In mathematics, when we talk about integrating, we mean converting a formula for velocity into a formula for position, or a formula for acceleration into one for velocity—in other words, to do the opposite of a differentiation. In game development, the term is often used slightly differently; to integrate means to perform the

position or velocity updates. From this point on, I will stick to the second use, since we will have no need to do any other kind of integration.

Vector Integral Calculus

Just as we saw for differentiation, vectors take the place of scalars in the update functions. Again, this is not the case for mathematics in general, and most of the formulas you find in mathematical textbooks on integration will not work for vectors. The two integrals we will use in this book—Equations 2.7 and 2.8—have the same form for both scalar and vector terms. So we can write

$$\boldsymbol{p}' = \boldsymbol{p} + \dot{\boldsymbol{p}}t$$

and perform the calculation on a component-by-component basis:

$$\boldsymbol{p}' = \boldsymbol{p} + \dot{\boldsymbol{p}}t = \begin{bmatrix} p_x + \dot{p}_x t \\ p_y + \dot{p}_y t \\ p_z + \dot{p}_z t \end{bmatrix}$$

This could be converted into code as in:

```
position += velocity * t;
```

using the overloaded operator forms of + and * we defined earier. In fact, this is exactly the purpose of the addScaledVector method, so we can write:

```
position.addScaledVector(velocity, t);
```

and compute it in single operation, rather than risking our compiler deciding to create and pass around extra vectors on the stack.

We have now implemented almost all the mathematics we need for our particle engine. We will implement the integration step in the next chapter, after we look at the physics involved in simulating particles.

2.3 SUMMARY

Vectors form the basis of all the mathematics in this book. As we've seen, they are easy to manipulate numerically and through simple routines in code. It is important to remember, however, that vectors are geometric—they represent positions and movements in space. It is often simpler to understand the formulas in this book in terms of their corresponding geometric properties, rather than numerically.

Describing positions and movements in terms of vectors is fine, but to make a physics engine, we'll need to begin to link the two, that is, to encode into our physics engine the laws of physics that say how position, movement and time are connected. That is the subject of Chapter 3.

2.4 EXERCISES

Exercise 2.1
Decompose the following vector

$$\begin{bmatrix} 2 \\ -2 \\ -2 \end{bmatrix}$$

into its magntiude and direction.

Exercise 2.2
(a) Calculate the scalar product:

$$\begin{bmatrix} 3 \\ 1 \\ 2 \end{bmatrix} \cdot \begin{bmatrix} 0 \\ 2 \\ -1 \end{bmatrix}$$

(b) What does the result of (a) tell us about the angle between the two vectors?

Exercise 2.3
Calculate the scalar product of a vector with itself.

(a) Which other method that we have defined corresponds to this value?

(b) Is it more or less efficient to calculate this value using a scalar product?

Exercise 2.4
Assume the following vector,

$$\begin{bmatrix} 1 \\ 2 \\ 3 \end{bmatrix}$$

and another vector containing an unknown, x,

$$\begin{bmatrix} 7 \\ -2 \\ x \end{bmatrix}$$

If we know that the two vectors are perpendicular to one another, what is the value of x?

Exercise 2.5

(a) Use the scalar product to find the angle between the following vectors:

$$\begin{bmatrix} 0 \\ 1 \\ 1 \end{bmatrix}$$

$$\begin{bmatrix} 0 \\ -1 \\ 0 \end{bmatrix}$$

(b) Calculate the angle using the vector product. If you are doing this as an assignment, you must show your work.

Exercise 2.6

Assume the following vectors:

$$\widehat{a} = \frac{1}{\sqrt{2}} \begin{bmatrix} 0 \\ 1 \\ 1 \end{bmatrix}$$

and

$$b = \begin{bmatrix} 1 \\ 2 \\ 3 \end{bmatrix}$$

(a) Calculate the scalar product $c = \widehat{a} \cdot b$.

(b) Calculate the value of vector d where $d = b - c\widehat{a}$.

(c) What is the angle between vectors \widehat{a} and d? Geometrically, what have we done to get this result?

Exercise 2.7

If a vector starts at

$$\begin{bmatrix} 1 \\ 2 \\ 3 \end{bmatrix}$$

and changes with velocity

$$\begin{bmatrix} 1 \\ -1 \\ 2 \end{bmatrix}$$

per second, what will it be after 10 seconds?

3

THE LAWS OF MOTION

Physics engines are based on Newton's laws of motion. In later sections, we will begin to use results that were added to Newton's original work, but the fundamentals are his.

Newton discovered three laws of motion that describe with great accuracy how point masses behave. A point mass is somewhat imaginary: it is an object that has mass, but no size. It is an object, therefore, that can't rotate, but otherwise moves around normally. It might seem that this fantasy is particularly useless: every real object does have size, after all. But the physics of many things can be simplified to point masses. Newton used his laws very successfully in describing the motion of planets. Clearly, planets have considerable size, but on the scale of their orbits, Newton found he could treat them as point masses.

The term *point masses* is rarely used in game physics, however. Almost always we call them "particles." So we have to be a little careful: what we're doing shouldn't be confused with particle physics, which studies tiny particles such as electrons or photons that definitely do not conform to Newton's laws. For this book we'll follow the rest of the game development community and call them particles rather than point masses.

Later in the book we will move beyond particles and add the physics of rotating. This introduces additional complications and new laws that were added to Newton's laws decades later. Even in these cases, however, the point-mass laws still can be seen at work.

Before we look at the laws themselves, and how they are implemented, we need to look at how to represent a particle in code.

Copyright © 2010, Elsevier Inc. All rights reserved.
DOI: 10.1016/B978-0-12-381976-5.00003-6

3.1 THE PARTICLE

A particle has a position, but no orientation. In other words, we can't tell what direction a particle is pointing: it either doesn't matter or it doesn't make sense. In the former category are bullets: in a game we don't really care which direction a bullet is pointing in, we just care what direction it is traveling and whether it hits the target. In the second cateogry are sparks of light, from an explosion for example—because the spark is a dot of light, it doesn't make sense to ask which direction it is pointing.

For each particle we'll need to keep track of various properties: current position, velocity, and acceleration. We will add properties to the particle as we go. Position, velocity, and acceleration are all vectors.

The particle can be implemented with the following structure:

```
/**
 * A particle is the simplest object that can be simulated in the
 * physics system.
 */
class Particle
{
protected:
    /**
     * Holds the linear position of the particle in
     * world space.
     */
    Vector3 position;

    /**
     * Holds the linear velocity of the particle in
     * world space.
     */
    Vector3 velocity;
    /**
     * Holds the acceleration of the particle.  This value
     * can be used to set acceleration due to gravity (its primary
     * use), or any other constant acceleration.
     */
    Vector3 acceleration;
};
```

Excerpt from file include/cyclone/particle.h

Using this structure, we can apply some basic physics to create our first physics engine.

3.2 THE FIRST TWO LAWS

There are three laws of motion put forward by Newton; for now we will need only the first two. They deal with the way an object behaves in the presence and absence of forces.

The first two laws of motion follow:

1. An object continues with a constant velocity unless a force acts upon it.

2. A force acting on an object produces acceleration that is proportional to the object's mass.

The First Law

The first law tells us what happens if there are no forces around. The object will continue to move with a constant velocity. In other words, the velocity of the particle will never change, and its position will continue to be updated based on the velocity. This may not be intuitive, as moving objects we see in the real world will slow and come to a stop eventually if they aren't being constantly forced along. In this case, the object is actually experiencing a force, the force of drag. In the real world, we can't get away from forces acting on a body; the closest phenomenon that we can imagine is the movement of objects in space. Newton-1 tells us that if we *could* remove all forces, then objects would continue to move at the same speed forever.

In our physics engine we could simply assume that there are no forces at work and use Newton-1 directly. To simulate drag, we could add special drag forces. This is fine for the simple engine we are building in this part of the book, but can cause problems with more complex systems. The problem arises because the processor that performs the physics calculations isn't completely accurate. This inaccuracy can lead to objects getting faster of their own accord.

A better solution is to incorporate a rough approximation of drag directly into the engine. This allows us to make sure objects aren't being accelerated by numerical inaccuracy, and it can allow us to approximate real-world drag. If we need complicated drag (such as aerodynamic drag in a flight simulator or racing game) we can still do that the long way, by creating a special drag force. I will call our simple and inaccurate form of drag "damping" to avoid confusion.

To support damping, we add another property to the particle class as follows:

```
──────── Excerpt from file include/cyclone/particle.h ────────
class Particle
{
    // ... Other Particle code as before ...

    /**
     * Holds the amount of damping applied to linear
     * motion. Damping is required to remove energy added
     * through numerical instability in the integrator.
```

```
    */
    real damping;
};
```

When performing the integration, we will remove a proportion of the object's velocity at each update. The damping parameter controls how much velocity is left after the update. If the damping is zero then the velocity will be reduced to nothing, meaning that the object couldn't sustain any motion without a force and would look odd to the player. A value of 1 means that the object keeps all its velocity (equivalent to no damping). If you don't want the object to look like it is experiencing drag, but still want to use damping to avoid numerical problems, then values slightly less than 1 are optimal. A value of 0.999 might be perfect, for example.

The Second Law

The second law tells us how forces alter the motion of an object. A force is something that changes the *acceleration* of an object (i.e., the rate of change of velocity). One implication of this law is that we cannot do anything to an object to directly change its position or velocity: we can only do that indirectly by applying a force to change the accleration and wait until the object reaches our target position or velocity.

Just as for the first law, we will need to abuse this law later on in the book, to make things look good. For now we'll leave it intact.

Because of the second law, we will treat the acceleration of the particle differently to the velocity and position. Both velocity and position keep track of a quantity from frame to frame during the game. They change, but not directly, and only by the process of integration.

Acceleration, by contrast, can be different from one moment to another; the forces applied are different. We can simply set the acceleration of an object as we see fit (although we'll use the force equations below) and the behavior of the object will look fine. If we directly set the velocity or position, the particle will appear to jolt or jump. Because of this, the position and velocity properties will only be altered by the physics engine and should not be manually altered (other than setting up the initial position and velocity for an object, of course). The acceleration property can be set at any time, and it will be left alone by the integrator.

3.2.1 THE FORCE EQUATIONS

The second part of the second law tells us how force is related to the acceleration. For the same force, two objects will experience different accelerations depending on their mass. The formula relating the force to the acceleration is the famous

$$f = ma = m\ddot{p} \qquad\qquad [3.1]$$

The first form, $F = ma$, is the more famous; the second form uses our notation for acceleration as the second derivative of position. We can manipulate this equation to give us the acceleration in terms of the force:

$$\ddot{p} = \frac{1}{m} f \qquad\qquad [3.2]$$

where f is the force and m is the mass.

In a physics engine, we typically find the forces applying to each object and use Equation 3.2 to find the acceleration, which can then be applied to the object by the integrator. For the engine we are creating in this part of the book, we won't be using forces that vary. We can set the acceleration in advance using this equation, without having to use it at every update. In the remainder of the book, however, it will be a crucial step to carry out at least once per frame.

So far all the equations have been given in their mathematics textbook form, applied to scalar values. As we saw in the last chapter on calculus, we can convert them easily to use vectors. For instance,

$$\ddot{p} = \frac{1}{m} f$$

The force is a vector, as was acceleration.

3.2.2 ADDING MASS TO PARTICLES

We need to add mass to our particle definition, alongside its position, velocity, acceleration, and damping. Each particle needs its own mass, so that we can correctly calculate its response to forces. We could just do this in the most obvious way: add a scalar mass value for each object. There is a better way to get the same effect, however.

First, there is an important thing to note about Equation 3.2. If the mass of an object is zero, then any non-zero force will generate infinite acceleration. This is not a situation that should ever occur: no particle that we can simulate should ever have zero mass. If we try to simulate a zero mass particle it will cause divide-by-zero errors in the code. Zero mass particles are both physically impossible and practically dangerous.

It is often useful, however, to simulate *infinite* masses. These are objects that no force of any magnitude can move. They might be just as physically impossible, but they are very useful for immovable objects in a game: the walls or floor, for example, cannot be moved. If we feed an infinite mass into Equation 3.2, then the acceleration will be zero, as we want. As long as such an object has zero initial velocity, it will always stay in the same place.

Unfortunately, we cannot represent a true infinity in most computer languages, and the optimized mathematics instructions on all common game processors do not cope well with infinities. We have to get slightly creative. Ideally we want a solution where it is easy to get infinite masses but impossible to get zero masses.

Note that in Equation 3.2 we use 1 over the mass to calculate our acceleration. Because we never use the 3.1 form of the equation, we can speed up our calculations

by storing 1 over the mass. We call this the inverse mass. This solves our problem for representing objects of zero or infinite mass: infinite mass objects have a zero inverse mass, which is easy to set. Objects of zero mass would have an infinite inverse mass, which cannot be specified in most programming languages.

We update our particle class to include the inverse mass as follows:

```
class Particle
{
    // ... Other Particle code as before ...

    /**
     * Holds the inverse of the mass of the particle. It
     * is more useful to hold the inverse mass because
     * integration is simpler, and because in real-time
     * simulation it is more useful to have objects with
     * infinite mass (immovable) than zero mass
     * (completely unstable in numerical simulation).
     */
    real inverseMass;
};
```
Excerpt from file include/cyclone/particle.h

It is really important to remember that you are dealing with the inverse mass, and not the mass. It is quite easy to set the mass of the particle directly, without remembering, only to see it have a completely inappropriate behavior on screen, such as barely movable barrels zooming off at the slightest tap.

To help with this, I've made the `inverseMass` data field protected in my version of the `Particle` class. To set the inverse mass, I use an accessor function. I have provided functions for `setInverseMass` and `setMass`. Most of the time it is more convenient to use the latter, unless we are trying to set an infinite mass.

3.2.3 MOMENTUM AND VELOCITY

Although Newton-1 is most often introduced in terms of velocity, it is a misrepresentation. It is not velocity that is constant in the absence of any force, but momentum.

Momentum is the product of velocity and mass. Since mass is normally constant, we can assume that velocity is therefore constant by Newton-1. In the event that a traveling object is changing mass, then its velocity would also be changing, even with no force.

We don't need to worry about this for our physics engine, because we are not dealing with situations where mass changes. This will be an important distinction when we consider rotations later, however, because rotating objects can change the

way their mass is distributed. Under the rotational form of Newton-1, that means a change in rotational speed with no other forces acting.

3.2.4 THE FORCE OF GRAVITY

Gravity is the most important force in a physics engine. In the real world, gravity applies between every pair of objects, attracting them together with a force that depends on their mass and distance. Newton also discovered this fact, and along with the three laws of motion, he used it to explain the motion of planets and moons with a new level of accuracy.

The formula he developed is called the law of universal gravitation:

$$f = G\frac{m_1 m_2}{r^2} \qquad [3.3]$$

where m_1 and m_2 are the masses of the two objects, r is the distance between their centers, f is the resulting force, and G is the "universal gravitational constant," a scaling factor derived from observation of planetary motion.

The effects of gravity between two objects the size of a planet are significant; the effects between a (relatively) small objects such as a car, or even a building, are small. Our experience of gravity is completely dominated by the Earth. We notice the pull of the moon in the way our tides work, but other than that we only experience gravity pulling us down to the planet's surface. I don't notice the gravitational force beween me and my computer, for example. The same thing will apply to our physics engine: the only gravity we'll be interested in simulating is between each object and the ground.

Because we are only interested in the pull of the Earth, we can simplify Equation 3.3. First, we can assume that m_1 is always constant (i.e., the Earth doesn't change mass). Second, and less obviously, we can assume that r is also constant. This is due to the huge distances involved. The distance from the surface of the Earth to its center is so huge (6400 km) that there is almost no difference in gravity between standing at sea level and standing on the top of a mountain. For the accuracy we need in a game, we can therefore assume the r parameter is constant.

With these assumptions, Equation 3.3 simplifies to:

$$f = mg \qquad [3.4]$$

where m is the mass of the object we are simulating, f is the force, as before, and g is a constant that includes the universal gravitational constant, the mass of the Earth, and its radius:

$$g = G\frac{m_{\text{earth}}}{r^2}$$

This constant, g, is an acceleration, which we shall measure in meters per second. On Earth this g constant has a value of around $10\ \text{ms}^{-2}$ (scientists sometimes use a value

of 9.807 ms^{-2}, although because of the variations in r and other effects, this is a global average rather than a measured value).

Equation 3.3 tells us the force that a mass experiences. And using our simplifications, this force depends on the mass of the object. If we work out the acceleration using Equation 3.2, then we get:

$$\ddot{p} = \frac{1}{m}\, mg = g$$

In other words, no matter what mass the object has, it will always accelerate at the same rate due to gravity. As the legend goes, Galileo dropped a heavy and a light object from the Tower of Pisa and they hit the ground at the same time.[1]

This means that the most significant force we need to apply in our engine can be applied directly as an acceleration. There is no point using Equation 3.4 to calculate a force, then using Equation 3.2 to convert it back into an acceleration. In this iteration of the engine we will introduce gravity as the sole force at work on particles, and it will be applied directly as an acceleration.

The Value of *g*

It is worth noting that although the acceleration due to gravity on Earth is about 10 ms^{-2}, this doesn't look very convincing on screen. Games are intended to be more exciting than the real world: things happen more quickly and at a greater intensity.

Creating simulations with a g value of 10 ms^{-2} can look dull and insipid. Most developers use higher values, from around 15 ms^{-2} for shooters (to avoid projectiles having arcs that are too curved) up to 20 ms^{-2} typical of driving games. Some developers go further and incorporate the facility to tune the g value on an object-by-object basis. Our engine will include this facility.

Gravity typically acts in the down direction, unless you are going for a special effect. In most games, the Y axis represents up and down in the game world, and almost exclusively the positive Y axis points up.

The acceleration due to gravity can therefore be represented as a vector with the following form:

$$g = \begin{bmatrix} 0 \\ -g \\ 0 \end{bmatrix}$$

where g is the value we discussed above, and \boldsymbol{g} is the acceleration vector we will use to update the particle in the next section.

1. I say legend, because if you actually do this experiment, you'll see that they don't hit the ground at the same time. As we've already seen, on Earth you can't escape drag, and because drag doesn't depend on an object's mass, it won't be the same for the two objects. There is excellent footage from the moon, however, showing a hammer and a feather being dropped and hitting the lunar surface at the same time.

3.3 The Integrator

We now have all the equations and background needed to finish the first implementation of the engine. At each frame, the engine needs to look at each object in turn, work out its acceleration, and perform the integration step. The calculation of the acceleration in this case will be trivial: we will use the acceleration due to gravity only.

The integrator consists of two parts—one to update the position of the object, and the other to update its velocity. The position will depend on the velocity and acceleration, while the velocity will depend only on the acceleration.

Integration requires a time interval over which to update the position and velocity: because we update every frame, we use the time interval between frames as the update time. If your engine is running on a console that has a consistent frame rate, then you can hard code this value (although it is wise not to do so, because the same console can have different frame rates in different territories, and eventually you'll want to port your game or run it slowly for debugging). If you are running on a PC with a variable frame rate, then you probably need to time the duration of the frame.

Typically developers will time a frame, and then use that value to update the next frame. This can cause noticeable jolts if the frame durations are dramatically inconsistent, but the game is unlikely to feel smooth in this case anyway, so it is a common rule of thumb.

Another major approach to timing is to decouple the physics entirely from the drawing loop, running it in its own thread at a fixed update interval (which should still be adjustable in your code). This is particularly important if you need your physics to be reproducible in multiplayer games.

In my sample code I use a central timing system that calculates the duration of each frame. The physics code we will develop here simply takes in a time parameter when it updates, and doesn't care how this value was calculated.

3.3.1 The Update Equations

We need to update both position and velocity; each is handled slightly differently.

Position Update

In Chapter 2 we saw that integrating the acceleration twice gives us the following equation for the position update:

$$p' = p + \dot{p}t + \frac{1}{2}\ddot{p}\,t^2$$

This is a well-known equation seen in high school and undergraduate textbooks on applied mathematics. We could use this equation to perform the position update in

the engine, with code something like:

```
object.position += object.velocity * time +
                   object.acceleration * time * time * 0.5;
```

or

```
object.position.addScaledVector(object.velocity, time);
object.position.addScaledVector(object.acceleration, time * time * 0.5);
```

In fact, if we are running the update every frame, then the time interval will be very small (typically, 0.033 s for a 30 frames-per-second game). If we look at the acceleration part of this equation, we are taking half of the squared time (which gives 0.0005). This is such a small value that it is unlikely the acceleration will have much of an impact on the change in position of an object.

For this reason we typically ignore the acceleration entirely in the position update and use the simpler form,

$$p' = p + \dot{p}t$$

This is the equation we will use in the integrator throughout this book.

If your game regularly uses short bursts of huge accelerations, then you might conclude that you would be better off using the longer form of the equation. If you do intend to use huge accelerations, however, you are likely to get all sorts of other accuracy problems in your engine—all physics engines typically become unstable with very large accelerations. Later in the book, we will develop a whole alternative set of tools for applying very short bursts of high acceleration.

Velocity Update

The velocity update has a similar basic form:

$$\dot{p}' = \dot{p} + \ddot{p}t$$

Earlier in the chapter, however, we introduced another factor to alter the velocity: the damping parameter. The damping parameter is used to remove a bit of velocity at each frame. This is done by simply multiplying the velocity by the damping factor,

$$\dot{p}' = \dot{p}d + \ddot{p}t \qquad [3.5]$$

where d is the damping for the object.

This form of the equation hides a problem, however. No matter whether we have a long or a short time interval over which to update, the amount of velocity being removed is the same. If our frame rate suddenly improves, then there will be more updates per second and the object will suddenly appear to have more drag. A more correct version of the equation solves this problem by incorporating the time into the drag part of the equation,

$$\dot{p}' = \dot{p}d^t + \ddot{p}t \qquad [3.6]$$

where the damping parameter d is now the proportion of the velocity retained each second, rather than each frame.

Calculating one floating-point number to the power of another is a relatively slow process on most modern hardware. If you are simulating a huge number of objects, then it is normally best to avoid recaculating this value for each particle. You could, for example, rewrite your code so that all particles have the same damping value—then you only have to calculate d^t once per frame, and use it for all objects.

A different approach favored by many engine developers is to use Equation 3.5, with a damping value very near to 1, which is so small that it will not be noticable to the player, but big enough to solve the numerical instability problem. In this case, a variation in frame rate will not make any visual difference. Drag forces can then be created and applied as explicit forces acting on each object (as we'll see in Chapter 5). Unfortunately, this simply moves the problem to another part of the code, the part where we calculate the size of the drag force. For this reason, I prefer to make the damping parameter more flexible and allow it to be used to simulate visible levels of drag.

I will use the full form in this book, as given in Equation 3.6.

3.3.2 THE COMPLETE INTEGRATOR

We can now implement our integrator. The code looks like this:

```
                    Excerpt from file include/cyclone/particle.h
class Particle
{
    // ... Other Particle code as before ...

    /**
     * Integrates the particle forward in time by the given amount.
     * This function uses a Newton-Euler integration method, which is a
     * linear approximation to the correct integral. For this reason it
     * may be inaccurate in some cases.
     */
    void integrate(real duration);
};
```

```
———————————— Excerpt from file include/cyclone/precision.h ————————————
/** Defines the precision of the power operator. */
#define real_pow powf
```

```
———————————————— Excerpt from file src/particle.cpp ————————————————
#include <assert.h>
#include <cyclone/particle.h>

using namespace cyclone;

void Particle::integrate(real duration)
{
    // We don't integrate things with infinite mass.
    if (inverseMass <= 0.0f) return;

    assert(duration > 0.0);

    // Update linear position.
    position.addScaledVector(velocity, duration);

    // Work out the acceleration from the force.
    // (We'll add to this vector when we come to generate forces.)
    Vector3 resultingAcc = acceleration;

    // Update linear velocity from the acceleration.
    velocity.addScaledVector(resultingAcc, duration);

    // Impose drag.
    velocity *= real_pow(damping, duration);

    // Clear the forces.
    clearAccumulator();
}
```

I have added the integration method to the Particle class because it simply updates the particle's internal data. It takes a time interval and updates the position and velocity of the particle, returning no data.

3.4 SUMMARY

In two short chapters we've gone from coding vectors to a first complete physics engine.

The laws of motion are elegant, simple, and incredibly powerful. The fundamental connections that Newton discovered drive all the physical simulations in this book. Calculating forces and integrating position and velocity based on force and time are the fundamental steps of all physics engines, complex or simple.

Although we now have a physics engine that can be used in games (and is equivalent to the systems used in many hundreds of published games), it isn't yet suitable for a wide range of physical applications. In Chapter 4 we'll look at some of the applications that it can support and some of its limitations.

3.5 EXERCISES

Exercise 3.1
An equal force is applied for 1 s to two stationary objects, *a* and *b*. The mass of *a* is double that of *b*. After the force has been applied (and assuming no other forces are involved), which object will be moving the fastest and by how much faster? Give your answer as a multiplier (e.g., *a* is moving three times as fast as *b*—that's the wrong answer, by the way).

Exercise 3.2
The value of Newton's universal gravitational constant is approximately $6.67 \times 10^{-11} \mathrm{m^3\,kg^{-1}s^{-2}}$. Using Equation 3.3, calculate the force between two people, each weighing 100 kg, who are standing 1 m apart.

Exercise 3.3
Kinetic energy is given by $\frac{1}{2}m|v|^2$, where *m* is the mass of the object and *v* is its velocity. Add a method to your `Particle` class to calculate and return the kinetic energy. We will see a use for this value at the end of the book when we look at putting a simulation to sleep.

Exercise 3.4
A particle begins at

$$\begin{bmatrix} 1 \\ 2 \\ 3 \end{bmatrix}$$

and is moving with velocity

$$\begin{bmatrix} 1 \\ -1 \\ 2 \end{bmatrix} \text{ per second,}$$

and acceleration

$$\begin{bmatrix} 0 \\ 1 \\ -1 \end{bmatrix} \text{ per second per second.}$$

(a) Use Equation 2.9 to calculate what its position will be after 5 s.

(b) Use Equations 2.7 and 2.8 to calculate its position and velocity after 1 s.

(c) Repeat part b for an additional 4 s.

(d) Compare the results from parts a and c. How much error has been introduced by using the simpler equation?

Exercise 3.5

In the text we looked at two ways to represent damping: Equations 3.5 and 3.6. Implement a small test program that repeatedly simulates a pair of particles moving under gravity for a fixed duration (1 s, for example). One particle should use Equation 3.5 and the other 3.6. Use random durations for the frame (within some small margin) to simulate a variable frame rate. How much difference, on average, is there between the velocities of the two particles at the end of each simulation?

THE PARTICLE
PHYSICS ENGINE

W̱e now have our first working physics engine. It is capable of simulating the movement of particles under gravity.

Considering that it is such a simple piece of code, I've spent a long time talking about the theory behind it. This will become important later in the book when we repeat the same kind of logic for the rotation of objects.

At the moment our engine is fairly limited, as it can only deal with isolated particles, and they cannot interact in any way with their environment. Although these are serious limitations that will be addressed in the next part of the book, we can still do some useful things with we what we have.

In this chapter, we will look at how to set up the engine to process ballistics, that is, bullets, shells, and the like. We will also use the engine to create a fireworks display. Both of these applications are presented in skeleton form here, with no rendering code. They can be found with full source code on the website.

4.1 BALLISTICS

One of the most common applications of physics simulation in games is to model ballistics. This has been the case for two decades, predating the current vogue for physics engines.

In our ballistics simulation, each weapon fires a particle. Particles may represent anything from bullets to artillery shells, from fireballs to laser bolts. Regardless of the object being fired, we will call this a "projectile."

Copyright © 2010, Elsevier Inc. All rights reserved.
DOI: 10.1016/B978-0-12-381976-5.00004-8

Each weapon has a characteristic muzzle velocity, the speed at which the projectile is emitted from the weapon. This will be very fast for a laser bolt, and probably considerably slower for a fireball. For each weapon, the muzzle velocity used in the game is unlikely to be the same as its real-world equivalent.

4.1.1 SETTING PROJECTILE PROPERTIES

The muzzle velocity for the slowest real-world guns is on the order of $250\,\mathrm{ms}^{-1}$, whereas tank rounds designed to penetrate armor plate can move at $1800\,\mathrm{ms}^{-1}$. The muzzle velocity of an energy weapon such as a laser would be the speed of light: $300{,}000{,}000\,\mathrm{ms}^{-1}$. Even for relatively large game levels, any of these values is too high. A bullet that can cross a game level in half a second would be practically invisible to the player. If this speed is required, then it is better not to use a physics simulation, but to simply cast a ray through the level the instant that the weapon is shot and check if it collides with the target.

Instead, if we want the projectile's motion to be visible, we use muzzle velocities that are in the region of 5 to $25\,\mathrm{ms}^{-1}$, for a human-scale game (if your game represents half a continent, and each unit is the size of a city, then it would be correspondingly larger). This causes two knock-on effects that we have to cope with.

First, the mass of the particle should be larger than in real life, especially if you are working with the full physics engine later in the book and you want impacts to look impressive (being able to shoot a crate and topple it over, for example). The effect that a projectile has when it impacts depends on both its mass and its velocity: if we drop the velocity, we should increase the mass to compensate. The equation that links energy, mass, and speed is

$$e = ms^2$$

where e is the energy, and s is the *speed* of the projectile (this equation doesn't work with vectors, so we can't use velocity). If we want to keep the same energy, we can work out the change in mass for a known change in speed as follows[1]:

$$\Delta m = (\Delta s)^2$$

Real-world ammunition ranges from a gram in mass up to a few kilograms for heavy shells and beyond for other tactical weapons (the bunker-busting shells used in the second Gulf War are more than $1000\,\mathrm{kg}$ in weight). A typical 5-g bullet that normally travels at $500\,\mathrm{ms}^{-1}$ might be slowed to $25\,\mathrm{ms}^{-1}$. This is a Δs of 20. To get the same energy, we need to give it 400 times the weight, or $2\,\mathrm{kg}$.

Most projectiles shouldn't slow too much in flight, so the damping parameter would be near 1. Shells and mortars may arch under gravity, but other types of projectiles should barely feel the effect. If they were traveling at very high speed, then they wouldn't have time to be pulled down by gravity to a great extent, but since

1. I am using the symbol Δ here to mean the difference in mass or speed as a *factor* of the original. So, $500 \rightarrow 50$ has a Δ value of 0.1 for our purposes. It is more common to see it refer to the difference between the two quantities, or -450 in the previous example.

FIGURE 4.1 Screenshot of the **ballistic** demo.

we've slowed them down, gravity will have longer to do its work. Likewise, if we are using a higher gravity coefficient in the game, it will make the ballistic trajectory far too severe: well-aimed projectiles will hit the ground only a few meters in front of the character. To avoid this, we lower the gravity. For a known change in speed, we can work out a "realistic" gravity value using the formula,

$$g_{\text{bullet}} = \frac{1}{\Delta s} g_{\text{normal}}$$

where g_{normal} is the gravity you'd expect if the particle was traveling at full speed. This would be $10 \, \text{ms}^{-2}$ for most games (Earth gravity, i.e., not the same as the general gravity being used elsewhere in the simulation, which is typically higher).

For our bullet example, we therefore have a g_{bullet} of $0.5 \, \text{ms}^{-2}$.

4.1.2 IMPLEMENTATION

The **ballistic** demo in the source code (shown in Figure 4.1) gives you the choice of four weapons: a pistol, an artillery piece, a fireball, and a laser gun (indicated by name at the bottom of the screen). When you click the mouse, a new round is fired. The code that creates a new round and fires it looks like this:

```
——————— Excerpt from file src/demos/ballistic/ballistic.cpp ———————
// Set the properties of the particle.
switch(currentShotType)
{
case PISTOL:
    shot->particle.setMass(2.0f); // 2.0kg
    shot->particle.setVelocity(0.0f, 0.0f, 35.0f); // 35m/s
    shot->particle.setAcceleration(0.0f, -1.0f, 0.0f);
    shot->particle.setDamping(0.99f);
    break;
```

```
case ARTILLERY:
    shot->particle.setMass(200.0f); // 200.0kg
    shot->particle.setVelocity(0.0f, 30.0f, 40.0f); // 50m/s
    shot->particle.setAcceleration(0.0f, -20.0f, 0.0f);
    shot->particle.setDamping(0.99f);
    break;

case FIREBALL:
    shot->particle.setMass(1.0f); // 1.0kg - mostly blast damage
    shot->particle.setVelocity(0.0f, 0.0f, 10.0f); // 5m/s
    shot->particle.setAcceleration(0.0f, 0.6f, 0.0f); // Floats up
    shot->particle.setDamping(0.9f);
    break;

case LASER:
    // Note that this is the kind of laser bolt seen in films,
    // not a realistic laser beam!
    shot->particle.setMass(0.1f); // 0.1kg - almost no weight
    shot->particle.setVelocity(0.0f, 0.0f, 100.0f); // 100m/s
    shot->particle.setAcceleration(0.0f, 0.0f, 0.0f); // No gravity
    shot->particle.setDamping(0.99f);
    break;
}

// Set the data common to all particle types.
shot->particle.setPosition(0.0f, 1.5f, 0.0f);
shot->startTime = TimingData::get().lastFrameTimestamp;
shot->type = currentShotType;

// Clear the force accumulators.
shot->particle.clearAccumulator();
```

Note that each weapon configures the particle with a different set of values. The surrounding code is skipped here for brevity (you can refer to the source code to see how and where variables and data types are defined).

The physics update code looks like this:

```
––––––––––––– Excerpt from file src/demos/ballistic/ballistic.cpp –––––––––––––
// Update the physics of each particle in turn.
for (AmmoRound *shot = ammo; shot < ammo+ammoRounds; shot++)
{
    if (shot->type != UNUSED)
    {
```

```
        // Run the physics.
        shot->particle.integrate(duration);

        // Check to see if the particle is now invalid.
        if (shot->particle.getPosition().y < 0.0f ||
            shot->startTime+5000 < TimingData::get().lastFrameTimestamp||
            shot->particle.getPosition().z > 200.0f)
        {
            // We simply set the shot type to be unused, so the
            // memory it occupies can be reused by another shot.
            shot->type = UNUSED;
        }
    }
}
```

It simply calls the integrator on each particle in turn. After it has updated the particle, it checks whether the particle is below zero height, in which case it is removed. The particle will also be removed if it is a long way from the firing point (100 m), or if it has been in flight for more than 5 s. In a real game you would use some kind of collision detection system to check if the projectile had collided with anything. Additional game logic could then be used to reduce the hit points of the target character, or add a bullet-hole graphic to a surface.

Because we have no detailed collision model at this stage, it is difficult to show the effect of the energy in each projectile. When combined with the collisions and contacts in the later parts of the book, this is obvious. I've provided a version of the demo (see the screenshot in Figure 4.2) called **bigballistic** that includes objects to shoot at that are simulated using the full physics engine. You can clearly see the different impact effects of the different types of projectiles in this simulation.

FIGURE 4.2 Screenshot of the **bigballistic** demo.

FIGURE 4.3 Screenshot of the **fireworks** demo.

4.2 FIREWORKS

Our second example may appear less useful, but demonstrates a common application of particle physics used in most games. Fireworks are just a very ostentatious application of a particle system that could be used to display explosions, flowing water, and even smoke and fire.

The **fireworks** demo in the source code allows you to create an interactive fireworks display. You can see a display in progress in Figure 4.3.

4.2.1 THE FIREWORKS DATA

In our fireworks display we need to add extra data to the basic particle structure. First, we need to know what kind of particle it represents. Fireworks consist of a number of payloads: the initial rocket may burst into several lightweight minifireworks that explode again after a short delay. We represent the type of firework by an integer value.

Second, we need to know the age of the particle. Fireworks consist of a chain reaction of pyrotechnics with carefully timed fuses. A rocket will first ignite its rocket motor, and then after a short time of flight, the motor will burn out as the explosion stage detonates. This may scatter additional units, each of which has a fuse of the same length, allowing the final bursts to occur at roughly the same time (not exactly the same time, however, as that would look odd). To support this, we keep the age for each particle and update it at each frame.

The firework structure can be implemented in this way:

```
────── Excerpt from file src/demos/fireworks/fireworks.cpp ──────
/**
 * Fireworks are particles, with additional data for rendering and
 * evolution.
 */
```

```
class Firework : public cyclone::Particle
{
public:
    /** Fireworks have an integer type, used for firework rules. */
    unsigned type;

    /**
     * The age of a firework determines when it detonates. Age gradually
     * decreases; when it passes zero the firework delivers its payload.
     * Think of age as fuse left.
     */
    cyclone::real age;
};
```

I've used an object-oriented approach here, and made the firework structure a subclass of the particle structure. This allows me to add just the new data without changing the original particle definition.

4.2.2 FIREWORK RULES

To define the effect of a composite firework, which may be made up of several of our firework effects, we need to be able to specify how one type of particle changes into another. We do this as a set of rules: for each firework type we store an age, and a set of data for additional fireworks that will be spawned when the age is passed. This is held in a rules data structure with the following form:

—————— Excerpt from file **src/demos/fireworks/fireworks.cpp** ——————

```
/**
 * Firework rules control the length of a firework's fuse and the
 * particles it should evolve into.
 */
struct FireworkRule
{
    /** The type of firework that is managed by this rule. */
    unsigned type;

    /** The minimum length of the fuse. */
    cyclone::real minAge;

    /** The maximum length of the fuse. */
    cyclone::real maxAge;

    /** The minimum relative velocity of this firework. */
```

```
        cyclone::Vector3 minVelocity;
        /** The maximum relative velocity of this firework. */
        cyclone::Vector3 maxVelocity;

        /** The damping of this firework type. */
        cyclone::real damping;

        /**
         * The payload is the new firework type to create when this
         * firework's fuse is over.
         */
        struct Payload
        {
            /** The type of the new particle to create. */
            unsigned type;

            /** The number of particles in this payload. */
            unsigned count;

            /** Sets the payload properties in one go. */
            void set(unsigned type, unsigned count)
            {
                Payload::type = type;
                Payload::count = count;
            }
        };

        /** The number of payloads for this firework type. */
        unsigned payloadCount;

        /** The set of payloads. */
        Payload *payloads;
    };
```

Rules are provided in the code, and defined in a single function that controls the behavior of all possible fireworks. The following is a sample of that function:

```
────────── Excerpt from file src/demos/fireworks/fireworks.cpp ──────────
void FireworksDemo::initFireworkRules()
{
    // Go through the firework types and create their rules.
    rules[0].init(2);
    rules[0].setParameters(
```

```
        1, // type
        0.5f, 1.4f, // age range
        cyclone::Vector3(-5, 25, -5), // min velocity
        cyclone::Vector3(5, 28, 5), // max velocity
        0.1 // damping
        );
    rules[0].payloads[0].set(3, 5);
    rules[0].payloads[1].set(5, 5);

    rules[1].init(1);
    rules[1].setParameters(
        2, // type
        0.5f, 1.0f, // age range
        cyclone::Vector3(-5, 10, -5), // min velocity
        cyclone::Vector3(5, 20, 5), // max velocity
        0.8 // damping
        );
    rules[1].payloads[0].set(4, 2);

    rules[2].init(0);
    rules[2].setParameters(
        3, // type
        0.5f, 1.5f, // age range
        cyclone::Vector3(-5, -5, -5), // min velocity
        cyclone::Vector3(5, 5, 5), // max velocity
        0.1 // damping
        );
    // ... and so on for other firework types ...
}
```

In a game development studio, it is often the art staff who need to decide how the particles in a game will behave. In this case it is inconvenient to have the rules defined in code. A full game is likely to have some kind of editing tool that allows art staff to author the particle appearance and behavior. These rules are then inferred from the resulting data file.

4.2.3 THE IMPLEMENTATION

In each frame, each firework has its age updated, and is checked against the rules. If its age is past the threshold, then it will be removed and more fireworks will be created in its place (the last stage of the chain reaction spawns no further fireworks).

The firework update function now looks like this:

```
—————————— Excerpt from file src/demos/fireworks/fireworks.cpp ——————————
class Firework : public cyclone::Particle
{
public:
    /**
     * Updates the firework by the given duration of time. Returns true
     * if the firework has reached the end of its life and needs to be
     * removed.
     */
    bool update(cyclone::real duration)
    {
        // Update our physical state.
        integrate(duration);

        // We work backward from our age to zero.
        age -= duration;
        return (age < 0) || (position.y < 0);
    }
};
```

Note that if we don't have any spare firework slots when a firework explodes into its components, then not all the new fireworks will be initialized. In other words, when resources are tight, older fireworks get priority. This allows us to put a hard limit on the number of fireworks being processed, which can avoid having the physics slow down when things get busy. Many developers use a different strategy in their engines: give priority to newly spawned particles, and remove old particles to make way.

Your choice of strategy depends on the application. For particles being constantly emitted from a source, such as smoke, my approach would produce odd-looking oscillations. In the **fireworks** demo, it is the better choice.

The code that actually creates new fireworks looks like this:

```
—————————— Excerpt from file src/demos/fireworks/fireworks.cpp ——————————
struct FireworkRule
{
    /**
     * Creates a new firework of this type and writes it into the given
     * instance. The optional parent firework is used to base position
     * and velocity on.
     */
    void create(Firework *firework, const Firework *parent = NULL) const
    {
        firework->type = type;
```

```
            firework->age = random.randomReal(minAge, maxAge);

            cyclone::Vector3 vel;
            if (parent) {
                // The position and velocity are based on the parent.
                firework->setPosition(parent->getPosition());
                vel += parent->getVelocity();
            }
            else
            {
                cyclone::Vector3 start;
                int x = (int)random.randomInt(3) - 1;
                start.x = 5.0f * cyclone::real(x);
                firework->setPosition(start);
            }

            vel += random.randomVector(minVelocity, maxVelocity);
            firework->setVelocity(vel);

            // We use a mass of 1 in all cases (no point having fireworks
            // with different masses, since they are only under the influence
            // of gravity).
            firework->setMass(1);

            firework->setDamping(damping);

            firework->setAcceleration(cyclone::Vector3::GRAVITY);

            firework->clearAccumulator();
    }
};

void FireworksDemo::create(unsigned type, const Firework *parent)
{
    // Get the rule needed to create this firework.
    FireworkRule *rule = rules + (type - 1);

    // Create the firework.
    rule->create(fireworks+nextFirework, parent);

    // Increment the index for the next firework.
    nextFirework = (nextFirework + 1) % maxFireworks;
}
```

As fireworks are spawned, they have their particle properties set, with velocities determined with a random component. Note that I've used high damping values for several of the firework types; this allows them to drift back down to the ground slowly, which is especially important for fireworks that need to hang in the air before exploding.

In each frame, all of the currently active fireworks are updated. This is performed by a simple loop that first checks whether the firework should be processed (fireworks with a type of zero are defined to be inactive).

```
───────── Excerpt from file src/demos/fireworks/fireworks.cpp ─────────
for (Firework *firework = fireworks;
     firework < fireworks+maxFireworks;
     firework++)
{
    // Check to see if we need to process this firework.
    if (firework->type > 0)
    {
        // Does it need removing?
        if (firework->update(duration))
        {
            // Find the appropriate rule.
            FireworkRule *rule = rules + (firework->type-1);

            // Delete the current firework (this doesn't affect its
            // position and velocity for passing to the create function,
            // just whether it is processed for rendering or
            // physics.
            firework->type = 0;

            // Add the payload.
            for (unsigned i = 0; i < rule->payloadCount; i++)
            {
                FireworkRule::Payload * payload = rule->payloads + i;
                create(payload->type, payload->count, firework);
            }
        }
    }
}
```

These code fragments are taken from the **fireworks** demo in the accompanying source code. You can create your own fireworks display using the number keys to launch new fireworks (there are nine basic firework types).

Exactly the same kind of particle system is used in many game engines. By setting the gravity of particles to a very low value, or even having gravity pull some kinds of particle upward, we can create smoke, fire, waterfalls, explosions, sparks, rain, and many other effects.

The difference between each type of particle is simply one of rendering. Particles are normally drawn as a flat bitmap on screen, rather than as a 3D model. This is the approach I've used in the demo.

Most production particle systems also allow particles to rotate—not the full 3D rotation we will cover later in this book, but a screen rotation, so that each particle bitmap is not drawn with the same orientation on screen. It can be useful to have this rotation change over time. I will not try to implement this technique in this book. It is relatively easy to add a constant-speed rotation to particles, and forms one of the exercises for this chapter.

4.3 Summary

The particle physics engine is most suitable for special effects, such as the ballistics of projectile weapons and visual effects for explosions. A system built for visual effects is often simply called a "particle system."

In this chapter we've used a particle system to render fireworks. There are tens of other uses. Most games have some kind of particle system at work (often completely separate from the main physics engine, but increasingly they are united). By setting particles with different properties for gravity, drag, and initial velocity, it is possible to simulate everything from sparks to smoke and from fireballs to fireworks.

Eventually, however, single particles won't be enough. We'll need full 3D objects. In Part II of this book, we'll look at one way to simulate objects, by building structures out of particles connected by springs, rods, and cables. To handle these structures we'll need to consider more forces than just gravity on particles, the topic of Chapter 5.

4.4 Projects

Mini-Project 4.1
Add a grenade shot type to the **bigballistic** demo. Make sure that it behaves differently, but convincingly alongside the other ammunition types.

Mini-Project 4.2
Add two new firework types to the **fireworks** demo. Make sure that at least one of the fireworks you add spawns further fireworks when it reaches its maximum age.

Mini-Project 4.3

Add the ability to aim to the **bigballistic** demo. Extend the system to use several target blocks with varying masses, including at least one with infinite mass.

Mini-Project 4.4

Add one or more firework types to the **fireworks** demo to implement a Catherine wheel effect. Can this be done without using a force generator to implement the rotation?

Project 4.1

Create a game where a player has to keep a fireworks display going for as long as possible. By default, fireworks should not spawn others; they should just age and disappear. If a firework in flight is clicked, however, it should release a further shower of sparks. A player's turn is over when there are no more live fireworks to click. Make sure that you implement a range of interesting firework effects, with different speeds and age characteristics, to add variety to the game play.

Project 4.2

Create the training mode for a sniper game. The game level should consist of several targets of the same size at different locations and distances from the fixed player location. The player may turn to aim and fire at the targets, scoring points when the target is hit. Add a wind force (using a force generator from Chapter 5) that changes in a random way between each shot. The direction and strength of the wind should be indicated on screen to help the player plan the next shot.

PART II

Mass Aggregate Physics

5

ADDING GENERAL FORCES

In Part I, we built a particle physics engine that included the force of gravity. We looked at the mathematics of forces in Chapter 3, which let us simulate any force we liked by calculating the resulting acceleration.

In this chapter, we will extend our physics engine so it can cope with multiple different forces acting at the same time. We will assume that gravity is one force, although this can be removed or set to zero if required. We will also look at force generators, that is, code that can calculate forces based on the current state of the game world.

5.1 D'ALEMBERT'S PRINCIPLE

Although we have equations for the behavior of an object when a force is acting on it, we haven't considered what happens when more than one force is acting. Clearly the behavior is going to be different than if either force acts alone: one force could be acting in the opposite direction to another or reinforcing it in parallel. We need a mechanism to work out the overall behavior as a result of all forces.

D'Alembert's principle comes to the rescue here. The principle itself is more complex and far-reaching than we'll need to consider. It is based on a different form of the equations of motion, and relates quantities we're not directly manipulating. For our purposes it has two important implications. The first applies here, and the second will arise in Chapter 10.

Copyright © 2010, Elsevier Inc. All rights reserved.
DOI: 10.1016/B978-0-12-381976-5.00005-X

For particles, D'Alembert's principle implies that if we have a set of forces acting on an object, we can replace all those forces with a single force, which is calculated by:

$$f = \sum_i f_i$$

In other words, we simply add the forces together using vector addition, and we apply the single force that results.

To make use of this result, we use a vector as a force accumulator. In each frame we zero the vector and add each applied force in turn using vector addition. The final value will be the resultant force to apply to the object. We add a method to the particle that is called at the end of each integration step to clear the accumulator of the forces that have just been applied:

─────── **Excerpt from file include/cyclone/particle.h** ───────

```
class Particle
{
    // ... Other Particle code as before ...

    /**
     * Holds the accumulated force to be applied at the next
     * simulation iteration only. This value is zeroed at each
     * integration step.
     */
    Vector3 forceAccum;
    /**
     * Clears the forces applied to the particle. This will be
     * called automatically after each integration step.
     */
    void clearAccumulator();
};
```

─────── **Excerpt from file src/particle.cpp** ───────

```
void Particle::integrate(real duration)
{
    // We don't integrate things with infinite mass.
    if (inverseMass <= 0.0f) return;

    assert(duration > 0.0);

    // Update linear position.
    position.addScaledVector(velocity, duration);

    // Work out the acceleration from the force.
```

```
    Vector3 resultingAcc = acceleration;
    resultingAcc.addScaledVector(forceAccum, inverseMass);

    // Update linear velocity from the acceleration.
    velocity.addScaledVector(resultingAcc, duration);

    // Impose drag.
    velocity *= real_pow(damping, duration);

    // Clear the forces.
    clearAccumulator();
}
void Particle::clearAccumulator()
{
    forceAccum.clear();
}
```

We then add a method that can be called to add a new force into the accumulator:

```
                    Excerpt from file include/cyclone/particle.h
class Particle
{
    // ... Other particle code as before ...

    /**
     * Adds the given force to the particle to be applied at the
     * next iteration only.
     */
    void addForce(const Vector3 &force);
};
```

```
                    Excerpt from file src/particle.cpp
void Particle::addForce(const Vector3 &force)
{
    forceAccum += force;
}
```

This accumulation stage needs to be completed just before the particle is integrated. All the forces that apply need to have a chance to add themselves to the accumulator. We can do this by manually adding code to our frame update loop that adds the appropriate forces. This is appropriate for forces that will only occur for a few frames.

For forces that apply over an extended period of time, it would be better to have some automated mechanism. We can make it easier to manage these long-term forces by creating a registry. A force registers itself with a particle, and then will be asked to provide a force each frame. I called these "force generators."

5.2 FORCE GENERATORS

We have a mechanism for applying multiple forces to an object. We now need to work out where these forces come from. The force of gravity is fairly intuitive: it is always present for all objects in the game.

Some forces arise because of the behavior of an object, such as a dedicated drag force. Other forces are a consequence of the environment that an object finds itself in; a buoyancy force for a floating object or the blast force from an explosion are examples. Still other types of force are a result of the way that objects are connected together: we will look at forces that behave like springs in the next chapter. Finally, there are forces that exist because the player (or an AI-controlled character) has requested them, such as the acceleration force in a car or the thrust from a jetpack.

Another complication is the dynamic nature of some forces. The force of gravity is easy because it is always constant. We can calculate it once and leave it set for the rest of the game. Most other forces are constantly changing. Some change as a result of the position or velocity of an object: drag is stronger at higher speeds, and a spring's force is greater the more it is compressed. Others change because of external factors: an explosion dissipates, and the player's jetpack burst will come to a sudden end when they release the thrust button.

We need to be able to deal with a range of different forces with very different mechanics for their calculation. Some might be constant, others might apply some function to the current properties of the object (such as position and velocity), some might require user input, and others might be time-based.

If we simply programmed all these types of forces into the physics engine, and set parameters to mix and match them for each object, the code would rapidly become unmanageable. Ideally we would like to be able to abstract away the details of how a force is calculated and allow the physics engine to simply work with forces in general. This would allow us to apply any number of forces to an object, without the object knowing the details of how those forces are calculated.

I will do this through a structure called a "force generator." There can be as many different types of force generators as there are types or sources of force, but each object doesn't need to know how a generator works. The object uses a consistent interface to find the force associated with each generator; these forces can then be accumulated and applied in the integration step. This allows us to apply any number of forces, of any type we choose, to any object. It also allows us to create new types of forces for new games or levels, as we need to, without having to rewrite any code in the physics engine.

Not every physics engine has the concept of force generators: many require handwritten code to add forces, or else limit the possible forces to just a handful of

common options. Having a general solution is more flexible, and allows us to experiment more quickly.

To implement this we will use an object-oriented design pattern called an interface. Some languages (such as Actionscript) have this built in as part of the language, while in others it can be approximated with a regular class. Before we look at the force generator code, I will briefly review the concept of an interface, and its relative, polymorphism.

5.2.1 INTERFACES AND POLYMORPHISM

In programming, an interface is a specification of how one software component interacts with others. In an object-oriented language, it normally refers to a class: an interface is a specification of the methods, constants, data types, and exceptions (i.e., errors) that a class will expose. The interface itself is not a class, but rather a specification that any number of classes can fulfill. When a class fulfills the specification, we say that it *implements* the interface (in fact, Actionscript uses the explicit `implements` keyword to denote a class that implements an interface).

Interfaces show their power when used in polymorphism. *Polymorphism* is the ability of a language to use some software component on the basis that it fulfills a predefined specification, without having to know the exact component it is talking to. As long as the specification is met, we can easily change and add different implementations without altering the code that uses them.

This replaceability is key for our needs: we will create an interface for a force generator, and any number of implementations representing specific forces. Through polymorphism, our physics engine will not need to know what kind of force generators are running, as long as they implement the interface.

In C++, there is no dedicated interface structure in the language. Instead we use a base class, with a selection of pure virtual functions. This ensures that we can't create an instance of the base class. Each class that derives from the base class then has to implement all its methods before it can be instantiated.

5.2.2 IMPLEMENTATION

The interface for the force generator only needs to provide a current force. This can then be accumulated and applied to the object.

The interface we will use looks like this:

```
 ───────────── Excerpt from file include/cyclone/pfgen.h ─────────────
/**
 * A force generator can be asked to add a force to one or more
 * particles.
 */
class ParticleForceGenerator
```

```
{
public:

    /**
     * Overload this in implementations of the interface to calculate
     * and update the force applied to the given particle.
     */
    virtual void updateForce(Particle *particle, real duration) = 0;
};
```

The `updateForce` method is passed the duration of the frame for which the force is needed and a pointer to the particle that is requesting the force. The duration of the frame is needed for some force generators (we will encounter a spring-force generator in Chapter 6 that depends critically on this value).

We pass the pointer of the particle into the function so that a force generator does not need to keep track of the object itself. This also allows us to create force generators that can be attached to several objects at the same time. As long as the generator instance does not contain any data that is specific to a particular object, it can simply use the object passed in to calculate the force. Both the example force generators below have this property.

The force generator does not return any value. We could have it return a force to add to the force accumulator, but then force generators would have to return some force (even if it were zero), and that would remove flexibility we'll use later in the book when we support rotation. Instead, if a force generator wants to apply a force, it can call the `addForce` method to the object it is passed.

As well as the interface for force generators we need to be able to register which force generators affect which particles. We could add this into each particle with a data structure such as a linked list or a growable array of generators. This would be a valid approach, but it has performance implications: either each particle needs to have lots of wasted storage (using a growable array), or new registrations will cause lots of memory operations (creating elements in linked lists). For performance and modularity, I think it is better to decouple the design and have a central registry of particles and force generators. The one I have provided looks like this:

```
                        Excerpt from file include/cyclone/pfgen.h
/**
 * Holds all the force generators and the particles that they apply to.
 */
class ParticleForceRegistry
{
protected:

    /**
```

```
     * Keeps track of one force generator and the particle it
     * applies to.
     */
    struct ParticleForceRegistration
    {
        Particle *particle;
        ParticleForceGenerator *fg;
    };

    /**
     * Holds the list of registrations.
     */
    typedef std::vector<ParticleForceRegistration> Registry;
    Registry registrations;

public:
    /**
     * Registers the given force generator to apply to the
     * given particle.
     */
    void add(Particle* particle, ParticleForceGenerator *fg);

    /**
     * Removes the given registered pair from the registry.
     * If the pair is not registered, this method will have
     * no effect.
     */
    void remove(Particle* particle, ParticleForceGenerator *fg);

    /**
     * Clears all registrations from the registry. This will
     * not delete the particles or the force generators
     * themselves, just the records of their connection.
     */
    void clear();

    /**
     * Calls all the force generators to update the forces of
     * their corresponding particles.
     */
    void updateForces(real duration);
};
```

I have used the C++ standard template library's growable array, `stl::vector`. The implementation of the first three methods are simple wrappers around corresponding methods in the `stl::vector` data structure.

At each frame, before the update is performed, the force generators are all called. They will hopefully be adding forces to each particle's accumulator. Later these accumulated forces are used to calculate each particle's acceleration:

```
──────────────── Excerpt from file src/pfgen.cpp ────────────────
#include <cyclone/pfgen.h>

using namespace cyclone;

void ParticleForceRegistry::updateForces(real duration)
{
    Registry::iterator i = registrations.begin();
    for (; i != registrations.end(); i++)
    {
        i->fg->updateForce(i->particle, duration);
    }
}
```

5.2.3 A Gravity Force Generator

We can replace our previous implementation of gravity by a force generator. Rather than special-case code to apply a constant acceleration at each frame, gravity is represented as a regular force generator attached to each particle.

The implementation looks like this:

```
──────────────── Excerpt from file include/cyclone/pfgen.h ────────────────
/**
 * A force generator that applies a gravitational force. One instance
 * can be used for multiple particles.
 */
class ParticleGravity : public ParticleForceGenerator
{
    /** Holds the acceleration due to gravity. */
    Vector3 gravity;

public:

    /** Creates the generator with the given acceleration. */
    ParticleGravity(const Vector3 &gravity);
```

```
        /** Applies the gravitational force to the given particle. */
        virtual void updateForce(Particle *particle, real duration);
};
```

```
void ParticleGravity::updateForce(Particle* particle, real duration)
{
    // Check that we do not have infinite mass.
    if (!particle->hasFiniteMass()) return;

    // Apply the mass-scaled force to the particle.
    particle->addForce(gravity * particle->getMass());
}
```

Note that the force is calculated based on the mass of the object passed into the updateForce method. The only piece of data stored by the class is the acceleration due to gravity. One instance of this class could be shared among any number of objects.

5.2.4 A Drag Force Generator

We could also implement a force generator for drag. Drag is a force that acts on a body and depends on its velocity. A full model of drag involves more complex mathematics than we can easily perform in real time. Typically, in game applications we use a simplified model of drag where the drag acting on a body depends on the speed of the object and the square of its speed,

$$f_{drag} = -\hat{\boldsymbol{p}}(k_1|\hat{\boldsymbol{p}}| + k_2|\hat{\boldsymbol{p}}|^2) \qquad [5.1]$$

where k_1 and k_2 are two constants that characterize how strong the drag force is—they are usually called the "drag coefficients" and they depend on both the object and the type of drag being simulated.

The formula looks complex, but is simple in practice: it says that the force acts in the opposite direction to the velocity of the object (this is the $-\hat{\boldsymbol{p}}$ part of the equation; $\hat{\boldsymbol{p}}$ is the normalized velocity of the particle), with a strength that depends on both the *speed* of the object and the square of the speed.

Drag that has a k_2 value will grow faster at higher speeds. This is the case with the aerodynamic drag that keeps a car from accelerating indefinitely. At slow speeds, the car feels almost no drag from the air, but for every doubling of the speed, the drag almost quadruples.

The implementation for the drag generator looks like this:

```
_____ Excerpt from file include/cyclone/pfgen.h _____
/**
 * A force generator that applies a drag force. One instance
 * can be used for multiple particles.
 */
class ParticleDrag : public ParticleForceGenerator
{
    /** Holds the velocity drag coefficient. */
    real k1;

    /** Holds the velocity squared drag coefficient. */
    real k2;

public:

    /** Creates the generator with the given coefficients. */
    ParticleDrag(real k1, real k2);

    /** Applies the drag force to the given particle. */
    virtual void updateForce(Particle *particle, real duration);
};
```

```
_____ Excerpt from file src/pfgen.cpp _____
void ParticleDrag::updateForce(Particle* particle, real duration)
{
    Vector3 force;
    particle->getVelocity(&force);

    // Calculate the total drag coefficient.
    real dragCoeff = force.magnitude();
    dragCoeff = k1 * dragCoeff + k2 * dragCoeff * dragCoeff;

    // Calculate the final force and apply it.
    force.normalize();
    force *= -dragCoeff;
    particle->addForce(force);
}
```

Once again the force is calculated based only on the properties of the object it is passed. The only pieces of data stored by the class are the values for the two constants.

As before, one instance of this class could be shared among any number of objects that have the same drag coefficients.

This drag model is considerably more complex than the simple damping we used in Chapter 3. It can be used to model the kind of drag that a golf ball experiences in flight, for example. For the aerodynamics needed in a flight simulator, however, it will still not be sufficient: we will return to flight simulator aerodynamics in Chapter 11.

5.3 BUILT-IN GRAVITY AND DAMPING

Using the generators above we can replace both the damping and the acceleration due to gravity with force generators. This is a valid approach and one used by many different engines. It allows us to remove the special code that processes damping, and it means that we don't need to store an acceleration due to gravity with the object. It can be calculated among all the other forces during transient force accumulation.

Although it has some advantages in simplicity, this is not the approach I will use. Directly applying the damping and acceleration due to gravity, in the way we did in Chapter 3, is fast. If we have to calculate forces for them each time, we waste extra time performing calculations for which we already know the answer.

To avoid this, I keep damping and acceleration unchanged. If we need more complex drag, we can set a damping value nearer to 1, and add a drag force generator. Similarly if we needed some exotic form of gravity (for an orbiting space ship, for example), we could create a gravity force generator that provides the correct behavior and set the acceleration due to gravity to be zero.

5.4 SUMMARY

Forces are easily combined by adding their vectors together, and the resulting force acts as if it were the only force applied to an object. This is a result of D'Alembert's principle, and it allows us to support any number of general forces without having to know anything about how the forces are generated.

Throughout this book we'll see force generators of various kinds that simulate some kind of physical property by calculating a force to apply to an object. The code we've created in this chapter allows us to manage those forces, combining them and applying them before integrating.

Drag and gravity are important force generators, but they only replicate functionality we had in our particle physics engine. To move toward a mass aggregate physics engine, we need to start linking particles together. Chapter 6 introduces springs and other spring-like connections, using the force generator structure we've built in this chapter.

5.5 EXERCISES

Exercise 5.1
Implement an uplift force generator. The force generator should have an origin representing the center of the uplift. When the force generator is asked to apply its force, it should test the X-Z coordinate of the object against the origin. If this coordinate is within a given distance of the origin, then the uplift should be applied. Otherwise there is no force. We use only the X-Z coordinates to represent a chimney of rising uplift above a particular point, so the Y coordinate is irrelevant.

Exercise 5.2
Implement an airbrake force generator. This should contain a Boolean value. When the value is false (the airbrake is off), the generator should provide no force. When the value is true, the generator should provide a large drag force. Be careful not to make the drag too high, however, because the object being dragged might reverse direction.

Exercise 5.3
Implement a variant of the gravity force generator that pulls objects toward a fixed point (the attraction point), rather than using the down direction. You will have to calculate the direction to apply the force from the object to the attraction point, and make sure that it is scaled accordingly.

Exercise 5.4
Extend the gravity force generator from the previous exercise so that it scales the forces it applies based on the square of the distance from the attraction point. This provides a simple model of planetary gravity because it conforms to Equation 3.3.

6

SPRINGS AND
SPRING-LIKE
THINGS

One of the most useful forces we can create for our engine is a spring force. Although springs have an obvious use in driving games (for simulating the suspension of a car), they come into their own in representing soft, deformable, or non-solid objects of many kinds. Springs and particles alone can produce a whole range of impressive effects, such as ropes, flags, cloth garments, and water ripples. Along with the hard constraints we'll cover in the next chapter, they can represent almost any kind of object.

To extend our engine to support springs, this chapter will first cover the theory of springs, and then look at how they can be created for our engine. Finally, we'll look at a major problem in the simulation of springs.

6.1 HOOK'S LAW

Hook's law gives us the mathematics of springs. Hook discovered that the force exerted by a spring depends only on the distance the spring is extended or compressed. A spring extended twice as far from this rest position will exert twice the force. The formula is therefore:

$$f = -k\Delta l$$

Copyright © 2010, Elsevier Inc. All rights reserved.
DOI: 10.1016/B978-0-12-381976-5.00006-1

where Δl is the distance that the spring is extended or compressed, and k is called the "spring constant," a value that gives the stiffness of the spring. The force given in this equation is felt *at both ends* of the spring. In other words, if two objects are connected by a spring, then they will each be attracted together by the same force given by the equation above.

Note that we have used Δl in the equation. This is because, at rest, with no forces acting to extend or compress the spring, the spring will have some natural length. This is also called the "rest length," and has the symbol l_0. If the spring is currently at length l, then the force generated by the spring is

$$f = -k(l - l_0)$$

So far we have considered Hook's law only in terms of a one-dimensional spring. When it comes to three dimensions, we need to generate a force vector rather than a scalar. The corresponding formula for the force is

$$\boldsymbol{f} = -k(|\boldsymbol{d}| - l_0)\widehat{\boldsymbol{d}} \qquad [6.1]$$

where \boldsymbol{d} is the vector from one end of the spring to the other. The direction of this vector points *towards* the object we're generating a force for. It is given by

$$\boldsymbol{d} = x_A - x_B \qquad [6.2]$$

where x_A is the position of the end of the spring attached to the object under consideration, and x_B is the position of the other end of the spring.

Equation 6.1 states that if the spring is extended, the force should pull toward the other end of the spring (the $-\widehat{\boldsymbol{d}}$ component), with a magnitude given by the spring coefficient multiplied by the amount of extension of the spring (the $k(|\boldsymbol{d}| - l_0)$ part). $|\boldsymbol{d}|$ is the magnitude of the vector between the ends of the spring, which is just the length of the spring, making $(|\boldsymbol{d}| - l_0)$ just a different way of writing $(l - l_0)$.

Because Equation 6.1 is defined in terms of one end of the spring only (the end attached to the object we are currently considering), we can use it unmodified for the other end of the spring, when we come to process the object attached there. Alternatively, because the two ends of the spring always pull toward each other with the same magnitude of force, we know that if the force on one end is \boldsymbol{f}, then the force on the other will be $-\boldsymbol{f}$.

In our force generator below, we will calculate the force separately for each object, and not make use of this fact. A more optimized approach might use the same force generator for both objects involved, and cache the force calculation.

Spring Compression

In the discussion above I have only considered what happens when a spring is extended. A regular metal wire spring can also be compressed, in which case the force it generates will try to push its ends apart.

Equation 6.1 holds for compression as well as extension. When a spring is compressed below its rest length, the $(|d| - l_0)$ term will be negative. This negative will cancel with the $-\hat{d}$ term, leaving the force in the direction of \hat{d}. This will act to push the object away from the other end of the spring. So, we don't need to do anything special to support spring compression.

Spring-like behavior is very common in physical simulation. Some simulated elements will have both compression and extension (like a wire spring), others will just have compression (like a trampoline), and others just extension (like an elastic bungee).

The Limit of Elasticity

Real springs only follow Hook's law within a range of lengths, called their *limit of elasticity*. If you continue to extend a metal spring, eventually you will exceed its elasticity and it will deform. Similarly, if you compress a spring too much its coils will touch and further compression is impossible. The behavior outside the limit of elasticity is often very complex, and there is no single formula that can help us simulate it.

Assuming we could work out the behavior we wanted outside the limit of elasticity, we could encode the limits into our force generator to produce a realistic model of a spring. For extension, however, we are unlikely to need this sophistication. Using the simple Hook's model will mean that when the player sees a spring doing its most spring-like thing, they are unlikely to notice whether it behaves correctly beyond its limit of elasticity.

The only case I've seen of a real-time physics engine modeling springs extended beyond their limits of elasticity was a commercial driving simulator, where a more complex suspension model was needed. I've never seen it used in a game.

For compression, it is common to model a minimum compression length. This is a very common requirement for car suspensions when they hit their "stop." After being compressed to this point, they no longer act like springs but rather like a collision between two objects. We will cover this kind of hard constraint in the next chapter: it can't be easily modeled using a spring.

Spring-Like Things

Hook's law applies to a huge range of natural phenomena, beyond a coiled metal spring. Anything that resists being deformed will have some limit of elasticity in which Hook's law applies.

The applications are limitless. We can implement elastic bungees as springs. We could simulate the buoyancy of water in the same way, connecting the submerged object to the nearest point on the surface with an invisible spring. Some developers even use springs to control the camera as it follows a game character by applying a spring from the camera to a point just behind the character (see Figure 6.1).

FIGURE 6.1 The game's camera attached to a spring.

6.2 SPRING-LIKE FORCE GENERATORS

We will implement four force generators that are based on spring forces. Although each has a slightly different way of calculating the current length of the spring, they all use Hook's law to calculate the resulting force.

This section illustrates a feature of many physics systems. The core processing engine remains generic, but it is surrounded by helper classes and functions (in this case the different types of spring force generators) that are often quite similar to one another. In the remainder of the book, I will avoid going through similar variations in detail; you can find several suites of similar classes in the source code. This first time, however, it is worth looking at some variations in detail.

6.2.1 A BASIC SPRING FORCE GENERATOR

The basic spring generator simply calculates the length of the spring using Equation 6.2, and then uses Hook's law to calculate the force. It can be implemented like this:

```
——————— Excerpt from file include/cyclone/pfgen.h ———————
/**
 * A force generator that applies a spring force.
 */
class ParticleSpring : public ParticleForceGenerator
{
    /** The particle at the other end of the spring. */
    Particle *other;

    /** Holds the spring constant. */
    real springConstant;

    /** Holds the rest length of the spring. */
    real restLength;
```

```
public:

    /** Creates a new spring with the given parameters. */
    ParticleSpring(Particle *other,
        real springConstant, real restLength);

    /** Applies the spring force to the given particle. */
    virtual void updateForce(Particle *particle, real duration);
};
```

──────── **Excerpt from file include/cyclone/precision.h** ────────

```
/** Defines the precision of the absolute magnitude operator. */
#define real_abs fabsf
```

──────── **Excerpt from file src/pfgen.cpp** ────────

```
void ParticleSpring::updateForce(Particle* particle, real duration)
{
    // Calculate the vector of the spring.
    Vector3 force;
    particle->getPosition(&force);
    force -= other->getPosition();

    // Calculate the magnitude of the force.
    real magnitude = force.magnitude();
    magnitude = real_abs(magnitude - restLength);
    magnitude *= springConstant;

    // Calculate the final force and apply it.
    force.normalize();
    force *= -magnitude;
    particle->addForce(force);
}
```

The generator is created with three parameters: (1) a pointer to the object at the other end of the spring, (2) the spring constant, and (3) the rest length of the spring. We can create and add the generator using this code:

```
Particle a, b;
ParticleForceRegistry registry;
```

```
ParticleSpring ps(&b, 1.0f, 2.0f);
registry.add(&a, ps);
```

Because it contains data that depends on the spring, one instance cannot be used for multiple objects in the way that the force generators from Chapter 5 were. Instead we need to create a new generator for each object.[1]

Note also that the force generator (like the others we have met) creates a force for only one object. If we want to link two objects with a spring, then we'll need to create and register a generator for each:

```
Particle a, b;
ParticleForceRegistry registry;

ParticleSpring psA(&b, 1.0f, 2.0f);
registry.add(&a, psA);

ParticleSpring psB(&a, 1.0f, 2.0f);
registry.add(&b, psB);
```

6.2.2 AN ANCHORED SPRING GENERATOR

In many cases we don't want to link two objects together with a spring, but rather one end of the spring at a fixed point in space. This might be the case for the supporting cables on a springy rope bridge, for example. One end of the spring is attached to the bridge; the other is fixed in space. See Figure 6.2 for an example.

In this case, the form of the spring generator we created previously will not work. We can modify it so that the generator expects a fixed location rather than an object to link to. The force generator code is also modified to use the location directly rather than looking it up in an object. The anchored force generator implementation looks like this:

Excerpt from file `include/cyclone/pfgen.h`

```
/**
 * A force generator that applies a spring force, where
 * one end is attached to a fixed point in space.
 */
class ParticleAnchoredSpring : public ParticleForceGenerator
{
```

1. Strictly speaking, we *can* reuse the force generator. If we have a set of springs all connected to the same object, and having the same values for rest length and spring constant, we could use one generator for all of them. Rather than try to anticipate these obscure situations in practice, it is simpler to just assume that instances cannot be reused.

FIGURE 6.2 A rope bridge held up by springs.

```
protected:
    /** The location of the anchored end of the spring. */
    Vector3 *anchor;

    /** Holds the spring constant. */
    real springConstant;

    /** Holds the rest length of the spring. */
    real restLength;

public:
    /** Creates a new spring with the given parameters. */
    ParticleAnchoredSpring(Vector3 *anchor,
                           real springConstant,
                           real restLength);

    /** Applies the spring force to the given particle. */
    virtual void updateForce(Particle *particle, real duration);
};
```

——————————— **Excerpt from file src/pfgen.cpp** ———————————
```
void ParticleAnchoredSpring::updateForce(Particle* particle, real
                                         duration)
{
    // Calculate the vector of the spring.
    Vector3 force;
    particle->getPosition(&force);
    force -= *anchor;
```

```
        // Calculate the magnitude of the force.
        real magnitude = force.magnitude();
        magnitude = (restLength - magnitude) * springConstant;

        // Calculate the final force and apply it.
        force.normalize();
        force *= magnitude;
        particle->addForce(force);
}
```

If we wanted to connect the game's camera to the player's character, this is an approach we would use. Instead of an anchor point that never moves, however, we would recalculate and reset the anchor point for each frame based on the position of the character. The previous implementation needs no modification (other than a setAnchor method to give the new value); we would just need to perform the update of the anchor point somewhere in the game loop.

Alternatively, if our player character is represented as a particle in the engine, then we could use the original spring generator. We'd want the spring to be connected only in one direction, however, so the camera is dragged around by the player and not the other way around.

6.2.3 AN ELASTIC BUNGEE GENERATOR

An elastic bungee only produces pulling forces: you can scrunch it into a tight ball and it will not push back out, but it behaves like any other spring when extended. This is useful for keeping a pair of objects together—they will be pulled together if they stray too far, but they can get as close as they like without being separated.

The generator can be implemented like this:

Excerpt from file `include/cyclone/pfgen.h`

```
/**
 * A force generator that applies a spring force only
 * when extended.
 */
class ParticleBungee : public ParticleForceGenerator
{
    /** The particle at the other end of the spring. */
    Particle *other;

    /** Holds the spring constant. */
    real springConstant;
```

```
    /**
     * Holds the length of the bungee at the point it begins to
     * generate a force.
     */
    real restLength;

public:

    /** Creates a new bungee with the given parameters. */
    ParticleBungee(Particle *other,
        real springConstant, real restLength);

    /** Applies the spring force to the given particle. */
    virtual void updateForce(Particle *particle, real duration);
};
```

──────── **Excerpt from file src/pfgen.cpp** ────────

```
void ParticleBungee::updateForce(Particle* particle, real duration)
{
    // Calculate the vector of the spring.
    Vector3 force;
    particle->getPosition(&force);
    force -= other->getPosition();

    // Check if the bungee is compressed.
    real magnitude = force.magnitude();
    if (magnitude <= restLength) return;

    // Calculate the magnitude of the force.
    magnitude = springConstant * (restLength - magnitude);

    // Calculate the final force and apply it.
    force.normalize();
    force *= -magnitude;
    particle->addForce(force);
}
```

I have added a factory function to this class as well to allow us to easily connect two objects with a bungee.

This implementation assumes that the elastic connects to two objects. We could create a version of the code that connects an object to a fixed anchor point in space, exactly as before. The modifications we would need are exactly the same as we saw above: implementing this generator is one of the exercises for this chapter.

6.2.4 A BUOYANCY FORCE GENERATOR

A buoyancy force is what keeps an object afloat. The Greek mathematician Archimedes first worked out that the buoyancy force is equal to the weight of water that an object displaces.

The first part of Figure 6.3 shows a block submerged in the water. The block has a mass of 0.5 kg. Pure water has a density of $1000 \, \text{kgm}^{-3}$; in other words, a cubic meter of water has a mass of about 1 MT. The block in the figure has a volume of $0.001 \, \text{m}^3$, so it is displacing the same amount of water. The mass of this water would therefore be 1 kg.

Weight isn't the same as mass in physics. Mass is the property of an object that makes it resist acceleration. The mass of an object will always be the same. Weight is the force that gravity exerts on an object. As we have already seen, force is given by the equation

$$f = mg$$

where f is the weight, m is the mass, and g is the acceleration due to gravity. This means that on different planets, the same object will have different weights (but the same mass) because g changes.

On Earth, we assume $g = 10 \, \text{m s}^{-2}$, so an object with a weight of 1 kg will have a weight of $1 \times 10 = 10 \, \text{kN}$. The kN unit is a unit of weight: kilograms, kg, is *not* a unit of weight, despite what your bathroom scales might say! This causes space scientists various problems: because g is different, they can no longer convert English units such as pounds to kilograms using the conversion factors found in science reference books; pounds is a measure of weight and kilograms is a measure of mass.

So, back to buoyancy: our block in the first part of Figure 6.3 has a buoyancy force of 10 kN. In the second part of the figure only half is submerged, so using the same calculations, it has a buoyancy force of 5 kN.

Although we don't need to use it for our force generator, it is instructive to look at the weight of the object too. In both cases, the weight of the block is the same: 5 kN (a mass of 0.5 kg, multiplied by the same value of $g = 10 \, \text{m s}^{-2}$). So in the first part

FIGURE 6.3 A buoyant block submerged and partially submerged.

of the figure, the buoyancy force will push the block upward. In the second part of the figure, the weight is exactly the same as the buoyancy, so the object will stay at the same position, floating.

Calculating the exact buoyancy force for an object involves knowing exactly how it is shaped, because the shape affects the volume of water displaced, which is used to calculate the force. Unless you are designing a physics engine specifically to model the behavior of different shapes of boat hulls, you are unlikely to need this level of detail.

Instead we can use a spring-like calculation as an approximation. When the object is near the surface, we use a spring force to give it buoyancy. The force is proportional to the depth of the object, just as the spring force is proportional to the extension or compression of the spring. As we saw in Figure 6.3, this will be accurate for a rectangular block that is not completely submerged. For any other object it will be slightly inaccurate, but hopefully not enough to be noticeable.

When the block is completely submerged, it behaves slightly differently. Pushing it deeper in the water will not displace any more water; so as long as we assume water has the same density, the force when submerged will be constant. The point masses we are dealing with in this part of the book have no size, so we can't tell how big they are to determine whether they are fully submerged. We can simply use a fixed depth instead: when we create the buoyancy force we give a depth at which the object is considered to be fully submerged. At this point, the buoyancy force will not increase for deeper submersion.

By contrast, when the object is lifted out of the water, it will still have some part of itself submerged until it reaches its maximum submersion depth above the surface. At this point we consider the last part of the object to have left the water. In this case, there will be no buoyancy force at all, no matter how high we lift the object: it simply is displacing no more water.

So, the formula for the force calculation is:

$$f = \begin{cases} 0 & \text{when } d \leqslant 0 \\ v\rho & \text{when } d \geqslant 1 \\ dv\rho & \text{otherwise} \end{cases}$$

where ρ is the density of the liquid, v is the volume of the object, and d is the amount of the object submerged, given as a proportion of its maximum submersion depth (i.e., when it is fully submerged $d = 1$, and when it is fully out of the water $d = 0$). d is given by

$$d = \frac{y_o - y_w - s}{2s}$$

where s is the submersion depth (the depth at which the object is completely submerged), y_o is the y coordinate of the object, and y_w is the y coordinate of the liquid plane (assuming it is parallel to the XZ plane).

This can be implemented as follows:

─────────── **Excerpt from file include/cyclone/pfgen.h** ───────────

```
/**
 * A force generator that applies a buoyancy force for a plane of
 * liquid parallel to XZ plane.
 */
class ParticleBuoyancy : public ParticleForceGenerator
{
    /**
     * The maximum submersion depth of the object before
     * it generates its maximum buoyancy force.
     */
    real maxDepth;

    /**
     * The volume of the object.
     */
    real volume;

    /**
     * The height of the water plane above y = 0. The plane will be
     * parallel to the XZ plane.
     */
    real waterHeight;

    /**
     * The density of the liquid. Pure water has a density of
     * 1000 kg per cubic meter.
     */
    real liquidDensity;

public:

    /** Creates a new buoyancy force with the given parameters. */
    ParticleBuoyancy(real maxDepth, real volume, real waterHeight,
        real liquidDensity = 1000.0f);

    /** Applies the buoyancy force to the given particle. */
    virtual void updateForce(Particle *particle, real duration);
};
```

```
─────────── Excerpt from file src/pfgen.cpp ───────────
void ParticleBuoyancy::updateForce(Particle* particle, real duration)
{
    // Calculate the submersion depth.
    real depth = particle->getPosition().y;

    // Check if we're out of the water.
    if (depth >= waterHeight + maxDepth) return;
    Vector3 force(0,0,0);

    // Check if we're at maximum depth.
    if (depth <= waterHeight - maxDepth)
    {
        force.y = liquidDensity * volume;
        particle->addForce(force);
        return;
    }

    // Otherwise we are partly submerged.
    force.y = liquidDensity * volume *
        (depth - maxDepth - waterHeight) / 2 * maxDepth;
    particle->addForce(force);
}
```

I have assumed in this code that the buoyancy is acting in the up direction. I have therefore used only the y component of the object's position to calculate the length of the spring for Hook's law, making it simpler than calculating the force using vector operations.

The generator takes four parameters: the submersion depth parameter, as discussed above; the volume of the object; the height of the suface of the water; and the density of the liquid in which it is floating. If no density parameter is given, then water, with a density of $1000 \, \text{kg m}^3$ is assumed (ocean water has a density of 1020 to $1030 \, \text{kg m}^3$ up to $1250 \, \text{kg m}^3$ for the Dead Sea).

This generator applies to only one object, because it contains the data for the object's size and volume. One instance could be given to multiple objects with the same size and volume, floating in the same liquid, but it is probably best to create a new instance per object to avoid confusion.

6.3 STIFF SPRINGS

In real life almost everything acts as a spring. If a rock falls onto the ground, then the ground gives a little, like a very stiff spring. Collisions between objects could be

modeled in a similar way to the buoyancy force: the objects would be allowed to pass into one another (called "interpenetration") and a spring force would push them back out again.

With the correct spring parameters for each object, this method would give us perfect collisions. It is called the "penalty" method and has been used in many physics simulators, including several used in games.

If life were so simple, this book would be two hundred pages shorter. If you tried this approach (see the exercises for a suggestion on how), you'd find that everything in the game looks really spongy as it bounces around on soggy springs. We would have to increase the spring constant to a really high level. If you try to do that and run the engine, you will see everything go haywire: objects will almost instantly disappear off to infinity, and your program may even crash with numerical errors. This is the problem with stiff springs, and it makes penalty methods very difficult to use.

6.3.1 THE STIFF SPRINGS PROBLEM

To understand why stiff springs cause problems, we need to break down the behavior of a spring into short time steps. Figure 6.4 shows a spring's behavior over several time steps. In the first step, the spring is extended and we calculate the force at that point.

The force is applied to the end of the spring using the update function from Chapter 3:

$$\dot{p}' = \dot{p} + \ddot{p}t$$

In other words, the force is converted into an acceleration: the acceleration of the end of the spring *at that instant of time*. This acceleration is then applied to the object *for the entire time interval*. This would be accurate if the object didn't move, that is, if the spring were held at a constant extension over the entire time period.

In the real world, as soon as the spring has moved a bit, a tiny fraction of the time interval later, the force will have decreased slightly. So applying the same force for the whole time interval means we have applied too much force. In the figure, we see

FIGURE 6.4 A non-stiff spring over time.

that this doesn't matter very much; even though the force is too high, the end doesn't move far before the next time frame, and then a lower force is applied for the next time frame, and so on. The overall effect is that the spring behaves normally, but is slightly stiffer than the spring constant we specified.

Figure 6.5 shows the same problem, but with a much stiffer spring. Now the force in the first frame is enough to carry the end of the spring past the rest length and to compress the spring. In reality, the movement of the spring wouldn't do this: it would begin to move inward having had a huge instantaneous force applied, but this force would drop rapidly as the ends came closer together.

The figure shows that the spring has compressed more than it was extended originally. In the next time frame, it receives a force that tries to push its ends apart, and so it moves in the opposite direction. But it has an even greater force applied, so that it overshoots and is extended even farther. In each time frame the spring will oscillate with ever-growing forces until the end of the spring ends up at infinity. Clearly this is not accurate.

The longer the time frame we use, the more likely this is to happen. If your game uses springs and variable frame rates, you need to take a lot of care that your spring constants aren't too large when used on a very slow machine. If a player switches all the graphics options on, and slows their machine down to 10 frames per second (or slower), you don't want all your physics to explode!

We can address this problem by forcing small time periods for the update, or we can use several smaller updates for each frame we render. Either approach doesn't buy us much, however. The kinds of spring stiffness needed to simulate realistic collisions just aren't possible in the framework we have built so far.

Instead, we will have to use alternative methods to simulate collisions and other hard constraints.

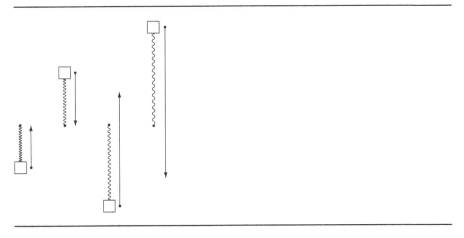

FIGURE 6.5 A stiff spring over time.

6.3.2 FAKING STIFF SPRINGS

This section will implement a more advanced spring force generator that uses a different method of calculating spring forces to help with stiff springs. It provides a hack for making stiff springs work in certain cases. In the remaining chapters of the book we will look at more robust techniques for simulating constraints, collisions, and contacts.

You can safely skip this section: the mathematics are not explored in detail; there are restrictions on where we can use faked stiff springs, and the formulation is not always guaranteed to work. In particular, while they fake the effect reasonably on their own, when more than one is combined, or when a series of objects is connected to them, the physical innacuracies in the calculation can interact nastily and cause serious problems. In the right situation, they can be a useful addition to your library of force generators, however.

Our approach to the problem is to try and predict how the force will change over the time interval. If we can predict the way the force changes, we can avoid applying the maximum force (from the start of the time period) to the whole time interval. Instead we can work out what the average force would be over the time period and use that.

This is sometimes called an *implicit spring*, and a physics engine that can deal with varying forces in this way is called "implicit," or "semi-implicit." For reasons we'll see at the end of the chapter, our engine can't do anything more than guess the correct force to generate. So I have called this approach "fake implicit force generation."

In order to work out the force equation, we need to understand how a spring will act if left to its own devices.

Harmonic Motion

A spring that has no friction or drag will oscillate forever. If we stretch such a spring to a particular extension, then release it, its ends will accelerate together. It will pass its natural length and begin to compress. When its ends are compressed to exactly the same degree as they were extended initially, it will begin to accelerate apart. This would continue forever. This kind of motion is well known to physicists as *simple harmonic motion*. The position of each end of the spring obeys the equation

$$\ddot{p} = -\chi^2 p \qquad [6.3]$$

where k is the spring constant, m is the mass of the object, and χ is defined, for convenience in the following equations, to be

$$\chi = \sqrt{\frac{k}{m}}$$

This kind of equation is called a "differential equation," as it links the different differentials together, sometimes with the original quantity, in this case the second differential \ddot{p} and the original p. Differential equations can sometimes be solved to

give an expression just in terms of the original quantity. In our case, the equation can be solved to give us an expression that links the position and initial velocity with the current time.[2] The expression is solved to give

$$\boldsymbol{p}_t = \boldsymbol{p}_0 \cos(\chi t) + \frac{\dot{\boldsymbol{p}}_0}{\chi} \sin(\chi t) \qquad [6.4]$$

where \boldsymbol{p}_0 is the position of the end of the spring *relative to the natural length* at the start of the prediction, and $\dot{\boldsymbol{p}}_0$ is the velocity at the same time.

We can substitute the time interval we are interested in (i.e., the duration of the current frame) into Equation 6.4, and work out where the spring would end up if were left to do its own thing. We can then create a force that is just big enough to get it to the correct location over the duration of the frame. If the final location needs to be \boldsymbol{p}_t, then the force to get it there would be

$$\boldsymbol{f} = m\ddot{\boldsymbol{p}}$$

and the acceleration $\ddot{\boldsymbol{p}}$ is given by

$$\ddot{\boldsymbol{p}} = (\boldsymbol{p}_t - \boldsymbol{p}_0)\frac{1}{t^2} - \dot{\boldsymbol{p}}_0 \qquad [6.5]$$

Note that although this gets the particle to the correct place, it doesn't necessarily get it there with the correct speed. We'll return to the problems caused by this failing at the end of the section.

Damped Harmonic Motion

A real spring experiences drag as well as spring forces. The spring will not continue to oscillate forever to the same point. Its maximum extension will become less with each oscillation, until eventually it settles at the rest length. This gradual decrease is caused by the drag that the spring experiences.

When we run our physics engine normally, the drag will be incorporated in the damping parameter. When we predict the behavior of the spring using the formula above, this does not happen.

We can include the damping in the equations to give a damped harmonic oscillator. The differential Equation 6.3 becomes

$$\ddot{\boldsymbol{p}} = -k\boldsymbol{p} - d\dot{\boldsymbol{p}}$$

where k is the spring constant (no need for χ in this case) and d is a drag coefficient (it matches the k_1 coefficient from Equation 5.1 in the previous chapter). This equation doesn't allow for drag that is proportional to the velocity squared, the k_2 value from

2. Not all differential equations have a simple solution, although most simple equations of the kind above do. Solving differential equations can involve applying a whole range of techniques and is beyond the scope of this book. When neccessary, I will provide the answers needed for the physics simulator. If you want to understand more about how I get these answers, you can consult any undergraduate-level calculus textbook for more details.

Equation 5.1. If we added this, the mathematics would become considerably more complex, for little visible improvement (remember, we're faking this in any case). So we stick with the simplest kind of drag.

Solving the differential equation gives an expression for the position at any time in the future:

$$\boldsymbol{p}_t = [\boldsymbol{p}_0 \cos(\gamma t) + \boldsymbol{c} \sin(\gamma t)]\, e^{-\frac{1}{2}dt}$$

where γ is a constant given by

$$\gamma = \frac{1}{2}\sqrt{4k - d^2}$$

and \boldsymbol{c} is a constant given by

$$\boldsymbol{c} = \frac{d}{2\gamma}\boldsymbol{p}_0 + \frac{1}{\gamma}\dot{\boldsymbol{p}}_0$$

Substituting the time interval for t in the equations above as before, we can get a value for \boldsymbol{p}_t, and calculate the acceleration required using Equation 6.5 as we did for regular harmonic motion.

Implementation

The code to implement a faked implicit spring force generator looks like this:

```
──────────────── Excerpt from file include/cyclone/pfgen.h ────────────────
/**
 * A force generator that fakes a stiff spring force, and where
 * one end is attached to a fixed point in space.
 */
class ParticleFakeSpring : public ParticleForceGenerator
{
    /** The location of the anchored end of the spring. */
    Vector3 *anchor;

    /** Holds the spring constant. */
    real springConstant;

    /** Holds the damping on the oscillation of the spring. */
    real damping;

public:

    /** Creates a new spring with the given parameters. */
    ParticleFakeSpring(Vector3 *anchor, real springConstant,
        real damping);
```

```
    /** Applies the spring force to the given particle. */
    virtual void updateForce(Particle *particle, real duration);
};
```

————————— Excerpt from file include/cyclone/precision.h —————————

```
/** Defines the precision of the sine operator. */
#define real_sin sinf

/** Defines the precision of the cosine operator. */
#define real_cos cosf

/** Defines the precision of the exponent operator. */
#define real_exp expf
```

————————— Excerpt from file src/pfgen.cpp —————————

```cpp
void ParticleFakeSpring::updateForce(Particle* particle, real duration)
{
    // Check that we do not have infinite mass.
    if (!particle->hasFiniteMass()) return;

    // Calculate the relative position of the particle to the anchor.
    Vector3 position;
    particle->getPosition(&position);
    position -= *anchor;

    // Calculate the constants and check that they are in bounds.
    real gamma = 0.5f * real_sqrt(4 * springConstant - damping*damping);
    if (gamma == 0.0f) return;
    Vector3 c = position * (damping / (2.0f * gamma)) +
        particle->getVelocity() * (1.0f / gamma);

    // Calculate the target position.
    Vector3 target = position * real_cos(gamma * duration) +
        c * real_sin(gamma * duration);
    target *= real_exp(-0.5f * duration * damping);

    // Calculate the resulting acceleration, and therefore the force.
    Vector3 accel = (target - position) * (1.0f / duration*duration) -
        particle->getVelocity() * duration;
    particle->addForce(accel * particle->getMass());
}
```

The force generator looks like the anchored regular spring generator we created earlier in the chapter, with one critical difference: it no longer has a natural spring length. This, and the fact that we have used an anchored generator rather than a spring capable of attaching two objects, is a result of some of the mathematics used above. The consequence is that we must always have a rest length of zero.

Zero Rest Lengths

If a spring has a zero rest length, then any displacement of one end of the spring results in extension of the spring. If we fix one end of the spring, then there will always be a force in the direction of the anchored end.

For a spring where both ends of the spring are allowed to move, the direction of the force is much harder to determine. The previous formulas assume that the force can be expressed in terms of the location of the object only. If we didn't anchor the spring, then we would have to include the motion of the other end of the spring in the equation, which would make it insoluble.

A similar problem occurs if we anchor one end, but use a non-zero rest length. In one dimension, a non-zero rest length is equivalent to moving the equilibrium point along a bit, as shown in Figure 6.6. The same is true in 3D, but because the spring is allowed to swivel freely, this equilibrium point is now in motion with the same problems as for a nonanchored spring.

So the previous equations only work well for keeping an object at a pre-determined fixed location. Just as for the previous anchored springs, we can move this location manually from frame to frame, as long as we don't expect the force generator to cope with the motion in its prediction.

Velocity Mismatches

So far we have only talked about position. Equation 6.5 calculates the force needed to get the object to its predicted position. Unfortunately, it will not get there with an

FIGURE 6.6 The rest length and the equilibrium position.

accurate velocity (although it will often be close). Could this equation end up increasing the velocity of the object each time, getting faster and faster and still exploding out to infinity?

For damped harmonic motion, when the anchor point is not in motion, the velocity resulting from performing this kind of prediction will never mount up to achieve this. The mathematics involved in demonstrating this is complex, so I'll leave it as an exercise for the talented skeptic.

Even though we won't get exploding velocities, the mismatch between the resulting velocity and the correct velocity causes the spring to behave with an inconsistent spring constant. Sometimes it will be stiffer than we specified, and sometimes it will be looser. In most cases it is not noticeable, but it is an inescapable consequence of faking the force in the way we have done.

Interacting with Other Forces

Another major limitation of the faked spring generator is the way that it interacts with other forces.

The equations above assume that the object is moving freely, not under the influence of any other forces. The spring force will decrease over the course of the time interval, because the spring is moving toward its rest length. If we have another force that is keeping the spring extended or compressed at a constant length, then the force *will* be constant, and the original force generator would give a perfect result, no matter what the spring constant is.

We could theoretically incorporate all the other forces into the prediction for the spring generator, and then it would return exactly the correct force. Unfortunately, to correctly work out the force, we'd need to know the behavior of all the objects being simulated. Simulating the behavior of all the objects is, of course, the whole purpose of the physics engine. So the only way we could get this to work is to put a full physics engine in the force calculations. This is not practical (in fact, strictly speaking, it is impossible, because in that engine we'd need another one, and so on ad infinitum).

For springs that are intended to be kept extended (such as the springs holding up the rope bridge earlier in the chapter), faked spring forces will be too small, often considerably too small. In practice, it is best to try to find a blend of techniques to get the effect you want, that is, using different spring force generators for different objects in the game.

I have used this faked force generator successfully to model the spring in a character's hair (and other wobbly body parts). The rest position is given by the original position of a hair vertex in the 3D model, and the spring force attracts the actual drawn vertex to this rest position. As the character moves, the hair bobs naturally. This method is ideally suited to the problem because the vertices don't have any other forces on them (a natural sag caused by gravity is incorporated by the artist in the model design), and they need to have very high spring coefficients to avoid looking too bouncy.

6.4 SUMMARY

A surprising number of physical effects can be modeled using Hook's law. Even effects that aren't elastic, such as buoyancy, have such similar properties to a spring that they can be implemented using similar code.

We've built a set of force generators that can be used in the remainder of the book to model anything that should appear elastic or bouncy. But we've also seen the start of a problem that motivates much of the rest of the book: springs with high spring constants (i.e., those that have a fast and strong bounce) are difficult to simulate on a frame-by-frame basis. When the action of the spring is faster than the time between simulated frames, then the spring can get unruly and out of control.

If it weren't for this problem, we could simulate almost anything using spring-like forces. All collisions, for example, would be easily handled. Even though we were able to fake stiff springs in some cases, the solution wasn't robust enough to cope with stiff springs in the general case, and so we need to find alternative approaches (involving significantly more complex code) to handle the very fast bounce of a collision. Chapter 7 looks at this, building a set of special case codes for handling collisions and hard constraints such as rods and inelastic cables.

6.5 EXERCISES

Exercise 6.1
Implement a spring generator that simulates extending a spring beyond its limit of elasticity. Store the limit of elasticity as a maximum distance. If the spring is extended beyond this, use a fraction of the spring's normal spring constant. This simulates the spring being stretched and deforming. This approach can also be used as a safeguard against springs exploding.

Exercise 6.2
Implement a lighter-than-air force generator. It is like a buoyancy force generator, but the amount of force diminishes. Any object with this force generator will therefore find its natural altitude, simulating the point where the density of the object matches the density of the surrounding air. Take care to implement the force generator so that it does not have an infinite force at ground level.

Exercise 6.3
Implement an overcrowding force generator. It should track a whole list of particles. When it calculates its force, it should check if any of these particles is within some distance. Any particles within this distance should generate a spring force that will act to separate them. This force generator allows particles to move independently, but prevents them from getting too close to one another.

Exercise 6.4
Implement a homing-bullet force generator. It is based on a spring force generator: given a target object it should generate a force toward that target; the farther away the target is, the greater the force should be. Unlike a spring, however, the generator should not use the *current* position of the object and its target. Instead, integrate the position of both particles using their velocity and some small time step (a second, for example). Use these new positions to calculate the force. This approach takes into account the current motion of the objects involved, provides a basic intelligence, and is the basis of some AI homing behaviors.

Exercise 6.5
Implement a simulation with a particle on a spring, and no gravity. The particle should be attached to a fixed point and start 10 units from that point. Use constant update intervals (of $\frac{1}{50}$s, for example). For a range of damping values, what is the maximum spring constant that you can use before the spring explodes?

Exercise 6.6
(a) Construct an equation that links a maximum spring constant and damping. You can do this either mathematically or by implementing the previous exercise and deriving the equation from the experimental data.

(b) Extend your equation to include the update interval.

7

HARD CONSTRAINTS

In the last chapter, we looked at springs both as a force generator, and as one way of having multiple objects affect one another. This is the first time we've had objects that move based on the motion of other objects.

While springs can be used to represent many situations, there are limits. When we want objects to be tightly coupled together, the spring constant we'd need is practically impossible to simulate. For sitations where objects are linked by stiff rods, or kept apart by hard collisions, springs are not a viable option.

In this chapter, I'll talk about hard constraints. Initially, we'll look at the most common hard constraints, which include collisions and contact between objects. The same mathematics can be used for other kinds of hard constraints that can be used to connect objects together, such as rods or unstretchable cables.

To cope with hard constraints in our physics engine, we'll need to leave the comfortable world of force generators. All the engines we're building in this book treat hard constraints differently from force generators. In Chapter 20, we'll look briefly at alternative approaches that unify them again.

7.1 SIMPLE COLLISION RESOLUTION

To cope with hard constraints, we'll add a collision resolution system to our engine. For the sake of this part of the book, a collision refers to any situation in which two objects are touching. In normal English, we think about collisions being violent processes where two objects meet with some significant closing velocity.

Copyright © 2010, Elsevier Inc. All rights reserved.
DOI: 10.1016/B978-0-12-381976-5.00007-3

For the purposes of this book, we can also think of two objects that just happen to be touching as being in a collision with no closing velocity. The same process we use to resolve high-speed collisions will be used to resolve resting contacts. This is a significant assumption that needs justifying, and I'll return to it later in the chapter and at various points later in the book. To avoid changing terminology later, I'll use the terms "collision" and "contact" interchangably during this chapter.

When two objects collide, their movement after the collision can be calculated from their movement before the collision: this process is called *collision resolution*. We resolve the collision by making sure the two objects have the correct motion that would result from the collision. Because collision happens in such a small instant of time (for most objects we can't see the process of collision happening, and it appears to be instant), we go in and directly manipulate the motion of each object, setting its velocity and possibly its position.

7.1.1 THE CLOSING VELOCITY

The laws governing the motion of colliding bodies depend on their closing velocity. The *closing velocity* is the total speed at which two objects are moving together.

Note also that this is a closing *velocity*, rather than a speed, even though it is a scalar quantity. Speeds have no direction; they are only ever positive (or zero) values. Velocities have direction. For vectors, the direction is given by the direction of the vector. For scalars, the direction is given by the sign of the value. So two objects that are moving apart from one another will have a closing velocity that is less than zero.

We calculate the closing velocity of two objects by finding the component of their velocity in the direction from one object to another:

$$v_c = \dot{\boldsymbol{p}}_a \cdot (\widehat{\boldsymbol{p}_b - \boldsymbol{p}_a}) + \dot{\boldsymbol{p}}_b \cdot (\widehat{\boldsymbol{p}_a - \boldsymbol{p}_b})$$

where v_c is the closing velocity (a scalar quantity), \boldsymbol{p}_a and \boldsymbol{p}_b are the positions of objects a and b, the dot (\cdot) is the scalar product, and $\widehat{\boldsymbol{p}}$ is the unit length vector in the same direction as p. This can be simplified to give

$$v_c = -(\dot{\boldsymbol{p}}_a - \dot{\boldsymbol{p}}_b) \cdot (\widehat{\boldsymbol{p}_a - \boldsymbol{p}_b}) \qquad [7.1]$$

Although it is just a convention, it is more common to change the sign of this quantity. Rather than a closing velocity, we are effectively working with a separating velocity.

Two objects that are closing in on one another will have a negative relative velocity, and objects that are separating will have a positive velocity. Mathematically, this is simply a matter of changing the sign of Equation 7.1 to give

$$v_s = (\dot{\boldsymbol{p}}_a - \dot{\boldsymbol{p}}_b) \cdot (\widehat{\boldsymbol{p}_a - \boldsymbol{p}_b}) \qquad [7.2]$$

where v_s is the separating velocity, which is the format we'll use in the rest of this book. You can stick with closing velocities if you like: it is simply a matter of preference, although you'll have to flip the sign of various quantities in the engine to compensate.

7.1.2 THE COEFFICIENT OF RESTITUTION

As we saw in the last chapter, when two objects collide, they compress together, and the spring-like deformation of their surfaces causes forces to build up that separate the objects. All of this happens in a very short space of time (too fast for us to simulate frame by frame, although long enough to be captured on very high-speed film). Eventually the two objects will no longer have any closing velocity.

Although this behavior is spring-like, in reality there is more going on. All kinds of things can be happening during the compression, and the peculiarities of the materials involved can cause very complicated interactions to take place. In reality we can't hope to capture the subtleties of the real process.

In particular, the spring model assumes that momentum (the product of mass and velocity) is conserved during the collision, as in

$$m_a \dot{\boldsymbol{p}}_a + m_b \dot{\boldsymbol{p}}_b = m_a \dot{\boldsymbol{p}}_a' + m_b \dot{\boldsymbol{p}}_b' \qquad [7.3]$$

where m_a is the mass of object a; $\dot{\boldsymbol{p}}_a$ is the velocity of object a before the collision, and $\dot{\boldsymbol{p}}_a'$ is the velocity after the collision. Collisions that correspond to this equation (and are therefore spring-like) are called "perfectly elastic."

Fortunately, most collisions don't stray too far from this idea. We can't hope to be accurate, but we can produce believable behavior by assuming the conservation of momentum, and we will use Equation 7.3 to model our collisions.

Equation 7.3 tells us about the total velocity before and after the collision, but it doesn't tell us about the individual velocities of each object. The individual velocities are linked together using the closing velocity, according to the equation,

$$v_s' = -c v_s$$

where v_s' is the separating velocity after the collision, v_s is the separating velocity before the collision, and c is a constant called the *coefficient of restitution*.

The coefficient of restitution controls the speed at which the objects will separate after colliding. It depends on the materials that are in collision. Different pairs of material will have different coefficients. Some objects bounce apart such as billiard balls or a tennis ball on a racquet. Other objects stick together when they collide, such as a snowball and a person's face.

If the coefficient is 1, then the objects will bounce apart with the same speed as they were closing. If the coefficient is zero, then the objects will coalesce and travel together (i.e., their separating velocity will be zero). Regardless of the coefficient of restitution, Equation 7.3 will still hold—the total momentum will be the same.

So we have two equations in two unknowns. We can therefore calculate values for $\dot{\boldsymbol{p}}_a'$ and $\dot{\boldsymbol{p}}_b'$.

7.1.3 THE COLLISION DIRECTION AND THE CONTACT NORMAL

So far we've talked in terms of collisions between two objects. Often we also want to be able to support collisions between an object and something we're not physically

simulating. This might be the ground, the walls of a level, or any other immovable object. We could represent these as objects of infinite mass, but it would be a waste of time, since by definition they never move.

If we have a collision between one object and some piece of immovable scenery, then we can't calculate the separating velocity in terms of the vector between the locations of each object; we only have one object. In other words, we can't use the $(\widehat{p_a - p_b})$ term in Equation 7.2, and so we need to replace it.

The $(\widehat{p_a - p_b})$ term gives us the direction in which the separating velocity is occurring. The separating velocity is calculated by the dot product of the relative velocity of the two objects and this term. If we don't have two objects, we can ask that the direction is given to us explicitly. It is the direction in which the two objects are colliding and is usually called the *collision normal* or *contact normal*. Because it is a direction, the vector should always have a magnitude of 1.

In cases where we have two particles colliding, then the contact normal will always be given by

$$\widehat{n} = (\widehat{p_a - p_b})$$

By convention, we always give the contact normal from object a's perspective. In this case, from a's perspective the contact is incoming from b, so we use $p_a - p_b$. To give the direction of collision from b's point of view, we could simply multiply by -1. In practice we don't do this explicitly, but factor this inversion into the code used to calculate the separating velocity for b. You'll see this in the code we implement later in the chapter, as a minus sign appears in b's calculations.

When a particle is colliding with the ground, we only have an object a (the particle), and no object b. In this case from object a's perspective, the contact normal will be

$$\widehat{n} = \begin{bmatrix} 0 \\ 1 \\ 0 \end{bmatrix}$$

assuming that the ground is level at the point of collision.

When we leave particles and begin to work with full rigid bodies, having an explicit contact normal becomes crucial even for interobject collisions. Without preempting later chapters, Figure 7.1 gives a taste of the situation we might come across. Here the two objects colliding, by virtue of their shapes, have a contact normal in almost exactly the opposite direction than we'd expect if we simply considered their locations. The objects arch over one another and the contact acts to prevent them moving apart, rather than keeping them together. At the end of this chapter, we'll look at similar situations for particles, which can be used to represent rods and other stiff connections.

With the correct contact normal, Equation 7.2 becomes

$$v_s = (\dot{p}_a - \dot{p}_b) \cdot \widehat{n} \tag{7.4}$$

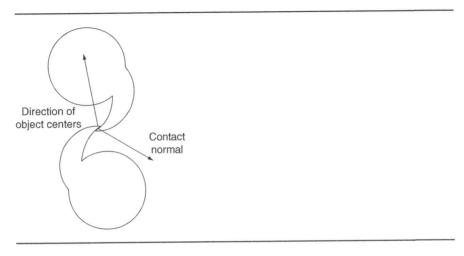

FIGURE 7.1 Contact normal is different from the vector between objects in contact.

7.1.4 IMPULSES

The change we need to make to resolve a collision is a change in velocity only. So far in the physics engine, we've only ever made changes to velocity using acceleration. Acceleration changes velocity by an amount that depends on time: if the acceleration is applied for a longer time, there will be a larger change in velocity. Here the changes are instant: the velocities immediately take on new values, and we don't want the duration of the frame to affect the result.

Recall that applying a force changes the acceleration of an object. If we instantly change the force, the acceleration instantly changes too. We can think of acting on an object to change its velocity in a similar way. Rather than a force, this is called an *impulse*, an instantaneous change in velocity. In the same way as we have

$$\boldsymbol{f} = m\ddot{\boldsymbol{p}} \qquad [7.5]$$

for forces, we have

$$\boldsymbol{g} = m\dot{\boldsymbol{p}} \qquad [7.6]$$

for impulses. Impulses are often written with the letter p. Instead, I will use \boldsymbol{g} to avoid confusion with the position of the object \boldsymbol{p}.

There is a major difference between force and impulse, however. An object has no acceleration unless it is being acted on by a force: we can work out the total acceleration by combining all the forces using D'Alembert's principle. On the other hand, an object will continue to have a velocity even if no impulses (or forces) are acting on it. The impulse therefore can only change the velocity; it is not completely responsible for the velocity. We can combine impulses using D'Alembert's principle, but the result

will be the total change in velocity, not the total velocity:

$$\dot{p}' = \dot{p} + \frac{1}{m} \sum_n g_i$$

where g_1, \ldots, g_n is the set of all impulses acting on the object. In practice we won't accumulate impulses in the way we did for forces. We will apply impulses as they arise during the collision resolution process. Each will be applied one at a time using the equation

$$\dot{p}' = \dot{p} + \frac{1}{m} g$$

The result of our collision resolution will be an impulse to apply to each object. The impulse will be immediately applied and will instantly change the velocity of the object.

There is one more important result to note about impulses before we move on to using them in collision resolution, and it is best seen using a technique called "dimensional analysis." If we fill in the units for Equation 7.5, we might put the mass m in kilograms (kg), and the velocity in meters per second per second (m s^{-2}). So the force is measured in kg m s^{-2}. This unit is called a Newton (N)[1]. Doing the same with Equation 7.6 gives a unit of kg m s^{-1}. We can write this in terms of Newtons in this way:

$$\text{kg m s}^{-1} = \text{kg m s}^{-2} \times \text{s} = \text{Ns}$$

So, impulses are measured in units of force multiplied by time. Or put another way, 1 Ns of impulse is equivalent to 1 N of force applied for 1 s. We can use this result to convert between forces and impulses: an impulse can always be represented as a force applied for some specific length of time, as in

$$g = ft$$

We will make use of this important result when we come to look at resting contact in the following section.

7.2 COLLISION PROCESSING

To handle collisions, we will create a new piece of code, the `ContactResolver`. It has the job of taking an entire set of collisions and applying the relevant impulses to the objects involved. Each collision is provided in a `Contact` data structure that looks like this:

1. I am using the standard SI units here, as in the rest of the book. This makes conversions much simpler. If I were to use pounds for the weight and feet per second per second as the acceleration, I would need a conversion factor to convert the resulting force into a sensible unit.

```
────────── Excerpt from file include/cyclone/pcontacts.h ──────────
/**
 * A contact represents two objects in contact (in this case
 * ParticleContact representing two particles). Resolving a
 * contact removes their interpenetration, and applies sufficient
 * impulse to keep them apart. Colliding bodies may also rebound.
 *
 * The contact has no callable functions, it just holds the
 * contact details. To resolve a set of contacts, use the particle
 * contact resolver class.
 */
class ParticleContact
{
public:
    /**
     * Holds the particles that are involved in the contact. The
     * second of these can be NULL for contacts with the scenery.
     */
    Particle* particle[2];

    /**
     * Holds the normal restitution coefficient at the contact.
     */
    real restitution;

    /**
     * Holds the direction of the contact in world coordinates.
     */
    Vector3 contactNormal;
};
```

The structure holds a pointer to each object involved in the collision, including a vector representing the contact normal (from the first object's perspective) and a data member for the coefficient of restitution for the contact. If we are dealing with a collision between an object and the scenery (i.e., there is only one object involved), then the pointer for the second object will be NULL.

To resolve one contact, we implement the collision equations from earlier in the section as follows:

```
────────── Excerpt from file include/cyclone/pcontacts.h ──────────
class ParticleContact
{
    // ... Other ParticleContact code as before ...
```

```
protected:
    /**
     * Resolves this contact for both velocity and interpenetration.
     */
    void resolve(real duration);

    /**
     * Calculates the separating velocity at this contact.
     */
    real calculateSeparatingVelocity() const;

private:
    /**
     * Handles the impulse calculations for this collision.
     */
    void resolveVelocity(real duration);
};
```

───────── Excerpt from file **src/pcontacts.cpp** ─────────

```
void ParticleContact::resolve(real duration)
{
    resolveVelocity(duration);
    resolveInterpenetration(duration);
}

real ParticleContact::calculateSeparatingVelocity() const
{
    Vector3 relativeVelocity = particle[0]->getVelocity();
    if (particle[1]) relativeVelocity -= particle[1]->getVelocity();
    return relativeVelocity * contactNormal;
}

void ParticleContact::resolveVelocity(real duration)
{
    // Find the velocity in the direction of the contact.
    real separatingVelocity = calculateSeparatingVelocity();

    // Check if it needs to be resolved.
    if (separatingVelocity > 0)
    {
        // The contact is either separating, or stationary;
        // no impulse is required.
        return;
    }
```

```
        // Calculate the new separating velocity.
        real newSepVelocity = -separatingVelocity * restitution;

        real deltaVelocity = newSepVelocity - separatingVelocity;

        // We apply the change in velocity to each object in proportion to
        // their inverse mass (i.e., those with lower inverse mass [higher
        // actual mass] get less change in velocity).
        real totalInverseMass = particle[0]->getInverseMass();
        if (particle[1]) totalInverseMass += particle[1]->getInverseMass();

        // If all particles have infinite mass, then impulses have no effect.
        if (totalInverseMass <= 0) return;

        // Calculate the impulse to apply.
        real impulse = deltaVelocity / totalInverseMass;

        // Find the amount of impulse per unit of inverse mass.
        Vector3 impulsePerIMass = contactNormal * impulse;

        // Apply impulses: they are applied in the direction of the contact,
        // and are proportional to the inverse mass.
        particle[0]->setVelocity(particle[0]->getVelocity() +
            impulsePerIMass * particle[0]->getInverseMass()
            );
        if (particle[1])
        {
            // Particle 1 goes in the opposite direction
            particle[1]->setVelocity(particle[1]->getVelocity() +
                impulsePerIMass * -particle[1]->getInverseMass()
                );
        }
}
```

This directly changes the velocities of each object to reflect the collision.

7.2.1 COLLISION DETECTION

Collision points will normally be found using a collision detector. A collision detector is a chunk of code responsible for finding pairs of objects that are colliding, or single objects that are colliding with some piece of immovable scenery.

In our engine, the end result of the collision detection algorithm is a set of Contact data structures filled with the appropriate information. Collision detection obviously

needs to take account of the geometries of the objects, that is, their shape and size. So far in the physics engine, we've assumed that we are dealing with particles, which lets us avoid taking any geometry into account.

This is a distinction we'll keep even with more complicated 3D objects: the physics simulation system (that part of the engine that handles laws of motion, collision resolution, and forces) will not need to know the details of the shape of the objects it is dealing with. The collision detection system is responsible for calculating any properties that are geometric, such as when and where two objects are touching, and the contact normal between them.

There are a whole range of algorithms used for working out contact points, and we'll implement a range of useful collision detection routines for full 3D objects in Chapter 12. For now, we'll assume that this is a magic process hidden inside a black box.

As one exception, I'll cover the simplest possible collision detection for particles represented as small spheres in the next chapter. This will allow us to build some useful physics systems with only the mass aggregate engine we are constructing. I'll leave all other details until after we've looked at full rotating rigid bodies in Chapter 10.

Some collision detection algorithms can take into account the way objects are moving and try to predict likely collisions in the future. Others simply look through the set of objects and check if any pairs of objects are interpenetrating.

Two objects are interpenetrating if they are partially embedded in one another, as shown in Figure 7.2. When we're processing a collision between partially embedded objects, it is not enough to only change their velocity. If the objects are colliding with a small coefficient of restitution, their separation velocity might be almost zero. In this case, they will never move apart and the player will see the objects stuck together in an impossible way.

As part of resolving collisions, we need to resolve interpenetration.

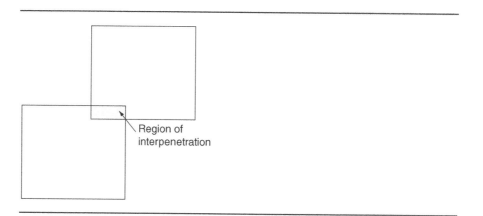

FIGURE 7.2 Interpenetrating objects.

7.2.2 RESOLVING INTERPENETRATION

When two objects are interpenetrating, we will move them apart just enough to separate them. We will expect the collision detector to tell us how far the objects have interpenetrated, as part of the Contact data structure that it creates. The calculation of the interpenetration depth depends on the geometries of the objects colliding. As seen previously, this is the domain of the collision detection system, rather than the physics simulator, and we'll treat it as a magic process until Chapter 12.

We add a data member to the contact data structure to hold this information:

```
               ———  Excerpt from file include/cyclone/pcontacts.h ———
class ParticleContact
{
    // ... Other ParticleContact code as before ...

    /**
     * Holds the depth of penetration at the contact.
     */
    real penetration;
};
```

Note that, just like the closing velocity, the penetration depth has both size and sign. A negative depth represents two objects that have no interpenetration. A depth of zero represents two objects that are merely touching.

To resolve the interpenetration, we check the interpenetration depth. If it is already zero or less, then we need to take no action; otherwise, we can move the two objects apart just far enough so that the penetration depth becomes zero. The penetration depth that is provided should be the depth of penetration *in the direction of the contact normal*. So if we move the objects in the direction of the contact normal by a distance equal to the penetration depth, the objects will no longer be in contact. The same occurs when we have just one object involved in the contact (i.e., it is interpenetrating with the scenery of the game): the penetration depth is in the direction of the contact normal.

So we know the total distance that needs to be moved (i.e., the depth) and the direction in which the objects will be moving. We need to work out how much each individual object should be moved.

If we have only one object involved in the contact, then this is simple: the object needs to move the entire distance. If we have two objects, then we have a whole range of choices. We could simply move each object by the same amount, by half of the interpenetration depth. This would work in some situations, but causes believability problems. Imagine that we are simulating a small box resting on a planet's surface. If the box is found slightly interpenetrating the surface, should we move the box and the planet out of the way by the same amount?

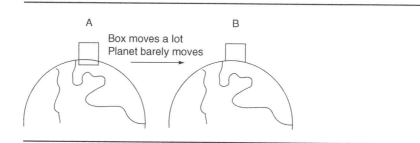

FIGURE 7.3 Interpenetration and reality.

We have to take into account how the interpenetration came to be in the first place, and what would have happened in the same situation in reality. Figure 7.3 shows the box and planet in penetration, and if real physics were in operation. We'd like to get as near to the situation in part B of the figure as possible.

To do this we move two objects apart in inverse proportion to their mass. An object with a large mass gets almost no change, and an object with a tiny mass gets to move a lot. If one of the objects has infinite mass, then it will not move; the other object gets moved the whole way.

The total motion of each object is equal to the depth of interpenetration:

$$\Delta p_a + \Delta p_b = d$$

where Δp_a is the scalar distance that object a will be moved (we'll return to the direction in the following). The two distances are related to each other according to the ratio of their masses:

$$m_a \Delta p_a = m_b \Delta p_b$$

which, combined, gives us

$$\Delta p_a = \frac{m_b}{m_a + m_b} d$$

and

$$\Delta p_b = \frac{m_a}{m_a + m_b} d$$

Combining these with the direction from the contact normal, we get a total change in the vector position of

$$\Delta \boldsymbol{p}_a = \frac{m_b}{m_a + m_b} d\boldsymbol{n}$$

and

$$\Delta \boldsymbol{p}_b = -\frac{m_a}{m_a + m_b} d\boldsymbol{n}$$

where \boldsymbol{n} is the contact normal. (Note the minus sign in the second equation; this is because the contact normal is given from object a's perspective.)

We can implement the interpenetration resolution equations with the following function:

```
———————— Excerpt from file include/cyclone/pcontacts.h ————————
class ParticleContact
{
    // ... Other ParticleContact code as before ...

private:
    /**
     * Handles the interpenetration resolution for this contact.
     */
    void resolveInterpenetration(real duration);
};
```

```
———————— Excerpt from file src/pcontacts.cpp ————————
void ParticleContact::resolveInterpenetration(real duration)
{
    // If we don't have any penetration, skip this step.
    if (penetration <= 0) return;

    // The movement of each object is based on their inverse mass,
    // so total that.
    real totalInverseMass = particle[0]->getInverseMass();
    if (particle[1]) totalInverseMass += particle[1]->getInverseMass();

    // If all particles have infinite mass, then we do nothing.
    if (totalInverseMass <= 0) return;

    // Find the amount of penetration resolution per unit
    // of inverse mass.
    Vector3 movePerIMass =
        contactNormal * (penetration / totalInverseMass);

    // Calculate the movement amounts.
    particleMovement[0] = movePerIMass * particle[0]->getInverseMass();
    if (particle[1]) {
        particleMovement[1] =
            movePerIMass * -particle[1]->getInverseMass();
    } else {
        particleMovement[1].clear();
    }
```

```
// Apply the penetration resolution.
particle[0]->setPosition(
    particle[0]->getPosition() + particleMovement[0]
    );

if (particle[1]) {
    particle[1]->setPosition(
        particle[1]->getPosition() + particleMovement[1]
        );
}
}
```

We now have code to apply the change in velocity at a collision, and to resolve objects that are interpenetrating. If you implement and run the contact resolution system, it will work well for medium-speed collisions, but objects resting (a particle resting on a table, for example) may appear to vibrate and may even leap into the air occasionally.[2]

To have a complete and stable contact resolution system we need to reconsider what happens when two objects are touching, but have a very small or zero closing velocity.

7.2.3 RESTING CONTACTS

Consider the situation shown in Figure 7.4. We have a particle resting on the ground. It is experiencing only one force, gravity. In the first frame, the particle accelerates downward. Its velocity increases, but its position stays constant (it has no velocity at the start of the frame). In the second frame, the position is updated, and the velocity increases again. Now it is moving downward and has begun to interpenetrate with the ground. The collision detector picks up on the interpenetration and generates a collision.

The contact resolver looks at the particle, and sees that it has a penetrating velocity of

$$\dot{p} = 2\ddot{p}t$$

Applying the collision response, the particle is given a velocity of

$$\dot{p}' = c\dot{p} = c2\ddot{p}t$$

2. I said medium speed here, because very high-speed collisions are notoriously difficult to cope with. The physics simulation we've provided will usually cope (except for insanely high speeds where lack of floating-point accuracy starts to cause problems), but collision detectors can start to provide strange results. For instance, it is possible for two objects to pass right through one another before the collision detector realizes they have even touched. If it does detect a collision, they may be at least halfway through one another and be separating again, in which case they have a positive separating velocity and no impulse is generated. We'll return to these issues when we create our collision detection system later in the book, although we will not be able to resolve them fully; they are an endemic problem with very high-speed collision detection.

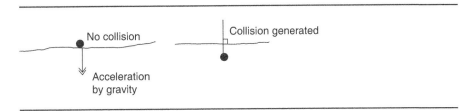

FIGURE 7.4 Vibration on resting contact.

and is moved out of interpenetration. In frame three, therefore, it has an upward velocity, which will carry it off the ground and into the air. The upward velocity will only be small, but it may be enough to be noticed. In particular, if frame one or two is abnormally long, the velocity will have a chance to significantly build up and send the particle skyward. If you implement this algorithm for a game with a variable frame rate, then slow down the frame rate (by dragging a window around, for example, or having email arrive in the background), any resting objects will suddenly jump.

To solve this problem we can do two things.

First, we need to detect the contact earlier. In the example, two frames have passed before we find out that there is a problem. If we set our collision detector so that it returns contacts that are nearly but not quite interpenetrating, then we get a contact to work with after frame one.

Second, we need to recognize when an object has velocity that could only have arisen from its forces acting for one frame. After frame one, the velocity of the particle is caused solely by the force of gravity acting on it for one frame. We can work out what the velocity would be if only the force had acted upon it, by simply multiplying the force by the frame duration. If the actual velocity of the object is less than or equal to this value (or even slightly above it, if we acknowledge that rounding errors can creep in), we know that the particle was stationary at the previous frame. In this case, the contact is likely to be a resting contact, rather than a colliding contact. Rather than performing the impulse calculation for a collision, we can apply the impulse that would result in zero separating velocity.

This is what would happen for a resting contact: no closing velocity would have time to build up, so there would be no separating velocity after the contact. In our case we are recognizing that the velocity we do have is likely to be only a by-product of the way we split time into frames, and we can therefore treat the object as if it had a zero velocity before the contact. The particle is given a zero velocity. This happens at every frame: in effect the particle always remains at frame one in Figure 7.4.

You could also look at this as a collision with a zero coefficient of restitution. So, as the closing velocity drops, the coefficient of restitution changes suddenly from being a bounce to a resting contact. Needless to say, if you only ever used zero coefficients of restitution, this distinction would be moot.

This series of microcollisions keep the objects apart. For this reason, an engine that handles resting contact in this way is sometimes called a *microcollision engine*.

Velocity and the Contact Normal

When we have two objects in resting contact, we are interested in their relative velocity rather than the absolute velocity of either. The two objects might be in resting contact with one another in one diretcion, but moving across each other in another direction. A box might be resting on the ground, even though it is skidding across the surface at the same time. We want the vibrating contacts code to cope with pairs of objects that are sliding across one another. This means we can't use the absolute velocity of either object.

To cope with this situation, the velocity and acceleration calculations are all performed in the direction of the contact normal only. We first find the velocity in this direction, and test to see whether it could have been solely caused by the component of the acceleration in the same direction. If so, then the velocity is changed so there is no separating or closing velocity in this direction. There still may be relative velocity in any other direction: but it is ignored.

We can add this special case code to the collision processing function in the following way:

```
                         Excerpt from file src/pcontacts.cpp
void ParticleContact::resolveVelocity(real duration)
{
    // Find the velocity in the direction of the contact.
    real separatingVelocity = calculateSeparatingVelocity();

    // Check if it needs to be resolved.
    if (separatingVelocity > 0)
    {
        // The contact is either separating, or stationary; there's
        // no impulse required.
        return;
    }

    // Calculate the new separating velocity.
    real newSepVelocity = -separatingVelocity * restitution;

    // Check the velocity buildup due to acceleration only.
    Vector3 accCausedVelocity = particle[0]->getAcceleration();
    if (particle[1]) accCausedVelocity -= particle[1]->getAcceleration();
    real accCausedSepVelocity = accCausedVelocity * contactNormal
        * duration;

    // If we've got a closing velocity due to aceleration buildup,
    // remove it from the new separating velocity.
    if (accCausedSepVelocity < 0)
```

```
    {
        newSepVelocity += restitution * accCausedSepVelocity;

        // Make sure we haven't removed more than was
        // there to remove.
        if (newSepVelocity < 0) newSepVelocity = 0;
    }

    real deltaVelocity = newSepVelocity - separatingVelocity;

    // We apply the change in velocity to each object in proportion to
    // their inverse mass (i.e., those with lower inverse mass [higher
    // actual mass] get less change in velocity).
    real totalInverseMass = particle[0]->getInverseMass();
    if (particle[1]) totalInverseMass += particle[1]->getInverseMass();

    // If all particles have infinite mass, then impulses have no effect.
    if (totalInverseMass <= 0) return;

    // Calculate the impulse to apply.
    real impulse = deltaVelocity / totalInverseMass;

    // Find the amount of impulse per unit of inverse mass.
    Vector3 impulsePerIMass = contactNormal * impulse;

    // Apply impulses: they are applied in the direction of the contact,
    // and are proportional to the inverse mass.
    particle[0]->setVelocity(particle[0]->getVelocity() +
        impulsePerIMass * particle[0]->getInverseMass()
        );
    if (particle[1])
    {
        // Particle 1 goes in the opposite direction.
        particle[1]->setVelocity(particle[1]->getVelocity() +
            impulsePerIMass * -particle[1]->getInverseMass()
            );
    }
}
```

To keep two objects in resting contact, we are applying a small change in velocity at each frame. The change is just big enough to correct the increase in velocity that would arise from them settling into one another over the course of one frame.

Other Approaches to Resting Contact

The microcollision approach I've given here is only one of many possibilities. Resting contact is one of two key challenges to get right in a physics engine (the other being friction; in fact, the two often go together). There are many routes of attack, as well as countless variations and tweaks.

My solution is somewhat ad hoc; effectively we second-guess the mistakes of a rough implementation, and then try to correct it after the event. This has the flavor of a hack, and despite being easy to implement and suitable for adding in friction (which we'll do in Chapter 15), it is frowned upon by engineering purists.

A more physically realistic approach would be to recognize that a force would be applied on the particle from the ground. This reaction force pushes the object back so that its total acceleration in the vertical direction becomes zero. No matter how hard the particle pushes down, the ground will push up with the same force. We can create a force generator that works in this way, making sure that there can be no acceleration into the ground.

This works okay for particles that can have only one contact with the ground. For more complex rigid bodies the situation becomes considerably more complex. We may have several points of contact between an object and the ground (or worse, we might have a whole series of contacts between an object and immovable resting points). It isn't immediately clear how to calculate the reaction forces at each contact so that the overall motion of the object is correct. We'll return to reaction forces in some depth in Chapter 15, and to more complex resolution methods in Chapter 20 at the end of the book.

7.3 THE CONTACT RESOLVER ALGORITHM

The collision resolver receives a list of contacts from the collision detection system, and needs to update the objects being simulated to take account of the contacts.

We have three bits of code for performing this update:

1. The collision resolution function that applies impulses to objects to simulate them bouncing apart.

2. The interpenetration resolution function that moves objects apart so that they aren't partially embedded in one another.

3. The resting contact code that sits inside the collision resolution function and keeps an eye out for contacts that might be resting rather than colliding.

Which of these functions needs calling for a contact depends on its separating velocity and interpenetration depth. Interpenetration resolution only needs to occur if the contact has a penetration depth greater than zero. Similarly, we might need to perform interpenetration resolution only, with no collision resolution, if the objects are interpenetrated but separating.

Regardless of the combination of functions needed, each contact is resolved one at a time. This is a simplification of the real world. In reality, each contact would occur at a slightly different instant in time or be spaced out over a range of time. Some contacts would apply their effects in series, and others would combine and act simultaneously on the objects that they affect. Some physics engines will try to accurately replicate this by treating sequential contacts in their correct order and resolving resting contacts all at the same time. In Section 7.3.2, we'll look at an alternative resolution scheme that honors sequential series. In Chapter 20, we'll look at systems to perform simultaneous resolution of multiple contacts.

For our engine, we'd like keep things simple and do neither. We'd like to resolve all the contacts one at a time at the end of a frame. We can still get very believable results with this scheme, with a considerably less complex implementation. To get the best results, however, we need to make sure that the contacts are resolved in a particular order.

7.3.1 RESOLUTION ORDER

If an object has two simultaneous contacts, as shown in Figure 7.5, then changing its velocity to resolve one contact may change its separating velocity at the other contact. In the figure, if we resolve the first contact, then the second contact stops being a collision at all, as it is now separating. If we resolve the second contact only, however, the first contact still needs to be resolved because the change in velocity isn't enough to save it.

To avoid doing unneccesary work in situations like this, we resolve the most severe contact first, that is, the contact with the lowest separating velocity (i.e., the most negative). In addition to the most convenient, this is also the most physically realistic thing we can do. In the figure, if we compared the behavior of the full three-object

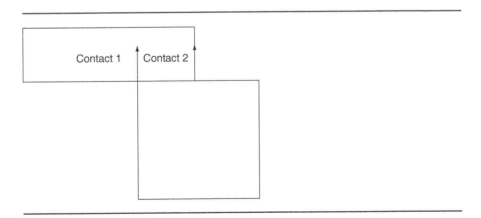

FIGURE 7.5 Resolving one contact may resolve another automatically.

situation with the behavior after having removed one of the two lower blocks, we would find that the final result is similar to the case where we have block A but not block B. In other words, the most severe collisions tend to dominate the behavior of the simulation. If we have to prioritize which collisions to handle, it should be those that give the most realism.

The figure illustrates a complication in our contact resolution algorithm. If we handle one collision, then we might change the separating velocity for other contacts. We can't just sort the contacts by their separating velocity, and then handle them in order. Once we have handled the first collision, the next contact may have a positive separating velocity and not need any processing.

There is also another, more subtle, problem that doesn't tend to arise in many particle situations. We could have a situation where we resolve one contact, then another, but resolving the second puts the first contact back into collision, so we need to re-resolve it. Fortunately, it can be shown that for certain types of simulation (particularly those with no friction, but some friction situations can also work), this looping will eventually settle into a correct answer. We'll not need to loop round forever, and we'll not end up with a situation where the corrections get bigger and bigger until the whole simulation explodes. Unfortunately, this equilibrium could still take a long time to reach, and there is no accurate way to estimate how long it will take. To avoid getting stuck, we place a limit on the number of resolutions that can be performed each frame.

The contact resolver we will use follows this algorithm:

1. Calculate the separating velocity of each contact, keeping track of the contact with the lowest (i.e., most negative) value.

2. If the lowest separating velocity is greater than or equal to zero, then we're done: exit the algorithm.

3. Process the collision response algorithm for the contact with the lowest separating velocity.

4. If we have more iterations, then return to Step 1.

The algorithm will automatically re-examine contacts that it has previous resolved, and it will ignore contacts that are separating. It resolves the most severe collision at each iteration.

The number of iterations allowed should be at least the number of contacts (to give them all a chance of getting seen at least once), and can be greater. For simple particle simulations having the same number of iterations as there are contacts can often work fine. I tend to use double as a rule of thumb, but more is needed for complex interconnected sets of contacts. You could also give the algorithm no iteration limit and see how it performs. This is a good approach for debugging when difficult situations arise.

You may have noticed that I've ignored interpenetration so far. We could combine interpenetration resolution with collision resolution and embed it in the algorithm

above. A better solution, in practice, is to separate the two into distinct phases. First, we resolve the collisions in order, using the algorithm above. Second, we resolve all interpenetrations.

Separating the two resolution steps allows us to use a different order to resolve interpenetration than for velocity. Once again we want to get the most realistic results. We can do this by resolving the contacts in order of severity, as before. If we combine the two stages, we'd be tied to a suboptimal order for one or another kind of resolution.

The interpenetration resolution follows the same algorithm as for collision resolution. As before, we need to recalculate all the interpenetration depths between each iteration. Recall that interpenetration depths are provided by the collision detector. We don't want to perform collision detection again after each iteration, as it is far too time consuming. To update the interpenetration depth, we keep track of how much we moved the two objects at the previous iteration. The objects in each contact are then examined. If either object was moved in the last frame, then its interpenetration depth is updated by finding the component of the move in the direction of the contact normal.

Putting all this together, we get the following contact resolver function:

```
                ──── Excerpt from file include/cyclone/pcontacts.h ────
/**
 * The contact resolution routine for particle contacts. One
 * resolver instance can be shared for the entire simulation.
 */
class ParticleContactResolver
{
protected:
    /**
     * Holds the number of iterations allowed.
     */
    unsigned iterations;

    /**
     * This is a performance tracking value; we keep a record
     * of the actual number of iterations used.
     */
    unsigned iterationsUsed;

public:
    /**
     * Creates a new contact resolver.
     */
    ParticleContactResolver(unsigned iterations);
```

```
/**
 * Sets the number of iterations that can be used.
 */
void setIterations(unsigned iterations);

/**
 * Resolves a set of particle contacts for both penetration
 * and velocity.
 */
void resolveContacts(ParticleContact *contactArray,
    unsigned numContacts,
    real duration);
};
```

──────── **Excerpt from file src/pcontacts.cpp** ────────

```
void ParticleContactResolver::resolveContacts(ParticleContact
                                            *contactArray, unsigned
                                            numContacts, real duration)
{
    unsigned i;

    iterationsUsed = 0;
    while(iterationsUsed < iterations)
    {
        // Find the contact with the largest closing velocity.
        real max = REAL_MAX;
        unsigned maxIndex = numContacts;
        for (i = 0; i < numContacts; i++)
        {
            real sepVel = contactArray[i].calculateSeparatingVelocity();
            if (sepVel < max &&
                (sepVel < 0 || contactArray[i].penetration > 0))
            {
                max = sepVel;
                maxIndex = i;
            }
        }

        // Do we have anything worth resolving?
        if (maxIndex == numContacts) break;

        // Resolve this contact.
        contactArray[maxIndex].resolve(duration);
```

```
            iterationsUsed++;
        }
    }
}
```

The number of iterations we use to resolve interpenetrations might not be the same as the number used in resolving collisions. We could implement the function to use a different limit in each case. In practice, there is rarely any need to have different values, as we can pass the same for both. As a simulation gets more complex with interacting objects, the number of collision iterations needed will increase at roughly the same rate as the number of interpenetration iterations. In the function above, I've used one iteration limit for both parts.

The recalculation of the closing velocity and interpenetration depth at each iteration is the most time-consuming part of this algorithm. For very large numbers of contacts, this can dominate the execution speed of the physics engine. In practice, most of the updates will have no effect: one contact may have no possible effect on another contact. In Chapter 16, we'll return to this issue and optimize the way collisions are resolved.

7.3.2 TIME-DIVISION ENGINES

There is another approach to creating a physics engine that avoids having to resolve interpenetration or generate a sensible resolution order for the contacts. Rather than have one update of the physics engine per frame, we could have many updates punctuated by collisions.

The theory goes like this:

- When there are no collisions, objects are moving around freely, using just the laws of motion and force generators we saw in Chapter 6.
- When a collision occurs, it is at the exact point that two objects touch. At this stage there is no interpenetration.
- If we can detect exactly when a collision occurs, we can use the normal laws of motion up to this point, stop, perform the impulse calculations, and then start up with the normal laws of motion again.
- If there are numerous collisions, we process them in order, and between each collision, we update the world using the normal laws of motion.

In practice, this kind of engine has the following algorithm:

1. Let the start time be the current simulation time, and the end time be the end of the current update request.
2. Perform a complete update for the entire time interval.
3. Run the collision detector and collect a list of collisions.
4. If there are no collisions, we are done: exit the algorithm.

5. For each collision, work out the exact time of the first collision.

6. Choose the first collision to have occurred.

7. If the first collision occurs after the end time, then we're done: exit the algorithm.

8. Remove the effects of the Step 2 update, and perform a new update from the start time to the first collision time.

9. Process the collision, applying the appropriate impulses (no interpenetration resolution is needed, because at the instant of collision the objects are only just touching).

10. Set the start time to be the first collision time, keep the end time unchanged, and return to Step 1.

This gives an accurate result, and avoids the problems with interpenetration resolution. It is a commonly used algorithm in engineering physics applications where accuracy is critical. Unfortunately, it is very time consuming. For each collision, we run the collision detector again and rerun the regular physics update every time. We still need to have special case code to cope with resting contacts; otherwise, the resting contacts will be returned as the first collision at every iteration. Even without resting contacts, numerical errors in the collision detection calculations can cause a never-ending cycle, that is, a constant stream of collisions occurring at the same time that causes the algorithm to loop endlessly.

For almost all game projects, this approach isn't practical. A once-per-frame update is a better solution, where all the contacts are resolved for velocity and interpenetration.

The "almost" I am thinking of is pool, snooker, or billiards games. In these cases, the sequence of collisions and the position of balls when they collide is critical. A pool game using once-per-frame physics might be believable when two balls collide, but strange effects can appear when the cue ball hits a tightly packed (but not quite touching) bunch of balls. For a serious simulation, it is almost essential to follow the algorithm above, with the advantage that if you are writing from scratch it is easier to implement without the interpenetration code (not to mention the simplifications you can get because all the balls have the same mass).

You can see this in pool simulation games running on older PCs. When you break off, there is a fraction of a second pause when the cue ball hits the pack, as the thousands of internal collisions are detected and handled sequentially.

For a simple arcade pool game, if you already have a once-per-frame physics engine available, it is worth a try: it may be good enough to do the job.

7.4 Collision-Like Things

Just as for springs, we will look at several types of connections that can be modeled using the techniques in this chapter.

You can think of a collision as acting to maintain two objects at least some minimum distance apart. A contact is generated between two objects if they ever get too close. In the same way, we can use contacts to keep objects together.

7.4.1 CABLES

A cable is a constraint that forces two objects to be no more than a specific distance apart. If we have two objects connected by a light cable, they will feel no effects as long as they are close together. When the cable is pulled taut, the objects cannot separate further. Depending on the characteristics of the cable, the objects may appear to bounce off this limit in the same way that objects colliding might bounce apart. Just like any other collision, the cable has a characteristic coefficient of restitution that controls this bounce effect.

We can model cables by generating contacts whenever the ends of the cable separate too far. The contact is very much like those used for collisions, except that its contact normal is reversed: it pulls the objects together rather than bouncing them apart. Similarly, the interpenetration depth of the contact corresponds to how far the cable has been stretched beyond its limit.

We can implement a contact generator for a cable in the following way:

——— **Excerpt from file include/cyclone/plinks.h** ———

```
/**
 * Links connect two particles together, generating a contact if
 * they violate the constraints of their link. It is used as a
 * base class for cables and rods, and could be used as a base
 * class for springs with a limit to their extension.
 */
class ParticleLink : public ParticleContactGenerator
{
public:
    /**
     * Holds the pair of particles that are connected by this link.
     */
    Particle* particle[2];

protected:
    /**
     * Returns the current length of the link.
     */
    real currentLength() const;

public:
    /**
```

```
          * Generates the contacts to keep this link from being
          * violated. This class can only ever generate a single
          * contact, so the pointer can be a pointer to a single
          * element, the limit parameter is assumed to be at least 1
          * (0 isn't valid), and the return value is 0 if the
          * cable wasn't overextended, or 1 if a contact was needed.
          *
          * NB: This method is declared in the same way (as pure
          * virtual) in the parent class, but is replicated here for
          * documentation purposes.
          */
        virtual unsigned addContact(ParticleContact *contact,
                                    unsigned limit) const = 0;
    };

    /**
     * Cables link a pair of particles, generating a contact if they
     * stray too far apart.
     */
    class ParticleCable : public ParticleLink
    {
    public:
        /**
         * Holds the maximum length of the cable.
         */
        real maxLength;

        /**
         * Holds the restitution (bounciness) of the cable.
         */
        real restitution;

    public:
        /**
         * Fills the given contact structure with the contact needed
         * to keep the cable from overextending.
         */
        virtual unsigned addContact(ParticleContact *contact,
                                    unsigned limit) const;
    };
```

```
──── Excerpt from file src/plinks.cpp ────
real ParticleLink::currentLength() const
{
    Vector3 relativePos = particle[0]->getPosition() -
                          particle[1]->getPosition();
    return relativePos.magnitude();
}

unsigned ParticleCable::addContact(ParticleContact *contact,
                                   unsigned limit) const
{
    // Find the length of the cable.
    real length = currentLength();

    // Check if we're overextended.
    if (length < maxLength)
    {
        return 0;
    }

    // Otherwise, return the contact.
    contact->particle[0] = particle[0];
    contact->particle[1] = particle[1];

    // Calculate the normal.
    Vector3 normal =
        particle[1]->getPosition() - particle[0]->getPosition();
    normal.normalize();
    contact->contactNormal = normal;

    contact->penetration = length-maxLength;
    contact->restitution = restitution;

    return 1;
}
```

This code acts as a collision detector: it examines the current state of the cable and can return a contact if the cable has reached its limit. This contact should then be added to all the others generated by the collision detector, and processed in the normal contact resolver algorithm.

7.4.2 RODS

Rods combine the behaviors of cables and collisions. Two objects linked by a rod cannot separate nor get closer together. They are kept at a fixed distance apart.

We can implement this in the same way as the cable contact generator. At each frame, we look at the current state of the rod, and generate either a contact to bring the ends inward or a contact to keep them apart.

We need to make two modifications to what we've seen so far, however. First, we should always use a coefficient of restitution of zero. It doesn't make sense for the two ends to either bounce together or apart. They should be kept at a constant distance from one another, so that the relative velocity along the line between them should be zero.

Second, if we apply just one of the two contacts (to separate or to close) each frame, we will end up with a vibrating rod. On successive frames the rod is likely to be too short and then too long, and each contact will drag it backward and forward. To avoid this, we generate both contacts in every frame. If either of the contacts is not needed (i.e., the separating velocity is greater than zero, or there is no interpenetration), then it will be ignored. Having the extra contact there helps the contact resolver algorithm not to overcompensate, and the rod will be more stable. The downside of this approach is that for complex assemblies of rods, the number of iterations needed to reach a really stable solution can rise dramatically. If you have a low iteration limit, the vibration can return.

We can implement our contact generator in the following way:

```
                    ─── Excerpt from file include/cyclone/plinks.h ───
/**
 * Rods link a pair of particles, generating a contact if they
 * stray too far apart or too close.
 */
class ParticleRod : public ParticleLink
{
public:
    /**
     * Holds the length of the rod.
     */
    real length;

public:
    /**
     * Fills the given contact structure with the contact needed
     * to keep the rod from extending or compressing.
     */
```

```
    virtual unsigned addContact(ParticleContact *contact,
                                 unsigned limit) const;
};
```

```
——————————— Excerpt from file src/plinks.cpp ———————————
unsigned ParticleRod::addContact(ParticleContact *contact,
                                  unsigned limit) const
{
    // Find the length of the rod.
    real currentLen = currentLength();

    // Check if we're overextended.
    if (currentLen == length)
    {
        return 0;
    }

    // Otherwise, return the contact.
    contact->particle[0] = particle[0];
    contact->particle[1] = particle[1];

    // Calculate the normal.
    Vector3 normal =
        particle[1]->getPosition() - particle[0]->getPosition();
    normal.normalize();

    // The contact normal depends on whether we're extending or
        compressing.
    if (currentLen > length) {
        contact->contactNormal = normal;
        contact->penetration = currentLen - length;
    } else {
        contact->contactNormal = normal * -1;
        contact->penetration = length - currentLen;
    }

    // Always use zero restitution (no bounciness).
    contact->restitution = 0;

    return 1;
}
```

The code always generates two contacts, which should be added to the list returned by the collision detector and passed to the contact resolver.

7.5 SUMMARY

We've now built a set of physics code that can connect particles using both hard constraints such as rods and cables and elastic constraints such as springs and bungees.

Rods and cables behave similarly to collisions between separate objects. Cables can cause particles joined together to bounce toward one another, in the same way that particles bounce off one another when they collide. In the same way, rods cause connected particles to stay togther, moving with a fixed separation distance. This is equivalent to collisions with no bounce, when the particles stick together and their closing velocity is reduced to zero.

Supporting both hard and elastic connections between particles allows us to combine particles into interesting larger structures and simulate them in our game.

This forms our second complete physics engine, the mass aggregate engine. Unlike the particle engine we built first, the mass aggregate engine is rare in published games. Its major exposure has been in a few 2D platform and casual games.

While it has largely been superceded by the more complex engines later in the book, it is still useful in some games in its own right. Chapter 8 looks at its strengths and selected applications.

7.6 EXERCISES

Exercise 7.1

Collect a selection of objects made from different (nonbreakable) materials and find a hard floor. Using a tape measure, drop each object from a known height (e.g., 1 m), and measure how high they bounce. The object should be dropped in such a way that it does not spin when falling or after bouncing; balls are best for this experiment. From the bounce height, h_{bounce}, and initial height, $h_{initial}$, you can calculate the coefficient of restitution, c, as follows:

$$c = \sqrt{\frac{h_{bounce}}{h_{initial}}}$$

Use the data you collect to create a table of coefficients of restitution between the floor and the materials you used.

Exercise 7.2

(a) Use the equation of motion,

$$p = \dot{p}t + \frac{1}{2}\ddot{p}t^2$$

from Chapter 1 to work out how long it would take for an object with a particular mass to hit the ground when dropped from some specific height.

(b) Use the equation

$$\dot{p} = \ddot{p}t$$

to work out the speed that the object would be traveling when it hits the ground.

(c) Combining both results, derive the equation shown in the previous exercise, that is,

$$c = \sqrt{\frac{h_{\text{bounce}}}{h_{\text{initial}}}}$$

Exercise 7.3

Two balls placed almost on top of one another are dropped from a height of 1 m. The bottom ball hits the ground and bounces with a coefficient of restitution of 0.5. An instant later (i.e., after having lost none of its new upward velocity), it hits the second ball, which is still traveling down. The collision between the balls has a coefficient of restitution of 0.75. The mass of the bottom ball is nine times that of the top ball. What is the upward speed of the top ball after its collision? Assume in this question that the balls have zero radius (i.e., each one drops the full meter before its contact), and gravity is $10 \, \text{m s}^{-2}$.

Exercise 7.4

A force of k is applied to an object for a small fraction of a second, t_k, less than the duration of one frame, t_f. Our simulation doesn't support applying forces for less than an entire frame, so if we wanted to simulate the effect of force k over a duration of t_k, how much force should we apply over our frame duration, t_f?

Exercise 7.5

(a) Implement a collision detector that can detect whether a particle has passed through the ground plane $(Y = 0)$ and generate a collision.

(b) Extend this code so that the objects can be spheres of some given size.

Exercise 7.6

Create another constraint that generates contacts if two objects get closer than a minimum distance apart, or if they get farther than some (possibly different) maximum distance. This constraint is similar to the rod, described above, but allows some margin in which no force is generated.

8

THE MASS
AGGREGATE
PHYSICS ENGINE

We've now built a mass aggregate physics engine capable of both particle simulation and constructions made of many objects connected by rods, cables, and springs. It's time to test the engine on some example scenarios.

The engine still has limits; in particular, it can't describe the way that objects rotate. We'll look at ways around this, faking the rotation of objects in terms of mass aggregates. It is a useful technique for some applications, and can eliminate the need for more advanced physics.

8.1 OVERVIEW OF THE ENGINE

The mass aggregate physics engine has three components:

1. The particles themselves keep track of their position and movement and their mass. To set up a simulation, we need to work out what particles are needed and set their initial position velocity. We also need to set their inverse mass. The acceleration of an object due to gravity is also held in the rigid body (this could be removed and replaced by a force, if you so desire).

2. The force generators are used to keep track of forces that apply over several frames of the game.

Copyright © 2010, Elsevier Inc. All rights reserved.
DOI: 10.1016/B978-0-12-381976-5.00008-5

145

3. The collision system accumulates a set of contact objects and passes them to the contact resolver. Any bit of code can generate new contacts. We have considered two: a collision detector and rod or cable constraints.

At each frame we take each particle, calculate its internal data, call its force generators, and call its integrator to update position and velocity. We then accumulate the contacts on the particle and pass all the contacts for all the particles into the collision resolver.

To make this process easier, we will construct a simple structure to hold any number of rigid bodies. We hold the rigid bodies in a stl::vector, exactly as we did for force generators (again you could use a linked list if you preferred not to use the STL). This is contained in a World class, representing the whole physically simulated world:

```
——————— Excerpt from file include/cyclone/pworld.h ———————
/**
 * Keeps track of a set of particles, and provides the means to
 * update them all.
 */
class ParticleWorld
{
public:
    typedef std::vector<Particle*> Particles;

protected:
    /**
     * Holds the particles.
     */
    Particles particles;
public:
    /**
     * Creates a new particle simulator that can handle up to the
     * given number of contacts per frame. You can also optionally
     * give a number of contact-resolution iterations to use. If you
     * don't give a number of iterations, then twice the number of
     * contacts will be used.
     */
    ParticleWorld(unsigned maxContacts, unsigned iterations=0);
};
```

At each frame, the startFrame method is first called, which sets up each object ready for the force accumulation:

```
                  ____ Excerpt from file include/cyclone/pworld.h ____
class ParticleWorld
{
    // ... Other ParticleWorld code as before ...

    /**
     * Initializes the world for a simulation frame. This clears
     * the force accumulators for particles in the world. After
     * calling this, the particles can have their forces for this
     * frame added.
     */
    void startFrame();
};
```

Additional forces can be applied after calling this method.

We will also create another system to register contacts. Just like we saw for force generators, we create a polymorphic interface for contact detectors.

```
                  ____ Excerpt from file include/cyclone/pcontacts.h ____
/**
 * This is the basic polymorphic interface for contact generators
 * applying to particles.
 */
class ParticleContactGenerator
{
public:
    /**
     * Fills the given contact structure with the generated
     * contact. The contact pointer should point to the first
     * available contact in a contact array, where limit is the
     * maximum number of contacts in the array that can be written
     * to. The method returns the number of contacts that have
     * been written.
     */
    virtual unsigned addContact(ParticleContact *contact,
                                unsigned limit) const = 0;
};
```

Each contact generator gets called in turn from the world, and can contribute any contacts it finds back to the world by calling its addContact method.

To execute the physics, the runPhysics method is called. This calls all the force generators to apply their forces, and then performs the integration of all objects, runs the contact detectors, and resolves the resulting contact list:

```
                    ─── Excerpt from file include/cyclone/pworld.h ───
class ParticleWorld
{
    // ... Other ParticleWorld code as before ...

    typedef std::vector<ParticleContactGenerator*> ContactGenerators;
    /**
     * Holds the force generators for the particles in this world.
     */
    ParticleForceRegistry registry;

    /**
     * Holds the resolver for contacts.
     */
    ParticleContactResolver resolver;

    /**
     * Contact generators.
     */
    ContactGenerators contactGenerators;

    /**
     * Holds the list of contacts.
     */
    ParticleContact *contacts;

    /**
     * Holds the maximum number of contacts allowed (i.e., the
     * size of the contacts array).
     */
    unsigned maxContacts;

    /**
     * Calls each of the registered contact generators to report
     * their contacts. Returns the number of generated contacts.
     */
    unsigned generateContacts();

    /**
     * Integrates all the particles in this world forward in time
```

```
      * by the given duration.
      */
     void integrate(real duration);

     /**
      * Processes all the physics for the particle world.
      */
     void runPhysics(real duration);

};
```

—————— **Excerpt from file src/pworld.cpp** ——————

```
unsigned ParticleWorld::generateContacts()
{
    unsigned limit = maxContacts;
    ParticleContact *nextContact = contacts;

    for (ContactGenerators::iterator g = contactGenerators.begin();
        g != contactGenerators.end();
        g++)
    {
        unsigned used =(*g)->addContact(nextContact, limit);
        limit -= used;
        nextContact += used;

        // We've run out of contacts to fill. This means we're missing
        // contacts.
        if (limit <= 0) break;
    }

    // Return the number of contacts used.
    return maxContacts - limit;
}

void ParticleWorld::integrate(real duration)
{
    for (Particles::iterator p = particles.begin();
        p != particles.end();
        p++)
    {
        // Integrate the particle by the given duration.
        p->integrate(duration);
    }
```

```
    }

    void ParticleWorld::runPhysics(real duration)
    {
        // First, apply the force generators.
        registry.updateForces(duration);

        // Then integrate the objects.
        integrate(duration);

        // Generate contacts.
        unsigned usedContacts = generateContacts();

        // And process them.
        if (usedContacts)
        {
            if (calculateIterations) resolver.setIterations(usedContacts * 2);
            resolver.resolveContacts(contacts, usedContacts, duration);
        }
    }
```

We add a call to startFrame at the start of each frame of the game, and a call to runPhysics wherever we want the physics to occur. A typical game loop might look like this:

```
void loop()
{
  while (true) {
    // Prepare the objects for this frame.
    world.startFrame();

    // Calls to other parts of the game code.
    runGraphicsUpdate();
    updateCharacters();

    // Update the physics.
    world.runPhysics();

    if (gameOver) break;
  }
}
```

8.2 Using the Physics Engine

We will look at a useful application of the mass aggregate engine—creating structures out of particle masses and hard constraints. Using this technique, we can create and simulate many larger objects. The possibilities are endless, such as crates, mechanical devices, even chains, vehicles, or (with the addition of springs) soft deformable blobs.

8.2.1 Rope Bridges and Cables

Sagging bridges, cables, and tilting platforms are all stalwarts of the platform game genre, as well as having applications in other genres.

We can set up a bridge using pairs of particles suspended by cables. Figure 8.1 shows an arrangement that has this effect. Each pair of particles along the bridge is linked with a rod constraint to keep them connected with their neighbors. Pairs of particles are likewise linked together to give the bridge some strength. The cables are cable constraints descending from a fixed point in space.

In the source code accompanying this book, the **bridge** demo shows this setup in operation. You can move an object (representing a character) over the bridge. The collision detector applies contacts to the nearest particles to the objects. Note that the bridge stretches and conforms to the presence of the heavy object. In the demo, the constraints are shown as lines in the simulation.

The collision detector needs some explanation. Because we have only particles in our simulation, but we want to give the impression of a bridge, it is not the collision between particles that interests us, but the collision between the character and the planks of the bridge. We will return later in the book to a more robust way of doing this. For the purposes of this chapter, I have created a custom collision detector. The detector treats the character as a sphere, and checks whether it intersects with any of

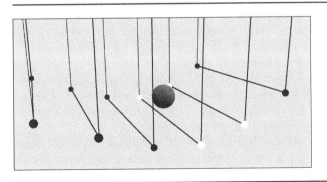

FIGURE 8.1 Screenshot of the **bridge** demo.

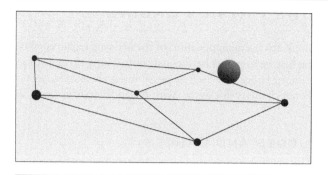

FIGURE 8.2 Screenshot of the **platform** demo.

the planks. A plank is a line segment between one pair of particles. If the object does intersect, then a contact is generated between the character object and the nearest of the plank particles. The contact normal is set based on the position of the object and the line of the plank.

Tilting platforms can use the same idea. Figure 8.2 shows a suitable structure. The accompanying **platform** demo shows this in operation: the platform will naturally tilt in one direction. A weight can be added to the opposite end, causing it to tilt back. The particles that make up the pivot of the platform have been set with infinite mass, to prevent them from moving. If the platform was intended to be mobile, they could be set with a mass similar to the other particles.

The simulation setup is similar to the **bridge** demo. You can download the full source code for both on the website.

8.2.2 FRICTION

One key limitation of this approach is the lack of friction in our contact model. It was a deliberate choice to leave out friction at this stage: we'll implement it as part of the engine in Part V. If you create mass aggregates, they will appear to slide over the ground as if skating on ice. Try replacing the infinite masses of the **platform** demo and see the platform slide about.

If you are intending to only implement a mass aggregate physics system, then it is worth skipping forward to Chapter 15. The discussion of friction there can be easily adapted for particle contacts. In fact, the mathematics is a little simpler: we can ignore all the rotational components of the contact.

For anything but the simplest assemblies of particle masses, it may be worth implementing the full physics engine in any case. You can create any object with a mass aggregate system, but as the number of constraints increases, so does the burden on the collision response system and the tendency for stiff constraints to flex slightly as groups of hard constraints compete to be resolved. A full rigid-body solution is the

most practical for general physics simulation. It is time to bite the bullet and move from particles to complete, rotating, extended objects.

8.2.3 BLOB GAMES

Over the last 5 years, mass aggregates have seen some use in games with "blobs" as central characters. The independent Gish, and the hit PSP game Loco Roco use 2D characters made up of a set of particles that move in ways we can replicate using our mass aggregate engine. I strongly suspect (but don't know) that a more complete physics engine is used in both games. But the characters themselves only require the features we have built so far.

Each character is made up of a series of particles. Only a handful are needed, though in Loco Roco, the number changes throughout the game. The particles are connected using soft springs, so they can move a reasonable distance apart. To avoid moving too far apart, the springs have a limit of elasticity, beyond which they act like cables. It is possible to also detect this situation and break the connection, allowing part of the character to fall away for future recapturing.

The difficult part of this setup is to render the characters nicely. The simplest approach is to draw a circle or sphere at each particle, making sure that they don't separate far enough to leave a gap. This gives the right general impression, but isn't entirely convincing. A more complete approach would have to generate new geometry for the character based on where its particles are lying. This could be a meta-ball type of algorithm (as seen in many 3D design packages) or more likely a custom piece of geometry-generating code.

The **blob** demo in the accompanying source code provides a simple implementation of this kind of character, using only the mass aggregate engine.

8.3 SUMMARY

While slightly cumbersome, a mass aggregate physics engine is capable of simulating some interesting and complex effects. Sets of relatively simple objects joined by a mixture of hard and elastic constraints are particularly suited to this approach.

The first examples we saw, rope bridges, have been simulated with a mass aggregate approach for many years. The second example showed how to build large objects out of a set of particles. While this can work successfully, it is prone to many problems. Objects made up of lots of particles and lots of hard constraints can be slightly unstable; they can appear to flex and bend when simulated, and in the worst case there can be noticeable vibration in the particles as their constraints pull them in different ways.

There is a better way to simulate a single large object. Rather than build it out of particles, we can treat it as a whole. To do this, we'll need to change our physics engine dramatically. As well as simulating the position, velocity, and acceleration of an object, we'll need to take into account how it rotates as it moves. This will introduce a large

amount of complexity into our physics engine, and will take us the rest of the book to implement properly. Chapter 9 takes the first step, introducing the mathematics of rotation.

8.4 PROJECTS

Mini-Project 8.1
Remove the infinite masses from the anchor points in the **platform** demo and see how the platform responds.

Mini-Project 8.2
Create a cube mass aggregate shape (using either of the demos in this chapter). How many rods do you need for it to keep a reasonably square shape?

Mini-Project 8.3
(a) Create a mass aggregate wheel, where the center of the wheel is fixed with infinite mass. The center should radiate spokes (made of rods) to masses on the circumference of the wheel. These masses should be joined by further rods to make the outer edge of the wheel.

(b) Add a force generator to the masses at the circumference of the wheel to make the wheel turn.

(c) Add the force generator to just a few of the masses on the circumference. Does this set of unbalanced forces cause the wheel to deform as it turns?

Project 8.1
Create a game in which the player controls a bouncing ball. The player can make the ball bounce left, right, or higher (add these movements using a custom force generator that responds to the player's key presses). Create a very simple level using mass aggregate objects such as a rope bridge or tilting platform. See the **bridge** and **platform** demos for examples of how to detect collisions between a spherical ball and these objects.

Project 8.2
Create a trebuchet game, with the structure of the trebuchet implemented as a mass aggregate system. There should be a base with infinite mass and a swinging arm, one end of which has a heavy counterweight. A particle is attached to the other end of the arm, and is released when it reaches a particular point of the swing. By changing the length of the arm, the weights of both the counterweight and the projectile, and the angle at which the projectile is released, the player can alter the projectile's trajectory.

PART III

Rigid-Body Physics

THE MATHEMATICS
OF ROTATIONS

T hus far we have covered a lot of ground on our way to building the first two physics engines. We have built a sophisticated system capable of simulating particles, either individually or connected into aggregates. To arrive at our goal of building a complete physics engine, we are missing two things:

- A robust, general-purpose collision detection system (currently we're using quite an ad hoc system of hard constraints and special case code).
- The ability of objects to rotate as well as move around linearly.

Collision detection is often a self-contained problem solved by a piece of code more or less independent of the physics engine. It will be the subject of Part IV of the book.

The second impacts the code we've already written: it is the difference between a complete rigid-body physics system and the mass aggregate systems we've seen so far. To add rotations, we'll need to go backward in the capability of our engine. We'll need to remove a good deal of functionality and rebuild it based on full rotating rigid bodies. Such treatments comprise this part of the book and Part V, most of the rest of the book.

This chapter focuses on the properties of rotating bodies, and considers the mathematical structures needed to represent and manipulate them. As in Chapter 2, we'll focus on understanding and implementing the mathematics here before building it into our physics engine in Chapter 10.

Copyright © 2010, Elsevier Inc. All rights reserved.
DOI: 10.1016/B978-0-12-381976-5.00009-7

9.1 ROTATING OBJECTS IN 2D

Before we look at rotations in three dimensions, it is worth understanding them in two. I will not implement any code from this section, but thinking about the 2D case is a good first step toward understanding three dimensions.

In two dimensions, we can represent any object's configuration in space by its 2D position and an angle that shows how it is oriented. Just as the position is specified relative to some fixed origin point, the angle is also given relative to a predetermined direction. Figure 9.1 illustrates this.

If the object is rotating, its orientation will change over time. Just as velocity is the first derivative of position (see Chapter 2), angular velocity is the first derivative of orientation with respect to time.

I will use the word "orientation" throughout this book to refer to the direction in which an object is facing. The word "rotation" is sometimes used for the same thing, but it can also mean the process of rotating, or the amount of rotation that has occurred.

To be specific, I'll try to only use "rotation" to mean a change in orientation. If something is rotated, it is natural to mean that its orientation has changed. So to rephrase the previous section, we could say that each orientation can be seen as a rotation from some predetermined reference orientation.

If an object is spinning, I'll continue to use the term "angular velocity" to mean the rate of change of orientation.

9.1.1 THE MATHEMATICS OF ANGLES

If we do any mathematics with orientations, we need to be careful, as many different orientation values can represent the same orientation. If we measure orientation in radians (there are 2π radians in the 360° of a circle), then the orientation of 2π is the same as 0. Developers normally set a fixed range of orientation values, say $(-\pi, \pi]$ (the square bracket indicates that π is included in the range, and the round bracket that $-\pi$ is not). If an orientation falls outside this range, it is brought back into the range. The mathematical routines that deal with this kind of orientation scalar can look messy, with lots of adjustments and checks.

Orientation = 0 Orientation = 100 Orientation = −100

FIGURE 9.1 Angle that an object is facing.

An alternative approach is to use vectors to represent orientation. We take a two-element vector representing the direction in which the object is pointing. The vector is related to the scalar value according to the equation

$$\boldsymbol{\theta} = \begin{bmatrix} \cos\theta \\ \sin\theta \end{bmatrix}$$ [9.1]

where θ is the angular representation of orientation, and $\boldsymbol{\theta}$ is the vector representation. I have assumed that zero orientation would see the object facing along the positive X axis, and that orientation increases in the counterclockwise direction. This is simply a matter of convention.

The vector form of orientation makes many (but not all) mathematical operations easier to perform, with less special case code and bounds checking. But in moving to a 2D representation, we have doubled the number of values representing our orientation. We have only one degree of freedom when deciding which direction an object should face, but the representation of a vector has two degrees of freedom. A *degree of freedom* is some quantity that we could change independent of others. A 3D position has three degrees of freedom, for example, because we can move it in any of three directions without altering its position in the other two. Calculating the number of degrees of freedom will be an important tool for understanding rotations in 3D.

Having this extra degree of freedom means that we could end up with a vector that doesn't represent an orientation. In fact, most vectors will not match Equation 9.1. In order to guarantee that our vector represents an orientation, we need to remove some of its freedom. We do this by forcing the vector to have a magnitude of 1. Any vector with a magnitude of 1 will match Equation 9.1, and we'll be able to find its corresponding angle.

There's a geometric way of looking at this constraint. If we draw a point at the end of all possible vectors with a magnitude of 1, we get a circle, as shown in Figure 9.2. We could say that a vector orientation correctly represents an orientation if it lies on this circle. If we find a vector that is supposed to represent an orientation but is slightly off (because of numerical errors in a calculation), we can fix it by bringing it onto the circle. Mathematically we do this by forcing its magnitude to be 1 by normalizing the vector.

If we build a 2D physics engine using vectors to represent orientations, we'd need to occasionally make sure that the orientations still lie on the circle by normalizing them.

Let's summarize these steps (not surprisingly we'll see them again later): we started with problems of bounds checking, which led us to use a representation with one more degree of freedom, which needed an extra constraint, which in turn led us to add in an extra step to enforce the constraint.

9.1.2 ANGULAR SPEED

When we look at the angular speed of an object (sometimes called its rotation), we don't have any of the problems we saw for orientation. An angular speed of 4π radians

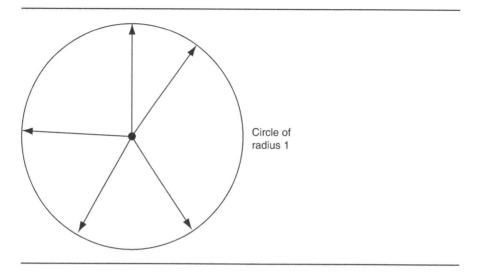

FIGURE 9.2 The circle of orientation vectors.

per second is different from 2π radians per second. Every angular speed, expressed as a single scalar value, is unique. So, the mathematics for angular speed is simple; we don't need bound checking and special case code, which in turn means that we don't need to use a vector representation. Instead, we can stick with our scalar value.

9.1.3 THE ORIGIN AND THE CENTER OF MASS

Before we leave two dimensions, it is worth considering what our position and orientation represent. When we were dealing with particles, the position represented the location of the particle. Particles by definition exist only at a single point in space, even though in this book we've stretched the definition slightly and treated them like small spheres.

The Origin of an Object

If we have a larger object, what does the position represent? The object is at many locations at the same time, as it covers an extended area.

The position that we store must represent some pre-agreed location for the object. This position is sometimes called the origin of the object. In a game we might choose the root of the spine of a character, or the center of the chassis of a car. The position doesn't need to be inside the object at all. Many developers represent the position of a character as a location between their heels resting on the ground.

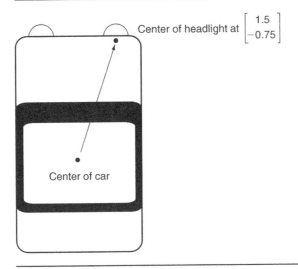

Center of headlight at $\begin{bmatrix} 1.5 \\ -0.75 \end{bmatrix}$

Center of car

FIGURE 9.3 The relative position of a car component.

As long as the location doesn't move around relative to the object, we can always determine where every bit of the object will be from just its position and orientation. Locations on the object are given *relative* to the origin of the object. If the origin of a car is in the center of its chassis, as shown in Figure 9.3, then its right headlight might be at a position of

$$\begin{bmatrix} 1.5 \\ -0.75 \end{bmatrix}$$

relative to the origin. If the car is moved so that its origin is at

$$\begin{bmatrix} 4 \\ 3.85 \end{bmatrix}$$

then its headlight will be at

$$\begin{bmatrix} 1.5 \\ -0.75 \end{bmatrix} + \begin{bmatrix} 4 \\ 3.85 \end{bmatrix} = \begin{bmatrix} 5.5 \\ 3.1 \end{bmatrix}$$

This movement is called *translation*—we are translating the car from one position to another.

Rotations

The same thing occurs if the object is facing in a different direction. In Figure 9.4, the car's position and orientation have been altered.

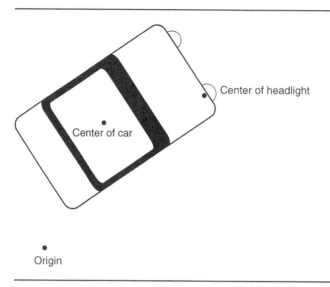

Center of headlight

Center of car

Origin

FIGURE 9.4 The car is rotated.

So how do we calculate the location of the headlight now? First, we need to turn the headlight around to represent the direction the car is facing.

We do this by using a third version of our orientation value. This time the orientation is expressed in matrix form. If you are unsure about matrices, I'll return to their mathematics when we come to implementing matrix classes for 3D below. You can skip the mathematics here if you do not need a refresher.

The matrix form of orientation looks like this:

$$\Theta = \begin{bmatrix} \cos\theta & -\sin\theta \\ \sin\theta & \cos\theta \end{bmatrix}$$

where θ is the orientation angle, as before. This matrix is usually called the *rotation matrix*: it can be used to rotate a vector by some angle. We can work out the new position of the headlight by multiplying the *relative* position of the headlight by the rotation matrix

$$q' = \begin{bmatrix} \cos\theta & -\sin\theta \\ \sin\theta & \cos\theta \end{bmatrix} q_b$$

where q_b is the relative location of the headlight. In our case, where $\theta = 3\pi/8$, we obtain the following:

$$q' = \begin{bmatrix} 0.38 & -0.92 \\ 0.92 & 0.38 \end{bmatrix} \begin{bmatrix} 1.5 \\ -0.75 \end{bmatrix} = \begin{bmatrix} 0.57 + 0.69 \\ 1.39 - 0.29 \end{bmatrix} = \begin{bmatrix} 1.27 \\ 1.10 \end{bmatrix}$$

where all values are given to two decimal places.

After applying the orientation in this way, we can then apply the change in position as before. The total process looks like this:

$$q = \Theta q_b + p \qquad [9.2]$$

where p is the position of the object. This equation works in both 2D and 3D, although the definition of Θ is different, as we'll see later in the chapter.

For our car example, we get:

$$q = \begin{bmatrix} 0.38 & -0.92 \\ 0.92 & 0.38 \end{bmatrix} \begin{bmatrix} 1.5 \\ -0.75 \end{bmatrix} + \begin{bmatrix} 4 \\ 3.85 \end{bmatrix} = \begin{bmatrix} 1.27 \\ 1.10 \end{bmatrix} + \begin{bmatrix} 4 \\ 3.85 \end{bmatrix} = \begin{bmatrix} 5.27 \\ 4.95 \end{bmatrix}$$

This calculation is called a *transformation*. We're calculating the location of part of an object based on the position and orientation of the origin of the object it belongs to and the relative position of the component. Transformations can be thought of as converting between different sets of coordinates. In this case, we're transforming from *object space* (the relative position of the component, also called *local space* or sometimes *body space*) to *world space* (the final coordinate of the component). I'll return to describing what I mean by world space and object space in more detail in Section 9.4.5.

The Composition of Rotations and Translations

One vital result to note is that any sequence of translations and rotations can be represented with a single position and orientation. In other words, no matter how many times I move and turn the car, we can always give a single set of values for its current position and orientation.

This is equivalent to saying that any combination of rotations and translations is equivalent to some single rotation followed by some single translation.

Rigid Bodies

The fact that all components of an object are fixed relative to its origin is the reason why we talk about rigid bodies when it comes to physics engines. If our car is an infant's toy made of squashable rubber, then knowing the position and orientation isn't enough to tell us where the headlight is: the headlight might have been stretched into a very different position.

Some physics engines can deal with simple soft bodies, but usually they work by assuming that the body is rigid, and then applying some after-effects to make it look soft. Or else they use a series of rigid bodies or particles joined by springs. In our engine, as well as the majority of game physics engines, we will only support rigid bodies.

Theoretically, we could choose any point on the object to be its origin. For objects that aren't being physically simulated, this is often the approach developers take, that is, to choose a point that is convenient for the artist or AI programmer to work

with. It is possible to create physics code that works with an arbitrary origin, but the code rapidly becomes very complicated. There is one position on every object where the origin can be set that dramatically simplifies the mathematics: the center of mass.

Center of Mass

The center of mass (often called the "center of gravity") is the balance point of an object. If you divide the object in two by cutting any straight line through this point, you will end up with two objects that have exactly the same weight. If the object is a two-dimensional shape, you can balance it on your finger by placing your finger at the center of mass.[1]

If you think of an object as being made up of millions of tiny particles (atoms, for example), you can think of the center of mass as being the average position of all these little particles, where each particle contributes to the average depending on its mass. In fact, this is how we can calculate the center of mass. We split the object into tiny particles and take the average position of all of them, as in

$$\boldsymbol{p}_{\text{cofm}} = \frac{1}{m} \sum_n m_i \boldsymbol{p}_i$$

where $\boldsymbol{p}_{\text{cofm}}$ is the position of the center of mass, m is the total mass of the object, and m_i is the mass and \boldsymbol{p}_i of particle i.

The center of mass of a sphere of uniform density will be located at the center point of the sphere. Similarly, with a cuboid, the center of mass will be at its geometric center. The center of mass isn't always contained within the object. A donut has its center of mass in the hole, for example. Appendix A gives a breakdown of a range of different geometries and where their center of mass is located.

The center of mass is important because it behaves in a very useful way. If we watch the center of mass of a rigid body, *it will always behave like a particle*. In other words, we can use exactly the same formulas we have used so far in this book to perform the force calculations and update the position and velocity for the center of mass. By selecting the center of mass as our origin position, we can completely separate the calculations for the linear motion of the object (which is the same as for particles) and its angular motion (for which we'll need extra mathematics).

Any physical behavior of the object can be decomposed into the linear motion of the center of mass, and angular motion around the same point. This is a profound and crucial result, but one that takes some time to prove: if you want the background, any good undergraduate textbook on mechanics will give details.

If we choose any other point as the origin, we can no longer separate the two kinds of motion; we'd need to take into account how the object was rotating in order to work

1. This isn't always possible. As we'll see, an object's center of mass may lie outside the bounds of the object. It is always the case that cutting an object through its center of mass gives you two halves of equal mass, however.

out where the origin is. Obviously this would make all our calculations considerably more complicated.

Some authors and instructors work through code either way (although typically only for a few results; when the mathematics gets really hard they give up). Personally, I think it is a very bad idea to even consider having your origin anywhere else but at the center of gravity. I'll assume this will always be the case for the rest of the book; if you want your origin somewhere else, you're on your own!

9.2 ORIENTATION IN 3D

In 2D we started out with a single angle for orientation. Problems with keeping this value in bounds led us to look at alternative representations. In many 2D games, a vector representation is useful, but the mathematics for angles alone isn't *so* difficult that you couldn't stick with the angle and adjust the surrounding code to cope.

Not surprisingly, there are similar problems in 3D. In 3D, however, the obvious representation is so fundamentally flawed that it is almost impossible to imagine providing the right workarounds to get it running. We will be forced to use an alternative representation. The representation we choose will, unfortunately, be a rather uncommon bit of mathematics, not something you were taught in high school.

I don't want to get bogged down in representations that *don't* work, but it is worth taking a brief look at the problems before we look at a range of solutions.

9.2.1 EULER ANGLES

In 3D an object has three degrees of freedom for rotation. By analogy, with the movement of aircraft we can call these yaw, pitch, and roll. Any rotation of the aircraft can be made up of a combination of these three maneuvers as illustrated in Figure 9.5.

For an aircraft, these rotations pivot about the three axes: *pitch* is a rotation about the X axis, *yaw* is about the Y axis, and *roll* is about the Z axis (assuming the reference orientation of an aircraft is looking down the Z axis, with the Y axis up).

Recall that a position is represented as a vector, where each component represents the distance from the origin in one direction. We could use a vector to represent rotation, where each component represents the amount of rotation about the corresponding axis. We have a similar situation to our 2D rotation, but here rather than a single angle, we need three, or one for each axis. These three angles are called *Euler angles*.

This is the most obvious representation of orientation. It has been used in many graphics applications. Several of the leading graphics modeling packages use Euler angles internally, and those that don't still represent orientations to the user as Euler angles.

Unfortunately, Euler angles are almost useless for our needs. We can see this by looking at some of the implications of working with them. You can follow this through

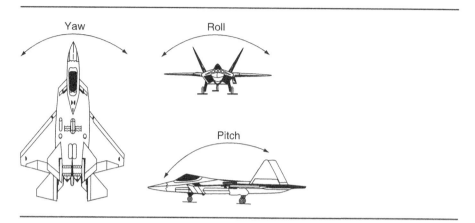

FIGURE 9.5 Aircraft rotation axes.

by making a set of axes with your hand (as described in Section 2.1.1), remembering that your imaginary object is facing in the same direction as your palm (along the Z axis) and your index pointer should be pointing up (i.e., the Y axis is vertical).

Imagine we first perform a pitch, by 30 degrees or so, keeping your thumb pointed in the same direction. The object now has its nose up in the air. Now perform a yaw by about the same amount, keeping your first finger pointed in the same direction. Note that the yaw axis (your first finger) is no longer pointing up: when we pitched the object the yaw axis also moved.

Remember where the object is pointing. Now start again, but perform the yaw first and then the pitch. Note now that the object will be in a slightly different position (if it doesn't seem to be different, then try it again with bigger rotations, until you can see the difference—the bigger the rotation, the bigger the difference). What does this mean? If we have a rotation vector like

$$\begin{bmatrix} 0.3 \\ 0.4 \\ 0.1 \end{bmatrix}$$

in which order do we perform the rotations? The result may be different for each order. What is more, because the order is crucial, we can't simply use regular vector mathematics to combine rotations. In particular,

$$\boldsymbol{r}_1 \cdot \boldsymbol{r}_2 = \boldsymbol{r}_2 \cdot \boldsymbol{r}_1$$

where \boldsymbol{r}_1 and \boldsymbol{r}_2 are two vectors, but the rotations themselves shouldn't behave like this (as we saw with the hand example). For rotations r_1 and r_2,

$$r_1 \cdot r_2 \neq r_2 \cdot r_1$$

In case you think that the problem is caused by moving the rotation axes around (i.e., keeping them welded to the object rather than fixed in the world), try it the other

way. Not only does the same problem still occur, but now we have another issue—gimbal lock.

Gimbal lock occurs when we rotate an object so that what started off as one axis now aligns with another. For example, assume we're applying the rotations in the order X, Y, and then Z. If we yaw around by 90 degrees (i.e., no X rotation, 90-degree Y rotation), the front of the object is now pointing in the negative X direction. Say we wanted to have the object roll slightly now (roll from its own point of view), but we can't do that. The axis we need (the local Z axis) is now pointing in the X direction, and we've already passed the point of applying X rotations.

So maybe we should have applied a little bit of X rotation first before rotating in the Y direction. Try it: you can't do it. For this particular problem, we could perform the rotations in a different order, such as ZYX. This would solve the problem for the example above, but there would be new orientations that this ordering couldn't represent. Once rotations of around 90 degrees come into play, we can't achieve all desired orientations with a combination of Euler angles. This is called *gimbal lock*.

There are ways to mitigate the problem by using combinations of axes, some of which move with the object and some of which are fixed in world space. Alternatively, we can repeat rotations around some axes. There are many different schemes, and some of them are more useful than others. All of them are characterized by very arbitrary mathematics, horrendous boundary conditions, and a tendency to find difficult situations that cause the system to crash long after you think it has been debugged.

Gimbal lock is a significant problem in real-world engineering as well. In order to calculate the orientation of an object (a spacecraft, for example), nested gyroscopes are used to keep track of the total amount of rotation the craft has experienced. These gyros suffer the same kind of ordering problems we've seen above, including gimbal lock. In NASA's Apollo moon program, to avoid the craft reaching gimbal lock and finding it impossible to represent the orientation of the spacecraft, restrictions were placed on the way that astronauts could control it. If the craft got too near gimbal lock, a warning would sound. There was no physical reason why the craft couldn't orient in that way; it was purely a feature of the ability to measure and do calculations with the orientation of the craft.

Fortunately, there are much better ways of dealing with orientation. They may not be so intuitive to visualize, and they may be impossible to build a gyroscope to measure, but their mathematics is a lot more reliable.

9.2.2 Axis-Angle

Any rotation or combination of rotations can be represented as a single rotation about an axis. In other words, no matter what combination of rotations takes place, we can always specify the orientation of an object as an axis and an angle.

This was obvious in the 2D case, but probably isn't so obvious now that we're in 3D. You can easily verify it for yourself with a small ball. Regardless of how you orient

the ball, you can get it into any other orientation by one rotation about a suitably chosen axis.

We could use this as a representation for orientation (it is called, not surprisingly, *axis-angle representation*). It is roughly equivalent to the angle representation we used for 2D, and suffers some of the same problems. In particular, we would need to perform bounds checking to make sure that the angle is always in the correct range $(-\pi, \pi]$.

Having a vector (for the axis) and an angle gives us four degrees of freedom. The rotation is only three degrees of freedom. The extra degree of freedom is removed by requiring that the vector representing the axis is normalized. It represents only a direction.

Another possible representation using axis and angle is the scaled axis representation. If the axis is normalized, then we can combine the axis and angle into a single vector. The direction of the vector gives the axis, and the magnitude of the vector gives the angle. The angle is therefore in the range $(0, \pi]$. We don't need to represent negative angles, because they are equivalent to a positive rotation in the opposite direction.

The scaled axis representation is the most compact representation we have. It has three values for three degrees of freedom, and it can represent any orientation. Although it will be useful to us later in the chapter when we come to look at angular velocity, it is almost never used to represent orientations.

This is for the same reasons we avoided a single-angle representation for 2D rotations. The mathematics involved in manipulating a scaled axis representation of orientation isn't simple. Unlike for the 2D case, we have more than just the bounds to worry about: it isn't clear how to combine rotations easily, because the axis as well as the angle needs to change.

So far, we've drawn a blank on compact representations that are practical to use. Up until a few years ago, the most common way to represent orientations went to the opposite extreme. Rather than use three values, a three-by-three matrix was used.

9.2.3 ROTATION MATRICES

If we are interested in the mathematics of combining rotations, then we could borrow from 3D graphics and represent orientations with a rotation matrix. In games, we regularly use matrices to represent rotations. In fact, chances are that whatever representation we use, we'll have to turn it into a rotation matrix and send it to the rendering engine in order to draw the object. Why not save the effort and use the rotation matrix from the start?

Using rotation matrices is a good solution, as we can represent any rotation with a rotation matrix, and the mathematics of combining these rotations is relatively simple and clean to implement.

The elements of the matrix follow:

$$\Theta = \begin{bmatrix} tx^2 + c & txy + sz & txz - sy \\ txy - sz & ty^2 + c & tyz + sx \\ txz + sy & tyz - sx & tz^2 + x \end{bmatrix}$$ [9.3]

where

$$\begin{bmatrix} x \\ y \\ z \end{bmatrix}$$

is the axis of rotation, $c = \cos\theta$, $s = \sin\theta$, $t = 1 - \cos\theta$, and θ is the angle.

Because the elements are related to the sine and cosine of the angle, rather than the angles themselves, we don't have to do any bounds checking. This is exactly as we saw in the 2D case. Combining two rotations is simply a matter of multiplying the two matrices together.

The downside with using rotation matrices is their numerous degrees of freedom. We are representing a three-degrees-of-freedom system with nine numbers. Floating-point arithmetic in the computer isn't totally accurate. So, we need to make sure that the matrix represents a rotation (as opposed to some other kind of transformation such as a skew or even mirror image), even after we've manipulated it in some way. As for the 2D case, we need to adjust its values periodically. With so many degrees of freedom, this adjustment process needs to take place more often than we'd like, and it isn't a trivial process like normalizing a vector is.

It is at this point that the rotation matrix becomes less practical than we'd like. It is workable (unlike the previous possible representations), but it isn't optimal.

Ideally, we'd like a representation that has the advantages of matrices: straightforward combination of rotations and no bounds checking, with fewer degrees of freedom. The solution, now almost ubiquitous, is to use a mathematical structure called a *quaternion*.

9.2.4 QUATERNIONS

The best and most widely used representation for orientations is the quaternion. A quaternion represents an orientation with four values related to the axis and angle in the following way:

$$\begin{bmatrix} \cos\frac{\theta}{2} \\ x\sin\frac{\theta}{2} \\ y\sin\frac{\theta}{2} \\ z\sin\frac{\theta}{2} \end{bmatrix}$$ [9.4]

where

$$\begin{bmatrix} x \\ y \\ z \end{bmatrix}$$

is the axis, and θ is the angle, as before.

Quaternions are not merely a four-element vector, however; their mathematics are more exotic. If you are allergic to mathematics, then feel free to skip this explanation and head for the implementation in the next section.

You may remember in high school mathematics learning about the square root of -1, the so-called *imaginary number* (in contrast to the real numbers), often written as i or j. So, $i^2 = -1$. A complex number is then made up of both a real number and some multiple of i, in the form $a + bi$. If your mathematical memory is very good, you might recall drawing complex numbers as coordinates in 2D (the Argand diagram), and deriving lots of their properties geometrically. Complex numbers have a very strong connection with geometry, and in particular rotations in 2D.

A quaternion is a number of the form $w + xi + yj + zk$, where i, j, and k are all *different* imaginary numbers. Each one squares to -1:

$$i^2 = j^2 = k^2 = -1$$

and when all are multiplied together, we also get -1:

$$ijk = -1$$

Together, these two equations provide the fundamental formula of quaternion algebra.[2] The second part of this result means that any two of the three imaginary numbers, when multiplied together, give us the third:

$$ijk = k^2 \implies ij = k$$

But beware, quaternion mathematics isn't commutative (in other words $ab \neq ba$ for at least some values of a,b), and in particular,

$$ij = -ji = k$$
$$jk = -kj = i$$
$$ki = -ik = j$$

by definition.

2. The formula is reputed to have been scratched in the stone of the Brougham Bridge near Dublin by the discoverer of quaternions, William Rowan Hamilton (the site is now marked by a plaque and the original carving, if it existed, cannot be seen).

With these laws we can combine quaternions by multiplication:

$$(w_1 + x_1 i + y_1 j + z_1 k) \times (w_2 + x_2 i + y_2 j + z_2 k) =$$
$$(w_1 w_2 - x_1 x_2 - y_1 y_2 - z_1 z_2) +$$
$$(w_1 x_2 + x_1 w_2 + y_1 z_2 - z_1 y_2)i +$$
$$(w_1 y_2 - x_1 z_2 + y_1 w_2 + z_1 x_2)j +$$
$$(w_1 z_2 + x_1 y_2 - y_1 x_2 + z_1 w_2)k$$

If the original two quaternions represent rotations according to Equation 9.4, then the resulting quaternion is equivalent to the two rotations combined. I will write quaternions using the notation $\hat{\theta}$. Rather than writing them out with their three imaginary and one real terms, I will write them as a four-element vector format to show their four components:

$$\hat{\theta} = w + xi + yj + zk = \begin{bmatrix} w \\ x \\ y \\ z \end{bmatrix}$$

Quaternions have four degrees of freedom to represent the three degrees of freedom of rotation. Clearly we have an extra degree of freedom that we need to constrain away.

In fact, for all rotations, Equation 9.4 implies that the magnitude of the quaternion is exactly 1. We calculate the magnitude of the quaternion in exactly the same way as we did for a three-element vector, by using a four-component version of Pythagoras's theorem:

$$\sqrt{w^2 + x^2 + y^2 + z^2}$$

To ensure that a quaternion always represents a rotation, we therefore need to make sure it has unit length, or

$$\sqrt{w^2 + x^2 + y^2 + z^2} = 1$$

We do this using a procedure identical to normalizing a vector, but operating on all four components of the quaternion. Just like for 2D rotation, we have fixed the problem of messy bound checking by adding an extra value to our representation, and then adding a constraint to remove the extra degree of freedom and to ensure that we only get rotations.

In the same way that normalizing our 2D vector representation gave us a point on a circle, normalizing a quaternion can be thought of as giving a point on the surface of a four-dimensional sphere. In fact, lots of the mathematics of quaternions can be derived based on the surface geometry of a four-dimensional sphere. While some developers like to think in these terms (or at least claim they do), personally I find four-dimensional geometry even more difficult to visualize than 3D rotations, so I tend to stick with the algebraic formulation I've given above.

9.3 ANGULAR VELOCITY AND ACCELERATION

Representing the current orientation of rigid bodies is only one part of the problem. We also need to be able to keep track of how fast and in what direction the bodies are rotating.

Recall that in 2D we could use a single value for the angular velocity without the need to perform bound checking. The same thing is true of angular velocity in 3D. We abandoned the scaled axis representation for orientations because of boundary problems. Once again, when we are concerned with the speed that an object is rotating, we have no bounds: the object can be rotating as fast as it likes.

Our solution is to stick with the scaled axis representation for angular velocity. It has exactly the right number of degrees of freedom, and without the problems of keeping its angle in bounds, the mathematics is simple enough for efficient implementation.

The angular velocity is a three-element vector that can be decomposed into an axis and rate of angular change,

$$\dot{\boldsymbol{\theta}} = r\widehat{\boldsymbol{a}}$$

where $\widehat{\boldsymbol{a}}$ is the axis around which the object is turning, and r is the rate at which it is spinning, which (by convention) is measured in radians per second.

The mathematics of vectors matches well with the mathematics of angular velocity. In particular, if we have an object spinning at a certain rate $\dot{\boldsymbol{\theta}}$, and we add to its rotation a spin at some rate in a new direction $\boldsymbol{\omega}$, then the new total angular velocity will be given by

$$\dot{\boldsymbol{\theta}}' = \dot{\boldsymbol{\theta}} + \boldsymbol{\omega}$$

In other words, we can add two angular velocities together using vector arithmetic and get a new, and correct, angular velocity.

Combining angular velocities is all very well, but we'll also need to update the orientation by angular velocity. For linear updates, we use the following formula:

$$\boldsymbol{p}' = \boldsymbol{p} + \dot{\boldsymbol{p}}t$$

We need some way to do the same for orientation and angular velocity, that is, to update a quaternion by a vector and a time. The equivalent formula is not much more complex:

$$\underset{\wedge}{\theta}' = \underset{\wedge}{\theta} + \frac{\Delta t}{2} \underset{\wedge}{\omega} \underset{\wedge}{\theta} \tag{9.5}$$

where

$$\underset{\wedge}{\omega} = \begin{bmatrix} 0 \\ \dot{\theta}_x \\ \dot{\theta}_y \\ \dot{\theta}_z \end{bmatrix}$$

which is a quaternion constructed from the angular velocity.

The angular velocity quaternion, ω, has a zero w component, and the remaining components taken directly from the three components of the angular velocity vector. It doesn't represent an orientation, so it shouldn't be normalized.

Note in Equation 9.5 that the multiplication (between ω and θ) is a quaternion multiplication, not a vector multiplication.

9.3.1 VELOCITY OF A POINT

In Section 9.1.3, we calculated the position of part of an object even when it had been moved and rotated. To process collisions between objects in Chapter 14 we'll also need to be able to calculate the velocity of any point of an object.

The velocity of a point on an object depends on both its linear and angular velocity:

$$\dot{q} = \dot{\theta} \times (q - p) + \dot{p} \qquad [9.6]$$

where \dot{q} is the velocity of the point, q is the position of the point in world coordinates, p is the position of the origin of the object, and $\dot{\theta}$ is the angular velocity of the object.

If we want to calculate the velocity of a known point on the object (the mirror on the side of a car, for example), we can calculate q from Equation 9.2.

9.3.2 ANGULAR ACCELERATION

Because angular acceleration is simply the first derivative of angular velocity, we can use the same vector representation in both acceleration and velocity. What is more, the relationships between them remain the same as for linear velocity and acceleration. In particular, we can update the angular velocity using the following equation:

$$\dot{\theta}' = \dot{\theta} + \ddot{\theta} t$$

where $\ddot{\theta}$ is the angular acceleration and $\dot{\theta}$ is the angular velocity, as before.

9.4 IMPLEMENTING THE MATHEMATICS

We've covered the theory. Now it's time to implement functions and data structures that are capable of performing the right mathematics. In Chapter 2, we created a Vector3 class that encapsulated vector mathematics; we'll now do the same thing for matrices and for quaternions. As part of this process, I'll introduce the mathematics of many operations for each type.

If you are working with an existing rendering library, you may already have matrix, vector, and quaternion classes implemented. There is nothing physics-specific in the implementations I give here. You should be able to use your own implementations

without alteration. I've personally worked with the DirectX utility library implementations on many projects without having to make any changes to the rest of the physics code.

9.4.1 THE MATRIX CLASSES

A matrix is a rectangular array of scalar values. They don't have the same obvious geometric interpretation as vectors did. We will use them in several different contexts, but in each case they will be used to change (transform) vectors.

Although matrices can be any size with any number of rows and columns, we will be primarily interested in two kinds: 3×3 matrices and 3×4 matrices. To implement matrices we could create a general matrix data structure, capable of supporting any number of rows and columns. We could implement matrix mathematics in the most general way, and use the same code for both of our matrix types (and other types of matrices we might need later). While this would be an acceptable strategy, having the extra flexibility is difficult to optimize. It would be better to create specific data structures for the types of matrices we need. This will be our approach.

We will create a data structure called `Matrix3` for 3×3 matrices, and `Matrix4` for 3×4 matrices.

The basic data structure for `Matrix3` looks like this:

```
────────── Excerpt from file include/cyclone/core.h ──────────
/**
 * Holds a 3 x 3 row major matrix representing a transformation in
 * 3D space that does not include a translational component. This
 * matrix is not padded to produce an aligned structure.
 */
class Matrix3
{
public:
    /**
     * Holds the tensor matrix data in array form.
     */
    real data[9];
};
```

The `Matrix4` data structure looks like this:

```
────────── Excerpt from file include/cyclone/core.h ──────────
/**
 * Holds a transform matrix, consisting of a rotation matrix and
 * a position. The matrix has 12 elements, and it is assumed that the
 * remaining four are (0,0,0,1), producing a homogenous matrix.
```

```
 */
class Matrix4
{
public:
    /**
     * Holds the transform matrix data in array form.
     */
    real data[12];
};
```

If you are used to other engines or math libraries, you may find it odd that I've defined a 3×4 rather than a 4×4 matrix. It is true that most libraries (including most rendering libraries) use 4×4 matrices. We could use a 4×4 matrix in our physics engine, but we'd need to change our position vectors to four-element vectors and the bottom row of our 4×4 matrices would always contain the same values. The reason for this isn't obvious, and I'll return to it in more detail when I describe homogeneous coordinates in Section 9.4.2.

I hope you'll agree there is nothing taxing in the implementations so far; we have only two arrays of numbers.

Just as we did for the Vector3 class in Chapter 2, we can add methods to these classes to implement their mathematics.

9.4.2 Matrix Multiplication

Since I've said that matrices exist mainly to transform vectors, let's look at this first. We transform a vector by multiplying it by the matrix

$$v' = Mv$$

which is often called post-multiplication, because the vector occurs after the matrix in the multiplication.

Matrix multiplication works in the same way whether we are multiplying two matrices or a matrix and a vector. In fact, we can think of a vector as simply a matrix with a single column, that is, a 3×1 matrix.

It is important to realize that matrix multiplication of all kinds is not commutative; in general, $ab \neq ba$. In particular, to multiply two matrices, the number of columns in the first matrix needs to be the same as the number of rows in the second. So if we wanted to do

$$vM$$

where M is a 3×3 matrix and v is a three-element vector, we would have a mismatch. The vector has one column, and the matrix has three rows. We cannot perform this multiplication, as it is undefined. Some game engines do use a pre-multiplication

scheme, but they do so by treating vectors as having one row and three columns, as in

$$\begin{bmatrix} x & y & z \end{bmatrix}$$

rather than the column form we have used. With a row vector we can perform pre-multiplication, but not post-multiplication. Confusingly, I have also seen pre-multiplication mathematics written with the vector after the matrix (i.e., a matrix and then a row vector), so it's worth taking care if you are liaising with existing code. I will use post-multiplication and column vectors exclusively in this book. If you are working with an engine that uses pre-multiplication, you will have to adapt the order in your code accordingly.

The result of matrix multiplication is a new matrix with the same number of rows as the first matrix in the multiplication, and the same number of columns as the second. So if we multiply a 3 × 3 matrix by a 3 × 1 vector, we get a matrix with 3 rows and 1 column (i.e., another 3 × 1 vector). If we multiply a 3 × 3 matrix by another 3 × 3 matrix, we end up with a 3 × 3 matrix.

If we multiply matrices A and B to give matrix C, each element in C is found by the formula:

$$C_{(i,j)} = \sum_k A_{(i,k)} B_{(k,j)}$$

where $C_{(i,j)}$ is the entry in matrix C at the i-th row and j-th column, and where k ranges up to the number of columns in the first matrix (i.e., the number of rows in the second—this is why they need to be the same).

For a 3 × 3 matrix multiplied by a vector, we get:

$$\begin{bmatrix} a & b & c \\ d & e & f \\ g & h & i \end{bmatrix} \begin{bmatrix} x \\ y \\ z \end{bmatrix} = \begin{bmatrix} ax + by + cz \\ dx + ey + fz \\ gx + hy + iz \end{bmatrix}$$

With this result, we can implement multiplication of a vector by a matrix. I have overloaded the * operator for the matrix class to perform the operation.

```
─────────── Excerpt from file include/cyclone/core.h ───────────
class Matrix3
{
    // ... Other Matrix3 code as before ...

    /**
     * Transform the given vector by this matrix.
     */
    Vector3 operator*(const Vector3 &vector) const
    {
        return Vector3(
            vector.x * data[0] + vector.y * data[1] + vector.z * data[2],
            vector.x * data[3] + vector.y * data[4] + vector.z * data[5],
```

```
            vector.x * data[6] + vector.y * data[7] + vector.z * data[8]
        );
    }

    /**
     * Transform the given vector by this matrix.
     */
    Vector3 transform(const Vector3 &vector) const
    {
        return (*this) * vector;
    }
};
```

Matrices as Transformations

Earlier in the chapter, I talked about using matrices to represent orientations. In fact, matrices can represent all kinds of transformations: rotations, scaling, sheering, and any combination of these.

The elements of the matrix control the transformation being performed, and it is worth getting to know how they do it.

We can think of the matrix

$$\begin{bmatrix} a & b & c \\ d & e & f \\ g & h & i \end{bmatrix}$$

as being made up of three vectors:

$$\begin{bmatrix} a \\ d \\ g \end{bmatrix}, \begin{bmatrix} b \\ e \\ h \end{bmatrix}, \text{and} \begin{bmatrix} c \\ f \\ i \end{bmatrix}$$

These three vectors represent where each of the three main axes X, Y, and Z will end up pointing after the transformation. For example, if we have a vector pointing along the positive X axis

$$\begin{bmatrix} 1 \\ 0 \\ 0 \end{bmatrix}$$

it will be transformed into the vector

$$\begin{bmatrix} a \\ d \\ g \end{bmatrix}$$

which we can verify with the matrix multiplication,

$$\begin{bmatrix} a & b & c \\ d & e & f \\ g & h & i \end{bmatrix} \begin{bmatrix} 1 \\ 0 \\ 0 \end{bmatrix} = \begin{bmatrix} a \times 1 + b \times 0 + c \times 0 \\ d \times 1 + e \times 0 + f \times 0 \\ g \times 1 + h \times 0 + i \times 0 \end{bmatrix} = \begin{bmatrix} a \\ d \\ g \end{bmatrix}$$

and so on for the other two axes. When I introduced vectors, I mentioned that their three components could be thought of as a position along three axes. The x component is the distance along the X axis and so on. We could write the vector as

$$\boldsymbol{v} = \begin{bmatrix} x \\ y \\ z \end{bmatrix} = x \begin{bmatrix} 1 \\ 0 \\ 0 \end{bmatrix} + y \begin{bmatrix} 0 \\ 1 \\ 0 \end{bmatrix} + z \begin{bmatrix} 0 \\ 0 \\ 1 \end{bmatrix}$$

In other words, a vector is made up of some proportion of each basic axis.

If the three axes move under a transformation, then the new location of the vector will be determined in the same way as before. The axes will have moved but the new vector will still combine them in the same proportions:

$$\boldsymbol{v}' = x \begin{bmatrix} a \\ d \\ g \end{bmatrix} + y \begin{bmatrix} b \\ e \\ h \end{bmatrix} + z \begin{bmatrix} c \\ f \\ i \end{bmatrix} = \begin{bmatrix} ax + by + cz \\ dx + ey + fz \\ gx + hy + iz \end{bmatrix}$$

Thinking about matrix transformations as a change of axis is an important visualization tool.

The set of axes is called a basis: we looked at orthonormal bases in Chapter 2, where the axes all have a length of 1 and are at right angles to one another. A 3×3 matrix will transform a vector from one basis to another. This is sometimes, not surprisingly, called a "change of basis."

Thinking back to the rotation matrices in Section 9.1.3, we saw how the position of a headlight on a car could be converted into a position in the game level. This is a change of basis. We start with the local coordinates of the headlight relative to the origin of the car, and end up with the world coordinates of the headlight in the game. We've moved from a basis where the Z axis is along the car and the X axis is across its width, to a basis where the X, Y, and Z axes are defined globally.

In the headlight example, we had two stages: first, we rotated the object (using a matrix multiplication, a change of basis), and then we translated it (by adding an offset vector). If we extend our matrices a little, we can perform both steps in one go. This is the purpose of the 3×4 matrix.

Three-by-Four Matrices

If you are thinking ahead you may have noticed that according to the matrix multiplication rules, we can't multiply a 3×4 matrix by a 3×1 vector. In fact, we want to end up doing just this, but to understand how, we need to look more closely at what the 3×4 matrix will be used for.

In the previous section, we looked at transformation matrices. The transformations that can be represented as a 3×3 matrix all keep the origin at the same place. To handle general combinations of movement and rotation in our game, we need to be able to move the origin around: there is no use modeling a car if it is stuck with its origin at the origin of the game level. We could do this as a two-stage process comprising a rotation matrix multiplication and then adding an offset vector. A better alternative is to extend our matrices and do it in one step.

First, we extend our vector by one element, so we have four elements, where the last element is always 1:

$$\begin{bmatrix} x \\ y \\ z \\ 1 \end{bmatrix}$$

The four values in the vector are called "homogeneous" coordinates, and they are used explicitly in a few graphics packages, but are behind the scenes in almost all 3D graphics systems. You can think of them as a four-dimensional coordinate if you like, although thinking in four dimensions probably may not help you visualize what we're doing with them much (it sure doesn't help me).

If we now take a 3×4 matrix,

$$\begin{bmatrix} a & b & c & d \\ e & f & g & h \\ i & j & k & l \end{bmatrix}$$

and multiply it in the normal way by our four-element vector,

$$\begin{bmatrix} a & b & c & d \\ e & f & g & h \\ i & j & k & l \end{bmatrix} \begin{bmatrix} x \\ y \\ z \\ 1 \end{bmatrix} = \begin{bmatrix} ax + by + cz + d \\ ex + fy + gz + h \\ ix + jy + kz + l \end{bmatrix} \qquad [9.7]$$

we get a combination of two effects. It is as if we had first multiplied by the 3×3 matrix,

$$\begin{bmatrix} a & b & c \\ e & f & g \\ i & j & k \end{bmatrix} \begin{bmatrix} x \\ y \\ z \end{bmatrix} = \begin{bmatrix} ax + by + cz \\ ex + fy + gz \\ ix + jy + kz \end{bmatrix}$$

and then added the vector,

$$\begin{bmatrix} ax + by + cz \\ ex + fy + gz \\ ix + jy + kz \end{bmatrix} + \begin{bmatrix} d \\ h \\ i \end{bmatrix} = \begin{bmatrix} ax + by + cz + d \\ ex + fy + gz + h \\ ix + jy + kz + l \end{bmatrix}$$

which is exactly the transform-then-move process we had before, but all in one step. If the first three columns give the directions of the three axes in the new basis, the fourth column gives us the new position of the origin.

We could also view this as multiplying a 4×4 matrix by the 1×4 vector:

$$
\begin{bmatrix} a & b & c & d \\ e & f & g & h \\ i & j & k & l \\ 0 & 0 & 0 & 1 \end{bmatrix}
\begin{bmatrix} x \\ y \\ z \\ 1 \end{bmatrix}
=
\begin{bmatrix} ax + by + cz + d \\ ex + fy + gz + h \\ ix + jy + kz + l \\ 1 \end{bmatrix}
$$

In other words, we start and end with a homogeneous coordinate. Because we are not interested in four-dimensional coordinates, the bottom row of the matrix is always $[0\ 0\ 0\ 1]$ and the last value in the vector is always 1. We can therefore use just the version given in Equation 9.7, and make the fourth value in the multiplied vector (the 1) magically appear as needed. We don't need to store it in the Vector3 class.

The matrix–vector multiplication gets implemented in the Matrix4 class as follows:

```
————————————— Excerpt from file include/cyclone/core.h —————————————
class Matrix4
{
    // ... Other Matrix4 code as before ...

    /**
     * Transform the given vector by this matrix.
     */
    Vector3 operator*(const Vector3 &vector) const
    {
        return Vector3(
            vector.x * data[0] +
            vector.y * data[1] +
            vector.z * data[2] + data[3],

            vector.x * data[4] +
            vector.y * data[5] +
            vector.z * data[6] + data[7],

            vector.x * data[8] +
            vector.y * data[9] +
            vector.z * data[10] + data[11]
        );
    }

    /**
```

```
    * Transform the given vector by this matrix.
    */
   Vector3 transform(const Vector3 &vector) const
   {
       return (*this) * vector;
   }
};
```

Multiplying Two Matrices

We can use exactly the same process to multiply two matrices. If we multiply two 3×3 matrices, we get another 3×3 matrix. This can be easily done with the following code:

```
——————————— Excerpt from file include/cyclone/core.h ———————————
class Matrix3
{
    // ... Other Matrix3 code as before ...

    /**
     * Returns a matrix, which is this one multiplied by the other given
     * matrix.
     */
    Matrix3 operator*(const Matrix3 &o) const
    {
        return Matrix3(
            data[0]*o.data[0] + data[1]*o.data[3] + data[2]*o.data[6],
            data[0]*o.data[1] + data[1]*o.data[4] + data[2]*o.data[7],
            data[0]*o.data[2] + data[1]*o.data[5] + data[2]*o.data[8],

            data[3]*o.data[0] + data[4]*o.data[3] + data[5]*o.data[6],
            data[3]*o.data[1] + data[4]*o.data[4] + data[5]*o.data[7],
            data[3]*o.data[2] + data[4]*o.data[5] + data[5]*o.data[8],

            data[6]*o.data[0] + data[7]*o.data[3] + data[8]*o.data[6],
            data[6]*o.data[1] + data[7]*o.data[4] + data[8]*o.data[7],
            data[6]*o.data[2] + data[7]*o.data[5] + data[8]*o.data[8]
            );
    }

    /**
     * Multiplies this matrix in place by the other given matrix.
     */
    void operator*=(const Matrix3 &o)
```

```
{
    real t1;
    real t2;
    real t3;

    t1 = data[0]*o.data[0] + data[1]*o.data[3] + data[2]*o.data[6];
    t2 = data[0]*o.data[1] + data[1]*o.data[4] + data[2]*o.data[7];
    t3 = data[0]*o.data[2] + data[1]*o.data[5] + data[2]*o.data[8];
    data[0] = t1;
    data[1] = t2;
    data[2] = t3;

    t1 = data[3]*o.data[0] + data[4]*o.data[3] + data[5]*o.data[6];
    t2 = data[3]*o.data[1] + data[4]*o.data[4] + data[5]*o.data[7];
    t3 = data[3]*o.data[2] + data[4]*o.data[5] + data[5]*o.data[8];
    data[3] = t1;
    data[4] = t2;
    data[5] = t3;

    t1 = data[6]*o.data[0] + data[7]*o.data[3] + data[8]*o.data[6];
    t2 = data[6]*o.data[1] + data[7]*o.data[4] + data[8]*o.data[7];
    t3 = data[6]*o.data[2] + data[7]*o.data[5] + data[8]*o.data[8];
    data[6] = t1;
    data[7] = t2;
    data[8] = t3;
}
};
```

Multiplying two matrices together in this way combines their effects. If matrices A and B are both transformations, then the matrix AB will represent the combined transformation. Order is crucial for both transformation and matrix multiplication: the matrix AB is a transformation that would result from *first* doing B, *then* doing A. In other words, the order of the transformations is the opposite of the order of the matrices in the multiplication. This is a gotcha that catches out even experienced developers from time to time.

So much for 3×3 matrices. How about for 3×4 matrices? From the rules of matrix multiplication, we can't multiply two 3×4 matrices together: the columns of the first matrix don't match the rows of the second. To make progress, we need to return to the full form of our 4×4 matrix. Remember that the matrix we are storing as

$$\begin{bmatrix} a & b & c & d \\ e & f & g & h \\ i & j & k & l \end{bmatrix}$$

is shorthand for

$$\begin{bmatrix} a & b & c & d \\ e & f & g & h \\ i & j & k & l \\ 0 & 0 & 0 & 1 \end{bmatrix}$$

We can certainly multiply two 4×4 matrices together. If we multiply two 4×4 matrices with $[0\ \ 0\ \ 0\ \ 1]$ as their bottom line, we end up with another matrix whose bottom line is $[0\ \ 0\ \ 0\ \ 1]$.

So in our code, when we come to multiply together two 3×4 matrices (to combine their transformations), we magically make the extra values appear, without storing them, exactly as we did for transforming vectors. The code looks like this:

───────── **Excerpt from file `include/cyclone/core.h`** ─────────

```
class Matrix4
{
    // ... Other Matrix4 code as before ...

    /**
     * Returns a matrix, which is this one multiplied by the other given
     * matrix.
     */
    Matrix4 operator*(const Matrix4 &o) const
    {
        Matrix4 result;
        result.data[0] = o.data[0]*data[0] + o.data[4]*data[1] +
                         o.data[8]*data[2];
        result.data[4] = o.data[0]*data[4] + o.data[4]*data[5] +
                         o.data[8]*data[6];
        result.data[8] = o.data[0]*data[8] + o.data[4]*data[9] +
                         o.data[8]*data[10];

        result.data[1] = o.data[1]*data[0] + o.data[5]*data[1] +
                         o.data[9]*data[2];
        result.data[5] = o.data[1]*data[4] + o.data[5]*data[5] +
                         o.data[9]*data[6];
        result.data[9] = o.data[1]*data[8] + o.data[5]*data[9] +
                         o.data[9]*data[10];

        result.data[2] = o.data[2]*data[0] + o.data[6]*data[1] +
                         o.data[10]*data[2];
        result.data[6] = o.data[2]*data[4] + o.data[6]*data[5] +
                         o.data[10]*data[6];
```

```
            result.data[10] = o.data[2]*data[8] + o.data[6]*data[9] +
                              o.data[10]*data[10];

            result.data[3] = o.data[3]*data[0] + o.data[7]*data[1] +
                              o.data[11]*data[2] + data[3];
            result.data[7] = o.data[3]*data[4] + o.data[7]*data[5] +
                              o.data[11]*data[6] + data[7];
            result.data[11] = o.data[3]*data[8] + o.data[7]*data[9] +
                              o.data[11]*data[10] + data[11];

            return result;
        }
    };
```

Some graphics libraries use a full 16-element matrix for transforms; most of those (but not all) will also use four-element vectors for position. They allow the programmer to work in four dimensions: there are some interesting graphical effects that are made possible this way, including the perspective transformations needed to model a camera. If you are relying on the mathematics libraries that these APIs provide, you will not need to worry about the number of entries in the matrix: chances are you'll only be using the first 12 for your physics development, but the other four won't harm you. If you are implementing the mathematics classes as I have been, then you have the choice of whether to use the full 4×4 or the optimized 3×4 matrix.

We added an extra padding element to our vector class, so that it sits nicely on machines with 128-bit math processors and 16-byte alignment. We don't need to do the same for matrices; since each row of the matrix is 16 bytes long (assuming we're using 32-bit, floating-point numbers; running this at double precision will be much slower in any case), the entire matrix will also be word aligned.

The code will take less memory if you use 3×4 matrices, and rely on the last unstored line of every matrix being [0 0 0 1]. But check whether the machine you are developing has built-in hardware-level support for matrix transformation; implementing your own routines and ignoring these will give worse performance (and take more effort) in the long run.

9.4.3 MATRIX INVERSE AND TRANSPOSE

A matrix represents a transformation, and we often need to find out how to reverse the transformation. If we have a matrix that transforms from an object's local coordinates to world coordinates, it will be useful to be able to create a matrix that gets us back again, that is, transforming world coordinates to local coordinates.

For example, if we determine that our car has collided with a barrier, our collision detector might tell us the position of the collision in world coordinates. We'd like to be able to turn this position into local coordinates to see which bit of the car got hit.

If a matrix transforms vectors from one basis to another, then the inverse of the matrix can convert them back. If we combine a matrix with its inverse, we get the *identity matrix*, a matrix representing a transformation that has no effect. In other words, if we transform a vector by a matrix, then by its inverse, we get back to where we started:

$$M^{-1}M = I$$

For a 3×3 matrix, the identity matrix is

$$I = \begin{bmatrix} 1 & 0 & 0 \\ 0 & 1 & 0 \\ 0 & 0 & 1 \end{bmatrix}$$

Inverting large matrices is a challenging computer science problem (in fact, it is the fundamental problem that the most complex game physics engines try to solve, as we'll see in Chapter 20). Techniques involve walking through the matrix and rearranging its elements using a range of mathematical manipulations. Fortunately, for 3×3 and 4×4 matrices, we can write the solutions directly. For a 3×3 matrix,

$$M = \begin{bmatrix} a & b & c \\ d & e & f \\ g & h & i \end{bmatrix}$$

the inverse is

$$M^{-1} = \frac{1}{\det M} \begin{bmatrix} ei - fh & ch - bi & bf - ce \\ fg - di & ai - cg & cd - af \\ dh - eg & bg - ah & ae - bd \end{bmatrix} \qquad [9.8]$$

where $\det M$ is the determinant of the matrix, which for a 3×3 matrix is

$$\det M = aei + dhc + gbf - ahf - gec - dbi$$

Because we take 1 over the determinant in Equation 9.8, the inverse only exists if the determinant is non-zero.

The reason the inverse has the form it does and the meaning of the determinant are beyond the scope of this book.[3] To understand why the equations above

3. A good rule of thumb that I use (which may offend mathematical purists) is to think of the determinant as the "size" of the matrix, or alternatively, the amount of scaling present in the transformation. In fact, for 2×2 dimensional matrices, the determinant is the area of the parallelogram formed from its column vectors, and for a 3×3 matrix it is the area of the parallelepiped formed from its three columns.

The inverse formula of Equation 9.8 can then be thought of as adjusting the elements, and dividing by the size of the matrix (deflating back to the original size). Thinking this way can cause problems with more advanced matrix math, so remember that it's only a mnemonic.

work, we'd need to cover various bits of matrix mathematics that we otherwise
wouldn't need. If you are interested in the features and mathematics of matri-
ces, any undergraduate textbook on matrix analysis will have these details. For an
even more exhaustive (if considerably tougher) reference, I recommend [Horn and
Charles, 1990] and [Horn and Charles, 1994], two highly respected references on the
topic.

We can implement our 3×3 matrix inverse as follows:

```
───────────── Excerpt from file include/cyclone/core.h ─────────────
class Matrix3
{
    // ... Other Matrix3 code as before ...

    /**
     * Sets the matrix to be the inverse of the given matrix.
     */
    void setInverse(const Matrix3 &m)
    {
        real t1 = m.data[0]*m.data[4];
        real t2 = m.data[0]*m.data[5];
        real t3 = m.data[1]*m.data[3];
        real t4 = m.data[2]*m.data[3];
        real t5 = m.data[1]*m.data[6];
        real t6 = m.data[2]*m.data[6];

        // Calculate the determinant.
        real det = (t1*m.data[8] - t2*m.data[7] - t3*m.data[8]+
                    t4*m.data[7] + t5*m.data[5] - t6*m.data[4]);

        // Make sure the determinant is non-zero.
        if (det == (real)0.0f) return;
        real invd = (real)1.0f/det;

        data[0] = (m.data[4]*m.data[8]-m.data[5]*m.data[7])*invd;
        data[1] = -(m.data[1]*m.data[8]-m.data[2]*m.data[7])*invd;
        data[2] = (m.data[1]*m.data[5]-m.data[2]*m.data[4])*invd;
        data[3] = -(m.data[3]*m.data[8]-m.data[5]*m.data[6])*invd;
        data[4] = (m.data[0]*m.data[8]-t6)*invd;
        data[5] = -(t2-t4)*invd;
        data[6] = (m.data[3]*m.data[7]-m.data[4]*m.data[6])*invd;
        data[7] = -(m.data[0]*m.data[7]-t5)*invd;
        data[8] = (t1-t3)*invd;
    }
```

```
    /** Returns a new matrix containing the inverse of this matrix. */
    Matrix3 inverse() const
    {
        Matrix3 result;
        result.setInverse(*this);
        return result;
    }

    /**
     * Inverts the matrix.
     */
    void invert()
    {
        setInverse(*this);
    }
};
```

Only square matrices have an inverse. For a 3×4 matrix, we need to again remember that our matrix is shorthand for a 4×4 matrix. The 4×4 matrix has an inverse that can be written in much the same way as the 3×3 matrix. And the resulting matrix will have a bottom row of [0 0 0 1], so we can represent the inverse as a 3×4 matrix.

Unfortunately, the algebra is much more complex than the 3×3 case, and it would run to about a page of equations. Assuming your aim is to implement the code, I'll skip the algebra and give the implementation:

Excerpt from file `include/cyclone/core.h`

```
class Matrix4
{
    // ... Other Matrix4 code as before ...

    /**
     * Returns the determinant of the matrix.
     */
    real getDeterminant() const;

    /**
     * Sets the matrix to be the inverse of the given matrix.
     */
    void setInverse(const Matrix4 &m);

    /** Returns a new matrix containing the inverse of this matrix. */
```

```
    Matrix4 inverse() const
    {
        Matrix4 result;
        result.setInverse(*this);
        return result;
    }

    /**
     * Inverts the matrix.
     */
    void invert()
    {
        setInverse(*this);
    }
};
```

```
                          ─── Excerpt from file src/core.cpp ───
real Matrix4::getDeterminant() const
{
    return data[8]*data[5]*data[2]+
        data[4]*data[9]*data[2]+
        data[8]*data[1]*data[6]-
        data[0]*data[9]*data[6]-
        data[4]*data[1]*data[10]+
        data[0]*data[5]*data[10];
}

void Matrix4::setInverse(const Matrix4 &m)
{
    // Make sure the determinant is non-zero.
    real det = getDeterminant();
    if (det == 0) return;
    det = ((real)1.0f)/det;

    data[0] = (-m.data[9]*m.data[6]+m.data[5]*m.data[10])*det;
    data[4] = (m.data[8]*m.data[6]-m.data[4]*m.data[10])*det;
    data[8] = (-m.data[8]*m.data[5]+m.data[4]*m.data[9]*m.data[15])*det;

    data[1] = (m.data[9]*m.data[2]-m.data[1]*m.data[10])*det;
    data[5] = (-m.data[8]*m.data[2]+m.data[0]*m.data[10])*det;
    data[9] = (m.data[8]*m.data[1]-m.data[0]*m.data[9]*m.data[15])*det;

    data[2] = (-m.data[5]*m.data[2]+m.data[1]*m.data[6]*m.data[15])*det;
```

```
    data[6] = (+m.data[4]*m.data[2]-m.data[0]*m.data[6]*m.data[15])*det;
    data[10] = (-m.data[4]*m.data[1]+m.data[0]*m.data[5]*m.data[15])*det;

    data[3] = (m.data[9]*m.data[6]*m.data[3]
              -m.data[5]*m.data[10]*m.data[3]
              -m.data[9]*m.data[2]*m.data[7]
              +m.data[1]*m.data[10]*m.data[7]
              +m.data[5]*m.data[2]*m.data[11]
              -m.data[1]*m.data[6]*m.data[11])*det;
    data[7] = (-m.data[8]*m.data[6]*m.data[3]
              +m.data[4]*m.data[10]*m.data[3]
              +m.data[8]*m.data[2]*m.data[7]
              -m.data[0]*m.data[10]*m.data[7]
              -m.data[4]*m.data[2]*m.data[11]
              +m.data[0]*m.data[6]*m.data[11])*det;
    data[11] =(m.data[8]*m.data[5]*m.data[3]
              -m.data[4]*m.data[9]*m.data[3]
              -m.data[8]*m.data[1]*m.data[7]
              +m.data[0]*m.data[9]*m.data[7]
              +m.data[4]*m.data[1]*m.data[11]
              -m.data[0]*m.data[5]*m.data[11])*det;
}
```

You'll note from this code that the inverse again exists only when the determinant of the matrix is non-zero.

The Matrix Transpose

Whenever the determinant is non-zero, we can always use the previous equations to find the inverse of a matrix. It is not the simplest process, however, and in some cases we can do much better.

If we have a matrix that represents a rotation only, we can make use of the fact that the inverse of the transformation is another rotation, about the same axis but the opposite angle. This is equivalent to inverting the axis, and using the same angle. We can create a matrix that rotates the same degree in the opposite direction by transposing the original matrix.

The transpose of a matrix,

$$M = \begin{bmatrix} a & b & c \\ d & e & f \\ g & h & i \end{bmatrix}$$

is made by swapping its rows and columns:

$$M^\top = \begin{bmatrix} a & d & g \\ b & e & h \\ c & f & i \end{bmatrix}$$

If M is a rotation matrix, then

$$M^\top = M^{-1}$$

We can implement this for our 3×3 matrix in the following way:

─────── **Excerpt from file include/cyclone/core.h** ───────

```
class Matrix3
{
    // ... Other Matrix3 code as before ...

    /**
     * Sets the matrix to be the transpose of the given matrix.
     */
    void setTranspose(const Matrix3 &m)
    {
        data[0] = m.data[0];
        data[1] = m.data[3];
        data[2] = m.data[6];
        data[3] = m.data[1];
        data[4] = m.data[4];
        data[5] = m.data[7];
        data[6] = m.data[2];
        data[7] = m.data[5];
        data[8] = m.data[8];
    }

    /** Returns a new matrix containing the transpose of this matrix. */
    Matrix3 transpose() const
    {
        Matrix3 result;
        result.setTranspose(*this);
        return result;
    }
};
```

It will be useful at several points in the engine to transpose rather than request a full inverse when we know the matrix is a rotation matrix only.

There is no point implementing a transpose function for the 3×4 matrix. It doesn't have a geometric correlate, as transposing a homogeneous matrix doesn't make sense geometrically. If there is any non-zero element in the fourth column, then it will be transposed into the fourth row, which we don't have in our matrix.

This makes sense: we will only use transposition to do cheap inverses on rotation matrices; if the 3×4 matrix were a pure rotation matrix with no translation, then it would have zeros in its fourth column. If this were the case, we could represent it as a 3×3 matrix.

There are other reasons to transpose a matrix, outside of our needs. If you are working with an existing matrix library with a full 4×4 matrix implementation, it is likely to have a transpose function.

9.4.4 CONVERTING A QUATERNION TO A MATRIX

In addition to the matrix manipulation above, we'll need an operation to convert a quaternion into a matrix. Your graphics engine is likely to need transformations expressed as a matrix, so in order to draw an object, we'll need to convert from its position vector and orientation quaternion into a transform matrix for rendering.

Sometimes we'll want just the rotation matrix in its 3×3 matrix form, and other times we'll want the full 3×4 transformation matrix.

In each case, the conversion from a quaternion to a matrix uses the results we saw in Sections 9.2.3 and 9.2.4, where both the quaternion and rotation matrix were expressed in terms of an axis and angle. We could reconstruct the axis and angle from the quaternion, and then feed it into Equation 9.3. If we do this, we find that the resulting expression simplifies into a matrix purely in terms of the coefficients of the quaternion,

$$\Theta = \begin{bmatrix} 1 - (2y^2 + 2z^2) & 2xy + 2zw & 2xz - 2yw \\ 2xy - 2zw & 1 - (2x^2 + 2z^2) & 2yz + 2xw \\ 2xz + 2yw & 2yz - 2xw & 1 - (2x^2 + 2y^2) \end{bmatrix}$$

where w, x, y, and z are the components of the quaternion

$$\theta = \begin{bmatrix} w \\ x \\ y \\ z \end{bmatrix}$$

When implemented, the 3×3 version including rotation only requires this step. The code looks like this:

─────── **Excerpt from file include/cyclone/core.h** ───────

```
class Matrix3
{
    // ... Other Matrix3 code as before ...
```

```
    /**
     * Sets this matrix to be the rotation matrix corresponding to
     * the given quaternion.
     */
    void setOrientation(const Quaternion &q)
    {
        data[0] = 1 - (2*q.j*q.j + 2*q.k*q.k);
        data[1] = 2*q.i*q.j + 2*q.k*q.r;
        data[2] = 2*q.i*q.k - 2*q.j*q.r;
        data[3] = 2*q.i*q.j - 2*q.k*q.r;
        data[4] = 1 - (2*q.i*q.i  + 2*q.k*q.k);
        data[5] = 2*q.j*q.k + 2*q.i*q.r;
        data[6] = 2*q.i*q.k + 2*q.j*q.r;
        data[7] = 2*q.j*q.k - 2*q.i*q.r;
        data[8] = 1 - (2*q.i*q.i  + 2*q.j*q.j);
    }
};
```

The 3 × 4 version, adding position to the rotation, looks like this:

```
————————————— Excerpt from file include/cyclone/core.h —————————————
class Matrix4
{
    // ... Other Matrix4 code as before ...

    /**
     * Sets this matrix to be the rotation matrix corresponding to
     * the given quaternion.
     */
    void setOrientationAndPos(const Quaternion &q, const Vector3 &pos)
    {
        data[0] = 1 - (2*q.j*q.j + 2*q.k*q.k);
        data[1] = 2*q.i*q.j + 2*q.k*q.r;
        data[2] = 2*q.i*q.k - 2*q.j*q.r;
        data[3] = pos.x;

        data[4] = 2*q.i*q.j - 2*q.k*q.r;
        data[5] = 1 - (2*q.i*q.i  + 2*q.k*q.k);
        data[6] = 2*q.j*q.k + 2*q.i*q.r;
        data[7] = pos.y;

        data[8] = 2*q.i*q.k + 2*q.j*q.r;
```

```
        data[9] = 2*q.j*q.k - 2*q.i*q.r;
        data[10] = 1 - (2*q.i*q.i  + 2*q.j*q.j);
        data[11] = pos.z;
    }
};
```

9.4.5 TRANSFORMING VECTORS

In Section 9.1.3, we looked at finding the position of part of an object, even when the object had been moved and rotated. This is a conversion between object coordinates (i.e., the position of the part relative to the origin of the object and its axes) and world coordinates (its position relative to the global origin and axes directions).

This conversion can be performed by multiplying the local coordinates by the object's transform matrix. The transform matrix, in turn, can be generated from the quaternion and position as we saw above. We end up with a 3×4 transform matrix. Working out the world coordinates given local coordinates and a transform matrix is a matter of simply multiplying the vector by the matrix:

```
Vector3 localToWorld(const Vector3 &local, const Matrix4 &transform)
{
    return transform.transform(local);
}
```

The opposite transform, from world coordinates to local coordinates, involves the same process, but using the inverse of the transform matrix. The inverse does the opposite of the original matrix, as it converts world coordinates into local coordinates.

```
Vector3 worldToLocal(const Vector3 &world, const Matrix4 &transform)
{
    Matrix4 inverseTransform;
    inverseTransform.setInverse(transform);

    return inverseTransform.transform(world);
}
```

We can simplify this code to perform the inverse and transform in a single step. If the transform matrix is made up of only a rotation and a translation (as it should be for our needs), the resulting code is simple and efficient.

First, we split the 3×4 matrix into two components—the translation vector (i.e., the fourth column of the matrix) and the 3×3 rotation matrix. Next, we perform

the inverse translation by simply subtracting the translation vector. Finally, we make use of the fact that the inverse of a 3×3 rotation matrix is simply its transpose, and multiply by the transpose. This can be done in a method that looks like this:

```
──────────────── Excerpt from file include/cyclone/core.h ────────────────
class Matrix4
{
    // ... Other Matrix4 code as before ...

    /**
     * Transform the given vector by the transformational inverse
     * of this matrix.
     */
    Vector3 transformInverse(const Vector3 &vector) const
    {
        Vector3 tmp = vector;
        tmp.x -= data[3];
        tmp.y -= data[7];
        tmp.z -= data[11];
        return Vector3(
            tmp.x * data[0] +
            tmp.y * data[4] +
            tmp.z * data[8],

            tmp.x * data[1] +
            tmp.y * data[5] +
            tmp.z * data[9],

            tmp.x * data[2] +
            tmp.y * data[6] +
            tmp.z * data[10]
        );
    }
};
```

which is called as follows:

```
Vector3 worldToLocal(const Vector3 &world, const Matrix4 &transform)
{
    return transform.transformInverse(world);
}
```

In Chapter 2, we saw that vectors can represent both positions and directions. This is a significant distinction when it comes to transforming vectors. So far we have looked at vectors representing positions. In this case, converting between local and object coordinates is a matter of multiplying by the transform matrix, as we have seen.

For direction vectors, however, the same is not true. If we start with a direction vector in object space, for example, the Z-axis direction vector

$$\begin{bmatrix} 0 \\ 0 \\ 1 \end{bmatrix}$$

and we multiply it by a transformation matrix, for example, the translation only

$$\begin{bmatrix} 1\ 0\ 0\ 1 \\ 0\ 1\ 0\ 0 \\ 0\ 0\ 1\ 0 \end{bmatrix}$$

we end up with a direction vector of

$$\begin{bmatrix} 1 \\ 0 \\ 1 \end{bmatrix}$$

Clearly, converting the local Z-axis direction vector into world coordinates for an object that has no rotation should give us the Z-axis direction vector. Directions should not change magnitude in any case. And if there is no rotation then the directions should not change in any way.

In other words, direction vectors should be immune to any translational component of the transformation matrix. We can do this by only ever multiplying the vector by a 3×3 matrix, which ensures that there is no translational component. Unfortunately, this will be inconvenient at several points, because we will have gone to the trouble of building a 3×4 transform matrix, and it would be a waste to create another matrix just for transforming directions. To solve this, we can add two specialized methods to the Matrix4 class to deal specifically with transforming vectors. One performs the normal transformation (from local to world coordinates), and the other performs the inverse (from world to local coordinates):

```
─────────── Excerpt from file include/cyclone/core.h ───────────
class Matrix4
{
    // ... Other Matrix4 code as before ...

    /**
     * Transform the given direction vector by this matrix.
```

```
    *
    */
   Vector3 transformDirection(const Vector3 &vector) const
   {
       return Vector3(
           vector.x * data[0] +
           vector.y * data[1] +
           vector.z * data[2],

           vector.x * data[4] +
           vector.y * data[5] +
           vector.z * data[6],

           vector.x * data[8] +
           vector.y * data[9] +
           vector.z * data[10]
       );
   }

   /**
    * Transform the given direction vector by the
    * transformational inverse of this matrix.
    */
   Vector3 transformInverseDirection(const Vector3 &vector) const
   {
       return Vector3(
           vector.x * data[0] +
           vector.y * data[4] +
           vector.z * data[8],

           vector.x * data[1] +
           vector.y * data[5] +
           vector.z * data[9],

           vector.x * data[2] +
           vector.y * data[6] +
           vector.z * data[10]
       );
   }
};
```

which can be called in the same way as before, as in

```
Vector3 localToWorldDirn(const Vector3 &local, const Matrix4 &transform)
{
    return transform.transformDirection(local);
}
```

and

```
Vector3 worldToLocalDirn(const Vector3 &world, const Matrix4 &transform)
{
    return transform.transformInverseDirection(world);
}
```

9.4.6 CHANGING THE BASIS OF A MATRIX

There is one final thing we'll need to do with matrices that hasn't been covered yet. Recall that we can think of a transformation matrix as converting between one basis and another, that is, between one set of axes and another. If the transformation is a 3 × 4 matrix, then the change can also involve a shift in the origin. We used this transformation to convert a vector from one basis to another.

We will also meet a situation in which we need to transform an entire matrix from one basis to another. This can be a little more difficult to visualize.

Let's say that we have a matrix M_t that performs some transformation, as shown in the first part of Figure 9.6 (the figure is in 2D for ease of illustration; the same principles apply in 3D). It performs a small rotation around the origin; part A of the figure shows an object being rotated.

Now let's say we have a different basis, but we want exactly the same transformation. In our new basis, we'd like to find a transformation that has the same effect (i.e., leaves the object at the same final position), but works with the new coordinate system. This is shown in part B of the figure: now the origin has moved (we're in a different basis), but we'd like the effect of the transformation to be the same. Clearly, if we applied M_t in the new basis, it would give a different end result.

Let's assume we have a transformation M_b between our original basis \mathcal{B}_1 and our new basis \mathcal{B}_2. Is there some way we can create a new transformation from M_t and M_b that would replicate the behavior that M_t gave us in \mathcal{B}_1, but in the new \mathcal{B}_2?

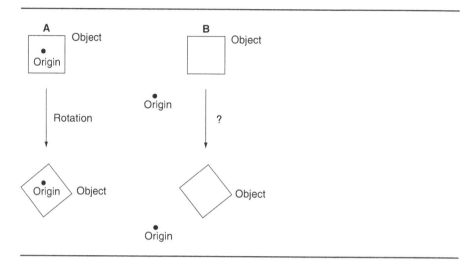

FIGURE 9.6 A matrix basis is changed.

The solution is to use M_b and M_b^{-1} in a three-stage process:

1. We perform the transformation M_b^{-1}, which takes us from \mathcal{B}_2 back into \mathcal{B}_1.

2. We then perform the original transform M_t, since we are now in the basis \mathcal{B}_1, where it was originally correct.

3. We then need to get back into basis \mathcal{B}_2, so we apply transformation M_b.

So we end up with

$$M_t' = M_b M_t M_b^{-1}$$

bearing in mind that multiplied matrices are equivalent to transformations carried out in right-to-left order.

We will need to use this function whenever we have a matrix expressed in one basis and we need it in another. We can do this using the multiplication and inverse functions we have already implemented: there is no need for a specialized function.

In particular, the technique will be indispensable in the next chapter when we come to work with the inertia tensor of a rigid body. At that stage, I will provide a dedicated implementation that takes advantage of some other properties of the inertia tensor to simplify the mathematics.

9.4.7 THE QUATERNION CLASS

We've covered the basic mathematical operations for matrices, and have a solid matrix and vector class implemented. Before we can move on, we also need to create a data structure to manipulate quaternions.

In this section, we will build a Quaternion class. The basic data structure looks like this:

```
                         Excerpt from file include/cyclone/core.h
/**
 * Holds a three-degrees-of-freedom orientation.
 */
class Quaternion
{
public:
    union {
        struct {
            /**
             * Holds the real component of the quaternion.
             */
            real r;

            /**
             * Holds the first complex component of the
             * quaternion.
             */
            real i;

            /**
             * Holds the second complex component of the
             * quaternion.
             */
            real j;

            /**
             * Holds the third complex component of the
             * quaternion.
             */
            real k;
        };

        /**
         * Holds the quaternion data in array form.
         */
        real data[4];
    };
};
```

9.4.8 NORMALIZING QUATERNIONS

As we saw in the earlier discussion, quaternions only represent a rotation if they have a magnitude of 1. All the operations we will be performing keep the magnitude at 1, but numerical inaccuracies and rounding errors can cause this constraint to be violated over time. From time to time, it is a good idea to renormalize the quaternion. We can perform this with the following method:

```
            Excerpt from file include/cyclone/core.h
class Quaternion
{
    // ... Other quaternion code as before ...

    /**
     * Normalizes the quaternion to unit length, making it a valid
     * orientation quaternion.
     */
    void normalize()
    {
        real d = r*r+i*i+j*j+k*k;

        // Check for zero-length quaternion, and use the no-rotation
        // quaternion in that case.
        if (d == 0) {
            r = 1;
            return;
        }

        d = ((real)1.0)/real_sqrt(d);
        r *= d;
        i *= d;
        j *= d;
        k *= d;
    }
};
```

9.4.9 COMBINING QUATERNIONS

We combine two quaternions by multiplying them together. This is exactly the same as for rotation (or any other transformation) matrices. The result of $\hat{q}\hat{p}$ is a rotation that is equivalent to performing rotation \hat{p} first and then \hat{q}.

As we saw in Section 9.2.4, the multiplication of two quaternions has the following form:

$$\begin{bmatrix} w_1 \\ x_1 \\ y_1 \\ z_1 \end{bmatrix} \begin{bmatrix} w_2 \\ x_2 \\ y_2 \\ z_2 \end{bmatrix} = \begin{bmatrix} w_1 w_2 - x_1 x_2 - y_1 y_2 - z_1 z_2 \\ w_1 x_2 + x_1 w_2 + y_1 z_2 - z_1 y_2 \\ w_1 y_2 - x_1 z_2 + y_1 w_2 + z_1 x_2 \\ w_1 z_2 + x_1 y_2 - y_1 x_2 + z_1 w_2 \end{bmatrix}$$

which is implemented as follows:

```
                     ── Excerpt from file include/cyclone/core.h ──
class Quaternion
{
    // ... Other quaternion code as before ...

    /**
     * Multiplies the quaternion by the given quaternion.
     */
    void operator *=(const Quaternion &multiplier)
    {
        Quaternion q = *this;
        r = q.r*multiplier.r - q.i*multiplier.i -
            q.j*multiplier.j - q.k*multiplier.k;
        i = q.r*multiplier.i + q.i*multiplier.r +
            q.j*multiplier.k - q.k*multiplier.j;
        j = q.r*multiplier.j + q.j*multiplier.r +
            q.k*multiplier.i - q.i*multiplier.k;
        k = q.r*multiplier.k + q.k*multiplier.r +
            q.i*multiplier.j - q.j*multiplier.i;
    }
};
```

9.4.10 ROTATING

We occasionally need to rotate a quaternion by some given amount. If a quaternion represents the orientation of an object, and we need to alter that orientation by rotating it, we could convert the orientation and the desired rotation into matrices and multiply them. But there is a more direct way to do this.

The amount of rotation is most simply represented as a scaled vector (since the rotation amount isn't bounded), just as we saw for angular velocity.

We can then alter the quaternion using the equation

$$\hat{\theta}' = \hat{\theta} + \frac{1}{2} \Delta\hat{\theta}\hat{\theta} \tag{9.9}$$

which is similar to the equation we saw in Section 9.3, but replaces velocity \times time with a single absolute angular change (θ).

Here, as in the case of angular velocity, the rotation is provided as a vector, converted into a non-normalized quaternion:

$$\begin{bmatrix} \Delta\theta_x \, \Delta\theta_y \, \Delta\theta_z \end{bmatrix} \rightarrow \begin{bmatrix} 0 \, \Delta\theta_x \, \Delta\theta_y \, \Delta\theta_z \end{bmatrix}$$

This can be implemented as:

―――――――― **Excerpt from file include/cyclone/core.h** ――――――――

```
class Quaternion
{
    // ... Other quaternion code as before ...

    void rotateByVector(const Vector3& vector)
    {
        Quaternion q(0, vector.x, vector.y, vector.z);
        (*this) *= q;
    }
};
```

9.4.11 UPDATING BY THE ANGULAR VELOCITY

The final operation we will need is to update the orientation quaternion by the angular velocity and a time. In Section 9.3, we saw that this is handled by the equation

$$\hat{\theta}' = \hat{\theta} + \frac{\delta t}{2}\hat{\omega}\hat{\theta}$$

where $\hat{\omega}$ is the quaternion form of the angular velocity, and t is the duration to update by. This can be implemented as:

―――――――― **Excerpt from file include/cyclone/core.h** ――――――――

```
class Quaternion
{
    // ... Other quaternion code as before ...

    /**
     * Adds the given vector to this one, scaled by the given amount.
     * This is used to update the orientation quaternion by a rotation
     * and time.
     *
     * @param vector The vector to add.
     *
     * @param scale The amount of the vector to add.
```

```
    */
    void addScaledVector(const Vector3& vector, real scale)
    {
        Quaternion q(0,
            vector.x * scale,
            vector.y * scale,
            vector.z * scale);
        q *= *this;
        r += q.r * ((real)0.5);
        i += q.i * ((real)0.5);
        j += q.j * ((real)0.5);
        k += q.k * ((real)0.5);
    }
};
```

We now have a quaternion class that contains all the functionality we need for the rest of the engine. As with vectors and matrices, there are a lot of other operations we could add: more conversions, other mathematical operators, and utility functions. If you are using an existing quaternion library, it might have many other functions defined, but those presented here are sufficient for our needs.

9.5 SUMMARY

We have come a long way in this chapter, and if you weren't familiar with matrices and quaternions before, then it's been a big step. We've now met all the mathematics we need to see us to our final physics engine at the end of the book.

In this chapter, I've hinted at the way some of this mathematics is used in the engine. Chapter 10 starts to rebuild our engine to support full 3D rigid bodies, with angular as well as linear motion.

9.6 EXERCISES

Exercise 9.1
A rotation about the X axis by 90 degrees, followed by a rotation about the Y axis by 90 degrees is equivalent to a rotation about the Z axis, followed by another about the X axis. About what angles?

Exercise 9.2
Buy yourself a cheap tennis ball or other ball of the same size. Draw six points on the ball: one each for the positive and negative X, Y, and Z axes, arranged in a right-handed basis. Orient the ball along some fixed reference direction (Y pointing up,

Z pointing in the direction you're looking, for example). Now rotate the ball in any way you choose, so that it is in a random orientation. Now rotate the ball about a single axis by placing your fingertips on opposite sides of the ball. You should be able to find one (and only one) such axis that allows you to rotate the ball back to its reference orientation. Pay attention to where the features of the ball began and ended. Can you work out a method for quickly finding the rotation axis needed to return the ball to its original orientation?

Exercise 9.3

(a) Perform the following quaternion multiplication:

$$\begin{bmatrix} r_1 \\ c_1 \\ 0 \\ 0 \end{bmatrix} \times \begin{bmatrix} r_2 \\ c_2 \\ 0 \\ 0 \end{bmatrix}$$

(b) The complex numbers from high school mathematics are of the form $r + ci$. What does the structure of your answer to (a) tell you about the relationship between complex numbers and quaternions?

Exercise 9.4

(a) A rigid body has the orientation quaternion,

$$\begin{bmatrix} \frac{1}{2} \\ \frac{1}{2} \\ \frac{1}{2} \\ \frac{1}{2} \end{bmatrix}$$

and is rotating with angular velocity,

$$\begin{bmatrix} 0 \\ \pi \\ 0 \end{bmatrix}$$

Using your understanding of rotation, what will the orientation of the rigid body be after 2 seconds?

(b) Derive the above result from Equation 9.5.

Exercise 9.5

A non-skewing affine transformation, represented by the 3×4 matrix,

$$\begin{bmatrix} a & b & c & d \\ e & f & g & h \\ i & j & k & l \end{bmatrix} \boldsymbol{p}$$

can be written as a combination of a 3×3 matrix for rotation and a vector addition for translation as follows:

$$\Theta p + t$$

Give the coefficents of Θ and t in terms of the coefficients of the original matrix (i.e., values a through l).

Exercise 9.6
Calculate the inverse of the affine transform matrix from the previous exercise:

$$\begin{bmatrix} a & b & c & d \\ e & f & g & h \\ i & j & k & l \end{bmatrix} p$$

Beware, as there's an easy (but perhaps not obvious) way and a difficult way to attempt this; the hard way will not give the correct result.

Exercise 9.7
Create a box with an unusual mass distribution by taking an empty cardboard box and securely taping small stones to various points on the inside surface. Now determine the center of mass of the box. For each axis of the box (length, width, and depth), find the point where the box balances on a thin pivot, such as a pencil. Mark that point by drawing a band completely around the box in the axis of the pivot. When you've repeated this for all three sides, you should have two lines crossing on each face of the box. The box should balance on a point pivot (such as a pen cap) at these points. Where is the center of mass of the box?

10

LAWS OF MOTION FOR RIGID BODIES

In this chapter we're going to repeat the work we did in Chapters 2, 3, and 5, this time working with rigid bodies rather than particles. We will do this by creating a new class, the RigidBody.

In Section 9.1.3, I mentioned that if an object's origin is placed at its center of mass, then its linear motion will be just like that of a particle. We'll make use of that fact in this chapter. Almost all the code for the linear motion of our rigid body is lifted directly from our particle class. To this foundation we will add two things:

1. The laws of motion for rotating bodies, equivalent to the way we implemented Newton's second law of motion.

2. The mathematics of forces that have both a linear and a rotational effect. In other words, for a given force applied, how much the object will rotate is determined.

With the rigid body in place, and these two extensions implemented, we will have a rigid body physics engine equivalent to the particle engine from Part I. Adding collisions and hard constraints will then occupy us for the remainder of this book.

10.1 THE RIGID BODY

We can start by creating a RigidBody class, containing the same information we had in the Particle class, and adding the extra data structures for the rotation that we met

Copyright © 2010, Elsevier Inc. All rights reserved.
DOI: 10.1016/B978-0-12-381976-5.00010-3

in the previous chapter. The code looks like this:

```
                    ─── Excerpt from file include/cyclone/body.h ───
/**
 * A rigid body is the basic simulation object in the physics
 * core.
 */
class RigidBody
{
protected:
    /**
     * Holds the inverse of the mass of the rigid body. It
     * is more useful to hold the inverse mass because
     * integration is simpler, and because in real-time
     * simulation it is more useful to have bodies with
     * infinite mass (immovable) than zero mass
     * (completely unstable in numerical simulation).
     */
    real inverseMass;

    /**
     * Holds the amount of damping applied to linear
     * motion. Damping is required to remove energy added
     * through numerical instability in the integrator.
     */
    real linearDamping;

    /**
     * Holds the linear position of the rigid body in
     * world space.
     */
    Vector3 position;

    /**
     * Holds the angular orientation of the rigid body in
     * world space.
     */
    Quaternion orientation;

    /**
     * Holds the linear velocity of the rigid body in
     * world space.
     */
    Vector3 velocity;
```

```
    /**
     * Holds the angular velocity, or rotation, or the
     * rigid body in world space.
     */
    Vector3 rotation;

    /**
     * Holds a transform matrix for converting body space into
     * world space and vice versa. This can be achieved by calling
     * the getPointIn*Space functions.
     */
    Matrix4 transformMatrix;

};
```

I have added a matrix to the class to hold the current transform matrix for the rigid body. This matrix is useful for rendering the object, and will be useful at various points in the physics too—so much so that it is worth the storage space to keep a copy with the rigid body.

The matrix should be derived from the orientation and position of the body once per frame, to make sure that it is correct. We will not update the matrix within the physics, or use it in any way where it might get out of sync with the orientation and position. We're not trying to store the same information twice. The position and orientation are in charge; the transform matrix member just acts as a cache to avoid repeatedly recalculating this important quantity.

I call this *derived data* and it is the first of a handful we'll add to the rigid body. If you are working on a highly memory-starved machine, you may want to remove this data, as it is only a copy of the existing information in a more convenient form. You can simply calculate it as it is needed. The same is true for all the derived data I will add to the rigid body.

Let's add a function to the class to calculate the transform matrix, and a function to calculate all derived data. Initially, calculateDerivedData will only calculate the transform matrix:

```
———————— Excerpt from file include/cyclone/body.h ————————
class RigidBody
{
    // ... Other RigidBody code as before ...

    /**
     * Calculates internal data from state data. This should be called
     * after the body's state is altered directly (it is called
```

```
     * automatically during integration). If you change the body's state
     * and then intend to integrate before querying any data (such as
     * the transform matrix), then you can omit this step.
     */
    void calculateDerivedData();
};
```

──────────── **Excerpt from file src/body.cpp** ────────────

```
/**
 * Inline function that creates a transform matrix from a
 * position and orientation.
 */
static inline void _calculateTransformMatrix(Matrix4 &transformMatrix,
                                   const Vector3 &position, const
                                   Quaternion &orientation)
{
    transformMatrix.data[0] = 1-2*orientation.j*orientation.j -
        2*orientation.k*orientation.k;
    transformMatrix.data[1] = 2*orientation.i*orientation.j -
        2*orientation.r*orientation.k;
    transformMatrix.data[2] = 2*orientation.i*orientation.k +
        2*orientation.r*orientation.j;
    transformMatrix.data[3] = position.x;

    transformMatrix.data[4] = 2*orientation.i*orientation.j +
        2*orientation.r*orientation.k;
    transformMatrix.data[5] = 1-2*orientation.i*orientation.i -
        2*orientation.k*orientation.k;
    transformMatrix.data[6] = 2*orientation.j*orientation.k -
        2*orientation.r*orientation.i;
    transformMatrix.data[7] = position.y;

    transformMatrix.data[8] = 2*orientation.i*orientation.k -
        2*orientation.r*orientation.j;
    transformMatrix.data[9] = 2*orientation.j*orientation.k +
        2*orientation.r*orientation.i;
    transformMatrix.data[10] = 1-2*orientation.i*orientation.i -
        2*orientation.j*orientation.j;
    transformMatrix.data[11] = position.z;
}

void RigidBody::calculateDerivedData()
{
```

```
        orientation.normalize();

        // Calculate the transform matrix for the body.
        _calculateTransformMatrix(transformMatrix, position, orientation);

}
```

Later we will add calls to further calculations for this method.

10.2 Newton-2 for Rotation

In Newton's second law of motion, we saw that the change in velocity depended on a force acting on the object and the object's mass:

$$\ddot{p} = m^{-1}f$$

For rotation, we have a very similar law. The change in angular velocity depends on two things: we have torque τ rather than force, and the moment of inertia I rather than mass.

$$\ddot{\theta} = I^{-1}\tau$$

Let's look at these two in more depth.

10.2.1 Torque

Torque (also sometimes called "moments") can be thought of as a twisting force. You may be familiar with a car having a lot of torque when it can apply a great deal of turning force to the wheels. An engine that can generate a lot of torque will be better at accelerating the spin of the wheels. If the car has poor tires, this will leave a big black mark on the road and a lot of smoke in the air; with appropriate grip, the rotation will be converted into forward acceleration. In either case, the torque is spinning the wheels—the forward motion is a secondary effect caused by the tires gripping the road.

Forces and torques and closely related. We can turn a force into a torque, turning a straight push or pull into a turning motion. Imagine turning a stiff nut with a wrench. You turn the nut by pushing or pulling on the handle of the wrench. When you turn up the volume knob on a stereo, you grip it by both sides and push up with your thumb and down with your finger (if you're right-handed). In either case you are applying a force and getting angular motion as a result.

The angular acceleration depends on the size of the force you exert, and how far from the turning point you apply it. Take the wrench and nut example: you can undo the nut if you exert more force onto the wrench, or if you push further along the

handle (or use a longer-handled wrench). When turning a force into a torque, the size of the force is important, as is the distance from the axis of rotation.

The equation that links force and torque is:

$$\tau = p_f \times f \qquad\qquad [10.1]$$

where f is the force being applied, and p_f is the point at which the force is being applied, relative to the origin of the object (i.e., its center of mass, for our purposes).

Every force that applies to an object will generate a corresponding torque. Whenever we apply a force to a rigid body, we'll need to use it in the way we have so far, that is, to perform a linear acceleration. We will *additionally* need to use it to generate a torque.

If you look at Equation 10.1, you may notice that any force applied so that f and p_f are in the same direction will have zero torque. Geometrically this is equivalent to saying that if the extended line of the force passes through the center of mass, then no torque is generated. Figure 10.1 illustrates this.

We'll return to this property in Section 10.3 when we combine all the forces and torques.

In 3D it is important to note that a torque needs to have an axis. We can apply a turning force about any axis we choose. So far we've considered cases such as the volume knob or nut where the axis is fixed. For a freely rotating object, however, the torque can act to turn the object about any axis. We give torques in a scaled axis representation, as in

$$\tau = a\widehat{d}$$

where a is the magnitude of the torque, and \widehat{d} is a unit-length vector in the axis around which the torque applies. We always consider that torques act clockwise when looking in the direction of their axis. To get a counterclockwise torque, we simply flip the sign of the axis.

Equation 10.1 provides our torque in the correct format: the torque is the vector product of the force (which includes its direction and magnitude) and the position of its application.

FIGURE 10.1 A force generating no torque.

10.2.2 THE MOMENT OF INERTIA

Torque is the rotational equivalent of force. Now we come to the moment of inertia, which is roughly the rotational equivalent of mass.

The moment of inertia of an object is a measure of how difficult it is to change the rotation speed of an object. Unlike mass, however, it depends on *how* you spin the object.

Take a long stick like a broom handle and twirl it. You have to put a fair amount of effort into getting it twirling. Once it is twirling, you likewise have to exert yourself a bit to stop it again. Now stand it on the ground on end; you can get it spinning lengthwise quite easily, with two fingers. And you can very easily stop its motion.

For any axis you care to spin an object about, it may have a different moment of inertia. The moment of inertia depends on the mass of the object and the distance of that mass from the axis of rotation. If you imagine the stick being made up of lots of particles, twirling the stick like a majorette involves accelerating particles that lie a long way from the axis of rotation. In comparison to when twirling the stick lengthwise, the particles of the stick are a long way from the axis. The inertia will therefore be greater, and the stick will be more difficult to rotate and stop.

We can calculate the moment of inertia about an axis in terms of a set of particles in the object as follows:

$$I_a = \sum_{i=1}^{n} m_i d_{p_i \to a}^2 \qquad [10.2]$$

where n is the number of particles, $d_{p_i \to a}$ is the distance of particle i from the axis of rotation a, and I_a is the moment of inertia about that axis. You may also see this equation in terms of an infinite number of particles, using an integral. For almost all applications, however, you can get away with splitting into a discrete set of particles and using the sum. This is particularly useful when trying to calculate the moment of inertia of an unusually shaped object. We'll return to the moments of inertia of different objects later in the section, and Appendix A, Section A.4 has a more complete list.

Clearly we can't use a single value for the moment of inertia like we did for mass. It depends completely on the axis we choose. About any particular axis, we have only one moment of inertia, but there are any number of axes we could choose. Fortunately, the physics of rigid bodies means that we don't need to have an unlimited number of different values either. We can compactly represent all of the different values in a matrix, called the *inertia tensor*.

Before I describe the inertia tensor in more detail, it is worth getting some terminology clear. The moments of inertia for an object are normally *represented* as an inertia tensor. However, the two terms are somewhat synonymous in physics engine development. The "tensor" bit also causes confusion. A tensor is simply a generalized version of a matrix. Whereas vectors can be thought of as a 1D array of values, and matrices are a 2D array, tensors can have any number of dimensions. So, both a vector and a matrix are tensors. Although the inertia tensor is called a tensor, for

our purposes it is always 2D. In other words, it is always just a matrix. It is sometimes called the "mass matrix," and we could call it the "inertia matrix," I suppose, but it's not a term that I've heard used. For most of this book, I'll just talk about the inertia tensor, meaning the matrix representing all the moments of inertia of a rigid body; such usage follows the normal idiom of game development.

The inertia tensor in 3D is a 3×3 matrix characteristic of a rigid body (in other words, we keep an inertia tensor for each body, just as each body had its own mass). Along the leading diagonals, the tensor has the moment of inertia about each of its three principal axes, X, Y, and Z:

$$\begin{bmatrix} I_x & & \\ & I_y & \\ & & I_z \end{bmatrix}$$

where I_x is the moment of inertia of the object about its X axis, *through its center of mass.* The same is true for I_y and I_z.

The remaining entries don't hold moments of inertia. They are called *products of inertia,* and are defined in this way:

$$I_{ab} = \sum_{i=1}^{n} m_i a_{p_i} b_{p_i}$$

where a_{p_i} is the distance of particle i from the center of mass of the object, in the direction of a.

We use this to calculate I_{xy}, I_{xz}, and I_{yz}. In the case of I_{xy}, we get

$$I_{xy} = \sum_{i=1}^{n} m_i x_{p_i} y_{p_i}$$

where x_{p_i} is the distance of the particle from the center of mass in the X-axis direction, which is the same for y_{p_i} in the Y-axis direction. Using the scalar products of vectors we get

$$I_{xy} = \sum_{i=1}^{n} m_i (\boldsymbol{p}_i \cdot \boldsymbol{x})(\boldsymbol{p}_i \cdot \boldsymbol{y}) \qquad [10.3]$$

Note that unlike the moments of inertia on the leading diagonal, each particle can contribute a negative value to this sum. In the moment of inertia calculation, the distance was squared, so its contribution is always positive. It is entirely possible to have a non-positive total product of inertia. Zero values are particularly common for many awkwardly shaped objects.

It is difficult to visualize what the product of inertia *means* in geometrical or mathematical terms. It represents the tendency of an object to rotate in a different direction to the direction that the torque is being applied. You may have seen this in the behavior of a child's top. You start by spinning it in one direction, but it jumps upside down and spins on its head almost immediately. For a freely rotating object, if you apply

a torque, you will not always get rotation about the same axis where you applied the torque. This is the effect that gyroscopes are based on: they resist the temptation to fall over because they transfer any gravity-induced falling rotation back into the opposite direction to stand up straight once more. The products of inertia control this process, that is, the transfer of rotation from one axis to another.

We place the products of inertia into our inertia tensor to give the final structure,

$$I = \begin{bmatrix} I_x & -I_{xy} & -I_{xz} \\ -I_{xy} & I_y & -I_{yz} \\ -I_{xz} & -I_{yz} & I_z \end{bmatrix} \qquad [10.4]$$

The mathematician Euler gave the rotational version of Newton's second law of motion in terms of this structure as follows:

$$\boldsymbol{\tau} = I\ddot{\boldsymbol{\theta}}$$

which gives us the angular acceleration in terms of the torque applied,

$$\ddot{\boldsymbol{\theta}} = I^{-1}\boldsymbol{\tau} \qquad [10.5]$$

where I^{-1} is the inverse of the inertia tensor, performed using a regular matrix inversion.

Note that because of the presence of the products of inertia, the direction of the torque vector $\boldsymbol{\tau}$ is not neccesarily the same as the angular acceleration vector $\ddot{\boldsymbol{\theta}}$ that results. In some cases it will be. In particular, if the products of inertia are all zero,

$$I = \begin{bmatrix} I_x & 0 & 0 \\ 0 & I_y & 0 \\ 0 & 0 & I_z \end{bmatrix}$$

and the torque vector is in one of the principal axis directions (X, Y, or Z), then the acceleration *will* be in the direction of the torque.

Many shapes have easy formulas for calculating their inertia tensor. A rectangular block, for example, of mass m and dimensions d_x, d_y, and d_z, aligned along the X, Y, and Z axes, respectively, has an inertia tensor of

$$I = \begin{bmatrix} \frac{1}{12}m(d_y^2 + d_z^2) & 0 & 0 \\ 0 & \frac{1}{12}m(d_x^2 + d_z^2) & 0 \\ 0 & 0 & \frac{1}{12}m(d_x^2 + d_y^2) \end{bmatrix}$$

Note that the products of inertia are all zero in this case. This is often true; if we can suitably orient many regular solids, the products of inertia become zero. A list of inertia tensors for common shapes is provided in Appendix A.

The Inverse Inertia Tensor

For exactly the same reasons as we saw for mass, we will store the inverse inertia tensor rather than the raw inertia tensor. The rigid body has an additional member added, a `Matrix3` instance:

```
───────── Excerpt from file include/cyclone/body.h ─────────
class RigidBody
{
    // ... Other RigidBody code as before ...

    /**
     * Holds the inverse of the body's inertia tensor. The
     * intertia tensor provided must not be degenerate
     * (that would mean the body had zero inertia for
     * spinning along one axis). As long as the tensor is
     * finite, it will be invertible. The inverse tensor
     * is used for similar reasons to the use of inverse
     * mass.
     *
     * The inertia tensor, unlike the other variables that
     * define a rigid body, is given in body space.
     */
    Matrix3 inverseInertiaTensor;
};
```

Having the inverse available allows us to calculate the angular acceleration directly from Equation 10.5 without performing the inverse operation each time. When setting up a rigid body, we can start with a regular inertia tensor, and then call the `inverse` function of the matrix and set the rigid body's inverse inertia tensor to the result:

```
───────── Excerpt from file scr/body.cpp ─────────
void RigidBody::setInertiaTensor(const Matrix3 &inertiaTensor)
{
    inverseInertiaTensor.setInverse(inertiaTensor);
}
```

10.2.3 INERTIA TENSOR IN WORLD COORDINATES

There is still one subtle complication to address before we can leave the inertia tensor. Throughout the discussion of moments of inertia, I have deliberately not distinguished between the object's local coordinates and the game's world coordinates.

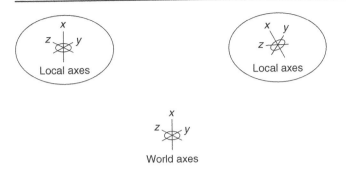

FIGURE 10.2 The moment of inertia is local to an object.

Consider the example in Figure 10.2. In the first example the object's local axes are in the same direction as the world's axes. If we apply a torque about the X axis, then we will get the same moment of inertia whether we work in local or world coordinates.

In the second part of the example, the object has rotated. Now which X axis do we need to use? In our engine we'll express the torque in world coordinates. So the rotation will depend on the moment of inertia of the object about the world's X axis. The inertia tensor is defined in terms of the object's axis, however. It is constant: we don't change the inertia tensor each time the object moves.

In the acceleration equation,

$$\ddot{\theta} = I^{-1}\tau$$

the torque τ and the resulting angular acceleration $\ddot{\theta}$ are both given relative to the world axes. So the inertia tensor we need should also be given in world coordinates.

We don't want to have to recalculate the inertia tensor by summing masses at each frame, so we need a simpler way to get the inertia tensor into world coordinates. We can achieve this by creating a new derived quantity: the inverse inertia tensor in world coordinates. At each frame, we can apply a change of basis transformation to convert the constant inertia tensor in object coordinates into the corresponding matrix in world coordinates.

As with the transform matrix, we add an update to recalculate the derived quantity in each frame. It gets put together in this way:

```
───────── Excerpt from file src/body.cpp ─────────
/**
 * Internal function to do an intertia tensor transform by a quaternion.
 * Note that the implementation of this function was created by an
 * automated code generator and optimizer.
 */
```

```
static inline void _transformInertiaTensor(Matrix3 &iitWorld,
                                           const Quaternion &q,
                                           const Matrix3 &iitBody,
                                           const Matrix4 &rotmat)
{
    real t4 = rotmat.data[0]*iitBody.data[0]+
        rotmat.data[1]*iitBody.data[3]+
        rotmat.data[2]*iitBody.data[6];
    real t9 = rotmat.data[0]*iitBody.data[1]+
        rotmat.data[1]*iitBody.data[4]+
        rotmat.data[2]*iitBody.data[7];
    real t14 = rotmat.data[0]*iitBody.data[2]+
        rotmat.data[1]*iitBody.data[5]+
        rotmat.data[2]*iitBody.data[8];
    real t28 = rotmat.data[4]*iitBody.data[0]+
        rotmat.data[5]*iitBody.data[3]+
        rotmat.data[6]*iitBody.data[6];
    real t33 = rotmat.data[4]*iitBody.data[1]+
        rotmat.data[5]*iitBody.data[4]+
        rotmat.data[6]*iitBody.data[7];
    real t38 = rotmat.data[4]*iitBody.data[2]+
        rotmat.data[5]*iitBody.data[5]+
        rotmat.data[6]*iitBody.data[8];
    real t52 = rotmat.data[8]*iitBody.data[0]+
        rotmat.data[9]*iitBody.data[3]+
        rotmat.data[10]*iitBody.data[6];
    real t57 = rotmat.data[8]*iitBody.data[1]+
        rotmat.data[9]*iitBody.data[4]+
        rotmat.data[10]*iitBody.data[7];
    real t62 = rotmat.data[8]*iitBody.data[2]+
        rotmat.data[9]*iitBody.data[5]+
        rotmat.data[10]*iitBody.data[8];

    iitWorld.data[0] = t4*rotmat.data[0]+
        t9*rotmat.data[1]+
        t14*rotmat.data[2];
    iitWorld.data[1] = t4*rotmat.data[4]+
        t9*rotmat.data[5]+
        t14*rotmat.data[6];
    iitWorld.data[2] = t4*rotmat.data[8]+
        t9*rotmat.data[9]+
        t14*rotmat.data[10];
    iitWorld.data[3] = t28*rotmat.data[0]+
        t33*rotmat.data[1]+
```

```
            t38*rotmat.data[2];
        iitWorld.data[4] = t28*rotmat.data[4]+
            t33*rotmat.data[5]+
            t38*rotmat.data[6];
        iitWorld.data[5] = t28*rotmat.data[8]+
            t33*rotmat.data[9]+
            t38*rotmat.data[10];
        iitWorld.data[6] = t52*rotmat.data[0]+
            t57*rotmat.data[1]+
            t62*rotmat.data[2];
        iitWorld.data[7] = t52*rotmat.data[4]+
            t57*rotmat.data[5]+
            t62*rotmat.data[6];
        iitWorld.data[8] = t52*rotmat.data[8]+
            t57*rotmat.data[9]+
            t62*rotmat.data[10];
    }

    void RigidBody::calculateDerivedData()
    {
        orientation.normalize();

        // Calculate the transform matrix for the body.
        _calculateTransformMatrix(transformMatrix, position, orientation);

        // Calculate the inertiaTensor in world space.
        _transformInertiaTensor(inverseInertiaTensorWorld,
            orientation,
            inverseInertiaTensor,
            transformMatrix);
    }
```

That's a lot of code, but what is happening is pretty simple: I'm applying the change of basis transform from Section 9.4.6 in a single operation.

When we transform the inertia tensor we are only interested in the rotational component of the object's transform. It doesn't matter where the object is in space, only the direction in which it is oriented. The code therefore treats the 4×3 transform matrix as if it were a 3×3 matrix (i.e., a rotation matrix only). Together these two optimizations make for considerably faster and shorter code.

So, for each frame we calculate the transform matrix, transform the inverse inertia tensor into world coordinates, and then perform the rigid-body integration with this transformed version. Before we look at the code to perform the final integration, we need to look at how a body reacts to an entire series of torques and forces (with their corresponding torque components).

10.3 D'ALEMBERT FOR ROTATION

Just as we have an equivalent of Newton's second law of motion, we can also use the implications of D'Alembert's principle to help us combine torques. Recall that D'Alembert's principle allows us to accumulate a whole series of forces into a single force, and then apply just this one force. The effect of the single accumulated force is identical to the effect of all its component forces. We take advantage of this by simply adding together all the forces applied to an object, and then only calculating its acceleration once, based on the resulting total.

The same principle applies to torques: the effect of a whole series of torques is equal to the effect of a single torque that combines them all. We have

$$\tau = \sum_i \tau_i$$

where τ_i is the i-th torque.

There is a complication, however. We saw earlier in the chapter that an off-center force can be converted into torques. To get the correct set of forces and torques, we need to take into account this calculation.

Fortunately, another consequence of D'Alembert's principle is that we can accumulate the torques caused by forces in exactly the same way as we accumulate any other torques. Note that we *cannot* merely accumulate the forces and then take the torque equivalent of the resulting force. We could have two forces (like the finger and thumb on a volume dial) that cancel each other out as linear forces, but combine to generate a large torque.

So, we have two accumulators: one for forces and another for torques. For each force applied, we add it to both the force and torque accumulator, where its torque is calculated by

$$\tau = p_f \times f$$

(i.e., Equation 10.1). For each torque applied, we accumulate just the torque (torques have no corresponding force component).

Some forces, such as gravity, will always apply to the center of mass of an object. In this case, there is no point trying to work out their torque component because they can never induce rotation. We allow this in our engine by providing a third route: adding a force with no position of application. In this case, we merely add the force to the force accumulator and bypass torque accumulation. In code it looks like this:

```
───────────── Excerpt from file include/cyclone/body.h ─────────────
class RigidBody
{
    // ... Other RigidBody code as before ...

    /**
     * Adds the given force to center of mass of the rigid body.
```

```
     * The force is expressed in world coordinates.
     */
    void addForce(const Vector3 &force);
};
```

─────────────── **Excerpt from file src/body.cpp** ───────────────

```
void RigidBody::addForce(const Vector3 &force)
{
    forceAccum += force;
    isAwake = true;
}
```

Finally, when we perform our per-frame setup of the body, we zero the torque, so that it can be accumulated as forces applied to the body:

─────────────── **Excerpt from file include/cyclone/body.h** ───────────────

```
class RigidBody
{
    // ... Other RigidBody code as before ...

    /**
     * Clears the forces and torques in the accumulators. This will
     * be called automatically after each intergration step.
     */
    void clearAccumulators();
};
```

─────────────── **Excerpt from file src/body.cpp** ───────────────

```
void RigidBody::integrate(real duration)
{
    // Clear accumulators.
    clearAccumulators();
}
void RigidBody::clearAccumulators()
{
    forceAccum.clear();
    torqueAccum.clear();
}
```

An important feature of the previous code is that the location of a force application is expressed in world coordinates. If you have a spring attached at a fixed point on an object, you'll need to recalculate the position of the attachment point in each

frame. You can do this simply by transforming the position of the object coordinates by the transform matrix, to get a position in world coordinates. Because this is such a useful thing to be able to do, I provide an additional force accumulation method to support it:

_____ **Excerpt from file include/cyclone/body.h** _____

```
class RigidBody
{
    // ... Other RigidBody code as before ...

    /**
     * Adds the given force to the given point on the rigid body.
     * Both the force and the application point are given in world
     * space. Because the force is not applied at the center of
     * mass, it may be split into both a force and torque.
     */
    void addForceAtPoint(const Vector3 &force,
                         const Vector3 &point);

    /**
     * Adds the given force to the given point on the rigid body.
     * The direction of the force is given in world coordinates,
     * but the application point is given in body space. This is
     * useful for spring forces, or other forces fixed to the
     * body.
     */
    void addForceAtBodyPoint(const Vector3 &force,
                             const Vector3 &point);
};
```

_____ **Excerpt from file src/body.cpp** _____

```
void RigidBody::addForceAtBodyPoint(const Vector3 &force,
                                    const Vector3 &point)
{
    // Convert to coordinates relative to center of mass.
    Vector3 pt = getPointInWorldSpace(point);
    addForceAtPoint(force, pt);

    isAwake = true;
}

void RigidBody::addForceAtPoint(const Vector3 &force,
                                const Vector3 &point)
```

```
{
    // Convert to coordinates relative to center of mass.
    Vector3 pt = point;
    pt -= position;

    forceAccum += force;
    torqueAccum += pt % force;

    isAwake = true;
}
```

Be careful: the direction of the force is still expected in *world* coordinates, whereas the application point is expected in *object* coordinates! This matches the most common way that these calculations are performed, but you could create yet another version that transforms both the force and the position into world coordinates. If you do that, be careful with the transformation of the force. It should be rotated only, and not transformed by the full 4×3 matrix (which adds the offset position to the vector).

10.3.1 Force Generators

We need to update the force generators we created for particles so that they work with rigid bodies. In particular, they may need to be able to apply a force at a particular point on the rigid body. If this isn't at the center of mass, we'll be generating both a force and a torque for our rigid body, as we saw in the previous section.

This is the logic of not having a force generator return just a single force vector: we won't know where the force is applied, or even whether it wants to express that location in world or object coordinates. Instead, we allow the force generator to apply a force in whatever way it wants. We can create force generators that call the method to apply a force at a point other than the body's center of mass, or they may just apply a force to the center of mass.

This means that the gravity force generator is almost the same. It is changed only to accept the rigid body type rather than a particle:

──────── **Excerpt from file include/cyclone/fgen.h** ────────

```
/**
 * A force generator can be asked to add a force to one or more
 * bodies.
 */
class ForceGenerator
{
public:
```

```
    /**
     * Overload this in implementations of the interface to calculate
     * and update the force applied to the given rigid body.
     */
    virtual void updateForce(RigidBody *body, real duration) = 0;
};

/**
 * A force generator that applies a gravitational force. One instance
 * can be used for multiple rigid bodies.
 */
class Gravity : public ForceGenerator
{
    /** Holds the acceleration due to gravity. */
    Vector3 gravity;

public:

    /** Creates the generator with the given acceleration. */
    Gravity(const Vector3 &gravity);

    /** Applies the gravitational force to the given rigid body. */
    virtual void updateForce(RigidBody *body, real duration);
};
```

──────── Excerpt from file **src/fgen.cpp** ────────

```
void Gravity::updateForce(RigidBody* body, real duration)
{
    // Check that we do not have infinite mass.
    if (!body->hasFiniteMass()) return;

    // Apply the mass-scaled force to the body.
    body->addForce(gravity * body->getMass());
}
```

The spring force generator now needs to know where the spring is attached on each object, and it should generate an appropriate force with its application point.

──────── Excerpt from file **include/cyclone/fgen.h** ────────

```
/**
 * A force generator that applies a spring force.
```

```
 */
class Spring : public ForceGenerator
{
    /**
     * The point of connection of the spring in local
     * coordinates.
     */
    Vector3 connectionPoint;

    /**
     * The point of connection of the spring to the other object
     * in that object's local coordinates.
     */
    Vector3 otherConnectionPoint;

    /** The particle at the other end of the spring. */
    RigidBody *other;

    /** Holds the spring constant. */
    real springConstant;

    /** Holds the rest length of the spring. */
    real restLength;

public:

    /** Creates a new spring with the given parameters. */
    Spring(const Vector3 &localConnectionPt,
           RigidBody *other,
           const Vector3 &otherConnectionPt,
           real springConstant,
           real restLength);

    /** Applies the spring force to the given rigid body. */
    virtual void updateForce(RigidBody *body, real duration);
};
```

─────── Excerpt from file **src/fgen.cpp** ───────

```
void Spring::updateForce(RigidBody* body, real duration)
{
    // Calculate the two ends in world space.
    Vector3 lws = body->getPointInWorldSpace(connectionPoint);
    Vector3 ows = other->getPointInWorldSpace(otherConnectionPoint);
```

```
// Calculate the vector of the spring.
Vector3 force = lws - ows;

// Calculate the magnitude of the force.
real magnitude = force.magnitude();
magnitude = real_abs(magnitude - restLength);
magnitude *= springConstant;

// Calculate the final force and apply it.
force.normalize();
force *= -magnitude;
body->addForceAtPoint(force, lws);
}
```

Torque Generators

We could follow the lead of the force generators and create a set of torque generators. They fit into the same force generator structure that we've used so far: calling the rigid body's addTorque method. You can use this to constantly drive a rotating object, such as a set of fan blades or the wheels of a car.

We don't need to create a new registry system or interface for torque generators. Because we allow force generators to apply forces in whatever way they choose, our torque generators can just be regular implementations of the ForceGenerator interface.

10.4 THE RIGID-BODY INTEGRATION

We're finally in the position to write the integration routine that will update the position and orientation of a rigid body based on its forces and torques.

It will have the same format as the integration function for a particle, with the addition of the rotation components discussed in the previous chapter. To correspond with the linear case, we add another data member to the rigid body to control angular velocity damping—the amount of angular velocity the body loses each second:

```
────────── Excerpt from file include/cyclone/body.h ──────────
class RigidBody
{
    // ... Other RigidBody code as before ...
```

```
    /**
     * Holds the amount of damping applied to angular
     * motion. Damping is required to remove energy added
     * through numerical instability in the integrator.
     */
    real angularDamping;

};
```

As with linear velocity, the angular velocity is updated with the equation

$$\dot{\theta}' = \dot{\theta}(d_a)^t + \ddot{\theta} t$$

where d_a is the angular damping coefficient.

The complete integration routine now looks like this:

─────── **Excerpt from file `src/body.cpp`** ───────

```cpp
void RigidBody::integrate(real duration)
{
    // Calculate linear acceleration from force inputs.
    lastFrameAcceleration = acceleration;
    lastFrameAcceleration.addScaledVector(forceAccum, inverseMass);

    // Calculate angular acceleration from torque inputs.
    Vector3 angularAcceleration =
        inverseInertiaTensorWorld.transform(torqueAccum);

    // Adjust velocities.
    // Update linear velocity from both acceleration and impulse.
    velocity.addScaledVector(lastFrameAcceleration, duration);

    // Update angular velocity from both acceleration and impulse.
    rotation.addScaledVector(angularAcceleration, duration);

    // Impose drag.
    velocity *= real_pow(linearDamping, duration);
    rotation *= real_pow(angularDamping, duration);

    // Adjust positions.
    // Update linear position.
    position.addScaledVector(velocity, duration);
```

```
    // Update angular position.
    orientation.addScaledVector(rotation, duration);

    // Normalize the orientation, and update the matrices with the new
    // position and orientation.
    calculateDerivedData();

    // Clear accumulators.
    clearAccumulators();
}
```

10.5 SUMMARY

The physics of angular motion is very similar to the physics of linear motion discussed in Chapter 3. In the same way that force is related to acceleration via mass, we've seen that torque is related to angular acceleration via the moment of inertia. The physics is similar, but in each case the mathematics is more complex and the implementation longer. The vector position corresponds to the quaternion for orientation, and the scalar valued mass matches a 3 × 3 inertia tensor.

The last two chapters have therefore been considerably more difficult than previous chapters. If you have followed through to get a rigid-body physics engine, you can be proud of yourself. There are significant limits to what we've built so far (notably we haven't brought collisions into the new engine), but there are also a lot of great things that you can do with what we have. Chapter 11 introduces some applications of the current engine.

10.6 EXERCISES

Exercise 10.1
A force of

$$\begin{bmatrix} 1 \\ 2 \\ 3 \end{bmatrix}$$

is applied to an object at a point

$$\begin{bmatrix} 1 \\ -1 \\ 0 \end{bmatrix}$$

relative to its center of mass. What is the torque generated by this force?

Exercise 10.2
You have an object made up of eight point masses, each of mass 1, arranged at the corners of a cube of size 2. The positions of each mass are therefore

$$\begin{bmatrix} \pm 1 \\ \pm 1 \\ \pm 1 \end{bmatrix}$$

Calculate the inertia tensor matrix of this object. You will need to use Equations 10.2 and 10.3.

Exercise 10.3
An object receives two forces. The first is

$$\begin{bmatrix} 1 \\ 2 \\ 3 \end{bmatrix}$$

applied at

$$\begin{bmatrix} 0 \\ -1 \\ 1 \end{bmatrix}$$

relative to its center of mass. The second is

$$\begin{bmatrix} 0 \\ 1 \\ 0 \end{bmatrix}$$

applied at

$$\begin{bmatrix} 0 \\ -1 \\ 0 \end{bmatrix}$$

relative to its center of mass. What is the total torque and force on the object from these two forces?

Exercise 10.4
Implement a torque generator that tries to keep its object spinning at a particular angular velocity. It should have a target angular velocity. If the current rotation is far from that target, it should apply a large torque. As the object nears its target angular

velocity, the torque should drop. To calculate how near the angular velocity is to the target, you will need to use the scalar product (but be careful about scaling).

Exercise 10.5

Implement a torque generator that tries to rotate its object into a particular orientation. This is the rotational equivalent of a spring: it has a rest orientation and uses torques to return the object to that orientation.

THE RIGID-BODY PHYSICS ENGINE

11

Our physics engine is now capable of simulating rigid bodies in full 3D. The spring forces and other force generators will work with this approach, but the hard constraints we discussed in Chapter 7 will not. We will look at collision detection in Part IV and then return to full 3D constraints in Part V.

Even without hard constraints, there is still a lot we can do. This chapter will look at two applications of physics that don't rely on hard constraints for their effects: boats and aircraft. We'll build a flight simulator and a boat model. Adding the aerodynamics from the flight simulator allows us to build a sailing simulation.

11.1 OVERVIEW OF THE ENGINE

The rigid-body physics engine has two components:

1. The rigid bodies themselves keep track of their position and movement, and their mass characteristics. To set up a simulation, we need to work out what rigid bodies are needed, and set their initial position, orientation, and velocities (both linear and angular). We also need to set their inverse mass and inverse inertia tensor. The acceleration of an object due to gravity is also held in the rigid body (this could be removed and replaced by a force, if you so desire).

2. The force generators are used to keep track of forces that apply over several frames of the game.

Copyright © 2010, Elsevier Inc. All rights reserved.
DOI: 10.1016/B978-0-12-381976-5.00011-5

We have removed the contact resolution system from the mass aggregate system (it will be reintroduced in Parts IV and V).

We can use the system we introduced in Chapter 8 to manage the objects to be simulated. In this case, however, they are rigid bodies rather than particles.

The World structure is modified accordingly:

```
——————————— Excerpt from file include/cyclone/world.h ———————————
/**
 * The world represents an independent simulation of physics.  It
 * keeps track of a set of rigid bodies, and provides the means to
 * update them all.
 */
class World
{
public:
    typedef std::vector<RigidBody*> RigidBodies;

protected:
    /**
     * Holds the rigid bodies being simulated.
     */
    RigidBodies bodies;

};
```

As before, each frame of the startFrame method is first called, which sets up each object by zeroing its force and torque accumulators, and calculating its derived quantities as follows:

```
——————————— Excerpt from file include/cyclone/world.h ———————————
class World
{
    // ... other World data as before ...

    /**
     * Initializes the world for a simulation frame. This clears
     * the force and torque accumulators for bodies in the
     * world. After calling this, the bodies can have their forces
     * and torques for this frame added.
     */
    void startFrame();
};
```

```
_____ Excerpt from file src/world.cpp _____

void World::startFrame()
{
    for (RigidBodies::iterator b = bodies.begin();
        b != bodies.end();
        b++)
    {
        b->clearAccumulators();
        b->calculateDerivedData();
    }
}
```

And again, additional forces can be applied after calling this method.

To execute the physics, the runPhysics method is called. This calls all the force generators to apply their forces and performs the integration of all objects:

```
_____ Excerpt from file include/cyclone/world.h _____

class World
{
    // ... other World data as before ...

    /**
     * Processes all the physics for the world.
     */
    void runPhysics(real duration);
};
```

```
_____ Excerpt from file src/world.cpp _____

void ParticleWorld::integrate(real duration)
{
    for (RigidBodies::iterator b = bodies.begin();
        b != bodies.end();
        b++)
    {
        // Integrate the body by the given duration.
        b->integrate(duration);
    }
}

void World::runPhysics(real duration)
{
    // First, apply the force generators.
```

```
    registry.updateForces(duration);

    // Then integrate the objects.
    integrate(duration);
}
```

It no longer calls the collision detection system. The calls to startFrame and runPhysics can occur in the same place in the game loop.

Note that I've made an additional call to the updateTransform method of each object. The object may have moved during the update (and in later sections during collision resolution), so its transform matrix needs updating before it is rendered. Each object is then rendered in turn using the rigid body's transform.

11.2 Using the Physics Engine

Both our sample programs for this physics engine use aerodynamics. We will create a new force generator that can fake some important features of flight aerodynamics, or enough to produce a basic flight model suitable for use in a flight action game. We will use the same generator to drive a sail model for a sailing simulator.

11.2.1 A Flight Simulator

There is no need for contact physics in a flight simulator, except with the ground, of course. Many flight simulators assume that if you hit something in an airplane, then it's all over: a crash animation plays and the player starts again. This makes it a perfect exercise for our current engine.

The dynamics of an aircraft are generated by the way air flows over its surfaces (both the surfaces that don't move relative to the center of mass, like the fuselage, and control surfaces that can be made to move or change shape, like the wings and rudder). The flow of air causes forces to be generated. Some forces, like drag, act in the same direction as the aircraft is moving. The most important force, lift, acts at right angles to the flow of air. As the aircraft's surfaces move at different angles through the air, the proportion of each kind of force can change dramatically. If the wing is slicing through the air, it generates lift, but if it is moving vertically through the air, then it generates no lift. We'd like to be able to capture this kind of behavior in a force generator that can produce sensible aerodynamic forces.

The Aerodynamic Tensor

To model the aerodynamic forces properly is very complex. The behavior of a real aircraft depends on the fluid dynamics of air movement. This is a horrendously complex discipline involving mathematics well beyond the scope of this book. To create a truly realistic flight simulator involves some specialized physics that I don't want to venture into.

To make our lives easier, I will use a simplification: the "aerodynamic tensor." The aerodynamic tensor is a way of calculating the total force that a surface of the airplane is generating based only on the speed of the air that is moving over it.

The tensor is a 3×3 matrix, exactly as we used for the inertia tensor. We start with a wind speed vector, and transform it using the tensor to give a force vector:

$$f_a = A v_w$$

where f_a is the resulting force, A is the aerodynamic tensor, and v_w is the velocity of the air. Just like we saw for the inertia tensor, we have to be careful of coordinates here. The velocity of the air and the resulting force are both expressed in world coordinates, but the aerodynamic tensor is in object coordinates. Again we need to change the basis of the tensor in each frame before applying this function.

To fly the plane we can implement control surfaces in one of two ways. The first, and most accurate way, is to have two tensors representing the aerodynamic characteristics when the surface is at its two extremes. At each frame, the current position of the control surface is used to blend the two tensors to create a tensor for the current surface position.

In practice, three tensors are sometimes needed to represent the two extremes plus the normal position of the control surface (which often has a quite different, and not intermediate, behavior). For example, a wing with its aileron (the control surface on the back of each wing) in line with the wing produces lots of lift, and only a modest amount of drag. With the aileron out of this position, either up or down, the drag increases dramatically, but the lift can be boosted or cut (depending on whether it is up or down).

The second approach is to actually tilt the entire surface slightly. We can do this by storing an orientation for the aerodynamic surface, and allowing the player to directly control some of this orientation. To simulate the aileron on the wing, the player might be effectively tilting the entire wing. As the wing changes orientation, the air flow over it will change, and its single aerodynamic tensor will generate correspondingly different forces.

The Aerodynamic Surface

We can implement an aerodynamic force generator using this technique. The force generator is created with an aerodynamic tensor, and it is attached to the rigid body at a given point. This is the point at which all its force will be felt. We can attach as many surfaces as we need to one rigid body. The force generator looks like this:

```
──────────── Excerpt from file include/cyclone/fgen.h ────────────
/**
 * A force generator that applies an aerodynamic force.
 */
class Aero : public ForceGenerator
{
```

```
protected:
    /**
     * Holds the aerodynamic tensor for the surface in body
     * space.
     */
    Matrix3 tensor;

    /**
     * Holds the relative position of the aerodynamic surface in
     * body coordinates.
     */
    Vector3 position;

    /**
     * Holds a pointer to a vector containing the wind speed of the
     * environment. This is easier than managing a separate
     * wind speed vector per generator and having to update it
     * manually as the wind changes.
     */
    const Vector3* windspeed;

public:
    /**
     * Creates a new aerodynamic force generator with the
     * given properties.
     */
    Aero(const Matrix3 &tensor, const Vector3 &position,
        const Vector3 *windspeed);

    /**
     * Applies the force to the given rigid body.
     */
    virtual void updateForce(RigidBody *body, real duration);

protected:
    /**
     * Uses an explicit tensor matrix to update the force on
     * the given rigid body. This is exactly the same as for updateForce,
     * except that it takes an explicit tensor.
     */
    void updateForceFromTensor(RigidBody *body, real duration,
                                const Matrix3 &tensor);
};
```

```
——— Excerpt from file src/fgen.cpp ———
void Aero::updateForce(RigidBody *body, real duration)
{
    Aero::updateForceFromTensor(body, duration, tensor);
}

void Aero::updateForceFromTensor(RigidBody *body, real duration,
                                 const Matrix3 &tensor)
{
    // Calculate total velocity (wind speed and body's velocity).
    Vector3 velocity = body->getVelocity();
    velocity += *windspeed;

    // Calculate the velocity in body coordinates.
    Vector3 bodyVel =
      body->getTransform().transformInverseDirection(velocity);

    // Calculate the force in body coordinates.
    Vector3 bodyForce = tensor.transform(bodyVel);
    Vector3 force = body->getTransform().transformDirection(bodyForce);

    // Apply the force.
    body->addForceAtBodyPoint(force, position);
}
```

The air velocity is calculated based on two values: the prevailing wind and the velocity of the rigid body. The prevailing wind is a vector, containing both the direction and magnitude of the wind. If the rigid body were not moving, it would still feel this wind. We could omit this value for a flight game that doesn't need to complicate the player's task by adding wind. It will become very useful when we come to model our sailing simulator in the next section, however.

This implementation uses a single tensor only. To implement control surfaces, we need to extend this in one of the ways we looked at above. I will choose the more accurate approach with three tensors to represent the characteristics of the surface at the extremes of its operation:

```
——— Excerpt from file include/cyclone/fgen.h ———
/**
 * A force generator with a control aerodynamic surface. This
 * requires three inertia tensors, for the two extremes and
 * ''resting'' position of the control surface. The latter tensor is
 * the one inherited from the base class, while the two extremes are
 * defined in this class.
 */
```

```
class AeroControl : public Aero
{
protected:
    /**
     * The aerodynamic tensor for the surface when the control is at
     * its maximum value.
     */
    Matrix3 maxTensor;

    /**
     * The aerodynamic tensor for the surface when the control is at
     * its minimum value.
     */
    Matrix3 minTensor;

    /**
    * The current position of the control for this surface. This
    * should range between -1 (in which case the minTensor value
    * is used), through 0 (where the base-class tensor value is
    * used) to +1 (where the maxTensor value is used).
    */
    real controlSetting;

private:
    /**
     * Calculates the final aerodynamic tensor for the current
     * control setting.
     */
    Matrix3 getTensor();

public:
    /**
     * Creates a new aerodynamic control surface with the given
     * properties.
     */
    AeroControl(const Matrix3 &base,
                const Matrix3 &min, const Matrix3 &max,
                const Vector3 &position, const Vector3 *windspeed);

    /**
     * Sets the control position of this control. This * should
    range between -1 (in which case the minTensor value * is
    used), through 0 (where the base-class tensor value is used) *
    to +1 (where the maxTensor value is used). Values outside that
```

```
    * range give undefined results.
    */
    void setControl(real value);

    /**
     * Applies the force to the given rigid body.
     */
    virtual void updateForce(RigidBody *body, real duration);
};
```

Excerpt from file `src/fgen.cpp`

```
Matrix3 AeroControl::getTensor()
{
    if (controlSetting <= -1.0f) return minTensor;
    else if (controlSetting >= 1.0f) return maxTensor;
    else if (controlSetting < 0)
    {
        return Matrix3::linearInterpolate(minTensor,
                                          tensor,
                                          controlSetting+1.0f);
    }
    else if (controlSetting > 0)
    {
        return Matrix3::linearInterpolate(tensor,
                                          maxTensor,
                                          controlSetting);
    }
    else return tensor;
}

void AeroControl::updateForce(RigidBody *body, real duration)
{
    Matrix3 tensor = getTensor();
    Aero::updateForceFromTensor(body, duration, tensor);
}
```

The linearInterpolate method is defined on the Matrix3 class as follows:

Excerpt from file `include/cyclone/core.h`

```
class Matrix3
{
    // ... Other Matrix3 code as before ...
```

```
/**
 * Interpolates a couple of matrices.
 */
static Matrix3 linearInterpolate(const Matrix3& a,
                                 const Matrix3& b,
                                 real prop);
};
```

```
———————————— Excerpt from file src/core.cpp ————————————
Matrix3 Matrix3::linearInterpolate(const Matrix3& a,
                                   const Matrix3& b,
                                   real prop)
{
    Matrix3 result;
    real omp = 1.0 - prop;
    for (unsigned i = 0; i < 9; i++) {
        result.data[i] = a.data[i] * omp + b.data[i] * prop;
    }
    return result;
}
```

Each control surface has an input wired to the player's (or AI's) control. It ranges from -1 to $+1$, where 0 is considered the "normal" position. The three tensors match these three positions. Two of the three tensors are blended together to form a current aerodynamic tensor for the setting of the surface. This tensor is then converted into world coordinates, and used as before.

Putting It Together

In the sample code, the **flightsim** demo shows this force generator in operation. You control a model aircraft (seen from the ground, for a bit of added challenge). The only forces applied to the aircraft are gravity (represented as an acceleration value) and the aerodynamic forces from surface and control-surface force generators. Figure 11.1 shows the aircraft in action.

I have used four control surfaces: two wings, a tailplane, and a rudder. The tailplane is a regular surface force generator, with no control inputs (in a real plane the tailplane usually does have control surfaces, but we don't need them). It has the following aerodynamic tensor:

$$A = \begin{bmatrix} -0.1 & 0 & 0 \\ 1 & -0.5 & 0 \\ 0 & 0 & -0.1 \end{bmatrix}$$

FIGURE 11.1 Screenshot of the **flightsim** demo.

Each wing has an identical control surface force generator. I have used two so that their control surfaces can be operated independently. They use the following aerodynamic tensors for each extreme of the control input:

$$A_{-1} = \begin{bmatrix} -0.2 & 0 & 0 \\ -0.2 & -0.5 & 0 \\ 0 & 0 & -0.1 \end{bmatrix}$$

$$A_0 = \begin{bmatrix} -0.1 & 0 & 0 \\ 1 & -0.5 & 0 \\ 0 & 0 & -0.1 \end{bmatrix}$$

$$A_1 = \begin{bmatrix} -0.2 & 0 & 0 \\ 1.4 & -0.5 & 0 \\ 0 & 0 & -0.1 \end{bmatrix}$$

When the player banks the aircraft, both wing controls work in the same direction. When the player rolls, the controls work in opposition.

Finally, I have added a rudder, a vertical control surface to regulate the yaw of the aircraft. It has the following tensors:

$$A_{-1} = \begin{bmatrix} -0.1 & 0 & -0.4 \\ 0 & -0.1 & 0 \\ 0 & 0 & -0.5 \end{bmatrix}$$

$$A_0 = \begin{bmatrix} -0.1 & 0 & 0 \\ 0 & -0.1 & 0 \\ 0 & 0 & -0.5 \end{bmatrix}$$

$$A_1 = \begin{bmatrix} -0.1 & 0 & 0.4 \\ 0 & -0.1 & 0 \\ 0 & 0 & -0.5 \end{bmatrix}$$

The surfaces are added to the aircraft in a simple setup function and the game loop is exactly as we've seen it before. The user input is passed to the game as it is received by the software (this is a function of the OpenGL system we are using to run the demos; in some engines you may need to call a function to explicitly ask for input). The input directly controls the current values for each control surface.

The full code for the demo can be found in the accompanying source.

11.2.2 A Sailing Simulator

Boat racing is another genre that doesn't require hard constraints, at least in its simplest form: if we want close racing with bumping boats, then we may need to add more complex collision support. For our purposes, we'll implement a simple sailing simulator for a single player.

The aerodynamics of the sail is very similar to the aerodynamics we used for flight simulation. We'll come back to the sail-specific setup in a moment, after we look at the floating behavior of the boat.

Buoyancy

What needs revisiting at this point is our buoyancy model. In Section 6.2.4, we created a buoyancy force generator to act on a particle. We need to extend this to cope with rigid bodies.

Recall that a submerged shape has a buoyancy that depends on the mass of the water it displaces. If that mass of water is greater than the mass of the object, then the net force will be upward and the object will float. The buoyancy force depends only on the volume of the object that is submerged. We approximated this by treating buoyancy like a spring: as the object is gradually more submerged, the force increases until it is considered to be completely underwater, whereupon the force is at its maximum. It doesn't increase with further depth. This is an approximation because it doesn't take into account the shape of the object being submerged.

In our original buoyancy generator, force directly acted on the particle. This is fine for representing balls or other regular objects. On a real boat, however, the buoyancy does two jobs: it keeps the boat afloat and upright. In other words, if the boat begins to lean over (say a gust of wind catches it), more of one side of the boat will be submerged and the added buoyancy on this side of the boat will act to right it.

This tendency to stay upright is caused by the torque component of the buoyancy force. Its linear component keeps the boat afloat, and its torque keeps it vertical. It does this because, unlike in our particle force generator, the buoyancy force doesn't act at the center of gravity.

A submerged part of the boat will have a center of buoyancy, as shown in Figure 11.2. The center of buoyancy is the point at which the buoyancy force can be thought to be acting. Like the buoyancy force itself, the center of buoyancy is related to the displaced water. The center of mass of the displaced water is the same as the center of buoyancy that it generates.

So just as the volume of water displaced depends on the shape of the submerged object, so does the center of buoyancy. The further the center of buoyancy is from the center of mass, the more torque will be generated and the better the boat will be at righting itself. If the center of mass is above the center of buoyancy, then the torque will apply in the opposite direction, and the buoyancy will act to topple the boat.

How do we simulate this in a game? We don't want to get into the messy details of the shape of the water being displaced, and finding its center of mass. Instead, we can simply fix the center of buoyancy to the rigid body. In a real boat, the center of buoyancy will move around as the boat pitches and rolls and a different volume of water is displaced. Most boats are designed so that this variation is minimized, however. Fixing the center of buoyancy doesn't look odd for most games; it shows itself mostly with big waves, but can be easily remedied, as we'll see below.

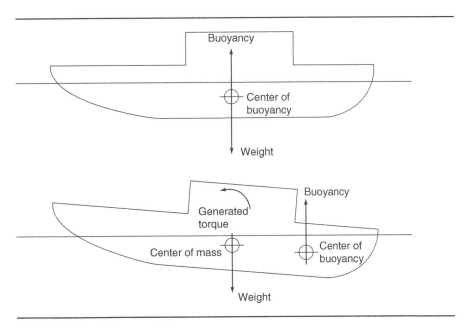

FIGURE 11.2 Different centers of buoyancy.

Our buoyancy force generator can be updated to take an attachment point; otherwise, it is as before:

─────────── **Excerpt from file include/cyclone/fgen.h** ───────────

```
/**
 * A force generator to apply a buoyant force to a rigid body.
 */
class Buoyancy : public ForceGenerator
{
    /**
     * The maximum submersion depth of the object before
     * it generates its maximum buoyancy force.
     */
    real maxDepth;

    /**
     * The volume of the object.
     */
    real volume;

    /**
     * The height of the water plane above y=0. The plane will be
     * parallel to the XZ plane.
     */
    real waterHeight;

    /**
     * The density of the liquid. Pure water has a density of
     * 1000 kg per cubic meter.
     */
    real liquidDensity;

    /**
     * The center of buoyancy of the rigid body, in body coordinates.
     */
    Vector3 centreOfBuoyancy;

public:

    /** Creates a new buoyancy force with the given parameters. */
    Buoyancy(const Vector3 &cOfB,
        real maxDepth, real volume, real waterHeight,
        real liquidDensity = 1000.0f);
```

```
    /**
     * Applies the force to the given rigid body.
     */
    virtual void updateForce(RigidBody *body, real duration);
};
```

There is nothing to stop us from attaching multiple buoyancy force generators to a boat to represent different parts of the hull. This allows us to simulate some of the shift in the center of buoyancy. If we have two buoyancy force generators, one at the front (fore) and one at the rear (aft) of a boat, then as it pitches forward and back (through waves, for example) the fore and aft generators will be at different depths in the water and will therefore generate different forces. The highly submerged front of the boat will pitch up rapidly and believably. Without multiple attachments, this wouldn't be anywhere near as believable, and may be obviously inaccurate.

For our sailing simulator, we will use a catamaran with two hulls and four buoyancy force generators, including one fore and one aft on each hull.

The Sail, Rudder, and Hydrofoils

We will use aerodynamics to provide both the sail and the rudder for our boat. The rudder is like the rudder on the aircraft: it acts to keep the boat going straight (or to turn under the command of the player). On many sailboats, there is both a rudder and a dagger board. The dagger board is a large vertical fin that keeps the boat moving in a straight line and keeps it from easily tipping over when the wind catches the sail. The rudder is a smaller vertical fin that can be tilted for turning. For our needs we can combine the two into one. In fact, in many high-performance sailing boats the two are combined in a single structure.

The sail is the main driving force of the boat, as it converts wind into forward motion. It acts very much like an aircraft wing, turning air flow into lift. In the case of a sailing boat, the lift is used to propel the boat forward. There is a misconception that the sail simply catches the air and the wind drags the boat forward. This can be achieved, certainly, and downwind an extra sail (the spinnaker) is often deployed to increase the aerodynamic drag of the boat, and cause it to be pulled along relative to the water. In most cases, however, the sail acts more like a wing than a parachute. In fact, the fastest boats can achieve incredible lift from their sails, and travel considerably faster than the wind speed.

Both the rudder and the sail are control surfaces; they can be adjusted to get the best performance. They are both rotated, rather than having pop-up control surfaces to modify their behavior (although the sail can have its tension adjusted on some boats). We will therefore implement a force generator for control surfaces using the second possible adjustment approach from Section 11.2.1: rotating the control surface. The force generator looks like this:

```
────────── Excerpt from file include/cyclone/fgen.h ──────────
/**
 * A force generator with an aerodynamic surface that can be
 * reoriented relative to its rigid body.
 */
class AngledAero : public Aero {
    /**
     * Holds the orientation of the aerodynamic surface relative
     * to the rigid body to which it is attached.
     */
    Quaternion orientation;

public:
    /**
     * Creates a new aerodynamic surface with the given properties.
     */
    AngledAero(const Matrix3 &tensor, const Vector3 &position,
        const Vector3 *windspeed);

    /**
     * Sets the relative orientation of the aerodynamic surface
     * relative to the rigid body that it is attached to. Note that
     * this doesn't affect the point of connection of the surface
     * to the body.
     */
    void setOrientation(const Quaternion &quat);

    /**
     * Applies the force to the given rigid body.
     */
    virtual void updateForce(RigidBody *body, real duration);
};
```

Note that the force generator keeps an orientation for the surface, and uses this, in combination with the orientation of the rigid body, to create a final transformation for the aerodynamic surface. There is only one tensor, but the matrix by which it is transformed is now the combination of the rigid body's orientaton and the adjustable orientation of the control surface.

Although I won't add them in our example, we could also add wings to the boat, that is, hydrofoils to lift it out of the water. These act just like wings on an aircraft, producing vertical lift. Typically, on a hydrofoil boat, they are positioned lower than any part of the hull. The lift raises the boat out of the water (whereupon there is no buoyancy force, of course, but no drag from the hull either) and only the hydrofoils

FIGURE 11.3 Screenshot of the **sailboat** demo.

remain submerged. The hyrdofoils can be easily implemented as modified surface force generators. The modification needs to make sure that the boat doesn't start flying: it generates no lift once the foil has left the water. In practice, a hydrofoil is often designed so that it produces less lift the higher the boat is out of the water, so the boat rapidly reaches its optimum cruising height. This behavior also wouldn't be difficult to implement by scaling back the tensor-generated force based on how near the wing is to the surface of the water. These modifications form part of one of the exercises for this chapter.

The Sailing Example

The **sailboat** demo in the accompanying source code puts all these bits together. You can control a catamaran on a calm ocean. The orientation of the sail and rudder are the only adjustments you can make. The prevailing wind direction and strength are indicated, as you can see from the screenshot in Figure 11.3.

The boat is set up with four buoyancy force generators, a sail, and a rudder. The wind direction changes slowly but randomly over time. It is updated in each frame with a simple recency weighted random function.

The update of the boat is exactly the same as for the aircraft demo, and user input is also handled as before. See the accompanying source code for a complete listing.

11.3 SUMMARY

In this chapter, we've met a set of real-game examples where our physics engine combines with real-world physics knowledge to produce a believable simulation. In the case of both sailing and flight, we use a simplification of fluid dynamics to quickly and simply generate believable behavior.

The aerodynamic tensor isn't sufficient for games that intend to simulate flight or sailing accurately. We'd need to do a lot more work for that. But as they stand they are perfectly sufficient for games that are not intended to be realistic.

The situations I chose for this chapter were selected carefully, however, not to embarrass the physics engine. As it stands, our engine is less capable than the mass aggregate engine we built in Part II of the book. To make it truly useful, we need to add collisions back in. Unfortunately, with rotations in place this becomes a significantly more complex process than we saw in Chapter 7. It is worth taking the time to get it right. In that spirit, before we consider the physics of collisions again, we'll build the code to detect and report collisions in our game. Part IV of the book does that.

11.4 PROJECTS

Mini-Project 11.1

(a) Add a new force generator to the **flightsim** demo to represent the propulsion force from the aircraft's engines (this is currently hardcoded in the update method).

(b) Allow the player to change the power going to the engines.

Mini-Project 11.2

Create a force generator, as in the previous project, to represent the propulsion of the aircraft. Allow the player to control the power of the propulsion and allow it to swivel between a forward force and a downward force. This will allow your aircraft to perform vertical take-off maneuvers.

Mini-Project 11.3

Change the **sailing** demo to represent a speedboat rather than a sailing boat. Make sure that the boat can't get any propulsion power when it has bounced out of the water.

Project 11.1

Create an airplane racing game. Using a simple aerodynamic model, allow the player to control an aircraft, including the power sent to its engines. The game level should consist of a series of hoops that need to be navigated in order in the minimum amount of time. You need to write code to detect whether a plane has passed through a hoop, but you shouldn't need to detect collisions with the hoop itself. The game should display the best lap time and the current lap time. You can extend the game with different airplanes having different performance and aerodynamic features.

Project 11.2

Create a rigid-body remake of the classic game Thrust. The player controls a ship that is under the influence of (very weak) gravity, but can be rotated and propelled.

If the ship hits a wall, it is destroyed (this neatly sidesteps our lack of contact physics). Use torque generators controlled by the player for rotation, and a force generator for propulsion.[1] Start with a simple shape for the level, such as a plane. This allows you to write the collision detect routine simply. This project can be extended with the ideas in the next part of the book to implement more complex level geometry.

1. The original Thrust game, by Jeremy Smith, did not use physics to control the rotation of the ship. The ship rotated at a constant velocity when the appropriate key was pressed.

PART IV

Collision Detection

12

COLLISION
DETECTION

In this chapter and the next we'll take a break from building the physics simulation and look at collision detection. In Chapter 7, we added contacts and collisions to a particle engine, but we removed them to introduce rotating rigid bodies. We're now on the road to putting them back in the engine.

This chapter and Chapter 13 give an overview of where the contact and collision information comes from, and how it is generated. The collision detection system we'll build is quite simple and relatively rudimentary. It is enough to get your physics system working, but I have avoided going into too much detail. There are books longer than this one on this subject alone, and there are many pitfalls and complications that would require discussion.

In Chapter 7, I simply assume that contacts and collisions are generated somehow and provided to the engine for resolution. Beyond very simple cases such as rods and cables, we didn't see how that collision detection is performed. If you are working with an existing collision detection library, then you can take this same approach and skip to Chapter 14, where we look at how contact data is processed. There are a number of excellent collision detection libraries available, some opensource. If your aim is to focus on building the physics, then that might be the best option.

If you are working with an existing game engine, it is likely to have a collision detection system that you can use. It is still worth reading through the following two chapters, however. Some rendering engines provide collision detection routines that are inefficient (many use the same geometry as will be drawn, which is a waste of

Copyright © 2010, Elsevier Inc. All rights reserved.
DOI: 10.1016/B978-0-12-381976-5.00012-7

253

processing time) or don't provide the kind of detailed contact data that the physics system needs.

I will step through a particular approach to collision detection that is useful for smaller games. It is also useful as a jumping-off point to a more complete system, and to raise the kinds of issue that are common to all collision detectors.

If you need to build a complete and comprehensive collision detection system, then I'd recommend Ericson [2005], in the same series as this book. It contains a great deal of detail on tradeoffs, architecture, and optimization that are invaluable for a robust end product.

12.1 THE COLLISION DETECTION PIPELINE

Collision detection can be a very time-consuming process. Each object in the game may be colliding with any other object in the game, and each such pair needs to be checked. If there are hundreds of objects in the game, there may be hundreds of thousands of checks needed. And to make things worse, each check needs to understand the geometry of the two objects involved, which might consist of thousands of polygons. So to perform a complete collision detection, we may need huge numbers of time-consuming checks. This is not possible in the fraction of a second that we have between frames.

Fortunately, there is plenty of room for improvement. The two key problems—having too many possible collisions and having time-consuming checks—have independent solutions.

To reduce the number of checks needed, we can use a two-step process:

- First, we try to find sets of objects that are *possibly* in contact with one another, but without being too concerned about whether they actually are. This is typically quite a fast process that can use rules of thumb and specialized data structures to eliminate the vast majority of possible collision checks. It is called *coarse collision detection* or *broad-phase collision detection.*

- Then a second chunk of code looks at the candidate collisions and does the check to determine whether they actually are in contact. This is *fine collision detection* or *narrow-phase collision detection*. Objects that are in contact are examined to determine the exact data for that contact (we saw this in Chapter 7, where the Contact data structure has a number of pieces of data that need to be provided). This is sometimes called *contact generation*. The results of this step form the input to the physics engine.

The first element is covered in this chapter, and the second will be covered in Chapter 13.

Figure 12.1 shows the collision detection pipeline diagrammatically. The broad-phase detector takes as input all of the objects in the game world. It is responsible for generating a series of object pairs that need further checking. The narrow-phase detector takes these pairs and performs the geometry-based checking.

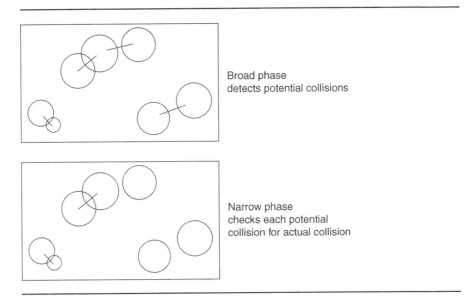

Broad phase
detects potential collisions

Narrow phase
checks each potential
collision for actual collision

FIGURE 12.1 The collision detection pipeline.

To reduce the time taken for each check, the geometry is typically simplified. A special geometry just for collision detection is often created, making contact tests far simpler. This is primarily an issue when we get to narrow-phase collision detection, so it will be discussed in Section 13.1.

12.2 BROAD-PHASE COLLISION DETECTION

The first phase of collision detection is tasked with quickly filtering down all the possible collisions into a much smaller set. This smaller set is then sent to the narrow-phase collision detector to analyze each object's geometry and find collisions and contacts.

Although we can separate these two steps conceptually, we don't always separate them in code. It is usually more convenient to have the broad-phase collision detector simply call the narrow-phase collision detector for each possible collision, as it finds them. I have seen developers separate these pieces of code, however, when they know they'll be using a range of different approaches for broad-phase or narrow-phase collision detection: having separate chunks of code allows them to be configured more easily.

Another benefit of keeping these separate is the ability to add other helper classes in the pipeline. An example is shown in Figure 12.2. Here an additional layer of code can take the set of candidate collisions from the broad-phase collision detector and further filter them. In this book we'll assume a two-stage process, as this is by far the most common.

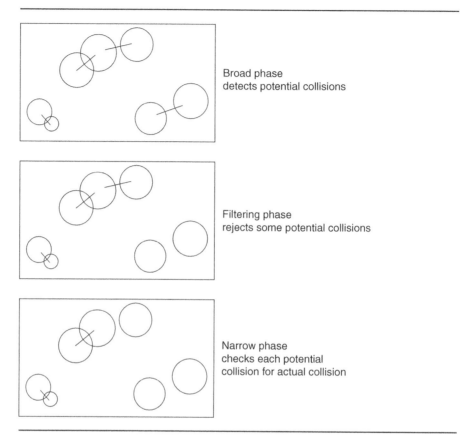

Broad phase
detects potential collisions

Filtering phase
rejects some potential collisions

Narrow phase
checks each potential
collision for actual collision

FIGURE 12.2 A three-stage collision detection pipeline.

12.2.1 REQUIREMENTS

Our broad-phase collision detector needs to have some key features:

- It should be conservative. In other words, all the collisions in the game should be contained in the list of checks. It is allowed to generate checks that end up not being collisions (called *false positives*), but it should not fail to generate checks that would be collisions (called *false negatives*).

- It should generate as small a list as possible. In combination with the item above, this means that the smallest list that it could return is the list of checks that will actually lead to contacts. In that case, the coarse collision detection would be performing a fully accurate collision detection, and there would be no need for further checks. In practice, however, the set of checks it returns will normally contain many false positives.

■ It should be as fast as possible. It may be possible to generate close to the optimum number of required checks, but it defeats the object of the coarse collision detector if it takes a long time to do so.

Most approaches to broad-phase collision detection rely on keeping additional data about the objects in the scene, data that is not needed by the physics engine and narrow-phase collision detector. Objects are held in a data structure that corresponds to the structure of the scene. The collision detector can then query this data structure and rapidly generate the candidate checks to pass on to the narrow-phase detector.

There are two major approaches to structuring this data: the first groups nearby objects together, and then forms groups of groups, and so on; the second has a series of slots for different areas of the scene, and places objects in their appropriate slot. In this chapter, I have called the first approach *bounding volume hierarchies* and the second *spatial partitioning*. Be aware that the latter term is somewhat fluid: it is most commonly used in this way, but sometimes bounding volume hierarchies are also described as spatial partitioning, because they too partition space in some way. We'll look at these two approaches in turn.

12.3 Bounding Volume Hierarchies

A bounding volume is an area of space that is known to contain all of an object. To represent the volume for broad-phase collision detection, a simple shape is used, typically a sphere or a box. The shape is made large enough so that the entire object is guaranteed to be inside of the shape. Figure 12.3 shows two objects with spherical bounding volumes.

The shape can then be used to perform some simple intersection tests. If two objects have bounding volumes that don't touch, then there is no way in which the objects within them can be in contact. We can perform rapid intersection tests on the

Spherical bounding volume

Complex object

FIGURE 12.3 A spherical bounding volume.

bounding volumes, and only if they overlap do we need to do further work to see if the objects intersect. This matches our requirements from Section 12.2.1.

Ideally, bounding volumes should be as close fitting to their object as possible. If two close-fitting bounding volumes touch, then their objects are likely to touch. If most of the space inside the bounding volumes isn't occupied, then touching bounding volumes is unlikely to mean that the objects are in contact.

Spheres are convienient because they are easy to represent. Storing the center of the sphere and its radius is enough:

```
struct BoundingSphere
{
    Vector3 center;
    real radius;
};
```

It is also very easy to check whether two spheres overlap (see Chapter 13 for more detail and code). They overlap if the distance between their centers is less than the sum of their radii. Spheres are a good choice of bounding volumes for most objects.

Rectangular boxes are also often used. They can be represented as a central point and a set of dimensions, one for each direction. These dimensions are often called "half-sizes" or "half-widths" because they represent the distance from the central point to the edge of the box, which is half the overall size of the box in the corresponding direction.

```
struct BoundingBox
{
    Vector3 center;
    Vector3 halfSize;
};
```

There are two common ways to use boxes as bounding volumes: either aligned to the world coordinates (called *axis-aligned bounding boxes*, or AABBs), or aligned to the object coordinates (called *object-bounding boxes*, or OBBs). It is common for OBBs to be able to be oriented differently from the object they are enclosing. They still rotate with the object and are expressed in object space, but they have a constant offset orientation. This allows even tighter fitting in some cases, but adds an extra orientation to their representation and some overhead when working with them. The BoundingBox data structure defined above would work for either axis-aligned bounding boxes or object-bounding boxes with the same orientation as the rigid body they contained. For a general object-bounding box, we'd need to have a separate orientation quaternion in the bounding box structure. Spheres have no such distinction because they don't change under rotation.

For tall and thin objects, a bounding box will fit much more tightly than a bounding sphere. But detecting touching boxes is much more complex than detecting touching spheres, and so spheres are often a good place to start.

There are other bounding volume representations possible, with their own strengths and weaknesses. None are very widespread, however, so I will ignore them for the purposes of this chapter. They are more commonly used for narrow-phase detection, and so are discussed in Ericson [2005].

In the rest of this chapter, I will use only bounding spheres. Anything that can be done with bounding spheres can be done with bounding boxes. Typically, the box version has exactly the same algorithm, but will have a more complex (and therefore time-consuming) intersection test. To come to grips with the algorithms, bounding spheres are simpler to work with.

As a tradeoff, however, it's important to remember that we're using these volumes as a first check to see if objects are touching. If we had more accurate bounding volumes, then the first check would be more accurate, so we'd have less follow-on work to do. In many cases (particularly with lots of box-like things in the game, such as crates), bounding spheres will generate lots more potential collisions than bounding boxes. Then the time we save in doing the simpler sphere collision tests will be lost by having lots of potential collisions to reject using the more complex narrow-phase collision detection routines in Chapter 13.

12.3.1 HIERARCHIES

With each object enclosed in a bounding volume, we can do a cheap test to see if objects are likely to be in contact. If the bounding volumes are touching, then the check can be returned from the broad-phase collision detector for a more detailed examination by the narrow-phase collision detector.

This speeds up collision detection dramatically, but it still involves checking every pair of objects. We can avoid doing most of these checks by arranging bounding volumes in hierarchies.

A bounding volume hierarchy (BVH) has each object in its bounding volume at the leaves of a tree data structure. The lowest-level bounding volumes are connected to parent nodes in the data structure, each of which has its own bounding volume. The bounding volume for a parent node is big enough to enclose all the objects descended from it.

We could calculate the bounding box at each level in the hierarchy so that it best fits the object contained within it. This would give us the best possible set of hierarchical volumes. Many times, however, we can take the simpler route of choosing a bounding volume for a parent node that encompasses the bounding volumes of all its descendants. This leads to larger bounding volumes near the root of the tree, but recalculation of bounding volumes can be much faster. There is a tradeoff, therefore, between query performance (determining potential collisions) and the speed of building the data structure.

Figure 12.4 illustrates a hierarchy containing four objects and three layers. Note that there are no objects attached to parent nodes in the figure. This isn't an absolute

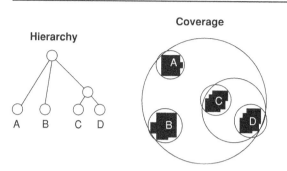

FIGURE 12.4 A spherical bounding volume hierarchy.

requirement: we could have objects higher in the tree, providing that their bounding volume completely encompasses their descendants. In most implementations, however, objects are only found at the leaves. It is also common practice to have only two children for each node in the tree (i.e., a binary tree data structure). There are mathematical reasons for doing this (in terms of the speed of execution of collision queries), but the best reason to use a binary tree is ease of implementation: it makes the data structure compact, and simplifies several of the algorithms we discuss in the following sections.

We can use the hierarchy to speed up collision detection: if the bounding volumes of two parent nodes in the tree do not touch, then *none* of the objects that descend from those nodes can possibly be in contact. By testing two bounding volumes high in the hierarchy, we can exclude all their descendants immediately.

If the two high-level nodes do touch, then the children of each node need to be considered. Only combinations of these children that touch can have descendants that are in contact. The hierarchy is descended recursively; at each stage only those combinations of volumes that are touching are considered further. The algorithm finally generates a list of potential contacts between objects. This list is exactly the same as would have been produced by considering each possible pair of bounding volumes, but it is typically found to be many times faster.[1]

Assuming that the hierarchy encompasses all the objects in the game, the code to get a list of potential collisions looks like this:

─── Excerpt from file `include/cyclone/collide_broad.h` ───
```
/**
 * Stores a potential contact to check later.
 */
```

1. I say typically because it is possible that a bounding hierarchy would be slower to query than checking all possible combinations. If all the objects in the game are touching or nearly touching one another, then almost every bounding volume check will come up positive. In this case, having the overhead of descending the hierarchy adds time. Fortunately, this situation only occurs rarely, and usually only when there are very few objects. With a larger number of objects, there are checks that will fail, and the hierarchy becomes faster.

```
struct PotentialContact
{
    /**
     * Holds the bodies that might be in contact.
     */
    RigidBody* body[2];
};

/**
 * A template class for nodes in a bounding volume hierarchy. This
 * class uses a binary tree to store the bounding volumes.
 */
template<class BoundingVolumeClass>
class BVHNode
{
public:
    /**
     * Holds the child nodes of this node.
     */
    BVHNode * children[2];

    /**
     * Holds a single bounding volume encompassing all the
     * descendants of this node.
     */
    BoundingVolumeClass volume;

    /**
     * Holds the rigid body at this node of the hierarchy.
     * Only leaf nodes can have a rigid body defined (see isLeaf).
     * Note that it is possible to rewrite the algorithms in this
     * class to handle objects at all levels of the hierarchy,
     * but the code provided ignores this vector unless firstChild
     * is NULL.
     */
    RigidBody * body;

    /**
     * Checks whether this node is at the bottom of the hierarchy.
     */
    bool isLeaf() const
    {
        return (body != NULL);
    }
```

```
    /**
     * Checks the potential contacts from this node downward in
     * the hierarchy, writing them to the given array (up to the
     * given limit). Returns the number of potential contacts it
     * found.
     */
    unsigned getPotentialContacts(PotentialContact* contacts,
                                  unsigned limit) const;
};

// Note that because we're dealing with a template here, we
// need to have the implementations accessible to anything that
// imports this header.

template<class BoundingVolumeClass>
bool BVHNode<BoundingVolumeClass>::overlaps(
    const BVHNode<BoundingVolumeClass> * other
    ) const
{
    return volume->overlaps(other->volume);
}

template<class BoundingVolumeClass>
unsigned BVHNode<BoundingVolumeClass>::getPotentialContacts(
    PotentialContact* contacts, unsigned limit
    ) const
{
    // Early out if we don't have the room for contacts, or
    // if we're a leaf node.
    if (isLeaf() || limit == 0) return 0;

    // Get the potential contacts of one of our children with
    // the other.
    return children[0]->getPotentialContactsWith(
        children[1], contacts, limit
        );
}

template<class BoundingVolumeClass>
unsigned BVHNode<BoundingVolumeClass>::getPotentialContactsWith(
    const BVHNode<BoundingVolumeClass> *other,
    PotentialContact* contacts,
```

```
        unsigned limit
        ) const
{

    // Early out if we don't overlap or if we have no room
    // to report contacts.
    if (!overlaps(other) || limit == 0) return 0;

    // If we're both at leaf nodes, then we have a potential contact.
    if (isLeaf() && other->isLeaf())
    {
        contacts->body[0] = body;
        contacts->body[1] = other->body;
        return 1;
    }

    // Determine which node to descend into. If either is
    // a leaf, then we descend the other. If both are branches,
    // then we use the one with the largest size.
    if (other->isLeaf() ||
        (!isLeaf() && volume->getSize() >= other->volume->getSize()))
    {
        // Recurse into self.
        unsigned count = children[0]->getPotentialContactsWith(
            other, contacts, limit
            );

        // Check that we have enough slots to do the other side too.
        if (limit > count) {
            return count + children[1]->getPotentialContactsWith(
                other, contacts+count, limit-count
                );
        } else {
            return count;
        }
    }
    else
    {
        // Recurse into the other node.
        unsigned count = getPotentialContactsWith(
            other->children[0], contacts, limit
            );

        // Check that we have enough slots to do the other side too.
        if (limit > count) {
```

```
                return count + getPotentialContactsWith(
                    other->children[1], contacts+count, limit-count
                    );
            } else {
                return count;
            }
        }
    }
}
```

This code can work with any kind of bounding volume hierarchy, as long as each node implements the overlaps method to check whether two volumes overlap. The bounding sphere hierarchy is implemented by instantiating this template with the following BoundingSphere node:

```
─────────── Excerpt from file include/cyclone/collide_broad.h ───────────
/**
 * Represents a bounding sphere that can be tested for overlap.
 */
struct BoundingSphere
{
    Vector3 center;
    real radius;

public:
    /**
     * Creates a new bounding sphere at the given center and radius.
     */
    BoundingSphere(const Vector3 &center, real radius);

    /**
     * Creates a bounding sphere to enclose the two given bounding
     * spheres.
     */
    BoundingSphere(const BoundingSphere &one, const BoundingSphere &two);

    /**
     * Checks whether the bounding sphere overlaps with the other given
     * bounding sphere.
     */
    bool overlaps(const BoundingSphere *other) const;

};
```

─────────── **Excerpt from file src/collide_broad.cpp** ───────────

```cpp
BoundingSphere::BoundingSphere(const BoundingSphere &one,
                               const BoundingSphere &two)
{
    Vector3 centerOffset = two.center - one.center;
    real distance = centerOffset.squareMagnitude();
    real radiusDiff = two.radius - one.radius;

    // Check whether the larger sphere encloses the small one.
    if (radiusDiff*radiusDiff >= distance)
    {
        if (one.radius > two.radius)
        {
            center = one.center;
            radius = one.radius;
        }
        else
        {
            center = two.center;
            radius = two.radius;
        }
    }

    // Otherwise, we need to work with partially
    // overlapping spheres.
    else
    {
        distance = real_sqrt(distance);
        radius = (distance + one.radius + two.radius) * ((real)0.5);

        // The new center is based on one's center, moved toward
        // two's center by an amount proportional to the spheres'
        // radii.
        center = one.center;
        if (distance > 0)
        {
            center += centerOffset * ((radius - one.radius)/distance);
        }
    }

}

bool BoundingSphere::overlaps(const BoundingSphere *other) const
```

```
{
    real distanceSquared = (center - other->center).squareMagnitude();
    return distanceSquared < (radius+other->radius)*(radius+other
                                                      ->radius);
}
```

In a full collision detection system, it is common to have a method to query the hierarchy against a known object as well. This is simpler still, as the object's bounding volume is checked against the root of the hierarchy, and as long as it overlaps, each descendant is checked recursively.

12.3.2 BUILDING THE HIERARCHY

An important question to ask at this stage is how the hierarchy gets constructed. It may be that your graphics engine has a bounding volume hierarchy already in place. Bounding volume hierarchies are used extensively to reduce the number of objects that need to be drawn. The root node of the hierarchy has its volume tested against the current camera. If any part of the bounding volume can be seen by the camera, then its child nodes are checked recursively. If a node can't be seen by the camera, then none of its descendants need to be checked. This is the same algorithm we used for collision detection: in fact, it is effectively checking for collisions with the viewable region (called the *camera frustum*) of the game level.

In some cases, a graphics engine may not have an existing bounding volume hierarchy to determine what objects can be seen, or if you are creating a game from scratch you'll have to create your own. Ideally, the hierarchy should have some key properties:

- The volume of the bounding volumes should be as small as possible at each level of the tree. This means that when constructing a parent node, we should choose child nodes that are close together.

- Child bounding volumes of any parent should overlap as little as possible. Often this clashes with the first requirement, and in general it is better to prefer smaller volumes than minimal overlaps. In fact, if you choose a minimal overlap at some low level of the tree, it is likely to cause greater overlaps higher up the tree. Consequently, a tree with an overall low overlap is likely to fulfill both requirements.

- The tree should be as balanced as possible. We want to avoid very deep branches while others are very shallow. The worst-case scenario is a tree with only one long branch. In this case, the advantage of having a hierarchy at all is minimal. The biggest speed-up is gained when all branches are roughly the same length.

There are various ways to construct a hierarchy, and each is a compromise between speed and quality. For worlds where objects don't move much, a hierarchy can be

created offline (i.e., not when the game is running, but rather while the level is loading, or more likely as part of building the level before it ships). For very dynamic worlds where objects are constantly in motion, the hierarchy needs to be rebuilt during the game.

I will give an overview and flavor of how hierarchies can be constructed, but there are many more variations and techniques than I can describe in detail here. You can find more information in Ericson [2005].

There are three algorithm families for building a BVH:

Bottom Up: The bottom-up approach (illustrated in Figure 12.5) starts with a list of unprocessed bounding volumes corresponding to individual objects. Pairs of these volumes are chosen based on our goals for a good hierarchy. A new parent node is added that encloses the pair. This parent node then replaces its two children in the unprocessed list. The process continues until there is only one node left in the list—this is the root of the hierarchy.

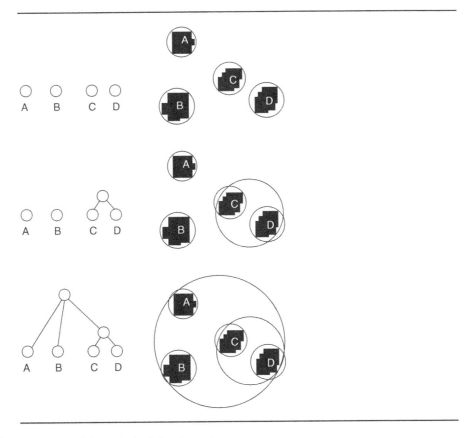

FIGURE 12.5 Bottom-up hierarchy building in action.

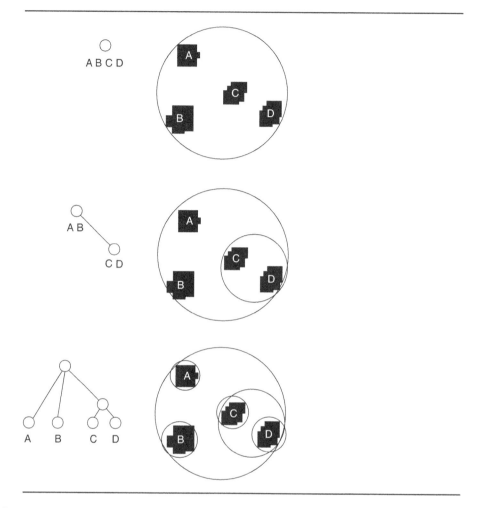

FIGURE 12.6 Top-down hierarchy building in action.

Top Down: The top-down approach (illustrated in Figure 12.6) starts with the same unprocessed list as before. At each iteration of the algorithm, the objects in the list are separated into two groups so that each group is clustered together. The same algorithm then applies to each group, splitting it into two, until there is only one object in each group. Each split represents a node in the tree.

Insertion: The insertion approach (illustrated in Figure 12.7) is the only one suitable for use during the game. It can adjust the hierarchy without having to rebuild it completely. The algorithm begins with an existing tree (it can be an empty tree, if we are starting from scratch). An object is added to the tree by descending the tree recursively: at each node the child is selected that would best accommodate

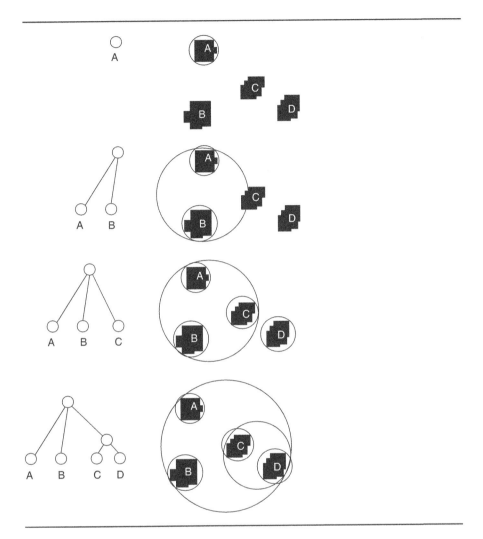

FIGURE 12.7 Insertion hierarchy building in action.

the new object. Eventually an existing leaf is reached, which is then replaced by a new parent containing both the existing leaf and the new object.

Each algorithm has many variations. The exact criteria used to group nodes together has a major effect on the quality of the tree. The bottom-up approach generally searches for nearby objects to group; the top-down approach can use any number of clustering techniques to split the set; and the insertion approach needs to decide which child would be best to recurse into at each level of the tree. The specifics of the tradeoffs involved are complex, and to get optimum results they require a good deal of fine-tuning and experimentation.

Fortunately, even a simple implementation will give us reasonable tree quality, and a good speed-up for the broad-phase collision detector. For our implementation, I have selected an insertion algorithm, for the flexibility of being usable during the game. Given the sphere hierarchy we created previously, we can implement the insertion algorithm as follows:

```
───────────── Excerpt from file include/cyclone/collide_broad.h ─────────────
template<class BoundingVolumeClass>
class BVHNode
{
    // ... Other BVHNode code as before ...

    /**
     * Inserts the given rigid body, with the given bounding volume,
     * into the hierarchy. This may involve the creation of
     * further bounding volume nodes.
     */
    void insert(RigidBody* body, const BoundingVolumeClass &volume);
};

template<class BoundingVolumeClass>
void BVHNode<BoundingVolumeClass>::insert(
    RigidBody* newBody, const BoundingVolumeClass &newVolume
    )
{
    // If we are a leaf, then the only option is to spawn two
    // new children and place the new body in one.
    if (isLeaf())
    {
        // Child one is a copy of us.
        children[0] = new BVHNode<BoundingVolumeClass>(
            this, volume, body
            );

        // Child two holds the new body.
        children[1] = new BVHNode<BoundingVolumeClass>(
            this, newVolume, newBody
            );

        // And we now lose the body (we're no longer a leaf).
        this->body = NULL;

        // We need to recalculate our bounding volume.
        recalculateBoundingVolume();
```

```
        }

        // Otherwise, we need to work out which child gets to keep
        // the inserted body. We give it to whoever would grow the
        // least to incorporate it.
        else
        {
            if (children[0]->volume.getGrowth(newVolume) <
                children[1]->volume.getGrowth(newVolume))
            {
                children[0]->insert(newBody, newVolume);
            }
            else
            {
                children[1]->insert(newBody, newVolume);
            }
        }
    }
}
```

At each node in the tree, we choose the child whose bounding volume would be least expanded by the addition of the new object. The new bounding volume is calculated based on the current bounding volume and the new object. The line between the centers of both spheres is found, as is the distance between the extremes of the two spheres along that line. The center point is then placed on that line between the two extremes, and the radius is half the calculated distance. Figure 12.8 illustrates this process.

Note that the combined bounding sphere encompasses both child bounding spheres—typically, the sphere that encloses the child objects is not the smallest one. We suffer this extra wasted space for performance reasons. To calculate the bounding sphere around two objects, we'd need to get down to the nitty-gritty of their geometries. For very complex objects, this could make the process too slow for in-game use.

We can perform a similar algorithm to remove an object. In this case, it is useful to be able to access the parent node of any node in the tree, so we need to extend the data structure holding the hierarchy to have this parent link. It now looks like the following:

—————— **Excerpt from file `include/cyclone/collide_broad.h`** ——————

```
template<class BoundingVolumeClass>
class BVHNode
{
    // ... Other BVHNode code as before ...

    /**
```

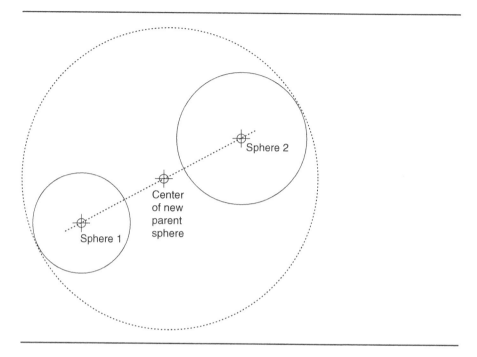

FIGURE 12.8 Working out a parent bounding sphere.

```
      * Holds the node immediately above us in the tree.
      */
     BVHNode * parent;
};
```

Removing an object from the hierarchy involves replacing its parent node with its sibling, and recalculating the bounding volumes further up the hierarchy. Figure 12.9 illustrates this process. It can be implemented as follows:

```
——————— Excerpt from file include/cyclone/collide_broad.h ———————
template<class BoundingVolumeClass>
class BVHNode
{
    // ... Other BVHNode code as before ...

    /**
     * Deletes this node, removing it first from the hierarchy,
```

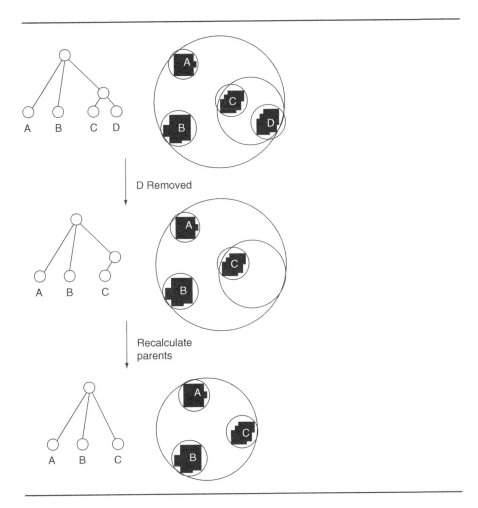

FIGURE 12.9 Removing an object from a hierarchy.

```
     * along with its associated rigid body and child nodes. This
     * method deletes the node and all its children (but obviously
     * not the rigid bodies). This also has the effect of deleting
     * the sibling of this node, and changing the parent node so
     * that it contains the data currently in the system. Finally,
     * it forces the hierarchy above the current node to reconsider
     * its bounding volume.
     */
    ~BVHNode();
};
```

```
template<class BoundingVolumeClass>
BVHNode<BoundingVolumeClass>::~BVHNode()
{
    // If we don't have a parent, then we ignore the sibling
    // processing.
    if (parent)
    {
        // Find our sibling.
        BVHNode<BoundingVolumeClass> *sibling;
        if (parent->children[0] == this) sibling = parent->children[1];
        else sibling = parent->children[0];

        // Write its data to our parent.
        parent->volume = sibling->volume;
        parent->body = sibling->body;
        parent->children[0] = sibling->children[0];
        parent->children[1] = sibling->children[1];

        // Delete the sibling (we blank its parent and
        // children to avoid processing/deleting them).
        sibling->parent = NULL;
        sibling->body = NULL;
        sibling->children[0] = NULL;
        sibling->children[1] = NULL;
        delete sibling;

        // Recalculate the parent's bounding volume.
        parent->recalculateBoundingVolume();
    }

    // Delete our children (again, we remove their
    // parent data so we don't try to process their siblings
    // as they are deleted).
    if (children[0]) {
        children[0]->parent = NULL;
        delete children[0];
    }
    if (children[1]) {
        children[1]->parent = NULL;
        delete children[0];
    }
}
```

12.3.3 SUBOBJECT HIERARCHIES

Some objects you'll need to simulate are large or have awkward shapes. It is difficult to create any simple bounding volume that fits tightly around them. For any particular bounding volume shape, there will be additional objects that simply don't suit that format. In each case the bounding volume is too large, and the coarse collision detector will return too many false positives.

To solve this problem, it is possible to use multiple bounding volumes for one object, arranged in a hierarchy. In Figure 12.10, we have a long thin object with a protrusion. Neither the bounding box nor sphere fit nicely around it. If we use a hierarchy of bounding objects, we can provide a much closer fit. In this case, the bounding boxes provide a better fit, although using a hierarchy of lots of bounding spheres would also work.

The algorithm for detecting collisions is the same as for the single-object hierarchical bounding volume. Rather than stopping at the bounding volume for the whole object, we can perform a finer-grained set of checks while still using the simple bounding volume comparison. The only adjustment we'll need is to never generate potential contacts between the different bounding volumes of one object. In the figure, for example, the two boxes will always be in contact, and we won't want the collision resolution system to do anything about it.

We could also use the same approach to build hierarchy for the game level itself. Clearly, most game levels are so large that their bounding volume is likely to encompass all other objects (although outdoor levels represented as a box can exclude objects at a high altitude). To get a better fit, we can decompose the level into a hierarchy of bounding volumes. Because of the box-like structure of most game levels (rectangular walls, flat floors, and so on), a bounding box hierarchy is typically better than bounding spheres.

While this is acceptable, provides good performance, and has been used in some games, a more popular approach is to use a spatial partitioning scheme to generate collisions with the game level.

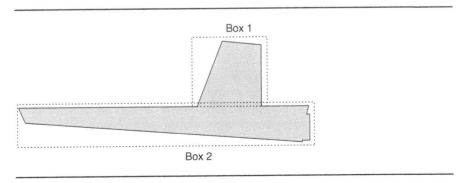

FIGURE 12.10 A subobject bounding volume hierarchy.

12.4 Spatial Partitioning

Several different approaches to coarse collision detection fall under the banner of *spatial partitioning*. The distinction between the data structures used in spatial partitioning algorithms (I'll call these *spatial data structures*) and bounding volume hierarchies is somewhat blurry.

A bounding volume hierarchy groups objects together based on their relative positions and sizes. If the objects move, then the hierarchy will move too. For different sets of objects, the hierarchy will have a very different structure.

A spatial data structure is locked to the world. If an object is found at some location in the world, it will be mapped to a particular position in the data structure. A spatial data structure doesn't change its structure depending on what objects are placed within it. This makes it much easier to construct the data structure, because we can normally place objects directly in the data structure based on their coordinates.

In reality the line between the two is blurred, and a combination of techniques is sometimes used (hierarchies embedded in a spatial data structure, for example, or less commonly a spatial data structure at one node in a hierarchy). It is also worth noting that even when no bounding volume hierarchies are used, it is very common to use bounding volumes around each object. In the remainder of this chapter, I will assume that objects are wrapped in a bounding volume: it makes many of the algorithms far simpler.

This section looks at three common spatial partitioning schemes, each with its own spatial data structures: binary space partition (BSP) trees, quad- and oct-trees, and grids. In most games, only one of these will be used.

12.4.1 Binary Space Partitioning

A BSP tree is queried in a similar way to a bounding volume hierarchy. It is a binary tree data structure, and a recursive algorithm starts at the top of the tree and descends into child nodes only if they are capable of taking part in a collision.

Rather than use bounding volumes, however, each node in the BSP defines a plane that divides all space in two. It has two child nodes, one for each side of the plane. Objects lying on the front side of the plane will be a descendant of one node, and those on the back side will descend from the other. Objects that cross the plane are handled differently: they can be directly attached to another child node;[2] placed in the child node that they are nearest to; or more commonly, placed in both child nodes.

The dividing planes at each node can have any position and orientation, allowing all space to be divided up in arbitrary ways. Figure 12.11 shows a 2D version, but the same structure works for 3D.

2. This is a common optimization, but strictly produces a ternary rather than a binary tree. It is still called a BSP; however, I've never heard it called a ternary space partitioning tree.

Each plane in the BSP is represented as a vector position and a normalized vector direction:

```
struct Plane
{
    Vector3 position;
    Vector3 direction;
};
```

This is a very common way to represent a plane: the position is any location on the plane, and the direction points out at right angles to the plane. The same plane can be generated if we reverse the direction: it would still be at right angles to the plane, but facing in the opposite direction. The fact that the direction vector points out from one side of the plane means that we can distinguish one side from the other. Any object is either on the side where the direction is pointing (we'll call this the "front" side), or the other ("back") side. This distinction allows us to select the appropriate child node in the BSP.

To determine what side of the plane an object lies on, we make use of the geometric interpretation of the scalar product, given in Chapter 2. Recall that the scalar product allows us to find the component of one vector in the direction of another:

$$c = (\boldsymbol{p}_o - \boldsymbol{p}_P) \cdot \boldsymbol{d}_P$$

where \boldsymbol{p}_o is the position of the object we are interested in (we normally use the position of the center of its bounding volume), \boldsymbol{p}_P is the position of any point on the plane (i.e., the point we are using to store the plane), and \boldsymbol{d}_P is the direction that the plane is facing.

If c is positive, then the center of the object lies on the front side of the plane. If it is negative, then the object lies on the back side. If c is zero, then it lies exactly on the plane. The direction vector, \boldsymbol{d}_P, should be a normalized vector, in which case $|c|$ gives the distance of the object from the plane.

Assuming that the object has a spherical bounding volume, we can determine whether it is completely on one side of the plane by checking if

$$|c| \geq r_o$$

where r_o is the radius of the bounding volume for the object.

We can build a BSP tree from nodes that contain a plane and two child nodes:

```
struct BSPNode
{
    Plane plane;
    BSPNode front;
```

```
        BSPNode back;
};
```

In practice, each child node (front and back) can hold either another node or a set of objects. Unlike for bounding volume hierarchies, BSPs normally allow any number of objects at a leaf of the tree.

This could be implemented in C++ as follows:

```
typedef vector<Object*> BSPObjectSet;

enum BSPChildType
{
    NODE,
    OBJECTS
};

struct BSPChild
{
    BSPChildType type;

    union {
        BSPNode *node;
        BSPObjectSet *objects;
    };
};

struct BSPNode
{
    Plane plane;
    BSPChild front;
    BSPChild back;
};
```

or using polymorphism, inheritance, and C++ runtime time inference (RTTI):

```
struct BSPElement
{
};

struct BSPObjectSet : public BSPElement
{
```

```
        vector<Object*> objects;
};

struct BSPNode : public BSPElement
{
    Plane plane;
    BSPElement front;
    BSPElement back;
};
```

The leaves of all spatial data structures will usually be capable of carrying any number of objects. This is where bounding volume hierarchies can be useful—the group of objects at the leaf of the BSP can be represented as a BVH:

```
enum BSPChildType
{
    NODE,
    OBJECTS
};

struct BSPChild
{
    BSPChildType type;

    union {
        BSPNode *node;
        BoundingSphereHierarchy *objects;
    };
};

struct BSPNode
{
    Plane plane;
    BSPChild front;
    BSPChild back;
};
```

Let's assume that we have a BSP tree where objects that intersect a plane are placed in both child nodes. In other words, one object can be at several locations in the tree. This is the most common approach to intersecting plane-spanning objects, in my experience.

The only collisions that can possibly occur are between objects that are at the same leaf in the tree. We can simply consider each leaf of the tree in turn, if it has at least two objects contained within it; then all pair combinations of those objects can be sent to the fine collision detector for detailed checking.

If we place a bounding volume hierarchy at the leaves of the BSP tree, we can then call the BVH algorithm for each hierarchy. In this case, we have two broad-phase collision detection algorithms working in concert.

If there are many objects, some large objects, or lots of partition planes, then having an object in multiple branches of the tree can lead to much larger data structures and poor performance. The algorithm above can be modified to detect collisions when overlapping objects are only sent to one child node, or are held in a third child with the parent node. One of the exercises in this chapter expands on this idea.

BSP trees are common in rendering engines, and just like for bounding volume hierarchies, you may be able to use an existing implementation for your physics system. They are also commonly used to detect collisions between the level geometry and the game level. Figure 12.11 shows a small BSP for part of a game level. Here the BSP doesn't hold objects at its leaves, but a Boolean indication of whether the object is colliding or not. An object is tested against each plane, recursively. If it intersects the plane, both children are checked; otherwise, only one is checked, as before. If the object reaches a leaf that is marked as a collision, then we know a collision has occurred.

Because most collisions will occur between moving objects and the level geometry (which typically cannot change or move in any way), the BSP approach is very useful. Unfortunately, it requires a complex preprocessing stage to build an optimal BSP from the level geometry.

FIGURE 12.11　A BSP for level geometry.

12.4.2 Oct-Trees and Quad-Trees

Oct-trees and quad-trees are spatial tree data structures with many similarities to both BSPs and BVHs. Quad-trees are used for two dimensions (or three dimensions where most objects will be stuck on the ground), and oct-trees for three dimensions. In many 3D games, a quad-tree is as useful as an oct-tree and requires less memory, so I'll focus on that first.

A quad-tree is made up of a set of nodes, each with four descendants. Each node splits space into four areas that intersect at a single point. A node can be represented as a vector position and four children:

```
enum QuadTreeSector
{
    BOTTOM_LEFT, BOTTOM_RIGHT, TOP_LEFT, TOP_RIGHT
};

class QuadTreeNode
{
    Vector3 position;
    QuadTreeNode child[4];
};
```

Testing which of the four areas an object lies in is a simple matter of comparing the corresponding components of their position vector. For an object at (1,4,5) and a QuadTreeNode at (2,0,0), we know that it must be in the top-left area as shown in Figure 12.12, because the x coordinate of the object is less than the node's coordinate, and the z coordinate is greater. We can calculate which child in the array to use with the following simple algorithm:

```
class QuadTreeNode
{
    // ... Other code as before ...

    unsigned int getChildIndex(const Vector3 &objectCentre)
    {
        unsigned int index = 0;
        if (objectCentre.x > position.x) index += 1;
        if (objectCentre.z > position.z) index += 2;
        return index;
    }
}
```

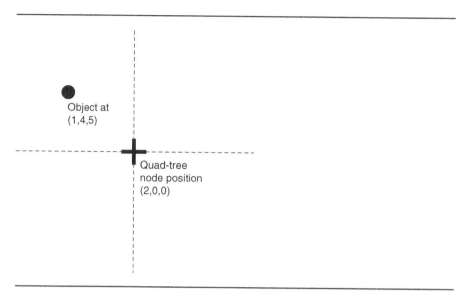

FIGURE 12.12 Identifying an object's location in a quad-tree.

where the indices for each area match those in the QuadTreeSector enumerated type defined above.

An oct-tree works in exactly the same way, but has eight child nodes, and performs a comparison on each of the three vector components to determine where an object is located:

```
enum QuadTreeSector
{
    LOWER_BOTTOM_LEFT, LOWER_BOTTOM_RIGHT,
    HIGHER_BOTTOM_LEFT, HIGHER_BOTTOM_RIGHT,
    LOWER_TOP_LEFT, LOWER_TOP_RIGHT,
    HIGHER_TOP_LEFT, HIGHER_TOP_RIGHT
};

class OctTreeNode
{
    Vector3 position;
    OctTreeNode child[8];

    unsigned int getChildIndex(const Vector3 &objectCentre)
    {
        unsigned int index;
        if (objectCentre.x > position.x) index += 1;
```

```
            if (objectCentre.y > position.y) index += 2;
            if (objectCentre.z > position.z) index += 4;
            return index;
        }
    }
```

Although in theory the position vector for each node can be set anywhere, it is common to see quad- and oct-trees with each node dividing the remaining space in half. Starting with an axis-aligned bounding box that covers all the objects in the game, the top-level node is positioned at the center point of this box. This effectively creates four boxes of the same size (for a quad-tree; eight are created for an oct-tree).

Each of these boxes is represented by a node, whose subdivision position is at the center point of that box, creating four (or eight) more boxes of the same size, and so on down the hierarchy. There are two advantages in using this halving. First, it is possible to get rid of the position vector from the QuadTreeNode or OctTreeNode data structure, and to calculate the point on the fly during recursion down the tree. This saves memory.

Second, it means we don't need to perform any calculations to find the best location to place each node's split point. This makes it much faster to build the initial hierarchy.

Other than their method of recursion and the number of children at each node, the quad- and oct-tree work in exactly the same way as the BSP tree. The algorithms that work with a BSP tree for determining collisions are the same with a quad- or oct-tree, but the test is simpler and there are more possible children to recurse into.

Like with the BSP tree, we also have to decide where to put objects that overlap the dividing lines. In the code examples above, I have assumed the object goes into the child that contains its center. We could instead place the object into all the children that it touches, as we did for the BSP tree, and have the same simple broad-phase collision detection—only objects that are in the same leaf can possibly be in collision.

Quad-trees are particularly useful for outdoor scenes, where objects are placed on a landscape. They are less useful than BSP trees for indoor games, because they can't be used as easily for collision detection with the walls of the level. And, just like BSP trees, they are often used for optimizing rendering and may be part of any existing rendering engine you are using.

Because we query a quad- or oct-tree in the same way we query BSPs, I will skip the listing here. See the accompanying code for a complete implementation.

12.4.3 GRIDS

Our penultimate spatial partitioning scheme takes the idea of a recursive quad-tree and regularizes it. If we draw the split pattern of a halving quad-tree that is several layers deep, we see that it forms a grid (Figure 12.13).

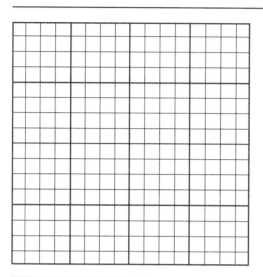

FIGURE 12.13 A quad-tree forms a grid.

Rather than use a tree structure to represent a regular grid, we could simply use a regular grid. A grid is an array of locations in which there may be any number of objects. It is not a tree data structure, because the location can be directly determined from the position of the object. This makes it much faster to find where an object is located than recursing down a tree.

The grid has the following structure:

```
class Grid
{
    unsigned int xExtent;
    unsigned int zExtent;
    ObjectSet *locations; // An array of size (xExtent * zExtent).

    Vector origin;
    Vector inverseCellSize;
};
```

where xExtent and zExtent store the number of cells in each direction of the grid; the x and z components of the inverseCellSize vector contain 1 divided by the size of each cell (we use 1 over the value rather than the actual size, to speed up the algorithm

below); the *y* component is normally set to 1; and `origin` is the origin of the grid. The grid should be large enough so that any object in the game is contained within it.

To determine which location contains the center of an object, we use a simple algorithm:

```
class Grid
{
    // ... Previous code as before ...

    def getLocationIndex(const Vector& objectCentre)
    {
        Vector square = objectCentre.componentProduct(inverseCellSize);
        return (unsigned int)(square.x) + xExtent*(unsigned int)
        (square.z);
    }
};
```

In this code snippet, we first find which square the object is in by dividing each component by the size of the squares (we do the division by multiplying by 1 over the value). This gives us a floating-point value for each component in the vector called `square`. These floating-point values need to be converted into unsigned integers. The integer values are then used to find the index in the grid array, which is returned.

Just as in the BSP and quad-tree, we need to decide what to do with objects that overlap the edge of a square. It is most common to simply place them into one cell or the other, although it would be possible to place them into all cells they overlap. As before, the latter makes it faster to determine the set of possible collisions, but can take up considerably more memory. I'll look at this simpler approach first, before returning to the more complex case.

In a grid where each cell contains all the objects that overlap it, the set of collisions can be generated very simply. Two objects can only be in collision if they occupy the same location in the grid. We can simply look at each location containing more than one object, and check each pair for possible collisions.

Unlike with tree-based representations, the only way we can tell if a location contains two or more objects is to check it. Whereas for a tree we stored the number of objects at each node, and could completely leave out branches that couldn't generate collisions, there is no such speed-up here.

To avoid searching thousands of locations for possible collisions (which for a small number of objects may take longer than if we'd not performed broad-phase collision detection at all), we can create a set of locations in the grid data structure containing more than one object. When we add an object to a cell, if the cell now contains

two objects, it should be added to the occupied list. Likewise, when we remove an object from a cell, if the cell now contains just one object, it should be removed from the list:

```
class Grid
{
    // ... Previous code as before ...

    std::vector<ObjectSet*> activeSets;

    def add(Object* object)
    {
        unsigned location = getLocationIndex(object->center);
        ObjectSet *set = locations + location;
        if (set.size() == 1) activeSets.insert(set);
        set.add(object);
    }

    def remove(Object* object)
    {
        unsigned location = getLocationIndex(object->center);
        ObjectSet *set = locations + location;
        if (set.size() == 2) activeSets.erase(set);
        set.remove(object);
    }
};
```

I've assumed that all the data associated with one object (its bounding volume, rigid body data, etc.) is held in an Object class instance. I've also assumed that the collection of objects in the ObjectSet data structure has methods to add and remove objects. I've used the C++ standard template library's set container type here to hold the set of locations containing more than one object (insert, erase, and size are methods defined by std::set).

With these methods, determining a complete set of collisions is just a matter of walking through each active set and passing all pair-wise combinations to the fine-grained collision detector.

If objects are larger than the size of a cell, they will need to occupy many cells in the grid. This can lead to very large memory requirements with lots of wasted space. For a reasonable-size game level running on a PC, this might not be an issue, but for large levels or memory-constrained platforms, it can be unacceptable.

If we place an object in just one grid cell (the cell in which its center is located, normally), then the broad-phase collision detection routine needs to check for colli-

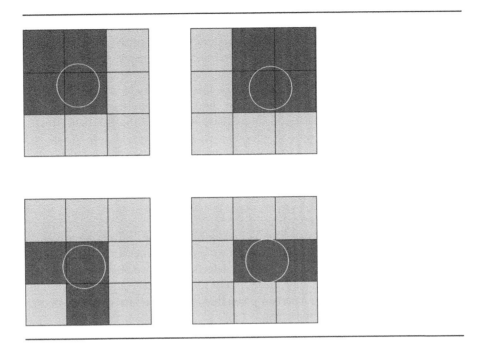

FIGURE 12.14 An object may occupy up to four same-sized grid cells.

sions with objects in neighboring cells. For an object that is the same size as the cell, it needs to check a maximum of three neighbors, from a possible set of eight (see Figure 12.14). This rapidly increases, however, as the object gets bigger. For an object four times the size of the cell, 15 from a possible 24 neighbors need to be considered. It is possible to write code to check the correct neighbors, but for very large objects it involves lots of wasted effort.

A hybrid data structure can be useful in this situation, using multiple grids of different sizes. It is called a *multiresolution map.*

12.4.4 MULTIRESOLUTION MAPS

A multiresolution map is a set of grids with increasing cell sizes. Objects are added into one of the grids only, in the same way as for a single grid. The grid is selected based on the size of the object. Cells in the smallest grid are bigger than the object.

Often the grids are selected so that each one has cells four times the size of the previous one (i.e., twice the width and twice the length for each cell). This allows the multiresolution map to directly calculate which grid to add an object to.

During broad-phase collision detection, the map uses a modified version of the single-grid algorithm. For each grid, it creates a potential collision between each

object and objects in the same or neighboring cells (there are a maximum of three neighbors to check now because objects can't be in a grid cell that is smaller than they are). In addition, the object is checked against all objects in all cells in larger-celled grids that overlap.

We don't need to check against objects in smaller-celled grids, because the small objects are responsible for checking against larger objects.

For each grid in the map, we can use the grid data structure with the same set of occupied cells. However, we need to add a cell to the active list if it contains any objects at all (they may be in contact with neighbors).

12.5 Summary

Collision detection is a complex and time-consuming process. To do it exhaustively takes too long for real-time physics, so some optimization is needed.

We can split collision detection into two phases: a broad phase that finds possible contacts (some may turn out not to be real contacts, but it should never miss a collision); and a narrow phase that checks potential collisions in detail and works out the contact properties.

Broad-phase collision detection works by wrapping objects in a simple bounding volume, such as a sphere or box, and performing checks on the collision volume. The collision volumes can be arranged in a hierarchy that allows entire branches to be excluded, or in a spatial data structure that allows nearby objects to be accessed together.

There are tradeoffs between the methods used in this chapter, and there is potential to blend several approaches together. One important factor to consider is how the rendering engine manages objects when deciding if they should be drawn. If your renderer has a system in place, it would be advisable to try and use or adapt it to save memory and implementation time.

The result of the broad phase is a set of possible contacts that need to be checked in more detail. We will look at the algorithms needed to perform these checks in Chapter 13.

12.6 Exercises

Exercise 12.1
Suppose that we have a BSP tree. An object in the tree has moved by a small amount. Implement an algorithm to make sure that the object is in the correct locations in the tree, without having to rebuild the entire tree.

Exercise 12.2
Implement a two-stage broad-phase collision detection system that uses both a BSP tree and, at each leaf of the tree, an optional bounding volume hierarchy.

Exercise 12.3

Implement a method for the bounding volume hierarchy that generates the overlapping objects for a given object (i.e., one that isn't in the hierarchy). The broad algorithm is given in Section 12.3.1, but the code does not appear there.

Exercise 12.4

In a BSP, rather than placing an object into both children of a plane that the object intersects, we could place it into a new list that belongs to the plane itself.

(a) How would this affect the algorithm for calculating the overlapping objects?

(b) Implement the new algorithm.

Exercise 12.5

Use the quad- or oct-tree implementation as the basis of a multiresolution map. Once more the approach is described in the text, but the implementation is not given. You will need to extend the object definition to include its size: assume that you are using spherical bounding boxes.

Exercise 12.6

(a) Create a system that generates a series of random points in 3D space (we'll use these points to represent an object with complex geometry). Use this set of points to create a bounding sphere and a bounding box. Calculate the volume of each shape. On average, which bounding shape is smaller, and by how much?

(b) If you have access to libraries for other distributions of random numbers (such as Gaussian), how does switching to one of these affect the result?

13

GENERATING
CONTACTS

Broad-phase collision detection is the first stage of generating contacts and determining collisions. The algorithms in the previous chapter produce a list of object pairs that then need to be checked in more detail to see whether they do in fact collide, and to determine more detail about the contact if they do.

Many collision detection systems perform this check for each pair and return a single point of maximum interpenetration if the objects are in contact. That is not what we need. We need to generate all contacts between the pair of objects. There may be any number of such contacts, depending on the shape of the objects touching. Representing the collision with just a single contact works fine for some combinations of objects (like a sphere and the ground plane, for example), but not for others (such as a car and the ground—which wheel do we choose?).

Contact generation is more complex than single-intersection collision detection, and takes more processor time to complete. Often we will have a two-stage process of contact generation: a narrow-phase collision detection step to determine if there are contacts to generate, and then a contact generation step to work out all the contacts that are present.

Just because we have performed a broad-phase filtering step, it doesn't mean we can take as much time as we like to perform fine collision detection and contact generation. Performance is, if anything, more critical at this point. We can dramatically improve the performance by executing collision detection against a simplified geometry rather than the full-resolution used for rendering.

Copyright © 2010, Elsevier Inc. All rights reserved.
DOI: 10.1016/B978-0-12-381976-5.00013-9

The bulk of this chapter looks at generating the contacts between geometric primitives that are useful as stand-in collision geometry. We will consider a range of such primitives, from the simple spheres we've been using up to now, to arbitrary 3D volumes. For each pair of primitives, we can create a contact generation algorithm to determine whether they intersect, and their contact data if they do.

There are lots of possible primitives, and so there are many combinations. Fortunately, the techniques tend to group into a few approaches. This chapter looks at these major approaches by considering a representative selection of intersection types.

Covering all options exhaustively is beyond the scope of this book. There are other books, including van den Bergen [2003], Ericson [2005], and Eberly [2010], that explicitly cover more material than I can cover here.

13.1 COLLISION GEOMETRY

The complex visual geometry in many games is too detailed for speedy contact generation. Instead it is simplified into a chunky geometry created just for the physics. If this chunky geometry consists of certain geometric primitives (i.e., spheres, boxes, cylinders, etc.), then the collision detection algorithms can be simpler than for general-purpose meshes.

In many physics engines, these special primitive shapes are impractical: without human intervention it can be difficult to work out what primitives to use for each object. Building the collision geometry is a step that many developers want to automate, and so the easiest approach is to use polyhedral meshes throughout. Even here, however, we can improve performance. If an object can be built up out of one or more convex meshes, then the collision detection is still simpler than for arbitrary meshes.

The collision geometry isn't the same as the bounding volumes used in broad-phase collision detection. So typically objects in the game will have one or more bounding volumes, some collision geometry, and then any number of different sets of rendering geometry for different levels of detail.

The simplest geometry to use for collision detection and contact generation is the sphere, hence its use in the broad-phase algorithms of the previous chapter. Despite being fast, spheres aren't always terribly useful. Boxes are also relatively quick to process, and can be used in more situations. Other primitives, such as capsules, disks, cylinders, and trimmed primitives, can also be useful. Finally, our chunky polyhedral meshes mop up any remaining use cases.

One situation we'll frequently need to consider is the collision of objects with the background level geometry. Most commonly this means collisions with the ground or some other plane (walls can typically be represented as planes too). To support these, we'll also add planes to our list of primitives, even though we don't normally use them to represent moving objects in the scene.

It is important to remember that the primitives your game needs will depend to some extent on the game. We'll look in detail at planes, spheres, boxes, and convex

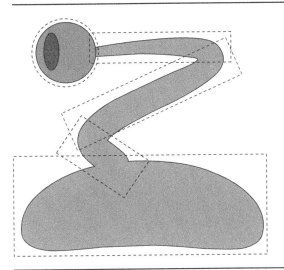

FIGURE 13.1 An object approximated by an assembly of primitives.

meshes in this chapter. The principles are the same for any other kind of primitive, however.

13.1.1 PRIMITIVE ASSEMBLIES

The vast majority of objects can't easily be approximated by a single primitive shape. Some concave objects can't be approximated even by a convex mesh. Rather than use arbitrary meshes (with their associated high performance penalties), we can use assemblies of primitives as collision geometry.

Figure 13.1 shows an object approximated by an assembly of boxes and spheres. To collide two assemblies we need to find all collisions between all pairs of primitives in each object. In this way the assembly acts something like the hierarchy of bounding volumes that we saw in the previous chapter. As before, we never need to perform collision detection between the components of one object.

We can represent assemblies as a list of primitives, with a transform matrix that offsets each primitive from the origin of the object:

```
struct PrimitiveInSet
{
    Primitive *primitive;
    Matrix4 offset;
};
```

```
struct PrimitiveSet : extends Primitive
{
    std::vector<PrimitiveInSet> primitives;
};
```

13.2 Contact Generation

As seen at the start of this chapter, there is an important distinction to make between collision detection and contact generation:

Collision Detection: Determines if a pair of objects are interpenetrating. Often the algorithms used allow the collision detector to return a penetration depth and a point of collision. Typically, they will only detect one such point for a pair of primitives.

Contact Generation: Determines if a pair of objects are interpenetrating and returns a set of contact data if they are. The contact data contains all the information needed to resolve the contacts. This includes the point of contact (or the area for broader contacts) on each object, and the direction and extent of deepest interpenetration at that contact.

I stress this distinction, because it affects the algorithms that we can easily apply to contact generation for a physics engine.

One of the most elegant general-purpose collision detection algorithms, for example, is the *Gilbert Johnson Keerthi distance algorithm* (normally called just GJK). It cannot return all the data we need for a contact. To use it, we would need to write a further algorithm that, when an interpenetration is detected, performs additional processing to determine where and in what direction. GJK is widely used as a collision detection routine for game physics, but if you want to experiment with it, you need to be aware that it won't work for you without modification.

Even algorithms that can give us the data we need without modification, such as the *separating axis theorem* (SAT; see Section 13.4), often produce at most one contact per pair of objects. We can see the problem with having only one contact in Figure 13.2. Here one box is lying across another. In the first part of the figure, the result of a typical collision detection system is shown; the box is slightly (microscopically) twisted, so one edge generates the contact. In the second part of the figure, we have the desired set of contacts from a physics-friendly contact generator.

In Section 13.5, we'll look at how to use a technique called *contact coherence* to extend algorithms that only generate one contact. This lets us avoid the worst behavior associated with generating only one contact. But even then it isn't perfect, and it involves writing a good deal of bookkeeping code.

Most books on collision detection will not tell you how to build a complete system that can be used in a physics engine. They will miss out the calculation of important

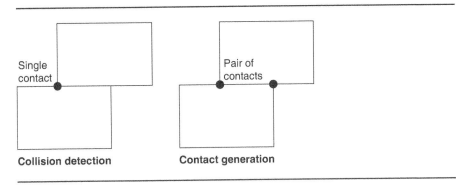

FIGURE 13.2 Collision detection and contact generation.

contact information, or provide algorithms where that information is difficult to access. In fact, most commercial or open-source collision detection systems aren't immediately suitable for physics applications. If you are using a third-party collision detector, it is worth making sure that it does what you need it to before starting to integrate.

13.2.1 CONTACT TYPES

When two objects are in contact or interpenetrating, the contact patch can be of any 3D shape. When we resolve contacts, this makes things very difficult. In Part II, we dealt with contacts and hard constraints where the contact or interpenetration was treated as a single point. These "point contacts" were fairly easy to deal with.

Now that we're dealing with full 3D shapes, we'd like to be able to deal with contacts that are as simple as possible. Fortunately, we can get believable behavior using point contacts with full rigid bodies, but we will have to think more carefully about how we generate them.

Figure 13.3 shows the six ways in which two 3D objects can be in contact, that is, every combination of face, edge, and vertex. Each of these cases generates only one contact point. For each case, that would be the only contact point we'd need to generate.

In many situations, however, we have more than one of these contact cases present at the same time. Consider Figure 13.3 again. We have two kinds of contact here. There is an edge–edge contact, and two edge–vertex contacts. In these cases we can believably simulate the contact using only the edge–vertex contacts, as shown in Figure 13.3. The edge–vertex contacts take priority over the edge–edge contact.

When deciding which contacts to prioritize in this way, we use a heuristic that determines which are most likely to give the best behavior. We can order the contact cases as follows:

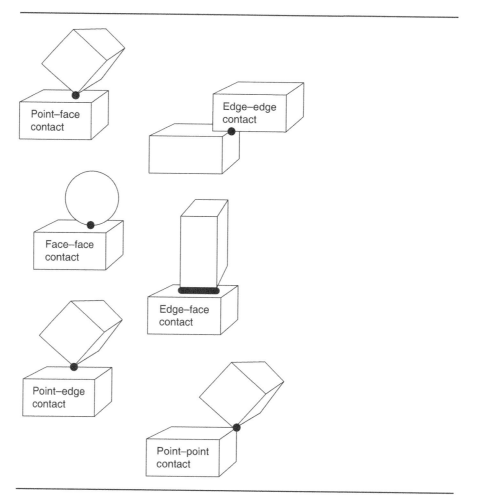

FIGURE 13.3 3D cases of contact.

1. Vertex–face and edge–edge (nonparallel edges)
2. Edge–face and face–face
3. Vertex–edge, vertex–vertex, and edge–edge (parallel edges)

Cases earlier in the list should be generated first. If we have a face–face contact, for example, we will have one of two situations. Either one of the faces will be curved, so that the face–face contact is at a single point, or else at least three contacts from the first item in the list (vertex–face or edge–edge) will be present. In the latter case, we don't need to worry about the face–face contact at all, because the three other contacts will produce believable behavior. If we have several contacts of different types at the

same level in this list (both vertex–face and edge–edge contacts, for example), we have to return all of them; none can take priority.

We have one further optimization to make to this scheme. Some of the contact cases only occur if the objects in the scene are set to just the right position. A vertex–vertex contact, for example, is highly unlikely to occur in practice, unless the objects were explicitly arranged to generate it. If we fail to detect or correct for a vertex–vertex contact, the objects will interpenetrate slightly on the next frame, whereupon one of the higher priority contacts will be found. Figure 13.4 shows this in a two-dimensional cross-section. On the second frame the interpenetration could be interpreted as either a vertex–vertex contact, or as a face–vertex contact. Because of the priority order of contact generation, we'll be interpreting it as a face–vertex contact.

Because of this, we usually don't even bother to try and detect certain types of contact. Vertex–vertex contacts are particularly difficult to generate good contact data for, and because they are so rare, it is most common to ignore this case entirely. If we happen to get a vertex–vertex contact in our simulation, then the collision detector will ignore it, and in the following frame it will have turned into a different kind of collision that can be handled. This inaccuracy is not noticeable. In the priority orders given above, it is normal to ignore the contacts of the lowest priority group: vertex–vertex, and vertex–edge and parallel edge–edge contacts.

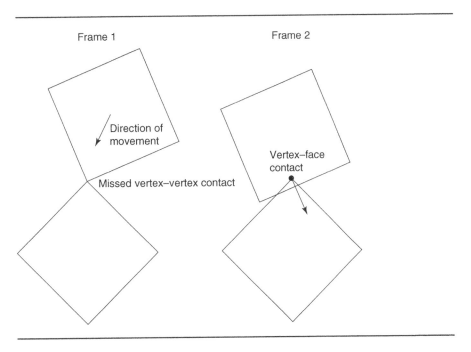

FIGURE 13.4 Ignoring a vertex–vertex contact.

For the primitives we'll be considering (plane, box, sphere, and convex polyhedral mesh), these contact cases, orderings, and exceptions mean that we can write contact generation algorithms that check the valid contact cases in the correct order, and be confident that we can exit when we find a match.

In the collision between a box and a plane, for example, the only possible contacts are vertex–face contacts—between a vertex of the box and the face of the plane. There can be no edge–face or face–face contacts without at least two vertex–face contacts.

In collisions between two convex polyheadral meshes (which by definition have no curved surfaces), we only check for vertex–face and edge–edge contacts. There can be no face–face or face–edge contacts without at least two vertex–face or edge–edge contacts. Again, we ignore the vertex–edge and vertex–vertex cases. We can work through the other primitive combinations in the same way.

13.2.2 CONTACT DATA

In Chapter 14, we will use several pieces of data to resolve each contact. This data will need to be calculated and initialized by the contact generator:

Collision point: This is the point of contact between the objects. In practice, objects will be somewhat interpenetrating and there may be many possible points. In practice, the selection of a point from the many options is largely arbitrary and doesn't drastically affect the physics. Different collision detection algorithms naturally generate different contact points and we can largely use them as is.

Collision normal: This is the direction in which an impact impulse will be felt between the two objects. When we implemented collisions for non-rotating objects in Chapter 7, this was the direction in which interpenetrating objects should be moved apart. By convention, the two objects in the collision are always kept in the same order, and the contact normal points from the first object toward the second. We will assume this convention throughout the contact resolution code in this book.

Penetration depth: This is the amount that the two objects are interpenetrating. It is measured along the direction of the collision normal passing through the collision point, as shown in Figure 13.5.

Collision restitution: This determines how much bounce is in the collision. We don't calculate this in the same way as the data above, because for our purposes, we'll assume it depends only on the bodies involved in the collision, not on their geometric configuration. In the following code I will assume this value is given to us.

Friction: This controls whether the two objects can slide along the contact. As for restitution, this is a value we'll assume is given to us.

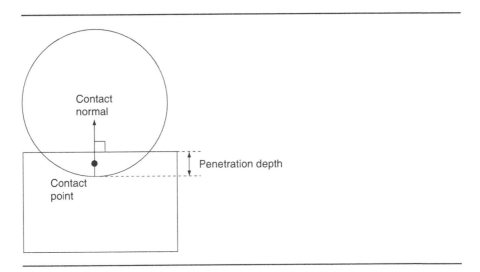

FIGURE 13.5 The relationship among the collision point, collision normal, and penetration depth.

The previous elements are stored in a contact data structure as follows:

```
_____ Excerpt from file include/cyclone/contacts.h _____

/**
 * A contact represents two bodies in contact. Resolving a
 * contact removes their interpenetration, and applies sufficient
 * impulse to keep them apart. Colliding bodies may also rebound.
 * Contacts can be used to represent positional joints, by making
 * the contact constraint keep the bodies in their correct
 * orientation.
 */
class Contact
{
    /**
     * Holds the position of the contact in world coordinates.
     */
    Vector3 contactPoint;

    /**
     * Holds the direction of the contact in world coordinates.
     */
    Vector3 contactNormal;
```

```
/**
 * Holds the depth of penetration at the contact point. If both
 * bodies are specified, then the contact point should be midway
 * between the interpenetrating points.
 */
real penetration;
};
```

Before looking at the particulars of the collision algorithms for different pairs of primitives, it is worth looking at each contact case in turn and how its parameters are determined.

13.2.3 VERTEX–FACE CONTACTS

This is one of the two most common and important types of contact. Whether the face is flat or curved, the contact properties are generated in the same way, as seen in Figure 13.6.

The contact normal is given by the normal of the surface at the point of contact. The contact normal is therefore only dependent on the object whose face is in collision. The object on the vertex side of the contact can be in any orientation.

On a curved surface, it may not be clear which point of the face to use when generating the normal. If the vertex (i.e., the point that is in contact with the face) is penetrated into the face, then it is projected back onto the face in some way before the normal is calculated. The exact details of this projection usually don't matter much.

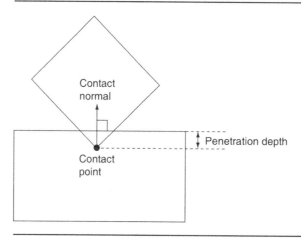

FIGURE 13.6 The vertex–face contact data.

In our case, this will only be an issue with collisions involving spheres, where it is easy to project the vertex back to the nearest point on the sphere's surface.

The contact point can be any point involved in the contact. The vertex itself is such a point, and since it is available to us without modification, we use it directly.

The penetration depth is calculated as the distance between the vertex and the face, in the direction of the contact normal.

13.2.4 EDGE–EDGE CONTACTS

This is the second important type of contact, and is critical for objects with flat sides, such as boxes or polyhedral meshes. The contact data is shown in Figure 13.7.

The contact normal is at right angles to the tangents of both edges. The vector product is used to calculate this.

The contact point is typically the closest point on one edge to the other edge. Some developers use it a point midway between the two edges, which takes longer to calculate but which can be marginally more accurate. Personally, I haven't found a problem with the nearest-point approach.

The penetration depth is the distance between the two edges.

13.2.5 EDGE–FACE CONTACTS

Edge–face contacts are only used with curved surfaces (the edge of a capsule, for example, or the surface of a sphere). The contact data is generated in a very similar way to point–face contacts, as shown in Figure 13.8.

The contact normal is given by the normal of the face, as before. The edge direction is ignored in this calculation.

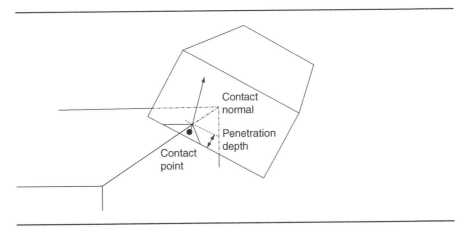

FIGURE 13.7 The edge–edge contact data.

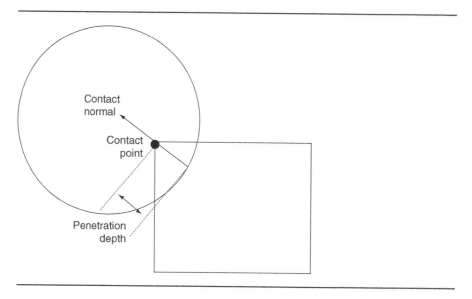

FIGURE 13.8 The edge–face contact data.

The contact point can be tricky to calculate. We'd like it to be the point of deepest penetration. In the general case, with an arbitrary 3D shape, we'd have to do a lot of work to calculate this. Fortunately, for most simple primitives (including those we'll be working with in this chapter), there is an easy way to find this point.

Because of the way that the contact point is calculated, we normally have direct access to the penetration depth. If not, then it needs to be calculated the long way by working out the distance between the edge and the face along the direction of the normal passing through the contact point.

13.2.6 FACE–FACE CONTACTS

Face–face contacts occur when a curved surface comes in contact with another face whether curved or flat, such as a sphere on a plane. Figure 13.9 shows the properties of this contact.

The contact normal is given by the normal of one of the faces. In theory the faces should have opposite contact normals: two faces can't touch except where their normals are in the opposite directions. In practice, however, this isn't perfect and the fact that objects may interpenetrate means that the actual normals may be misaligned. It is easier to use just one consistently and ignore any misalignment. The choice of which to use might be suggested by the algorithm (we'll see that sometimes it is convenient to choose a particular object), but doesn't affect the quality of the simulation.

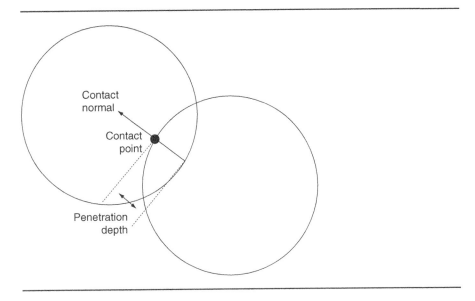

FIGURE 13.9 The face–face contact data.

The contact point is again difficult to calculate in the general case. And once again, using the primitives in this chapter we can often get directly at the point of greatest penetration. If not, then we need to select some point (pretty arbitrarily in the code I've seen that does this) from inside the interpenetrating volume.

The contact point calculation will normally give us direct access to the penetration depth. In the general case, we'll have to write code to work out the distance between the faces along the direction of the normal passing through the contact point.

13.2.7 TESTING BEFORE GENERATING CONTACTS

Some of the contact generation algorithms can be quite time consuming. The coarse collision detection will generate candidate pairs of objects that may later be found not to be in contact. We can make collision detection much more efficient by creating algorithms that exit early if no contact is found.

There are numerous opporunities to do this as part of the contact generation algorithms we will look at in subsequent sections, and the code takes advantage of as many of these as possible.

Some of the primitive collisions have completely different algorithms that can determine if there is a contact without generating the contacts themselves. If such an algorithm exists and it is fast enough, it can be useful to call it as a first stage:

```
if (inContact())
{
    findContacts();
}
```

We call this an *early out*—it allows the algorithm to exit early without doing unnecessary work. These testing algorithms are often found as collision detection routes in books on game graphics and can be used in your code for that purpose.

In many cases, however, the work that the quick check would need to do is the same as we need to do during contact generation, or the speed-up of doing both would be minimal for the number of times our fast test would fail. In these cases, the contact generation algorithm should be used on its own. Finding the appropriate tradeoff between these algorithms is usually a matter of profiling your code.

13.3 SIMPLE COLLISION ALGORITHMS

Each of the collision algorithms in this chapter takes two primitives and tests whether they are in contact. If they are in contact, it returns one or more contact data structures representing the contact.

Most algorithms only return zero or one contact, but some return more. Even those that return at most one contact can be extended, incorporating coherence (Section 13.5) to generate more. To cope with these algorithms, we'll need the flexibility to generate any number of contacts.

The simplest way to do this is to start with an array or list of possible contacts. This array is then passed into each contact generation routine. If the routine finds contacts, it can write them into the array.

In the accompanying source code I have encapsulated this process into a class:

___ **Excerpt from file include/cyclone/collide_narrow.h** ___

```
/**
 * A helper structure that contains information for the detector to use
 * in building its contact data.
 */
struct CollisionData
{
    /** Holds the contact array to write into. */
    Contact *contacts;

    /** Holds the maximum number of contacts the array can take. */
    int contactsLeft;
};
```

Each contact generation routine has the same form:

```
void generateContacts(const Primitive &firstPrimitive,
                      const Primitive &secondPrimitive,
                      CollisionData *data);
```

The `Primitive` class holds all the data that any contact generator will need to know about one object in the contact. This includes the rigid-body data (providing position and orientation), and the offset of the primitive from the coordinate origin of the rigid body:

```
class Primitive
{
public:
    RigidBody *body;
    Matrix4 offset;
};
```

Throughout this chapter I will assume that the offset matrix represents a translation and rotation only—it has no scaling or skewing effect. We could make this much simpler and assume that the primitive is aligned perfectly with the center of the rigid body with no rotation (as would be the case if we had a cylinder primitive representing a barrel, for example). Unfortunately, this would not work for assemblies of objects, nor rigid bodies with centers of mass that aren't at their geometric center. For flexibility it is best to allow primitives to be offset from their rigid bodies.

Each implemented contact generation function will use a subtype of `Primitive` with some additional data (such as `Sphere` and `Plane`). I'll introduce these types as we go along.

13.3.1 COLLIDING TWO SPHERES

The first primitive we'll work with is the sphere. Colliding two spheres is as simple as it gets. Two spheres are in contact if the distance between their centers is less than the sum of their radii.

If they are in contact, then there will be precisely one contact point: each sphere consists of one surface, so it will be a face–face contact. This is shown in Figure 13.9.

The point of deepest contact is located along the line between the sphere centers. This is exactly the same algorithm as we saw in Chapter 7 looking at particle collisions.

To implement this we need a data structure for a sphere. Spheres are completely defined by their center point and radius:

```
class Sphere
{
public:
    Vector3 position;
    real radius;
};
```

The center point of the sphere is given by the offset from the origin of the rigid body, the data for which is contained in the offset data member of the Primitive class. So the sphere implementation we'll use will extend Primitive and look like this:

```
class Sphere : public Primitive
{
public:
    real radius;
};
```

The contact generation algorithm takes two spheres and may add a contact to the contact data. Because the algorithm to determine if the two spheres collide is part of determining the contact data, we don't have a separate algorithm to provide an early out:

```
                        Excerpt from file src/collide_narrow.cpp
unsigned CollisionDetector::sphereAndSphere(
    const CollisionSphere &one,
    const CollisionSphere &two,
    CollisionData *data
    )
{
    // Make sure we have contacts.
    if (data->contactsLeft <= 0) return 0;

    // Cache the sphere positions.
    Vector3 positionOne = one.getAxis(3);
    Vector3 positionTwo = two.getAxis(3);

    // Find the vector between the objects.
```

```
Vector3 midline = positionOne - positionTwo;
real size = midline.magnitude();

// See if it is large enough.
if (size <= 0.0f || size >= one.radius+two.radius)
{
    return 0;
}

// We manually create the normal, because we have the
// size to hand.
Vector3 normal = midline * (((real)1.0)/size);

Contact* contact = data->contacts;
contact->contactNormal = normal;
contact->contactPoint = positionOne + midline * (real)0.5;
contact->penetration = (one.radius+two.radius - size);
contact->setBodyData(one.body, two.body,
    data->friction, data->restitution);

data->addContacts(1);
return 1;
}
```

Note at the end of this code that the values for restitution and friction are copied from the `CollisionData` structure provided in the collision that is generated. I'm assuming that these values are set somehow before my contact generator routine is called. We'll return to these values in the next part of the book when we consider contact resolution.

13.3.2 COLLIDING A SPHERE AND A PLANE

Colliding a sphere with a plane is just as simple as colliding a sphere with another. The sphere collides with the plane if the distance of the center of the sphere is farther from the plane than the sphere's radius.

The distance of a point from a plane is given by:

$$d = p \cdot l - l$$

where l is the normal vector of the plane and l is the offset of the plane. This is a standard way to represent a plane in 3D geometry.

We can represent the plane in code as:

```
class Plane : public Primitive
{
public:
    Vector3 normal;
    real offset;
};
```

Planes are almost always associated with immovable geometry rather than a rigid body, so the rigid-body pointer in the Primitive class will typically be NULL.

The algorithm takes a sphere and a plane, and may add a contact to the contact data. Again the algorithm is simple enough not to benefit from a separate early-out algorithm:

```
—————— Excerpt from file src/collide_narrow.cpp ——————
unsigned CollisionDetector::sphereAndHalfSpace(
    const CollisionSphere &sphere,
    const CollisionPlane &plane,
    CollisionData *data
    )
{
    // Make sure we have contacts.
    if (data->contactsLeft <= 0) return 0;

    // Cache the sphere position.
    Vector3 position = sphere.getAxis(3);

    // Find the distance from the plane.
    real ballDistance =
        plane.direction * position -
        sphere.radius - plane.offset;

    if (ballDistance >= 0) return 0;

    // Create the contact; it has a normal in the plane direction.
    Contact* contact = data->contacts;
    contact->contactNormal = plane.direction;
    contact->penetration = -ballDistance;
    contact->contactPoint =
        position - plane.direction * (ballDistance + sphere.radius);
    contact->setBodyData(sphere.body, NULL,
```

```
        data->friction, data->restitution);

    data->addContacts(1);
    return 1;
}
```

Strictly, this isn't a sphere–plane collison but a sphere–half-space collision. Figure 13.10 shows the difference. The half-space is treated as if the whole region on the back of the plane is solid. So, an object interpenetrating will always have its contact normal pointing in the direction of the plane normal. Even if the object is completely behind the plane, the contact will be generated. True planes are infinitely thin. An object on the back side of the plane will have its contact normal in the opposite direction to the plane normal. True planes are rarely needed in a game, but half-spaces are common. They are normally used to represent the ground and, within a BSP-tree (which effectively puts bounds on their size), they can be used to represent walls. In these cases, a half-space collision is needed.

To modify the algorithm to perform true plane–sphere collisions, we need to check if the distance is either greater than the radius of the sphere or less than the negative of that radius:

—————————— **Excerpt from file src/collide_narrow.cpp** ——————————
```
unsigned CollisionDetector::sphereAndTruePlane(
    const CollisionSphere &sphere,
    const CollisionPlane &plane,
    CollisionData *data
    )
{
    // Make sure we have contacts.
```

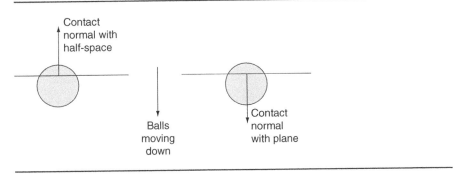

FIGURE 13.10 The difference in contact normal for a plane and a half-space.

```
if (data->contactsLeft <= 0) return 0;

// Cache the sphere position.
Vector3 position = sphere.getAxis(3);

// Find the distance from the plane.
real centerDistance = plane.direction * position - plane.offset;

// Check if we're within radius.
if (centerDistance*centerDistance > sphere.radius*sphere.radius)
{
    return 0;
}

// Check which side of the plane we're on.
Vector3 normal = plane.direction;
real penetration = -centerDistance;
if (centerDistance < 0)
{
    normal *= -1;
    penetration = -penetration;
}
penetration += sphere.radius;

// Create the contact; it has a normal in the plane direction.
Contact* contact = data->contacts;
contact->contactNormal = normal;
contact->penetration = penetration;
contact->contactPoint = position - plane.direction * centerDistance;
contact->setBodyData(sphere.body, NULL,
    data->friction, data->restitution);

data->addContacts(1);
return 1;
}
```

Both are implemented in the accompanying source code, but only the half-space is used in any of the demos.

13.3.3 COLLIDING A BOX AND A PLANE

We've introduced the sphere primitive now, so it is time to move on to the box, our second primitive. First, we'll consider the contact generation algorithm for collisions

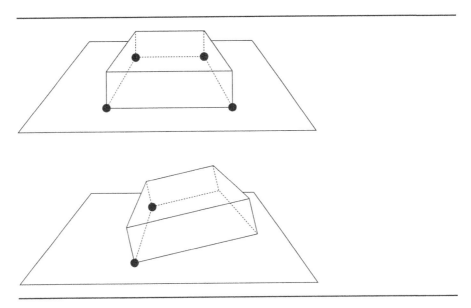

FIGURE 13.11 Contacts between a box and a plane.

between a box and a plane (strictly a half-space). This is the first algorithm we've met that can return more than one contact.

Remember that we are trying to approximate complicated contact or interpenetration shapes with one or more contacts at single points. As part of that, we have a priority ordering for the kinds of contact cases we want to consider, and we want to return contacts that are as high in that order as possible.

As described in Section 13.2, a box–plane collision can always be represented as a series of vertex–face contacts, which are in our highest priority group. If the box is resting flat on the plane, then we return a contact for each corner vertex of the box's contact face. Similarly, if an edge is colliding with the plane, we return contacts for the vertices at either end of that edge.

So there can be up to four contacts, and each is a point–face contact. Figure 13.11 illustrates this.

We can find the set of contacts by simply checking each vertex of the box one by one and generating a contact if it lies below the plane.[1] The check for each vertex looks just like the check we made with the sphere–plane detector:

$$d = p \cdot l - l$$

1. Generating contacts for a true plane, rather than a half-space, is somewhat more difficult, because we need to find the set of contacts on each side of the plane, and determine which side the box is on and generate contacts for the opposite set. For a half-space, we simply test whether vertices are through the plane.

Because the vertices are only points, and have no radius, we simply need to check if the sign of *d* is positive or negative. A collision therefore occurs if:

$$p \cdot l < l$$

For one vertex at *p* the code to generate a contact looks like this:

```
—————————— Excerpt from file src/collide_narrow.cpp ——————————
// Calculate the distance from the plane.
real vertexDistance = vertexPos * plane.direction;

// Compare this to the plane's distance.
if (vertexDistance <= plane.offset)
{
    // Create the contact data.

    // The contact point is halfway between the vertex and the
    // plane.  We multiply the direction by half the separation
    // distance and add the vertex location.
    contact->contactPoint = plane.direction;
    contact->contactPoint *= (vertexDistance-plane.offset);
    contact->contactPoint = vertexPos;
    contact->contactNormal = plane.direction;
    contact->penetration = plane.offset - vertexDistance;

    // Write the appropriate data.
    contact->setBodyData(box.body, NULL,
        data->friction, data->restitution);

    // Move on to the next contact.
    contact++;
    contactsUsed++;
    if (contactsUsed == data->contactsLeft) return contactsUsed;
}
```

The full algorithm runs this code for each vertex of the box. We can generate the set of vertices from a box data structure that looks like this:

```
class Box : public Primitive
{
public:
    Vector3 halfSize;
};
```

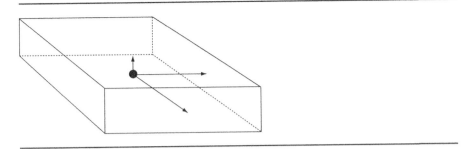

FIGURE 13.12 The half-sizes of a box.

where halfSize gives the extent of the box along each axis. The total size of the box along each axis is twice this value, as shown in Figure 13.12.

The vertices of the box are then given by:

```
Vector3 vertices[8] =
{
  Vector3(-halfSize.x -halfSize.y -halfSize.z),
  Vector3(-halfSize.x -halfSize.y +halfSize.z),
  Vector3(-halfSize.x +halfSize.y -halfSize.z),
  Vector3(-halfSize.x +halfSize.y +halfSize.z),
  Vector3(+halfSize.x -halfSize.y -halfSize.z),
  Vector3(+halfSize.x -halfSize.y +halfSize.z),
  Vector3(+halfSize.x +halfSize.y -halfSize.z),
  Vector3(+halfSize.x +halfSize.y +halfSize.z)
};

for (unsigned i = 0; i < 8; i++)
{
  vertices[i] = offset * vertices[i];
}
```

where offset is the rotation and translation matrix from the Primitive class.

The complete algorithm simply generates each vertex in turn and uses the implementation of the test at the start of this section to check it against the plane:

```
─────────── Excerpt from file src/collide_narrow.cpp ───────────
unsigned CollisionDetector::boxAndHalfSpace(
    const CollisionBox &box,
    const CollisionPlane &plane,
    CollisionData *data
```

```
      )
{
    // Make sure we have contacts.
    if (data->contactsLeft <= 0) return 0;

    // Check for intersection.
    if (!IntersectionTests::boxAndHalfSpace(box, plane))
    {
        return 0;
    }

    // We have an intersection, so find the intersection points. We can
       make
    // do with only checking vertices. If the box is resting on a plane
    // or on an edge, it will be reported as four or two contact points.

    // Go through each combination of + and - for each half-size.
    static real mults[8][3] = {{1,1,1},{-1,1,1},{1,-1,1},{-1,-1,1},
                               {1,1,-1},{-1,1,-1},{1,-1,-1},{-1,-1,-1}};

    Contact* contact = data->contacts;
    unsigned contactsUsed = 0;
    for (unsigned i = 0; i < 8; i++) {

        // Calculate the position of each vertex.
        Vector3 vertexPos(mults[i][0], mults[i][1], mults[i][2]);
        vertexPos.componentProductUpdate(box.halfSize);
        vertexPos = box.transform.transform(vertexPos);

        // Calculate the distance from the plane.
        real vertexDistance = vertexPos * plane.direction;

        // Compare this to the plane's distance.
        if (vertexDistance <= plane.offset)
        {
            // Create the contact data.

            // The contact point is halfway between the vertex and the
            // plane. We multiply the direction by half the separation
            // distance and add the vertex location.
            contact->contactPoint = plane.direction;
            contact->contactPoint *= (vertexDistance-plane.offset);
            contact->contactPoint = vertexPos;
            contact->contactNormal = plane.direction;
```

```
                contact->penetration = plane.offset - vertexDistance;

                // Write the appropriate data.
                contact->setBodyData(box.body, NULL,
                    data->friction, data->restitution);

                // Move on to the next contact.
                contact++;
                contactsUsed++;
                if (contactsUsed == data->contactsLeft) return contactsUsed;
            }
        }

        data->addContacts(contactsUsed);
        return contactsUsed;
    }
```

Note that there are variations of this algorithm that avoid generating and testing all vertices. By comparing the direction of each box axis against the plane normal, we can trim down the number of vertices that need to be checked.

Despite the marginal theoretical advantage of such an algorithm, I have found them to have no efficiency gain in practice. Generating and testing a vertex is so fast that additional checking has a marginal effect. If you are familiar with optimizing for SIMD hardware, you will also notice that this algorithm lends itself very easily to parallel implementation, which makes the alternatives even less attractive.

13.3.4 COLLIDING A BOX AND A SPHERE

Let's combine the two primitives we've discussed so far and look at how a box collides with a sphere. When a sphere collides with a box, we will always have a single contact. But it may be a contact of any of three types:

1. A vertex–face contact (in our top-priority group) will be generated if a vertex of the box is touching the surface of the sphere.

2. An edge–face contact (in our second group) is generated if the edge of the box is touching the surface of the sphere.

3. A face–face contact (again in our second group) is generated if the sphere is touching one side of the box.

In each case the sphere (which has no edges or vertices) contributes a face to the contact, and the box contributes the vertex, edge, or face. Figure 13.13 illustrates this.

Fortunately, the calculation in each of the three cases is similar and we will find that we don't have to worry which case we're dealing with in the code. In each case,

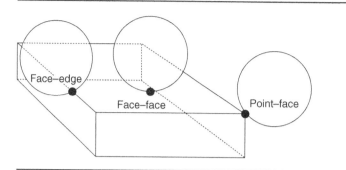

FIGURE 13.13 Contacts between a box and a sphere.

we find the point in the box that is closest to the center of the sphere. If the distance between the center and this point is less than the radius, then we know we have a collision. If we do, then we use this point as the contact point; we use the line from the point to the center of the sphere as the contact normal; and we use the calculation we did to test overlap to find the interpenetration depth.

If our contact represents a vertex–face or edge–face contact, then these calculations are exactly as we specified in Section 13.2. If we have a face–face contact, then the way we are generating the contact normal needs explanation. In Section 13.2.6, I said that when two objects have exactly touching faces, the face normals should be exactly opposite one another. But in reality, we might have interpenetration, which could allow them to differ. I suggest we pick one. The algorithm I am suggesting for sphere–box collisions effectively always picks the sphere. We're using the sphere's face normal for the vertex–face and edge–face cases, so we just use it for the face–face case too.

The only thing in this algorithm we haven't done in previous sections is to find the closest point in the box to the center of the sphere. To do this we need a two-step process:

- Convert the center point into the box's coordinate space. The box can be oriented in any direction, so the following calculations will be simpler if we can remove that orientation at the very beginning by doing calculations in the box's coordinate space.

- Clamp the coordinates of the transformed point by the half-sizes of the box, making sure that the clamped coordinates are in the same direction as the original coordinates.

The code to convert into the box's local coordinate space follows:

```
———— Excerpt from file src/collide_narrow.cpp ————
// Transform the center of the sphere into box coordinates.
Vector3 center = sphere.getAxis(3);
Vector3 relCenter = box.transform.transformInverse(center);
```

Note the inverse transform here, because we're converting something in world coordinates into local coordinates.

With this new point, we can then work out the distance from the center of the sphere to the target point, and exit if it is larger than the radius of the sphere. The code for this is simple:

```
————— Excerpt from file src/collide_narrow.cpp —————
Vector3 closestPt(0,0,0);
real dist;

// Clamp each coordinate to the box.
dist = relCenter.x;
if (dist > box.halfSize.x) dist = box.halfSize.x;
if (dist < -box.halfSize.x) dist = -box.halfSize.x;
closestPt.x = dist;

dist = relCenter.y;
if (dist > box.halfSize.y) dist = box.halfSize.y;
if (dist < -box.halfSize.y) dist = -box.halfSize.y;
closestPt.y = dist;

dist = relCenter.z;
if (dist > box.halfSize.z) dist = box.halfSize.z;
if (dist < -box.halfSize.z) dist = -box.halfSize.z;
closestPt.z = dist;

// Check to see if we're in contact.
dist = (closestPt - relCenter).squareMagnitude();
if (dist > sphere.radius * sphere.radius) return 0;
```

The contact properties need to be given in world coordinates, so before we calculate the contact normal, we'll need to find the closest point in world coordinates. This just means transforming the point we generated previously by the box's transform matrix:

```
————— Excerpt from file src/collide_narrow.cpp —————
Vector3 closestPtWorld = box.transform.transform(closestPt);
```

We can then calculate the contact properties as before in the chapter. The final code puts all this together to look like the following:

```
————— Excerpt from file src/collide_narrow.cpp —————
unsigned CollisionDetector::boxAndSphere(
    const CollisionBox &box,
```

```
      const CollisionSphere &sphere,
      CollisionData *data
      )
{
    // Transform the center of the sphere into box coordinates.
    Vector3 center = sphere.getAxis(3);
    Vector3 relCenter = box.transform.transformInverse(center);

    // Early out check to see if we can exclude the contact.
    if (real_abs(relCenter.x) - sphere.radius > box.halfSize.x ||
        real_abs(relCenter.y) - sphere.radius > box.halfSize.y ||
        real_abs(relCenter.z) - sphere.radius > box.halfSize.z)
    {
        return 0;
    }

    Vector3 closestPt(0,0,0);
    real dist;

    // Clamp each coordinate to the box.
    dist = relCenter.x;
    if (dist > box.halfSize.x) dist = box.halfSize.x;
    if (dist < -box.halfSize.x) dist = -box.halfSize.x;
    closestPt.x = dist;

    dist = relCenter.y;
    if (dist > box.halfSize.y) dist = box.halfSize.y;
    if (dist < -box.halfSize.y) dist = -box.halfSize.y;
    closestPt.y = dist;

    dist = relCenter.z;
    if (dist > box.halfSize.z) dist = box.halfSize.z;
    if (dist < -box.halfSize.z) dist = -box.halfSize.z;
    closestPt.z = dist;

    // Check to see if we're in contact.
    dist = (closestPt - relCenter).squareMagnitude();
    if (dist > sphere.radius * sphere.radius) return 0;

    // Compile the contact.
    Vector3 closestPtWorld = box.transform.transform(closestPt);

    Contact* contact = data->contacts;
    contact->contactNormal = (closestPtWorld - center);
```

```
        contact->contactNormal.normalize();
        contact->contactPoint = closestPtWorld;
        contact->penetration = sphere.radius - real_sqrt(dist);
        contact->setBodyData(box.body, sphere.body,
            data->friction, data->restitution);

        data->addContacts(1);
        return 1;
}
```

13.4 SEPARATING AXIS TESTS

The separating axis test (SAT) is one of the most useful concepts in collision detection, and will be the workhorse algorithm for the remaining contact generators in this section. The SAT says that if there is any axis along which two objects are separated, then you know those objects cannot be in contact. To perform this test we project the 3D objects we're interested in onto the 1D axis. Each object is simply mapped to a minimum and a maximum position along that axis. If those ranges overlap, then the axis cannot separate the objects. This is shown in Figure 13.14.

Note that an SAT can tell you there is definitely no contact between two objects. But if the test fails and finds an overlap, it does not tell you that there definitely is a contact. In order to find out whether two objects touch, you have to perform multiple SATs: if any passes then you know the objects don't touch; if they all fail, then you might be able to deduce a contact, if you have chosen your axes properly.

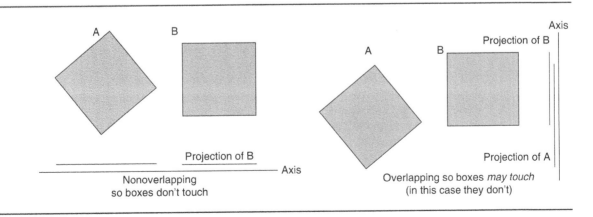

FIGURE 13.14 A separating axis test.

So how can we choose our axes? There are an infinite number of possible directions to choose from, and on first glance any one of them could be a separating axis.

Fortunately, for certain primitive shapes it can be shown that a particular set of axes is sufficient for performing SATs. One such primitive is the convex polyhedron. General convex polyhedra are our last primitive type, but it should be noted that boxes are also a more regular form of the same shape. In fact, we'll use the same theory for generating the SAT axes for both primitive types.

The set of axes needed are as follows:

- All faces on both objects give rise to an SAT axis equal to their face normal.
- All pairs of edges on different objects give rise to an SAT axis that is at right angles to both edges.
- Remove any duplicate axes or axes in the opposite direction.

For two boxes, therefore, we need to test 15 axes: 6 axes for the faces of the boxes (there are 12 faces, but boxes have pairs of parallel faces, so there will be at most 6 distinct axes), and 9 pairs of edge directions (again, there are 12 edges on each box, making $12 \times 12 = 144$ pairs of edges, but the edges fall parallel in groups of 4, making just $3 \times 3 = 9$ pairs to check).

The proof that these axes are necessary and sufficient is well beyond the scope of this book. But you should be able to convince yourself informally by considering how two convex polyhedra might touch. Any contact between them will either be edge–edge, or will involve a face.[2] For each of these cases, imagine moving the objects apart a microscopic amount. For contacts involving a face, only by choosing that face normal will you see the tiny gap; any other angle will miss it. Similarly for edges, only the direction at right angles to both edges will show the gap.

To perform the full collision detection, we loop over each of these required axes, performing the SAT. After the first SAT passes, we can exit with no contacts; if all of them fail, we know the objects are touching or overlapping.

13.4.1 GENERATING CONTACT DATA WITH SATs

If you read many books on collision detection, this is where you will end up. But we need to go further. We not only need to determine whether the objects overlap, but also where and by how much.

Fortunately, the SAT can help. The SAT can be generalized to say that if there is an axis on which two objects overlap by some amount, then the maximum interpenetration of those objects cannot be greater than that amount. In other words, if we find an axis on which two boxes appear to be overlapping by one unit, then we know that

2. Remember that we are ignoring the vertex–vertex and vertex–edge contacts. In fact, it can be shown that including these types of contacts wouldn't increase the number of axes needed. Faces and pairs of edges would be enough to detect all collisions.

the boxes interpenetrate by no more than one unit. One unit is the deepest interpenetration possible. Of course, as we've seen, we could go on to find another axis where the test passes, and then we know they don't touch at all. But this is just equivalent to saying that if an axis shows the objects separated by one unit, then we know they are no less than one unit apart. This is shown in Figure 13.15 for the 2D case. Note that in 2D, only face axes are required, and so only these four axes are shown.

We can use this result to find the contact data we need. For each SAT we do, we keep track of the axes on which the smallest overlap was found. We can still exit immediately if the overlap is found to be negative (i.e., the objects are separate on that axis). But if all our SATs fail, and we know that the objects overlap, then the stored axes tell us where the deepest interpenetration was found.

We get the remaining data for the contact in a different way, depending on what kind of axis our minimum fell on:

- If the minimum fell on an edge–edge axis, then the contact will be an edge–edge contact, and we already know the two edges involved.

- If the minimum fell on a face axis, then we know our contact will be a face–vertex contact (because we can't have face–face or edge–face contacts on convex polyhedra—there will always be vertex–face or edge–edge contacts that override them in the priority order). We have to find the vertex on the other object that has most interpenetrated that face.

The last thing to say about this approach is to point out that it generates at most only one contact. As we've seen, this isn't enough to properly simulate the contact

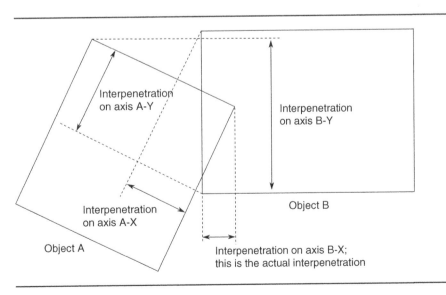

FIGURE 13.15 A separating axis test showing maximum interpenetration.

between two objects. In practice, returning only one contact per frame can lead to vibrations in the simulation and other problems. We need a way to access all the contacts. Fortunately, we can do this successfully without altering the algorithm above. Section 13.5 focuses on how this can be achieved.

13.4.2 COLLIDING TWO BOXES

Now that we have seen the theory of SATs, we can use it to implement the remaining collision generation routines for our primitives. We use the 15 SATs described in the previous section to work out if and where our two boxes are touching.

Each SAT is implemented by projecting the half-size of each box onto the separating axis in this way:

```
static inline real penetrationOnAxis(
    const CollisionBox &one,
    const CollisionBox &two,
    const Vector3 &axis,
    const Vector3 &toCenter
    )
{
    real oneProject = transformToAxis(one, axis);
    real twoProject = transformToAxis(two, axis);

    real distance = real_abs(toCenter * axis);

    // Return the overlap (i.e., positive indicates
    // overlap, negative indicates separation).
    return oneProject + twoProject - distance;
}
```

Here toCenter is the vector from the center of the first box to the center of the second. The first two lines calculate the half-length of each box along the axis, and the third line calculates the distance between them along that axis. If the distance is less than the sum of the two half-lengths, then there is interpenetration. The amount of interpenetration is returned.

We call each axis from code that keeps track of the smallest interpenetration so far, and can exit completely if a negative interpenetration is found (i.e., if the objects are found to be separated along that axis).

```
float bestOverlap = FLOAT_MAX;
unsigned bestCase;
```

```
for (unsigned index = 0; index < 15; index++) {
    Vector3 *axis = axes[index];

    // Check for axes that were generated by (almost) parallel edges.
    if (axis.squareMagnitude() < 0.001) continue;
    axis.normalize();

    real overlap = penetrationOnAxis(one, two, axis, toCenter);
    if (overlap < 0) return;
    if (overlap < bestOverlap) {
        bestOverlap = overlap;
        bestCase = index;
    }
}
```

The set of axes to be tested follows:

```
Vector3 axis[15];

// Face axes for object one.
axis[0] = one.getAxis(0);
axis[1] = one.getAxis(1);
axis[2] = one.getAxis(2);

// Face axes for object two.
axis[3] = two.getAxis(0);
axis[4] = two.getAxis(1);
axis[5] = two.getAxis(2);

// Edge-edge axes.
axis[6] = one.getAxis(0) % two.getAxis(0);
axis[7] = one.getAxis(0) % two.getAxis(1);
axis[8] = one.getAxis(0) % two.getAxis(2);
axis[9] = one.getAxis(1) % two.getAxis(0);
axis[10] = one.getAxis(1) % two.getAxis(1);
axis[11] = one.getAxis(1) % two.getAxis(2);
axis[12] = one.getAxis(2) % two.getAxis(0);
axis[13] = one.getAxis(2) % two.getAxis(1);
axis[14] = one.getAxis(2) % two.getAxis(2);
```

If you look at the accompanying source code, you'll notice a slightly different approach to this code. Rather than compile all the axes up front, and then loop through

them, I created them on the fly before each test. This means that if I find a test that passes and I exit the routine, I won't have wasted time calculating the remaining axes I never tested. This interleaving of concerns makes the code harder to read, however, so I have used a simplified version here. See the full code for the alternative approach.

The final stage is to calculate and fill the contact data. As described in the previous section, the approach at this point depends on whether our best contact fell on a face–axis test, or an edge–axis test.

Contact Based on Face Axis

In the face–axis test we know we'll have a vertex–face contact. We know that the face involved in the contact will be one of two. It will be the face pointing in the direction of the separating axes or in the opposite direction. Only one of these faces will be pointing in the direction of the other box, so we can determine which one we want very easily.

Once we know the face that is involved, we need to find out which of the other box's vertices is in contact. The following code performs both of these steps. It determines which face is involved, and then looks at the orientation of the second box to see which vertex would lie closest to the first box. This is the vertex it uses to generate the contact point:

```
// Which face is in contact?
if (axis * toCenter > 0)
{
    axis *= -1.0f;
}

// Which vertex is in contact (in two's coordinates)?
Vector3 vertex = two.halfSize;
if (two.getAxis(0) * normal < 0) vertex.x = -vertex.x;
if (two.getAxis(1) * normal < 0) vertex.y = -vertex.y;
if (two.getAxis(2) * normal < 0) vertex.z = -vertex.z;

// Convert to work coordinates.
vertex = otherBox.getTransform() * vertex;

// Create the contact data.
contact->contactNormal = axis;
contact->penetration = bestOverlap;
contact->contactPoint = vertex;
```

Contact Based on Edge–Edge

In the edge–edge case, again we need to work out which edges we're using. This time there are four possible edges for each of the axes involved. We identify the edge by finding any point along that edge. The point we choose will be midway along the edge. So, in object coordinates, it will have two coordinates equal to the corresponding half-size values (positive or negative), and the third coordinate equal to zero. The code steps through each coordinate and sets it to zero, plus half-size, or minus half-size, depending on the direction of the SAT axis:

```
Vector3 ptOnEdgeOne = one.halfSize;
Vector3 ptOnEdgeTwo = two.halfSize;
for (unsigned i = 0; i < 3; i++)
{
    if (i == oneAxisIndex) ptOnEdgeOne[i] = 0;
    else if (one.getAxis(i) * axis > 0) ptOnEdgeOne[i] = -ptOnEdgeOne[i];

    if (i == twoAxisIndex) ptOnEdgeTwo[i] = 0;
    else if (two.getAxis(i) * axis < 0) ptOnEdgeTwo[i] = -ptOnEdgeTwo[i];
}

// Move them into world coordinates (they are already oriented
// correctly, since they have been derived from the axes).
ptOnEdgeOne = one.transform * ptOnEdgeOne;
ptOnEdgeTwo = two.transform * ptOnEdgeTwo;
```

oneAxisIndex and twoAxisIndex are the indexes of the axis that was used to construct the SAT axis. So, for an SAT based on object one's Z-axis and object two's Y-axis, we'd have oneAxisIndex=2 and twoAxisIndex=1.

With a point on each edge, and the edge directions, we can calculate the contact point (the point of deepest interpenetration). We use the point midway between the point of closest approach on each edge. This is given by:

```
Vector3 getContactPoint(
    const Vector3 &axisOne, const Vector3 &axisTwo,
    const Vector3 &ptOnEdgeOne, const Vector3 &ptOnEdgeTwo,
    )
{
    // The vector between the test points on each edge.
    Vector3 toSt = ptOnEdgeOne - ptOnEdgeTwo;
```

```
    // How much of those vectors are in the direction of each edge?
    real dpStaOne = axisOne * toSt;
    real dpStaTwo = axisTwo * toSt;

    // Work out how far along each edge is the closest point.
    real smOne = axisOne.squareMagnitude();
    real smTwo = axisTwo.squareMagnitude();
    real dotProductEdges = axisTwo * axisOne;
    real denom = smOne * smTwo - dotProductEdges * dotProductEdges;
    real a = (dotProductEdges * dpStaTwo - smTwo * dpStaOne) / denom;
    real b = (smOne * dpStaTwo - dotProductEdges * dpStaOne) / denom;

    // Use a point midway between the two nearest points.
    Vector3 nearestPtOnOne = ptOnEdgeOne + axisOne * a;
    Vector3 nearestPtOnTwo = ptOnEdgeTwo + axisTwo * b;
    return nearestPtOnOne * 0.5 + nearestPtOnTwo * 0.5;
}
```

And we can use this method to fill the contact data:

```
contact->penetration = bestOverlap;
contact->contactNormal = axis;
contact->contactPoint = getContactPoint(
    axisOne, axisTwo, ptOnEdgeOne, ptOnEdgeTwo
    );
```

Again, I've shown a slightly rearranged and simplified version of the code to make the steps clearer.

13.4.3 COLLIDING CONVEX POLYHEDRA

Implementing box collisions has been significantly more complicated than the code for spheres. But we've actually done more work than it seems. Previously I mentioned that boxes are a kind of convex polyhedra. And in fact, the approaches we've taken to collision detection for boxes are generalizable for all kinds of convex polyhedra.

Collisions with a Half-Space: We know the only kinds of contacts that can occur are vertex–face contacts, where the half-space forms the face side of the contact. This means we can simply test the vertices of the object against the half-space and generate contacts for each vertex that has interpenetrated.

Collisions with a Sphere: There may be at most one contact, which may be vertex–face, edge–face, or face–face. In each case, the sphere contributes a face to the contact (it has no vertices or edges, after all). We only need to find the closest point on the object to the sphere's center. If that point is no farther away than the radius of the sphere, we know there is contact. The contact data can be generated simply from this point and the center of the sphere.

Collision with Another Convex Polyhedra: We can use a series of SATs to calculate the deepest interpenetration. The axes we test are those for each face, and the axes orthogonal to each pair of edges in different objects. There can be at most one resulting contact, which may be either vertex–face or edge–edge. Calculating data for the vertex–face case involves finding the vertex with the greatest interpenetration. In the edge–edge case, we find the points of closest approach of the two edges. As with the code for boxes, we'll often have multiple features that share the same separating axes, and we don't bother to test the duplicates. Before we can calculate the contact data, therefore, we need to do some extra work to figure out which of that axis's edges or faces contribute to the contact.

The most important difference between a regular box and a general convex polyhedra is one of scale. If our polyhedra has E edges, F faces, and V vertices, then the collision with a half-space described so far will be an $O(V)$ process, the collision with a sphere will be $O(E + F)$, and the collision with another polyhedra will be

$$O(F_1 + F_2 + E_1 E_2)$$

where F_1 and F_2, and E_1 and E_2 are the number of faces and edges, respectively, in the two polyhedra colliding.

This quadratic expression means that the processing requirements for SAT collision detection can quickly grow very large. Even for two cuboids, if there were no parallel sides or edges, we would have to test $6 + 6 + 12 \times 12 = 156$ axes. Most collision geometry is a good deal more complex than this—complex enough to make collision detection impractical.

There are a few ways that we can make progress. One way is to use techniques similar to those we've seen already: grouping parts of the objects together and doing tests on entire groups before doing tests on individual elements.

We can group parts of the collision geometry into a bounding volume hierarchy (though it is much more common to use bounding boxes than spheres at this point). This allows us to rapidly work out what parts of the two objects are colliding, allowing us to make fewer SATs to find the contact data.

This approach also has the advantage of allowing us to support non-convex polyhedra as long as each separate component we use is convex. It also provides support for some kinds of multicontact collisions that are hard to handle with the regular SAT approach we've seen thus far.

13.5 COHERENCE

The most efficient algorithms we've seen for calculating the collision between convex polyhedra all generate at most a single collision. As we saw at the start of this chapter, this isn't ideal for physical simulation. To get good results from our collision detector, we'll need to extend it.

Several developers I know have built their own custom versions of the SAT, GJK, or V-Clip algorithms that can generate more than one contact. But there isn't a standard way of doing it. In the SAT algorithm, for example, we can take multiple separating axes and use them as the basis of multiple contacts. But we have to be careful—other than the axis with the least interpenetration, we can't guarantee that other axes represent a contact, so we need to do extra work to check them after they are found. These problems can be solved, but I'm not aware of a standard solution.

There is another approach to generating multiple contacts, regardless of the underlying algorithm. In each frame we generate a single contact, using any of the algorithms we've met so far. This is resolved in the normal way. Because we only have one contact resolved, the collision resolution will not be perfect, and it is likely that the objects will interpenetrate again in the next frame. For collisions that should really have a number of contact points, the next frame's interpenetration will normally be different from the previous: a different pair of edges will be found, or a different vertex or face. This new interpenetration is detected as a contact in exactly the same way as before.

Our new code tracks these contacts on successive frames, retains them, and reintroduces them on successive frames. So in our case, in the second frame both contacts are added. The first contact might have a zero or negative interpenetration. This is okay, as we'll see; the contact resolver will cope. In fact, it can still be useful.

This process relies on the fact that objects don't move too far from frame to frame. This is called "coherence." It means that a contact in one frame is likely to be almost a contact in the following frame. Figure 13.16 shows this in action for two contacts in 2D.

The chances that an existing contact is useful in the next frame are high when the boxes are stable, but when they are moving, the contact may be completely wrong at the following frame. There are three things to note about this approach.

First, if we kept track of the contact data and reintroduced it in the next frame, we'd notice inaccurate collision response. It is true that a contact is often coherent, but its contact data usually isn't. What we store, therefore, is the pair of features on the two objects that generate the collision. From that pair of features, we calculate the contact data afresh.

For example, if we had an edge–edge contact, we'd store the two edges involved. On the following frame, we'd derive the contact normal from the two edges, recalculate their closest approach and use that to determine a collision point. This data would be correct for the current frame, even though the features in use would be carried over from the previous frame.

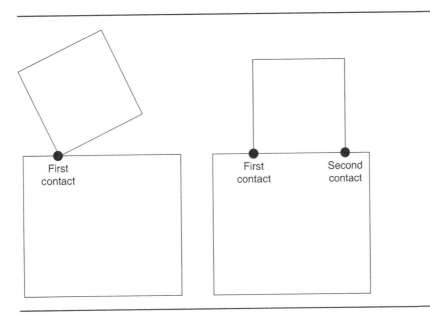

FIGURE **13.16** Sequence of contacts over two frames.

Second, therefore, we have to be careful not to use the same features again in the following frame. If we detect a collision between edge 1 and edge 2 on one frame, then again on the other, we only want to introduce the contact once. Having two duplicate contacts can confuse the collision resolution system.

Both of these considerations mean that we may need to alter our basic collision detection algorithm so it returns not only the contact data we've seen so far, but also unique identifiers for the features involved in that contact.

The third feature we need is the ability to forget about contacts that have happened. There are normally three criteria for this:

1. If the contact is more than a certain number of frames old, remove it from the cache. The exact number of frames requires some fine-tuning, but in systems I've implemented, a handful of frames is sufficient.

2. If the penetration depth is less than some limit, the contact has separated far enough to ignore it. At first glance, zero seems a good value for this, but the collision response system we'll build in the next part of the book can work with contacts that have a less-than-zero interpenetration (i.e., that are actually separated by some amount). When the contacts are resolved, such contacts can be brought into penetration, so it helps the contact resolution system to know about them in advance.

3. If the contact's separation velocity is greater than some limit, then the contact is considered to have bounced and is separating. Coherence isn't a good assumption in this case (since it assumes that not much has changed from frame to frame).

330 Chapter 13 *Generating Contacts*

In code, the coherence system has this structure:

```
struct FeatureRecord {
    FeatureID feature1;
    FeatureID feature2;
};

class Contact {
    // ... Other data as before ...
    FeatureRecord features;
};

class CoherenceContactGenerator {
    std::set<FeaturePair> cache;
    ContactGenerator generator;

    int generateContacts(ContactData &data) {
        int numContacts = generator.generateContacts(data);

        // Check if we have a contact to cache.
        if (numContacts) {
            Contact *lastContact = data.contacts - 1;
            cache.insert(lastContact.features);
        }

        // Go through each contact and check if we need to remove it.
        for (std::set<FeaturePair>::iterator i = cache.begin();
            i != cache.end(); ++i) {

            if (removeFeature(*i)) {
                cache.remove(i);
            } else {
                // Add this contact to the list of contacts.
                Contact *contact = createContactData(*i);
                data.add(contact);
            }
        }
    }
};
```

This is again a simplification of the full system, where I've removed the code to calculate collision data, which is the same as we've seen previously.

13.6 Summary

The collision detection algorithms in this chapter only give a flavor of the depth and complexity of building a robust collision detection system. Collision detection is a large field in its own right and there are many more approaches, caveats, and opportunities than I've had space to cover in this chapter.

You can use the collision detection system we've built in the last two chapters in its own right, and extend it as needed. Or you can elect to bring in a third-party collision detection system.

There are good open-source collision detection and contact generation algorithms available (such as SOLID and RAPID). You can use these alongside the physics you're developing in this book, or take their algorithms as inspiration for creating your own code.

Be warned though: there are so many cases and so many optimizations possible that it will end up as big a job to write a comprehensive collision detection system as it will be to create your physics engine to process the contacts.

With a collision detection system running correctly, it's time to return to our physics engine and process the collisions that we've found. In Chapter 14, we return to the issue of impact collision and build code to support collisions for full rotating rigid bodies.

13.7 Exercises

Exercise 13.1

(a) In Section 13.2.1, we saw the various types of contacts that can occur between two objects in 3D. List the equivalent types of contacts for objects in 2D.

(b) What generation order should be used?

Exercise 13.2
What is the maximum number of contacts we'd need to represent the collision between a cube and a cylinder?

Exercise 13.3
A cylinder is touching a cube, so the edge of the cylinder is in contact with one edge of the cube. At the point of contact, the edges are not parallel. How should the contact normal be calculated?

Exercise 13.4
The curved surface of a cylinder and a sphere are in contact. How should we calculate the contact normal?

Exercise 13.5
What set of axes would you need to test in order to perform an SAT between a box and a sphere?

PART V

Contact Physics

14

COLLISION
RESOLUTION

I t's time to look at the final, and most complex, stage of our physics system. We have a set of contact data from the collision detector (from Chapter 13), and we have the rigid-body equations of motion including torques and forces (from Chapter 10). We are now ready to combine the two and have rotating objects respond to contacts.

Just as in Chapter 7, we will first look in detail at the physics of collisions. We are building a microcollision physics engine, that is, one in which resting contacts are handled with lots of minicollisions (plus a bit of special-purpose code). Before we can get the microcollisions of resting contacts working, we need to look in detail at basic collision handling.

This chapter builds the first stage of our contact resolution system to handle collisions. Chapter 15 goes on to incorporate the collision response into more general and robust contact handling.

Because all contact handling in the engine is based on collisions, this chapter takes up the largest part of finishing our engine in terms of book pages, mathematical complexity, and implementation difficulty. If you find this chapter hard going, then try to persevere: it's mostly downhill from here on.

14.1 IMPULSE AND IMPULSIVE TORQUE

Recall that when a collision occurs between two objects in the real world, the material from which they are made compresses slightly. Whether it is a rubber ball or a stone,

Copyright © 2010, Elsevier Inc. All rights reserved.
DOI: 10.1016/B978-0-12-381976-5.00014-0

the molecules near the point of collision are pushed together fractionally. As they compress, they exert a force to try to return to their original shape.

Different objects have a different resistance to being deformed and a different tendency to return to their original shape. Combined together, the two tendencies give an object its characteristic bounce. A rubber ball can be easily deformed, but has a high tendency to return to its original shape, and so it bounces well. A stone has a high tendency to return to its original shape, but has a very high resistance to being deformed; it will bounce, but not very much. A lump of clay will have a low resistance to being deformed, and no tendency to return to its original shape; it will not bounce at all.

The force that resists the deformation causes the objects to stop colliding: their velocities are reduced until they are no longer moving together. At this point the objects are at their most compressed. If there is a tendency to return to their original shape, then the force begins to accelerate them apart until they are no longer deformed. At this point the objects are typically moving apart.

All this happens in the smallest fraction of a second, and for reasonably stiff objects (such as two pool balls), the compression distances are tiny fractions of a millimeter. In almost all cases, the deformation cannot be seen with the naked eye, as it is too small and over too quickly. From our perspective, we simply see the two objects collide and instantly bounce apart.

I have stressed what is happening at the minute level because it helps to understand the mathematics we will use. It would be impractical for us to simulate the bounce in detail, however. The spring-like compression is far too stiff and, as we've seen, the results we get with very stiff springs can be disastrous.

In Chapter 7 we saw that two point objects will bounce apart at a velocity that is a fixed multiple of their closing velocity immediately before the impact. To simulate this, we instantly changed the velocity of each object in the collision. This change in velocity is called an *impulse*.

14.1.1 Impulsive Torque

Now we are dealing with rotating rigid bodies, so things are not quite as simple. If you bounce an object while it is rotating, you will notice that the object not only rebounds linearly, but its angular velocity will change too.

It is not enough to apply the collision equations from Chapter 7, because they only take into account linear motion. We need to understand how the collision affects both linear and angular velocities.

Figure 14.1 shows a long rod being spun into the ground (we'll come back to collisions between two moving objects in a moment). Let's look closely at what would happen in the real world at the moment of collision. The second part of the figure shows the deformation of the object at the point of collision. This causes a compression force to push in the direction shown.

Looking at D'Alembert's principle in Chapter 10, we saw that any force acting on an object generates both linear and angular acceleration. The linear component is

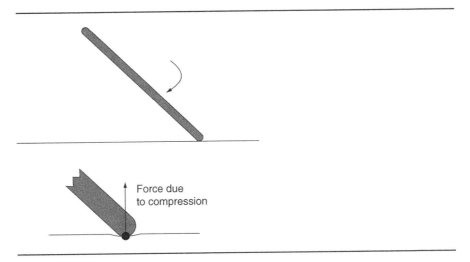

FIGURE 14.1 The rotational and linear components of a collision.

given by

$$\ddot{p} = \frac{1}{m}f$$

and the angular component by the torque,

$$\tau = p_f \times f$$

where the torque generates angular acceleration by

$$\ddot{\theta} = I^{-1}\tau$$

which is Equation 10.5.

So, in the case of the collision, it stands to reason that the collision will generate a linear change in velocity (the impulse) and an angular change in velocity. An instantaneous angular change in velocity is called an *impulsive torque* (also rarely called *moment of impulse* or *impulsive moment*, which sounds more like an impromptu wedding in Vegas to me).[1]

In the same way as we have

$$\tau = I\ddot{\theta}$$

for torques, we have

$$u = I\dot{\theta}$$

where u is the impulsive torque, I is the inertia tensor, and $\dot{\theta}$ is the angular velocity, as before. This is the direct equivalent of Equation 7.6 that dealt with linear impulses.

1. Strictly speaking, what we've called impulse is "impulsive force," or we could call it linear and angular impulse. But I'll continue to use just "impulse" to refer to the linear version.

And correspondingly, the change in angular velocity, $\Delta\dot{\boldsymbol{\theta}}$, is

$$\Delta\dot{\boldsymbol{\theta}} = I^{-1}\boldsymbol{u} \qquad [14.1]$$

In all these equations, I should be in world coordinates, as discussed in Section 10.2.3.

Impulses behave just like forces (remember, we're using them to represent the effect of forces over tiny distances and fractions of a second). In particular, for a given impulse, there will be both a linear component and an angular component. Just as the amount of torque is given by

$$\boldsymbol{\tau} = \boldsymbol{p}_f \times \boldsymbol{f}$$

the impulsive torque generated by an impulse is given by

$$\boldsymbol{u} = \boldsymbol{p}_f \times \boldsymbol{g} \qquad [14.2]$$

In our case, for collisions, the point of application (\boldsymbol{p}_f) is given by the contact point and the origin of the object:

$$\boldsymbol{p}_f = \boldsymbol{q} - \boldsymbol{p}$$

where \boldsymbol{q} is the position of the contact in world coordinates, and \boldsymbol{p} is the position of the origin of the object in world coordinates.

14.1.2 ROTATING COLLISIONS

The effect of the impulse at the collision is to have the two objects move apart. In particular, the exact point on each object that is involved in the collision will separate. And those points will follow the same equations that we met in Chapter 7. So if we tracked the two collision points (one from each object) around the time of the collision, we'd see that their separating velocity is given by

$$v_s' = -cv_s$$

where v_s is the relative velocity of the objects immediately before the collision, v_s' is the relative velocity after the collision, and c is the coefficient of restitution. In other words, the separation velocity is always in the opposite direction to the closing velocity, and is a constant proportion of its magnitude. The constant c depends on the materials of both objects involved.

Depending on the characteristics of the objects involved, and the direction of the contact normal, this separation velocity will be made up of both linear and rotational motion. Figure 14.2 shows different objects engaged in the same collision (again illustrated with a fixed ground plane for clarity). In each part of the figure, the closing velocity and the coefficient of restitution at the point of contact are the same, so the separating velocity is the same too.

The first object is lightweight, and is colliding almost head on. For any force generated during the collision, the corresponding torque will be small, because \boldsymbol{f} is almost parallel to \boldsymbol{p}_f. Its bounce will be mostly linear, with only a small rotational component.

The second object is heavier, but has a very small moment of inertia about the Z-axis. It is colliding off center. Here the torque generated will be large, and because

FIGURE 14.2 Three objects with different bounce characteristics.

the moment of inertia is very small, there will be a big rotational response. The rotational response is so large, in fact, that the linear component isn't large enough to bounce the object upward. Although the point of contact bounces back up (at the same velocity that the point of contact did in every other case), it is the rotation of the object that is doing most of the separating, so the linear motion continues downward, but at a slightly slower rate. You can observe this if you drop a ruler on the ground in the configuration shown. The ruler will start spinning away from the point of contact rapidly, but the ruler as a whole will not leap back into the air. The rotation is taking the bulk of the responsibility for separating the points of contact.

The third object collides in the same way as the second. In this case, however, although the mass is the same, its moment of inertia is much greater. It represents an object with more mass in its extreme parts. Here the linear impulse is greater, and the impulsive torque is smaller. The object bounces linearly and the compression force reverses the direction of rotation, but the resulting angular velocity is small.

14.1.3 HANDLING ROTATING COLLISIONS

Just as for particle collisions, we need two parts to our collision response. First, we need to resolve the relative motion of the two objects by applying impulse and impulsive torque. When we process a collision for velocity, we need to calculate four values: the impulse and impulsive torque for both objects in the collision. Calculating the balance of the linear and angular impulse to apply is our major mathematical challenge.

Because we only check for collisions at the end of each frame, objects may have already passed into one another. So we need to resolve any interpenetration that has occurred. The interpenetration can be handled in a very similar way to interpenetration for particles. But the impulse calculations we need to perform in the first part of our response allow us to do a more physically realistic interpenetration resolution. We'll return to this process in Section 14.3.

14.2 COLLISION IMPULSES

To resolve the relative motion of the two objects, we need to calculate four impulses, including the linear and angular impulses for each object. If there is only one object involved in the collision (if an object is colliding with an immovable object, such as the ground), then we only need two values—the impulse and impulsive torque for the moving object.

To calculate the impulse and impulsive force on each object, we go through the following series of steps:

1. We work in a set of coordinates that are relative to the contact: this makes lots of the math much simpler. So first we create a transform matrix to convert into and out of this new set of coordinates.

2. We work out the change in velocity of the contact point on each object per unit of impulse. Because the impulse will cause linear and angular motion, this value needs to take account of both components.

3. We invert the result of the last stage to find the impulse needed to generate any given velocity change.

4. We work out what the separating velocity at the contact point should be, what the closing velocity currently is, and the difference between the two. This is the desired change in velocity.

5. From the desired change in velocity, we can calculate the impulse that must be generated.

6. We split the impulse into its linear and angular components and apply them to each object.

Let's look at each of these stages in turn.

14.2.1 CHANGE TO CONTACT COORDINATES

Our goal is to work out what impulse we need to apply as a result of the collision. The impulse will generate a change in velocity. We can calculate the change in velocity we want to see, so we need to find the impulse that generates that change.

We are not interested in the linear and angular velocity of the entire object at this stage. For the purpose of the collision, we are only interested in the separating velocity of the contact points. As we saw in the previous section, we have an equation that tells us what the final separating velocity needs to be, so we'd like to be able to apply it simply.

The velocity of a point on an object is related to both its linear and angular velocity, according to Equation 9.6:

$$\dot{q} = \dot{\theta} \times (q - p) + \dot{p}$$

Because we are only interested in the movement of the colliding points at this stage, we can simplify the mathematics by doing calculations relative to the point of

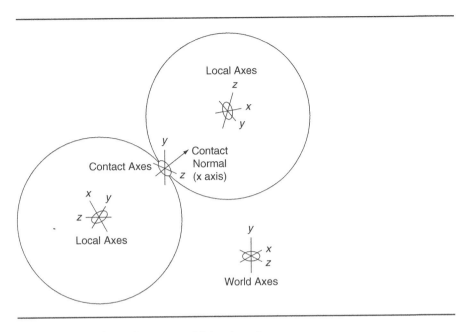

FIGURE 14.3 The three sets of coordinates: world, local, and contact.

collision. Recall from Chapter 13 that each contact has an associated contact point and contact normal. If we use this point as the origin, and the contact normal as one axis, we can form an orthonormal basis around it. Just as we have a set of world coordinates and sets of local coordinates for each object, we will have a set of contact coordinates for each contact.

Figure 14.3 shows the contact coordinates for one contact. Note that we are ignoring interpenetration at this stage. As part of the contact generation, we calculated a single representative point for each contact.

The Contact Coordinate Axes

The first stage of converting to contact coordinates is to work out the direction of each axis. We do this using the algorithm to calculate an orthonormal basis, seen in Section 2.1.9. The X-axis we know already—it is the contact normal generated by the collision detector. The Y-axis and Z-axis need to be calculated.[2]

Unfortunately, there can be any number of different Y- and Z-axes generated from one X-axis. We'll need to select just one. If we are working with anisotropic friction (friction that is different in different directions), then there will be one set of basis vectors that is most suitable. For the isotropic friction in this book, and friction less simulations, any set is just as valid. Since we are ignoring friction for now, we create

2. This is just a convention adopted in this book. There is no reason why the X-axis has to be the contact normal. Some people prefer to think of the Y-axis as the contact normal. If you are one of them, the rest of this section can be adjusted accordingly.

an arbitrary set of axes by starting with the Y-axis pointing down the world Y-axis (recall that the algorithm required the base axis, in our case the X-axis, plus an initial guess at a second axis, which may end up being altered). In Section 2.1.9, we saw an algorithm to make an orthonormal basis given *two* initial axes:

```
void makeOrthonormalBasis(Vector3 *x, Vector3 *y, Vector3 *z)
{
    x->normalize();
    (*z) = (*x) % (*y);
    if (z.squareMagnitude() == 0.0) return; // Or generate an error.
    z->normalize();
    (*y) = (*z) % (*x);
}
```

We can use this same algorithm, but we have to add in a Y-axis value too. Because we don't care about the directions of the Y- and Z-axes, we can choose any Y-axis. The world Y-axis, for example:

```
Vector y(0, 1.0, 0), z;
makeOrthonormalBasis(contactNormal, &y, &z);
```

We can improve the efficiency of this longhand form by manually performing the vector products (rather than calling the vector product operator in the Vector3 class). Note that if the initial Y-axis is pointing along the Y-axis, then any value for the resulting Z-axis must be at right angles to the Y-axis. This can only happen if the resulting Z-axis has a zero Y component. This allows us to directly set the Y coordinate of the Z-axis to zero without calculation. The shorthand code looks like this:

```
// The output axes.
Vector y, z;

// Scaling factor to ensure the results are normalized.
const real s = 1.0/real_sqrt(x.z*x.z + x.x*x.x);

// The new Z-axis is at right angles to the world Y-axis.
z.x = x.z*s;
z.y = 0;
z.z = -x.x*s;
```

```
// The new Y-axis is at right angles to the new X- and Z-axes.
y.x = x.y*z.x;
y.y = x.z*z.x - x.x*z.z;
y.z = -x.y*z.x;
```

There is one further problem to address. If the contact normal passed in (as the X-axis) is already pointing in the direction of the world space Y-axis, then we will end up with zero for all three components of the Z-axis. In this case, using the world-space Y-axis is not a good guess; we need to use another. We can test for this case and use either the world-space X-axis or Z-axis instead (remember, we don't care what direction these axes point in, as long as they are orthonormal to one another). The code I've implemented uses the world-space X-axis.

To make the algorithm as stable as possible, we perform this switch between using the world-space Y-axis and the X-axis, depending on which is closest to the contact normal. We could just switch when the contact normal is exactly in the direction of the Y-axis, but if it were very close to being in that direction, we may end up with numerical problems and an inaccurate result. It is better to maximize the size of the cross-product.

```
if (real_abs(x.x) > real_abs(x.y))
{
  // We're nearer the x-axis, so use the y-axis as before.
  // ...
}
else
{
  // We're nearer the y-axis, so use the x-axis as a guess.
  // ...
}
```

The Basis Matrix

Before we look at the complete code for calculating the basis, we need to look again at what it needs to output. So far I've assumed we'll end up with three vectors that make up an orthonormal basis.

It is often more convenient to work with a matrix rather than a set of three vectors. Recall in Section 9.4.2 that a matrix can be thought of as a transformation from one set of axes to another.

At several points in this section, we will need to convert between the contact axes (called contact coordinates, or contact space) and world space. To do this we need a matrix that performs the conversion.

As seen in Section 9.4.2, a transform matrix from local space into world space can be constructed by placing the three local-space axes as columns in the matrix. So if we have an orthonormal basis consisting of the three vectors,

$$\widehat{\boldsymbol{x}}_{\text{local}} = \begin{bmatrix} a \\ b \\ c \end{bmatrix}, \widehat{\boldsymbol{y}}_{\text{local}} = \begin{bmatrix} d \\ e \\ f \end{bmatrix}, \text{ and } \widehat{\boldsymbol{z}}_{\text{local}} = \begin{bmatrix} g \\ h \\ i \end{bmatrix}$$

we can combine them into a transform matrix,

$$M_{\text{basis}} = \begin{bmatrix} a\ d\ g \\ b\ e\ h \\ c\ f\ i \end{bmatrix}$$

If we have a set of coordinates expressed in local space and we want the coordinates of the same point in world space, we can simply multiply the transform matrix by the coordinate vector,

$$M\boldsymbol{p}_{\text{local}} = \boldsymbol{p}_{\text{world}}$$

In other words, the basis matrix converts local coordinates to world coordinates.

We can put this together into code. This function operates on the contact normal to create a set of orthonormal axes and then generates a basis matrix representing the contact coordinates. The matrix can act as a transformation to convert contact coordinates into world coordinates:

```
_____ Excerpt from file include/cyclone/contacts.h _____
class Contact
{
    // ... Other data as before ...

    /**
     * Calculates an orthonormal basis for the contact point, based on
     * the primary friction direction (for anisotropic friction) or
     * a random orientation (for isotropic friction).
     */
    void calculateContactBasis();
};
```

```
_____ Excerpt from file src/contacts.cpp _____
/*
 * Constructs an arbitrary orthonormal basis for the contact.  This is
 * stored as a 3 x 3 matrix, where each vector is a column (in other
 * words, the matrix transforms contact space into world space). The x
 * direction is generated from the contact normal, and the y and z
```

```
 * directions are set so that they are at right angles to it.
 */
void Contact::calculateContactBasis()
{
    Vector3 contactTangent[2];

    // Check whether the Z-axis is nearer to the X- or Y-axis
    if (real_abs(contactNormal.x) > real_abs(contactNormal.y))
    {
        // Scaling factor to ensure the results are normalized.
        const real s = (real)1.0f/
            real_sqrt(contactNormal.z*contactNormal.z +
            contactNormal.x*contactNormal.x);

        // The new X-axis is at right angles to the world Y-axis.
        contactTangent[0].x = contactNormal.z*s;
        contactTangent[0].y = 0;
        contactTangent[0].z = -contactNormal.x*s;

        // The new Y-axis is at right angles to the new X- and Z-axes.
        contactTangent[1].x = contactNormal.y*contactTangent[0].x;
        contactTangent[1].y = contactNormal.z*contactTangent[0].x -
            contactNormal.x*contactTangent[0].z;
        contactTangent[1].z = -contactNormal.y*contactTangent[0].x;
    }
    else
    {
        // Scaling factor to ensure the results are normalized.
        const real s = (real)1.0/
            real_sqrt(contactNormal.z*contactNormal.z +
            contactNormal.y*contactNormal.y);

        // The new X-axis is at right angles to the world X-axis.
        contactTangent[0].x = 0;
        contactTangent[0].y = -contactNormal.z*s;
        contactTangent[0].z = contactNormal.y*s;

        // The new Y-axis is at right angles to the new X- and Z-axes.
        contactTangent[1].x = contactNormal.y*contactTangent[0].z -
            contactNormal.z*contactTangent[0].y;
        contactTangent[1].y = -contactNormal.x*contactTangent[0].z;
        contactTangent[1].z = contactNormal.x*contactTangent[0].y;
    }
```

```
    // Make a matrix from the three vectors.
    contactToWorld.setComponents(
        contactNormal,
        contactTangent[0],
        contactTangent[1]);
}
```

The setComponents method of the Matrix3 class sets the columns in the matrix. It is implemented as:

```
───────────── Excerpt from file include/cyclone/core.h ─────────────
class Matrix3
{
    // ... Other Matrix3 code as before ...

    /**
     * Sets the matrix values from the given three vector components.
     * These are arranged as the three columns of the vector.
     */
    void setComponents(const Vector3 &compOne, const Vector3 &compTwo,
        const Vector3 &compThree)
    {
        data[0] = compOne.x;
        data[1] = compTwo.x;
        data[2] = compThree.x;
        data[3] = compOne.y;
        data[4] = compTwo.y;
        data[5] = compThree.y;
        data[6] = compOne.z;
        data[7] = compTwo.z;
        data[8] = compThree.z;
    }
};
```

Inverse Transformation

It is worth recapping the result seen in Section 9.4.3 here, namely that the inverse of a rotation matrix is the same as its transpose. Why are we interested in the inverse? Because, as well as converting from contact coordinates to world coordinates, we may have to go the other way.

To convert world coordinates into contact coordinates, we use the inverse of the basis matrix created in the code above. Inverting a matrix in general, as we have seen,

is complex. Fortunately, the basis matrix as we've defined it here represents a rotation only: it is a 3×3 matrix, so it can't have a translational component;[3] and because both the contact axes and the world axes are orthonormal, it cannot have any skewing or scaling involved.

This means that we can perform the transformation from world coordinates into contact coordinates by using the transpose of the basis matrix:

$$M_{\text{basis}}^{\top} = \begin{bmatrix} a & d & g \\ b & e & h \\ c & f & i \end{bmatrix}^{\top} = \begin{bmatrix} a & b & c \\ d & e & f \\ g & h & i \end{bmatrix}$$

This allows us to convert at will between contact coordinates and world coordinates. Whenever some calculation is easier in one than another, we can simply convert between them. We'll use this important result in the next section, and a great deal more in Chapter 15.

14.2.2 VELOCITY CHANGE BY IMPULSE

Remember that the change in motion of both objects in a collision is caused by the forces generated at the collision point by compression and resistance to deformation. Because we are representing the entire collision event as a single moment in time, we use impulses rather than forces. Impulses cause a change in velocity (both angular and linear, according to D'Alembert's principle, just like forces).

So if our goal is to calculate the impulse at the collision, we need to understand what effect an impulse will have on each object. We want to end up with a mathematical structure that tells us what the change in velocity of each object will be, for any given impulse.

For the frictionless contacts we're considering in this chapter, the only impulses generated at the contact are applied along the contact normal. We'd like to end up with a simple number, then, that tells us the change in velocity at the contact, in the direction of the contact normal, for each unit of impulse applied in the same direction.

As we have seen, the velocity change per unit impulse has two components: a linear component and an angular component. We can deal with these separately and combine them at the end.

It is also worth noting that the value depends on both bodies. We'll need to find the linear and angular velocity change for each object involved in the collision.

3. You may object here. Strictly speaking, we could have a translational component. After all, it makes sense for the contact point to be the origin of the contact coordinates. If we followed this approach, we'd need a larger matrix, and the inverse wouldn't be as simple. In the code we'll need, however, we never have to use this offset value—if we want the contact point, we have access to it directly from the contact data structure. Because of this we can simply ignore the translational component, treat the matrix as a rotation matrix, and take advantage of the cheap inverse.

The Linear Component

The linear component is very simple. The linear change in velocity for a unit impulse will be in the direction of the impulse, with a magnitude given by the inverse mass,

$$\Delta \dot{p}_d = m^{-1}$$

For collisions involving two objects, the linear component is simply the sum of the two inverse masses:

$$\Delta \dot{p}_d = m_a^{-1} + m_b^{-1}$$

Remember that this equation only holds for the linear component of velocity. It doesn't give the complete picture yet!

The Angular Component

The angular component is more complex. We'll need to bring together three equations we have encountered at various points in the book. For convenience, we'll use q_{rel} for the position of the contact relative to the origin of an object:

$$q_{\text{rel}} = q - p$$

First, Equation 14.2 tells us the amount of impulsive torque generated from a unit of impulse:

$$u = q_{\text{rel}} \times \widehat{d}$$

where d is the direction of the impulse (in our case, the contact normal).

Second, Equation 14.1 tells us the change in angular velocity for a unit of impulsive torque:

$$\Delta \dot{\theta} = I^{-1} u$$

And finally, Equation 9.6 tells us the total velocity of a point. If we remove the linear component, we get the equation for the linear velocity of a point due only to its rotation:

$$\dot{q} = \dot{\theta} \times q_{\text{rel}}$$

The rotation-induced velocity of a point (\dot{q}) depends on that point's position relative the origin of the object ($q - p$), and on the object's angular velocity ($\dot{\theta}$).

So we now have a set of equations that can get us from a unit of impulse, via the impulsive torque it generates, and the angular velocity that the torque causes, through to the linear velocity that results. Converting these three equations into code, we get:

```
Vector3 torquePerUnitImpulse =
    relativeContactPosition % contactNormal;
```

```
Vector3 rotationPerUnitImpulse =
    inverseInertiaTensor.transform(torquePerUnitImpulse);

Vector3 velocityPerUnitImpulse =
    rotationPerUnitImpulse % relativeContactPosition;
```

The result will be the velocity caused by rotation per unit impulse. As it stands, the result is a vector—a velocity in world space. But we are only interested in the velocity along the contact normal.

We need to transform this vector into contact coordinates using the transpose basis matrix as seen previously. This would give us a vector of velocities that a unit impulse would cause. We are only interested at this stage in the velocity in the direction of the contact normal. In contact coordinates, this is the X-axis, so our value is the X component of the resulting vector:

```
Vector3 velocityPerUnitImpulseContact =
    contactToWorld.transformTranspose(velocityPerUnitImpulse);

real angularComponent = velocityPerUnitImpulseContact.x;
```

Here the `transformTranspose` method is a convenience method that combines the effect of transforming a vector by the transpose of a matrix.[4] Although we could implement it in this way, there is a faster way of doing it. If we have a matrix multiplication,

$$\begin{bmatrix} a & b & c \\ d & e & f \\ g & h & i \end{bmatrix} \begin{bmatrix} x \\ y \\ z \end{bmatrix}$$

then the X component of the result is $xa + yb + zc$. The former is equivalent to the scalar product,

$$\begin{bmatrix} a \\ b \\ c \end{bmatrix} \cdot \begin{bmatrix} x \\ y \\ z \end{bmatrix}$$

In the case of contact coordinates, the vector

$$\begin{bmatrix} a \\ b \\ c \end{bmatrix}$$

4. It works by performing a regular matrix transformation, but selecting the components of the matrix in row rather than column order. See the accompanying source code for its implementation.

is the contact normal, as we saw when creating the basis matrix. So we can replace the full matrix transformation above with code of the form:

```
real angularComponent = velocityPerUnitImpulse * contactNormal;
```

There is another way to think of this final step. The `velocityPerUnitImpulse` is given in world coordinates. Performing the scalar product is equivalent to finding the component of this value in the direction of the contact normal, where the contact normal as a vector is also given in world coordinates.

It is better, in my opinion, to think in terms of the change of coordinates, because as we introduce friction in Chapter 15, the simple scalar product trick can no longer be used. It is important to realize that we are going through the same process in the nonfriction case, that is, finishing with a conversion from world to contact coordinates.

Putting It Together

For each object in the collision, we can now find the change in velocity of the contact point, per unit impulse.

For contacts with two objects involved, we have four values: the velocity caused by linear motion and by angular motion for each object. For contacts involving only one rigid body (i.e., contacts with immovable fixtures like the ground), we have just two values.

In both cases, we add the resulting values to get an overall change in velocity per unit impulse value. The entire process can be implemented as follows:

```
––––––––––––––– Excerpt from file src/contacts.cpp ––––––––
// Build a vector that shows the change in velocity in
// world space for a unit impulse in the direction of the contact
// normal.
Vector3 deltaVelWorld = relativeContactPosition[0] % contactNormal;
deltaVelWorld = inverseInertiaTensor[0].transform(deltaVelWorld);
deltaVelWorld = deltaVelWorld % relativeContactPosition[0];

// Work out the change in velocity in contact coordinates.
real deltaVelocity = deltaVelWorld * contactNormal;

// Add the linear component of velocity change.
deltaVelocity += body[0]->getInverseMass();

// Check as necessary the second body's data.
if (body[1])
```

```
{
    // Go through the same transformation sequence again.
    Vector3 deltaVelWorld = relativeContactPosition[1] % contactNormal;
    deltaVelWorld = inverseInertiaTensor[1].transform(deltaVelWorld);
    deltaVelWorld = deltaVelWorld % relativeContactPosition[1];

    // Add the change in velocity due to rotation.
    deltaVelocity += deltaVelWorld * contactNormal;

    // Add the change in velocity due to linear motion.
    deltaVelocity += body[1]->getInverseMass();
}
```

In this code the first body is considered. Its rotational component of velocity change is calculated and placed in the deltaVelocity component, followed by its linear component. If a second body is present in the contact, then the same process is repeated, and the deltaVelocity is incremented with the two components for body two. At the end of the process, deltaVelocity contains the total velocity change per unit impulse.

14.2.3 IMPULSE CHANGE BY VELOCITY

For frictionless collisions, this step is incredibly simple. If we have a single value for the velocity change per unit impulse (call it d), then the impulse needed to achieve a given velocity change is

$$g = \frac{v}{d} \qquad [14.3]$$

where v is the desired change in velocity and g is the impulse required.

14.2.4 CALCULATING THE DESIRED VELOCITY CHANGE

This stage of the algorithm has two parts. First, we need to calculate the current closing velocity at the contact point. Second, we need to calculate the exact change in velocity that we are looking for.

Calculating the Closing Velocity

Before we can calculate the velocity change we need, we have to know what the current velocity at the contact is. As seen above, velocity has both a linear and an angular component. To calculate the total velocity of one object at the contact point, we need both. We calculate its linear velocity and the linear velocity of the contact point due to rotation alone.

We can retrieve the linear velocity from an object directly, as it is stored in the rigid body. To retrieve the velocity due to rotation we need to use Equation 9.6 again. The total velocity of the contact point for one object is given by:

```
Vector3 velocity = body->getRotation() % relativeContactPosition;
velocity += body->getVelocity();
```

If there are two bodies involved in the collision, then the second body's values can be added to the velocity vector.

This gives us a total closing velocity in world coordinates. We need the value in contact coordinates, because we need to understand how much of this velocity is in the direction of the contact normal and how much is at a tangent to this. The components of the velocity that are not in the direction of the contact normal represent how fast the objects are sliding past one another; they will become important when we consider friction.

The conversion uses the basis matrix in the now familiar way:

```
contactVelocity = contactToWorld.transformTranspose(velocity);
```

For frictionless collisions we will only use the component of this vector that lies in the direction of the contact normal. Because the vector is in contact coordinates, this value is simply the X component of the vector.

Calculating the Desired Velocity Change

As I mentioned at the start of the chapter, the velocity change we are looking for is given by the same equation we used for particles:

$$v'_s = -cv_s \Rightarrow \Delta v_s = -v_s - cv_s = -(1 + c)v_s$$

In other words, we need to remove all of the existing closing velocity at the contact, and keep going so that the final velocity is c times its original value, but in the opposite direction. In code this is simply

```
real deltaVelocity = -contactVelocity.x * (1 + restitution);
```

If the coefficient of restitution, c, is zero, then the change in velocity will be sufficient to remove all existing closing velocity, but no more. In other words, the objects will end up not separating. If the coefficient is near 1, the objects will separate at almost the same speed they were closing at.

The value of the coefficient depends on the materials that are involved in the collision. Values around 0.4 look visibly very bouncy, like a rubber ball on a hard floor. Values above this can start to look unrealistic.

14.2.5 CALCULATING THE IMPULSE

With the desired velocity change in hand, the impulse is given by Equation 14.3. Because we are not concerned with friction, we are only concerned with the impulse in the direction of the contact normal. In contact coordinates, the contact normal is the X-axis, so the final impulse vector is

$$g_{\text{contact}} = \begin{bmatrix} g \\ 0 \\ 0 \end{bmatrix}$$

where g is the impulse, as above. This is implemented as follows:

```
──────── Excerpt from file src/contacts.cpp ────────
// Calculate the required size of the impulse.
Vector3 impulseContact;
impulseContact.x = desiredDeltaVelocity / deltaVelocity;
impulseContact.y = 0;
impulseContact.z = 0;
```

At this stage it is convenient to convert out of contact coordinates into world coordinates. This makes applying the impulse in the final stage simpler. We can do this using our basis matrix to change coordinates, as in

$$g_{\text{world}} = Mg_{\text{contact}}$$

which is implemented as follows:

```
──────── Excerpt from file src/contacts.cpp ────────
Vector3 impulse = contactToWorld.transform(impulseContact);
```

With the impulse calculated in world coordinates, we can go ahead and apply it to the objects in the collision.

14.2.6 APPLYING THE IMPULSE

To apply the impulse, we use Equations 7.6 and 14.1. The first tells us that linear impulses change the linear velocity of the object according to the formula

$$\dot{p} = \frac{g}{m}$$

The velocity change for the first object in the collision then will be:

```
Vector3 velocityChange = impulse * body[0]->getInverseMass();
```

The rotation change is given by Equation 14.1 as

$$\Delta\dot{\boldsymbol{\theta}} = I^{-1}\boldsymbol{u}$$

We first need to calculate the impulsive torque, \boldsymbol{u}, using Equation 14.2 again:

$$\boldsymbol{u} = \boldsymbol{q}_{\text{rel}} \times \boldsymbol{g}$$

In code this looks like:

```
Vector3 impulsiveTorque = impulse % relativeContactPosition;
Vector3 rotationChange =
    inverseInertiaTensor.transform(impulsiveTorque);
```

These calculations work for the first object in the collision, but not for the second, if there is one.

To apply the impulse to the second object, we first need to make an observation. We have calculated a single value for the impulse, but there may be two objects involved in the collision.

Just as in Chapter 7, both objects involved in a collision will receive the same sized impulse, but in opposite directions. And as we saw in Chapter 2, changing the direction of a vector to its opposite is equivalent to changing the sign of all its components.

We have worked so far using the contact normal as it was generated by the collision detector. By convention, the collision detector generates a contact normal from the first body's point of view. So the calculated impulse will be correct for the first body. The second body should receive the impulse in the opposite direction.

We can use the same code as above for the second body, but first we need to change the sign of the impulse:

```
// Calculate velocity and rotation change for object one.
// ...

impulse *= -1;

// Calculate velocity and rotation change for object two.
// ...
```

Finally, the velocity and rotation changes calculated for each object can be directly applied to the velocity and angular velocity of the rigid body, such as:

```
body->velocity += velocityChange;
body->rotation += rotationChange;
```

14.3 RESOLVING INTERPENETRATION

We have covered the procedure for representing the change in velocity when a collision happens. If the objects in our simulation were truly solid, this would be all that is needed.

Unfortunately, the objects can pass into one another before we detect that a collision has occurred. The simulation proceeds in time steps, during which no checking takes place. By the end of a time step when collision detection occurs, two objects can have touched and passed into one another. We need to resolve this interpenetration in some way; otherwise, objects in the game will not appear solid.

This is the same set of requirements seen in the aggregated mass engine. In that case, when two objects were interpenetrating, it was quite easy to move them apart. We moved each object back along the line of the contact normal to the first point where they no longer intersected.

14.3.1 CHOOSING A RESOLUTION METHOD

For rotating rigid bodies, the situation is a little more complex. There are several strategies we could employ to resolve interpenetration, which are summarized here.

Linear Projection

We could use the same algorithm as before, that is, changing the position of each object so that it is moved apart in the direction of the contact normal. The amount of movement should be the smallest possible so the objects no longer touch. For collisions involving two objects, the amount each moves is proportional to its inverse mass; so, a light object has to take on more of the movement than a heavy object.

This approach works and is very simple to implement (in fact, it uses the same code as for the mass aggregate engine). Unfortunately, it isn't very realistic. Figure 14.4 shows a block that has been knocked into the ground by another collision. If we use the linear projection interpenetration resolution method, the situation after the collision

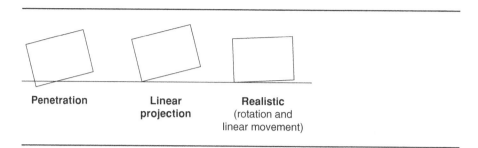

FIGURE 14.4　Linear projection causes realism problems.

is resolved will be as shown. This is in contrast to the third part of the figure that shows how a real box would behave.

Using linear projection makes objects appear to twitch strangely. If you will only be dealing with spherical objects, it is useful and very fast. For any other object, we need something more sophisticated.

Velocity-Based Resolution

Another strategy that is used in some physics engines is to take into account the linear and angular velocity of the objects in the collision. At some point in their motion the two objects will have just touched. Afterward they will continue to the end of the time step interpenetrating. To resolve the interpenetration, we could move them back to the point of first collision.

In practice, calculating this point of first collision is difficult and not worth worrying about. We can approximate it by considering only the contact point on each object as generated by the collision detector. We can move these two points back along the paths they followed until they no longer overlap in the direction of the contact normal.[5]

To move the objects back we need to keep track of the velocity and rotation of each object before any collision resolution began. We can then use these values to work out an equation for the path that each contact point takes, and work out when they first crossed over (i.e., when interpenetration began).

While this is a sensible strategy and can give good results, it has the effect of introducing additional friction into the simulation. Figure 14.5 shows an example of this. The object penetrates the ground while moving sideways at high speed. The velocity-based resolution method would move it back along its path as shown. It would appear to the user that the object hits the ground and sticks, even if there was no friction set for the collision.

5. This isn't the same as finding the first collision point because it is often not the points of deepest interpenetration (which is what the collision detector finds) that were the first to touch: in fact, it could be a completely different part of the objects that touched first.

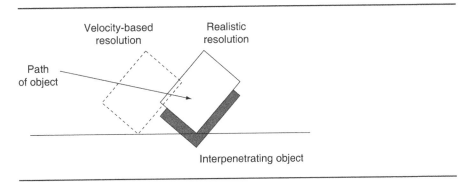

FIGURE 14.5 Velocity-based resolution introduces apparent friction.

Nonlinear Projection

A third option, and the one I will employ in this chapter, is based on the linear projection method. Rather than just moving the objects back linearly, we use a combination of linear and angular movement to resolve the penetration.

The theory is the same: we move both objects in the direction of the contact normal until they are no longer interpenetrating. The movement, rather than being exclusively linear, can also have an angular component.

For each object in the collision we need to calculate the amount of linear motion and the amount of angular motion so that the total effect is exactly enough to resolve the interpenetration. Just as for linear projection, the amount of motion each object makes will depend on the inverse mass of each object. Unlike linear projection, the balance between linear and angular velocity will depend on the inverse inertia tensor of each object.

An object with a high moment of inertia tensor at the contact point will be less likely to rotate, and so will take more of its motion as linear motion. If the object rotates easily, however, then angular motion will take more of the burden.

Figure 14.6 shows this applying the same situation we saw earlier. The result is still not exactly as it would be in reality, but the result is much nearer, and usually doesn't look odd. Figure 14.7 shows the shallow impact situation: the nonlinear projection method doesn't introduce any additional friction. In fact, it slightly diminishes the friction by allowing the object to slide further than it otherwise would. In practice, this appears to be far less noticeable than extra friction.

I will return to the details of implementing this algorithm later in the section.

Relaxation

Relaxation isn't, strictly speaking, a new resolution method. Relaxation resolves only a proportion of the interpenetration at one go, and can be used in combination with any other method. It is most commonly used with nonlinear projection, however.

Interpenetrating **Nonlinear projection** **Physically**
 (may not be perfect, **accurate**
 but is more believable)

FIGURE 14.6 Nonlinear projection is more believable.

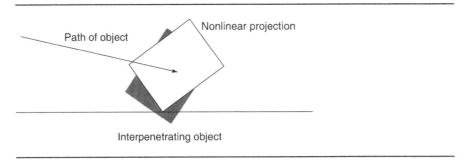

Nonlinear projection

Path of object

Interpenetrating object

FIGURE 14.7 Nonlinear projection does not add friction.

Relaxation is useful when there are lots of contacts on one object. As each contact is considered and resolved, it may move the object in such a way that other objects are now interpenetrated. For a brick in a wall, any movement in any direction will cause it to intepenetrate with another brick.

This can cause problems with the order in which interpenetration resolution is carried out, and can leave the simulation with contacts that still have noticeable penetration.

By performing more interpenetration resolution steps, but having each one only resolve a proportion of the interpenetration, a set of contacts can have a more equitable say over where an object ends up. Each gets to resolve a little, and then the others take their turn. This typically is repeated several times. In situations where previously there would be one or two contacts with obvious interpenetration, this method shares the interpenetration among all the conflicting contacts, which may be less noticeable.

Unfortunately, relaxation also makes it more likely that interpenetration is noticeable at the end of an update when there are few collisions. It is beneficial to have all contacts share a small degree of interpenetration when the alternative is having one very bad contact, but in most cases it is undesirable and a full-strength resolution step is more visually pleasing.

It is relatively simple to add relaxation to your engine (you simply multiply the penetration to resolve by a fixed proportion before performing the normal resolution algorithm). I'd advise you to build the basic system without relaxation, and then add it only if you find that you need to.

14.3.2 Implementing Nonlinear Projection

Let's look in more detail at the nonlinear projection method and get it working in our code.

We start knowing the penetration depth of the contact: this is the total amount of movement we'll need to resolve the interpenetration. Our goal is to find the proportion of this movement that will be contributed by linear and angular motion for each object.

We first make an assumption: imagine that the objects we are simulating were pushed together so that they deformed. Rather than the amount of interpenetration, we treat the penetration depth of the contact as if it were the amount of deformation. As seen in the section on resolving velocities, this deformation causes a force that pushes the objects apart. This force, according to D'Alembert's principle, has both linear and angular effects. The amount of each depends on the inverse mass and the inverse inertia tensor of each object.

Treating interpenetration in this way allows us to use the same mathematics seen in the previous section. We are effectively modeling how the two objects would be pushed apart by the deformation forces, using a physically realistic approximation to find the linear and angular components we need.

Calculating the Components

For velocity we were interested in the amount of velocity change caused by the rotation change from a single unit of impulse. This quantity is a measure of how resistant the object is to being rotated when an impulse or force is applied at the contact point.

To resolve penetration we use exactly the same sequence of equations. We find the resistance of the object to being moved in both a linear and angular way.

Recall that the resistance of an object to being moved is called its *inertia*. So, we are interested in finding the inertia of each object in the direction of the contact normal. This inertia will have a linear component and an angular component.

The linear component of inertia is, as before, simply the inverse mass. The angular component is calculated using the same sequence of operations we used previously. Together the code looks like this:

```
———— Excerpt from file src/contacts.cpp ————
// We need to work out the inertia of each object in the direction
// of the contact normal due to angular inertia only.
for (unsigned i = 0; i < 2; i++) if (body[i])
```

```
{
    Matrix3 inverseInertiaTensor;
    body[i]->getInverseInertiaTensorWorld(&inverseInertiaTensor);

    // Use the same procedure as for calculating frictionless
    // velocity change to work out the angular inertia.
    Vector3 angularInertiaWorld =
        relativeContactPosition[i] % contactNormal;
    angularInertiaWorld =
        inverseInertiaTensor.transform(angularInertiaWorld);
    angularInertiaWorld =
        angularInertiaWorld % relativeContactPosition[i];
    angularInertia[i] =
        angularInertiaWorld * contactNormal;

    // The linear component is simply the inverse mass.
    linearInertia[i] = body[i]->getInverseMass();

    // Keep track of the total inertia from all components.
    totalInertia += linearInertia[i] + angularInertia[i];
}
```

At the end of this loop we have the four values (two if our collision involves only a single body) that tell us the proportion of the penetration to be resolved by each component of each rigid body. The actual amount that each object needs to move is found by:

```
real inverseInertia = 1 / totalInertia;
linearMove[0] = penetration * linearInertia[0] * inverseInertia;
linearMove[1] = -penetration * linearInertia[1] * inverseInertia;
angularMove[0] = penetration * angularInertia[0] * inverseInertia;
angularMove[1] = -penetration * angularInertia[1] * inverseInertia;
```

The penetration value is negative for the second object in the collision for the same reason we changed the sign of the impulse for velocity resolution: the movement is given from the first object's point of view.

Applying the Movement

Applying the linear motion is simple. The linear move value gives the amount of motion required, and the contact normal tells us the direction in which the movement should take place:

```
body[i]->position += contactNormal * linearMove[i];
```

The angular motion is a little more difficult. We know the amount of linear movement we are looking for; we need to calculate the change in the orientation quaternion that will give us this amount. We do this in three stages. First, we calculate the rotation needed to move the contact point by one unit. Second, we multiply this by the number of units needed (i.e., the `angularMove` value). Finally, we apply the rotation to the orientation quaternion.

We can calculate the direction that the object needs to rotate using the same assumption as before: the rotation is caused by some kind of impulse (even though velocity does not change, but position and orientation do). If an impulse were exerted at the contact point, the change in rotation would be

$$\Delta \dot{\boldsymbol{\theta}} = I^{-1} \boldsymbol{u} = I^{-1}(q_{\text{rel}} \times \boldsymbol{g})$$

where q_{rel} is the relative position of the contact point, \boldsymbol{u} is the impulsive torque generated by the impulse, and \boldsymbol{g} is the impulse in the direction of the contact normal, as before. The code follows:

```
Vector3 inverseInertiaTensor;
body->getInverseInertiaTensorWorld(&inverseInertiaTensor);

Vector3 impulsiveTorque = relativeContactPosition % contactNormal;
Vector3 impulsePerMove =
    inverseInertiaTensor.transform(impulsiveTorque);
```

This tells us the impulsive torque needed to get one unit of motion. We are not really interested in impulses, because we already know the total distance that needs to be moved, and we can directly change the object. We don't need to worry about how forces get translated into motion.

To find the rotation needed to get one unit of movement, we simply multiply through by the inertia:

```
Vector3 rotationPerMove = impulsePerMove * 1/angularInertia;
```

The `rotationPerMove` vector now tells us the rotation we need to get one unit of movement. And we know that the total movement we want is `angularMove`, and so we know the total rotation to apply is

```
Vector3 rotation = rotationPerMove * angularMove;
```

To apply this rotation we use Equation 9.9, via the quaternion function updateByVector that we defined earlier.

14.3.3 AVOIDING OVERROTATION

There are two issues to address with the algorithm presented so far. The first is an assumption that slipped in without being commented on, and the second is a potential problem that can cause instability and odd-looking behavior. Both are related to objects being rotated too much as they are moved out of penetration.

Figure 14.8 shows an object that has severely interpenetrated. If the moment of inertia of the object is small but its mass is large, then most of the extraction will be down to angular movement. Clearly, no matter how much angular movement is imposed, the contact point will never get out of the object. The example is extreme, of course, but the problem is very real.

The instant an object begins rotating from an impulsive torque, the contact point will also begin to move. We have assumed that we can take the instantaneous change in position of the contact point (i.e., its velocity) and use that to work out how much rotation is needed. Making this assumption means that there will always be a solution for the rotation to apply, even in cases such as Figure 14.8, where no solution really exists.

In effect we have assumed that the contact point would continue to move in its initial direction forever at the same rate. Clearly, this is a wrong assumption, as the contact point would change its direction of motion as it rotates around the center of mass. For small rotations, the assumption is quite good. And we hope that most interpenetrations are not very large.

For large rotations, we have another problem, however. We have the possibility that we might rotate the object so far that the contact point will start to get closer again, or that another part of the object will come into penetration. Figure 14.9 shows this case. Even a modest rotation of the object can cause another penetration to occur.

For both issues, we need to limit the amount of rotation that can be part of our penetration resolution. Keeping this value small means that our small-rotation

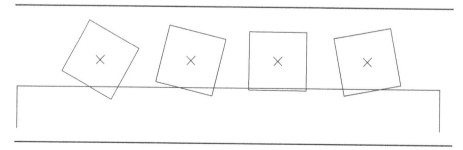

FIGURE 14.8 Angular motion cannot resolve the interpenetration.

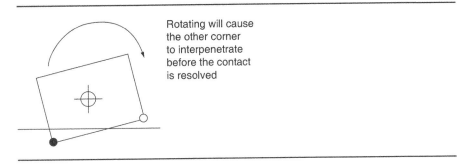

Rotating will cause
the other corner
to interpenetrate
before the contact
is resolved

FIGURE 14.9 Angular resolution causes other problems.

assumption is valid, and that we minimize the chance of causing other interpenetrations while resolving a particular one.

The amount of linear and angular motion we want is calculated and stored in four variables (two for single body collisions):

```
linearMove[0]
linearMove[1]
angularMove[0]
angularMove[1]
```

We can simply check that the values of angularMove are not too large. If they are, we can transfer some of the burden from them onto the corresponding linearMove component.

But what is "too large"? This is where we descend into the black art of tuning the physics engine. I haven't come across a sensible logical argument for choosing any particular strategy.

Some developers use a fixed amount, such as not allowing the angular move value to be greater than 0.5. This works well as long as the objects in the simulation are all roughly the same size. If some objects are very large, then a suitable limit for them may be unsuitable for smaller objects and vice versa.

It is also possible to express the limit in terms of a fraction of a revolution that the object can make. We could limit the rotation so that the object never turns through more than 45 degrees, for example. This accounts for differences in size, but it is more complex to work out the equivalent angular move for a specific angle of rotation.

A simple alternative is to scale the angular move by the size of the object (where the size of the object can be approximated by the magnitude of the relative contact position vector). So larger objects can have more angular movement. This is the approach I have used in the source code.

```
real limit = angularLimitConstant *
             relativeContactPosition.magnitude();

// Check that the angular move is within limits.
if (real_abs(angularMove) > limit)
{
    real totalMove = linearMove + angularMove;

    // Set the new angular move, with the same sign as before.
    if (angularMove >= 0) {
        angularMove = limit;
    } else {
        angularMove = -limit;
    }

    // Make the linear move take the extra slack.
    linearMove = totalMove - angularMove;
}
```

The value for angularLimitConstant needs to be determined by playing with your particular simulation. I have found that values around 0.2 give good results, although lower values are better when very bouncy collisions are used.

14.4 THE COLLISION RESOLUTION PROCESS

So far we have looked at resolving particular collisions for both velocity and interpenetration. Handling one collision on its own isn't very useful.

The collision detector generates any number of contacts, and all of these need to be processed. We need to build a framework in which any number of collisions can be processed at once. This final section of the chapter ties the previous algorithms together to that end. We will end up with a complete collision resolution system that can be used for simulations that don't need friction. In the next two chapters, we will extend the engine to handle friction, improve speed, and increase stability for objects resting on one another.

I mentioned in the introduction to the book that the choice of how to resolve a series of collisions is at the heart of how a physics system is engineered. Most of the commercial physics middleware packages process all of the collisions at the same time (or at least batch them into groups to be processed simultaneously). This allows them to ensure that the adjustments made to one contact don't disturb others.

We will steer a slightly different course. Our resolution system will look at each collision in turn, and correct it. It will process collisions in order of severity (fast collisions are handled first). It may be that resolving one collision in this way will

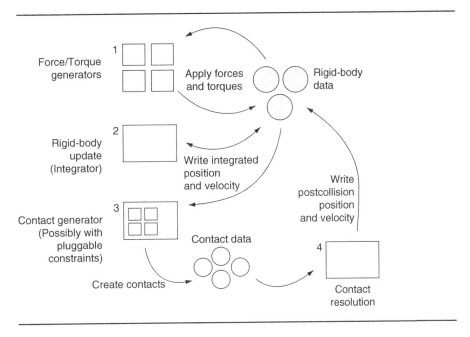

FIGURE 14.10 Data flow through the physics engine.

exacerbate others. We will have to structure the code so that it can take account of this problem.

In Chapter 20, I will look at simultaneous resolution approaches. There is a good chance that your physics needs will not require their sophistication, however. While they are more stable and accurate than the methods in this part of the book, they are very much more complex and can be considerably slower.

14.4.1 THE COLLISION RESOLUTION PIPELINE

Figure 14.10 shows a schematic of the collision resolution process. Collisions are generated by the collision detector, based on the collision geometry of the objects involved. These collisions are passed into a collision resolution routine, along with the rigid-body data for the objects involved.

The collision resolution routine has two components: a velocity resolution system and a penetration resolution system. These correspond to the two algorithms that have made up the majority of this chapter.

These two steps are independent of one another. Changing the velocity of the objects doesn't affect how deeply they are interpenetrating, and vice versa.[6] Physics

6. Actually, this is not strictly true: changing the position of objects can change the relative position of their contacts, which can affect the velocity calculations we've used in our algorithm. The effect is usually tiny, however, and for practical purposes we can ignore the interdependence.

engines that do very sophisticated velocity resolution, with all collisions handled at the same time, often still have a separate simpler penetration resolver that uses the algorithms we implemented above.

The collision resolver we will implement in this chapter is set in a class: CollisionResolver. It has a method resolveContacts that takes the entire set of collisions and the duration of the frame, and it performs the resolution in three steps: it calculates internal data for each contact, passes the contacts to the the penetration resolver, and then passes the contacts to the velocity resolver:

```
──────────── Excerpt from file include/cyclone/contacts.h ────────────
/**
 * The contact resolution routine. One resolver instance
 * can be shared for the entire simulation, as long as you need
 * roughly the same parameters each time (which is normal).
 */
class ContactResolver
{
    /**
     * Resolves a set of contacts for both penetration and
     * velocity. Contacts that cannot interact with each other
     * should be passed to separate calls to resolveContacts, as
     * the resolution algorithm takes much longer for lots of
     * contacts than it does for the same number of contacts in
     * small sets.
     */
    void resolveContacts(Contact *contactArray,
        unsigned numContacts,
        real duration);
};
```

```
──────────── Excerpt from file src/contacts.cpp ────────────
void ContactResolver::resolveContacts(Contact *contacts,
                                      unsigned numContacts,
                                      real duration)
{
    // Make sure we have something to do.
    if (numContacts == 0) return;

    // Prepare the contacts for processing.
    prepareContacts(contacts, numContacts, duration);

    // Resolve the interpenetration problems with the contacts.
    adjustPositions(contacts, numContacts, duration);
```

```
        // Resolve the velocity problems with the contacts.
        adjustVelocities(contacts, numContacts, duration);
}
```

We also add a friendly declaration to the contact data structure to allow the resolver to have direct access to its internals:

```
_____ Excerpt from file include/cyclone/contacts.h _____
class Contact
{
    // ... Other data as before ...

    /**
     * The contact resolver object needs access into the contacts to
     * set and affect the contacts.
     */
    friend ContactResolver;
};
```

14.4.2 PREPARING CONTACT DATA

Because we may be performing both a penetration resolution step and a velocity resolution step for each contact, it is useful to calculate information that both need in a central location. In addition, extra information needed to work out the correct order of resolution needs to be calculated.

In the first category are two bits of data:

- The basis matrix for the contact point, calculated in the calculateContactBasis method, and called contactToWorld.
- The position of the contact relative to each object. I called this relativeContactPosition in the previous code.

In the second category is the relative velocity at the contact point. We need this to resolve velocity, so we could just calculate it in the appropriate method. If we're going to resolve collisions in order of severity (the fastest first), we'll need this value to determine which collision to consider first. So it benefits from being calculated once and reused when needed. We can store these data in the Contact data structure:

```
_____ Excerpt from file include/cyclone/contacts.h _____
class Contact
{
    // ... Other data as before ...
```

```
protected:
    /**
     * A transform matrix that converts coordinates in the contact's
     * frame of reference to world coordinates. The columns of this
     * matrix form an orthonormal set of vectors.
     */
    Matrix3 contactToWorld;

    /**
     * Holds the closing velocity at the point of contact. This is set
     * when the calculateInternals function is run.
     */
    Vector3 contactVelocity;

    /**
     * Holds the required change in velocity for this contact to be
     * resolved.
     */
    real desiredDeltaVelocity;

    /**
     * Holds the world-space position of the contact point relative to
     * The center of each body. This is set when the calculateInternals
     * function is run.
     */
    Vector3 relativeContactPosition[2];
};
```

The preparation routine only needs to call each contact in turn and ask it to calculate the appropriate data:

```
————————— Excerpt from file include/cyclone/contacts.h —————————
class ContactResolver
{
    // ... Other ContactResolver code as before ...

    /**
     * Sets up contacts ready for processing. This ensures that their
     * internal data is configured correctly and the correct set of
     * bodies is made alive.
     */
    void prepareContacts(Contact *contactArray,
```

```
                              unsigned numContacts,
                              real duration);
};
```

────────── Excerpt from file src/contacts.cpp ──────────
```
void ContactResolver::prepareContacts(Contact* contacts,
                                      unsigned numContacts,
                                      real duration)
{
    // Generate contact velocity and axis information.
    Contact* lastContact = contacts + numContacts;
    for (Contact* contact=contacts; contact < lastContact; contact++)
    {
        // Calculate the internal contact data (inertia, basis, etc.).
        contact->calculateInternals(duration);
    }
}
```

In the `calculateInternals` method of the contact, we need to calculate each of the three bits of data: contact basis, relative position, and relative velocity:

────────── Excerpt from file include/cyclone/contacts.h ──────────
```
class Contact
{
    // ... Other data as before ...

protected:
    /**
     * Calculates internal data from state data. This is called before
     * the resolution algorithm tries to do any resolution. It should
     * never need to be called manually.
     */
    void calculateInternals(real duration);
};
```

────────── Excerpt from file src/contacts.cpp ──────────
```
void Contact::calculateInternals(real duration)
{
    // Check if the first object is NULL, and swap if it is.
    if (!body[0]) swapBodies();
    assert(body[0]);
```

```
    // Calculate a set of axes at the contact point.
    calculateContactBasis();

    // Store the relative position of the contact relative to each body.
    relativeContactPosition[0] = contactPoint - body[0]->getPosition();
    if (body[1]) {
        relativeContactPosition[1] =
        contactPoint - body[1]->getPosition();
    }

    // Find the relative velocity of the bodies at the contact point.
    contactVelocity = calculateLocalVelocity(0, duration);
    if (body[1]) {
        contactVelocity -= calculateLocalVelocity(1, duration);
    }

    // Calculate the desired change in velocity for resolution.
    calculateDesiredDeltaVelocity(duration);
}
```

The contact basis method was described earlier in the chapter. The relative position calculation should be straightforward. The remaining two components, swapping bodies and calculating relative velocity, deserve some comment.

Swapping Bodies

The first two lines make sure that if there is only one object in the collision, then it is in the zero position of the array. So far we have assumed that this is true. If your collision detector is guaranteed to only return single-object collisions in this way, then you can ignore this code.

To swap the bodies, we need to move the two body references and also reverse the direction of the contact normal. The contact normal is always given from the first object's point of view. If the bodies are swapped, then this needs to be flipped:

```
──────────── Excerpt from file include/cyclone/contacts.h ────────────
class Contact
{
    // ... Other data as before ...

    /**
     * Reverses the contact. This involves swapping the two rigid
     * bodies and reversing the contact normal. The internal
     * values should then be recalculated using calculateInternals
```

```
     * (this is not done automatically, as this method may be
     * called from calculateInernals).
     */
    void swapBodies();
};
```

─────────────── **Excerpt from file src/contacts.cpp** ───────────────

```
void Contact::swapBodies()
{
    contactNormal *= -1;

    RigidBody *temp = body[0];
    body[0] = body[1];
    body[1] = temp;
}
```

Calculating Relative Velocity

The relative velocity we are interested in is the total closing velocity of both objects at the contact point. This will be used to work out the desired final velocity after the objects bounce.

The velocity needs to be given in contact coordinates. Its X value will give the velocity in the direction of the contact normal, and its Y and Z values will give the amount of sliding that is taking place at the contact. We'll use these two values in the next chapter when we meet friction.

Velocity at a point, as we have seen, is made up of both linear and angular components:

$$\dot{q}_{\mathrm{rel}} = \dot{\theta} \times q_{\mathrm{rel}} + \dot{p}$$

where q_{rel} is the position of the point we are interested in, relative to the object's center of mass; p is the position of the object's center of mass (i.e., \dot{p} is the linear velocity of the entire object); and $\dot{\theta}$ is the object's angular velocity.

To calculate the velocity in contact coordinates, we use this equation, and then transform the result by the transpose of the contact basis matrix:

─────────────── **Excerpt from file include/cyclone/contacts.h** ───────────────

```
/**
 * Calculates and returns the velocity of the contact
 * point on the given body.
 */
Vector3 calculateLocalVelocity(unsigned bodyIndex, real duration);
```

```
─────────────── Excerpt from file src/contacts.cpp ───────────────
Vector3 Contact::calculateLocalVelocity(unsigned bodyIndex, real duration)
{
    RigidBody *thisBody = body[bodyIndex];

    // Work out the velocity of the contact point.
    Vector3 velocity =
        thisBody->getRotation() % relativeContactPosition[bodyIndex];
    velocity += thisBody->getVelocity();

    // Turn the velocity into contact coordinates.
    Vector3 contactVelocity = contactToWorld.transformTranspose(velocity);

    // Calculate the amount of velocity that is due to forces without
    // reactions.
    Vector3 accVelocity = thisBody->getLastFrameAcceleration() * duration;

    // And return it.
    return contactVelocity;
}
```

The calculateInternals method finds the overall closing velocity at the contact point by subtracting the second body's closing velocity from the first:

```
// Find the relative velocity of the bodies at the contact point.
contactVelocity = calculateLocalVelocity(0, duration);
if (body[1]) {
    contactVelocity -= calculateLocalVelocity(1, duration);
}
```

Because this algorithm uses both the contact basis matrix and the relative contact positions, it needs to be done last.

14.4.3 RESOLVING PENETRATION

We have visited each contact and calculated the data we'll need for both resolution steps. Now we turn our attention to resolving the interpenetration for all contacts.

This is done by taking each contact in turn and calling a method (applyPosition-Change) that contains the algorithm in Section 14.3 for resolving a single contact. We could do this simply in the same way as for prepareContacts before:

```
Contact* lastContact = contacts + numContacts;
for(Contact* contact=contacts; contact < lastContact; contact++)
{
    contact->applyPositionChange();
}
```

This would work, but isn't optimal. Figure 14.11 shows three interpenetrating contacts in a row. The second part of the figure shows what happens when the contacts are resolved in order. It ends up with a large interpenetration remaining. The third part of the figure shows the same set of contacts after resolving in reverse order. There is still interpenetration visible, but it is drastically reduced.

Rather than go through the contacts in order, resolving their interpenetration, we can resolve the collisions in penetration order. At each iteration we search through to find the collision with the deepest penetration value. This is handled through its applyPositionChange method in the normal way. The process is then repeated up to some maximum number of iterations (or until there are no more interpenetrations to resolve, whichever comes first).

This algorithm can revisit the same contacts several times. Figure 14.12 shows a box resting on a flat plane. Each corner is penetrating the surface; moving the first corner up will cause the second to descend further. Moving the second will cause

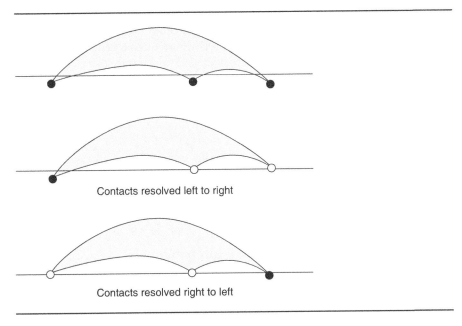

Contacts resolved left to right

Contacts resolved right to left

FIGURE 14.11 Resolution order is significant.

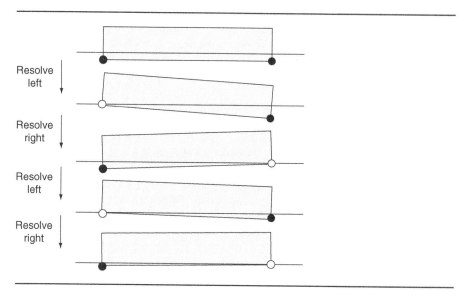

FIGURE 14.12 Repeating the same pair of resolutions.

the first to penetrate again, and so on. Given enough iterations, this situation will be resolved so that neither corner is penetrating. It is more likely that the iteration limit will be reached, however. If you check the number of iterations actually used, you will find that this situation is common and will consume all available iterations.

The same issue can also mean that a contact with a small penetration never gets resolved, as the resolution algorithm runs out of iterations before considering the contact. To prevent this situation, and to guarantee that all contacts get considered, we can run a single pass through all the contacts, and then move on to the best-first iterative algorithm. In practice, however, this is rarely necessary, and a best-first resolution system works well on its own. For fast-moving, tightly packed objects, simulations with longer time steps, or very small limits on the number of iterations, you may see problems.

Typically, objects gradually sinking into surfaces, and then suddenly jumping out a short way is a symptom of penetration resolution not getting to shallow contacts (i.e., the contacts are ignored until they get too deep, whereupon they are suddenly resolved). If this happens, you can add a pass through all contacts before the iterative algorithm.

Iterative Algorithm Implemented

To find the contact with the greatest penetration, we can simply look through each contact in the list. The contact found can then be resolved:

```
Contact* lastContact = contacts + numContacts;
for (unsigned i = 0; i < positionIterations; i++)
```

```
{
    Contact* worstContact = NULL;
    real worstPenetration = 0;
    for(Contact* contact = contacts; contact < lastContact; contact++)
    {
        if (contact->penetration > worstPenetration)
        {
            worstContact = contact;
            worstPenetration = contact->penetration;
        }
    }
    if (worstContact) worstContact->applyPositionChange();
    else break;
}
```

This method looks through the entire list of contacts at each iteration. If this were all we needed, then we could do better by sorting the list of contacts first, and then simply working through them in turn.

Unfortunately, the algorithm above doesn't take into account that an adjustment may change the penetration of other contacts. The penetration data member of the contact is set during collision detection. Movement of the objects during resolution can change the penetration depth of other contacts, as we saw in Figures 14.12 and 14.13.

To take this into account we need to add an update to the end of the algorithm:

```
for (unsigned i = 0; i < positionIterations; i++)
{
    // Find worstContact (as before) ...

    if (!worstContact) break;

    worstContact->applyPositionChange();

    updatePenetrations();
}
```

Here updatePenetrations recalculates the penetrations for each contact. To implement this method accurately, we'd need to go back to the collision detector and work out all the contacts again. Moving an object out of penetration may cause another contact to disappear altogether, or bring new contacts that weren't expected before. Figure 14.13 shows this in action.

Unfortunately, collision detection is far too complex to be run for each iteration of the resolution algorithm. We need a faster way.

FIGURE 14.13 Resolving penetration can cause unexpected contact changes.

Updating Penetration Depths

Fortunately there is an approximation we can use that gives good results. When the penetration for a collision is resolved, only one or two objects can be moved—the one or two objects involved in the collision. At the point where we move these objects (in the applyPositionChange method), we know how much they are moving both linearly and angularly.

After resolving the penetration, we keep track of the linear and angular motion we applied to each object. Then we check through all contacts and find those that also apply to either object. Only these contacts are updated, based on the stored linear and angular movement.

The update for one contact involves the assumption we've used several times in this chapter, that is, the only point involved in the contact is the point designated as the contact point. To calculate the new penetration value, we calculate the new position of the relative contact point for each object, based on the linear and angular movement we applied. The penetration value is adjusted based on the new position of these two points: if they have moved apart (along the line of the contact normal), then the penetration will be less; if they have overlapped, then the penetration will be increased.

If the first object in a contact has changed, then the update of the position will be:

```
cp = rotationChange[0].vectorProduct(
  c[i].relativeContactPosition[0]
  );

cp += velocityChange[0];

c[i].penetration -= rotationAmount[0]*cp.scalarProduct(
  c[i].contactNormal
  );
```

If the second object has changed, the code is similar, but the value is added at the end:

```
cp = rotationChange[1].vectorProduct(
  c[i].relativeContactPosition[1]
  );

cp += velocityChange[1];

c[i].penetration += rotationAmount[1]*cp.scalarProduct(
  c[i].contactNormal
  );
```

Finally, we need some mechanism for storing the adjustments made in the applyPositionChange method for use in this update. The easiest method is to add data members to the ContactResolver class.

The complete code puts these stages together: finding the worst penetration, resolving it, and then updating the remaining contacts. The full code looks like this:

```
─────────── Excerpt from file include/cyclone/contacts.h ───────────
class ContactResolver
{
    // ... Other ContactResolver code as before ...

    /**
     * Resolves the positional issues with the given array of constraints,
     * using the given number of iterations.
     */
    void adjustPositions(Contact *contacts,
        unsigned numContacts,
        real duration);
};
```

```
─────────── Excerpt from file src/contacts.cpp ───────────
void ContactResolver::adjustPositions(Contact *c,
                                      unsigned numContacts,
                                      real duration)
{
    unsigned i,index;
    Vector3 linearChange[2], angularChange[2];
    real max;
    Vector3 deltaPosition;
```

```
// Iteratively resolve interpenetrations in order of severity.
positionIterationsUsed = 0;
while (positionIterationsUsed < positionIterations)
{
    // Find biggest penetration.
    max = positionEpsilon;
    index = numContacts;
    for (i=0; i<numContacts; i++)
    {
        if (c[i].penetration > max)
        {
            max = c[i].penetration;
            index = i;
        }
    }
    if (index == numContacts) break;

    // Match the awake state at the contact.
    c[index].matchAwakeState();

    // Resolve the penetration.
    c[index].applyPositionChange(
        linearChange,
        angularChange,
        max);

    // Again this action may have changed the penetration of other
    // bodies, so we update contacts.
    for (i = 0; i < numContacts; i++)
    {
        // Check each body in the contact.
        for (unsigned b = 0; b < 2; b++) if (c[i].body[b])
        {
            // Check for a match with each body in the newly
            // resolved contact.
            for (unsigned d = 0; d < 2; d++)
            {
                if (c[i].body[b] == c[index].body[d])
                {
                    deltaPosition = linearChange[d] +
                        angularChange[d].vectorProduct(
                            c[i].relativeContactPosition[b]);

                    // The sign of the change is positive if we're
```

```
                                // dealing with the second body in a contact,
                                // and negative otherwise (because we're
                                // subtracting the resolution).
                                c[i].penetration +=
                                    deltaPosition.scalarProduct
                                            (c[i].contactNormal)
                                    * (b?1:-1);
                            }
                        }
                    }
                }
            positionIterationsUsed++;
        }
    }
```

14.4.4 RESOLVING VELOCITY

With penetration resolved we can turn our attention to velocity. This is the point at which different physics engines vary the most, with several different but excellent strategies for resolving velocity. We'll return to some of them in Chapter 20.

For this chapter, I have aimed for the simplest end of the spectrum: a velocity resolution system that works and is stable and is as fast as possible, but that avoids the complexity of simultaneously resolving multiple collisions. The algorithm is almost identical to the one for penetration resolution.

The algorithm runs in iterations. At each iteration, it finds the collision with the greatest closing velocity. If there is no collision with a closing velocity, then the algorithm can terminate. If there is a collision, then it is resolved in isolation, using the method we saw at the start of the chapter. Other contacts are then updated based on the changes that were made. If there are more velocity iterations available, then the algorithm repeats.

Updating Velocities

The major change from the penetration version of this algorithm is the equations for updating velocities. As before, we search through to find only those contacts with an object that has just been altered.

If the first object in the contact has changed, the update of the velocity looks like this:

```
cp = rotationChange[0].vectorProduct(
  c[i].relativeContactPosition[0]
  );
```

```
cp += velocityChange[0];

c[i].contactVelocity += c[i].contactToWorld.transformTranspose(cp);
c[i].calculateDesiredDeltaVelocity(duration);
```

The corresponding code for the second object looks like the following:

```
cp = rotationChange[0].vectorProduct(
  c[i].relativeContactPosition[1]
  );

cp += velocityChange[0];

c[i].contactVelocity -= c[i].contactToWorld.transformTranspose(cp);
c[i].calculateDesiredDeltaVelocity(duration);
```

The calculateDesiredDeltaVelocity function is implemented as follows:

```
void calculateDesiredDeltaVelocity(real duration)
{
    // If the velocity is very slow, limit the restitution.
    real thisRestitution = restitution;
    if (real_abs(contactVelocity.x) < velocityLimit)
    {
        thisRestitution = (real)0.0f;
    }

    // Combine the bounce velocity with the removed
    // acceleration velocity.
    desiredDeltaVelocity =
        -contactVelocity.x - thisRestitution * contactVelocity.x;
}
```

The version of this function defined in the accompanying source code is slightly different, because it includes code for handling microcollisions that are discussed in Chapter 15.

Once again, both cases need to be able to take their adjustment from either the first or second object of the contact that has been adjusted. The complete code listing is very similar to that shown for penetration, so I won't include it here. You can find it in the src/contacts.cpp file in the accompanying source code.

14.4.5 ALTERNATIVE UPDATE ALGORITHMS

I must confess that I have a natural distaste for algorithms that repeatedly loop over arrays finding maxima or that search through an array finding matching objects to adjust. After years of programming, I've learned to suspect that there is probably a much better way. Both these red flags crop up in the penetration and velocity resolution algorithms.

I spent a good deal of time preparing this book implementing alternatives and variations that would improve the theoretical speed of the algorithm. One such alternative that provides good performance is to keep a sorted list of the contacts. By way of illustration, I'll describe it here.

The list of contacts is built as a doubly linked list by adding two pointers in the contact data structure: pointing to the next and previous contacts in the list. Taking the penetration resolution algorithm as an example (although exactly the same thing happens for velocity resolution), we initially sort all the contacts into the doubly linked list in order of decreasing penetration.

At each iteration of the algorithm, the first contact in the list is chosen and resolved (it will have the greatest penetration). Now we need to update the penetrations of contacts that might have been affected. To do this I used another pair of linked lists in the contact data structure. These linked lists contain all the contacts that involve one particular object. There needs to be two such lists, because each contact has up to two objects involved. To hold the start of these lists, I added a pointer in the rigid-body class.

This means that if we know which rigid bodies were adjusted, we can simply walk through their list of contacts to perform the update. In (highly abbreviated) code, it looks something like the following:

```
class Contact
{
    // Holds the doubly linked list pointers for the ordered list.
    Contact * nextInOrder;
    Contact * previousInOrder;

    // Holds pointers to the next contact that involves each rigid body.
    Contact * nextObject[2];

    // ... Other data as before ...
}

class RigidBody
{
    // Holds the list of contacts that involve this body.
    Contact * contacts;
```

```
        // ... Other data as before ...
    }
```

At this point we have a set of contacts whose penetration values have changed. One contact has changed because it has been resolved, and possibly a whole set of other contacts have been changed because of the consequences of that resolution. All of these may now be in the wrong position in the ordered list. The final stage of this algorithm is to adjust their positions.

The easiest way to do this is to extract them from the main ordered list. Sort them as a new sublist, and then walk through the main list, inserting them in order at the correct point. In abbreviated code, this looks like:

```
Contact *adjustedList;
Contact *orderedList;

orderedList = sort(contacts);

for (unsigned i = 0; i < positionIterations; i++)
{
    // Make sure that the worst contact is bad.
    if (orderedList->penetration < 0) break;

    // Adjust its position.
    orderedList->applyPositionChange();

    // Move it to the adjusted list.
    moveToAdjusted(orderedList);

    // Loop through the contacts for the first body.
    Contact *bodyContact = orderedList->body[0].contacts;
    while (bodyContact)
    {
        // Update the contact.
        bodyContact->updatePenetration(positionChange, orientationChange);

        // Schedule it for adjustment.
        moveToAdjusted(bodyContact);

        // Find out which linked list to move along on, and then follow
        // it to get the next contact for this body.
        unsigned index = 0;
```

```
        if (bodyContact->body[0] != orderedList->body[0]) index = 1;
        bodyContact = bodyContact->nextObject[index];
    }

    if (orderedList->body[1])
    {
        // Do the same thing for the second body.
        // (Omitted for brevity.)
    }

    // Now sort the adjusted set.
    sortInPlace(adjustedList);

    // Insert them at the correct place.
    Contact *orderedListEntry = orderedList;
    while (orderedListEntry)
    {
        if (adjustedList->penetration > orderedListEntry->penetration)
        {
            Contact *contactToInsert = adjustedList;
            adjustedList = adjustedList->nextInOrder;
            insertIntoList(contactToInsert, orderedListEntry);
        }
    }
}
```

I've assumed that standard sorting and list manipulation routines are available, along with some extra methods I've used to hide the actual updates for the sake of brevity (we saw the code for these earlier).

Performance

There are tens of variations for this kind of ordering system, and lots of different ways to sort, keep lists, and perform updates. I implemented six different methods when experimenting for this book, including priority queues.

The best performance gain was obtained using the sorted list method above. Unfortunately, it was very minor. For frames with few contacts, and using some of the more general optimization techniques described in Chapter 16, the performance of the linked list version is considerably worse than the naive approach. With many tens of contacts between tightly packed objects,[7] it became more efficient.

7. If objects are not tightly packed, then it is possible to consider contacts in smaller batches, which is much more efficient. We'll look at this approach in detail in Chapter 16.

For several hundred contacts between tightly packed objects, it became significantly faster.

For the simulations I come across in the games I'm involved with, it simply isn't worth the extra development effort—I'd rather save having the extra pointers hanging around in the contact and rigid-body data structures. You may come across situations where the scale of the physics you are working with makes it essential. For anything in game development, it is essential to profile your code before trying to optimize it.

14.5 SUMMARY

Collision resolution involves some of the most complex mathematics we've discussed so far. For a single contact, we do it in two steps: resolving the interpenetration between objects and turning their closing velocity into rebounding velocity.

The velocity resolution algorithm involves working out the effect of applying an impulse to the contact point. This can then be used to work out the impulse that will generate the desired effect. The result is a single impulse value that modifies both the linear and angular velocity of each object involved.

Unlike the velocity resolution algorithm, penetration resolution does not correspond to a physical process (since rigid objects cannot interpenetrate in reality). Because of this, there is no perfectly accurate approach we can use, and we are left with a choice from lots of different approaches to get visibly believable behavior. In this chapter, we implemented an approach derived from the same compression and impulse mathematics used for velocity resolution.

Resolving one contact alone isn't very useful. To resolve the complete set of contacts, we used two similar algorithms: one to resolve all penetrations, and the second to resolve all velocities. Each algorithm considered collisions in order of their severity (i.e., penetration depth or closing velocity). The worst collision was resolved in isolation, and then other collisions that would be affected were updated. Each algorithm continued up to a fixed maximum number of iterations.

The resulting physics system is quite usable, and if you are following along, writing your own code, I'd recommend that you have a go at creating a demonstration program and see the results. The simulation has no friction, so objects slide across one another. For simple sets of objects, it is likely to work fine. For more complex scenarios, you may notice problems with objects vibrating or slow performance.

These three limitations are addressed in the next two chapters. Chapter 15 will look at the difference between the collisions we have been dealing with so far and resting contacts (this is part of the vibration problem), and will introduce friction.

14.6 Exercises

Exercise 14.1

An object has an inertia tensor of

$$\begin{bmatrix} a & 0 & 0 \\ 0 & b & 0 \\ 0 & 0 & c \end{bmatrix}$$

What is its inverse inertia tensor? If you know how to invert a matrix algebraically, you can do that to solve this problem. Alternatively, you can either work through the matrix inversion code by hand, or experiment with its results until you see the pattern (it shouldn't be difficult to spot).

Exercise 14.2

If we have a basis matrix for contact coordinates C, and a basis matrix for an object's local coordinates M, write an expression for transforming a vector in the object's local coordinates into contact coordinates.

Exercise 14.3

If we have a basis matrix for contact coordinates C, and a basis matrix for an object's local coordinates M, write an expression for transforming the object's inertia tensor I into contact coordinates.

Exercise 14.4

Imagine identical collisions between the ground and two straight metal bars. The collisions are configured so that only one end of the bar hits the ground. The first bar has all its mass concentrated at its ends, and the second has its mass concentrated in the center.

(a) After the collision, the point of contact will be separating. For which bar will the separation speed be greater (assuming both have the same coefficient of restitution)?

(b) After the collision, both centers of mass continue to move downward. Which center of mass will be moving faster?

Exercise 14.5

A flat box is lying on the ground. It has been microscopically rotated so that one corner is penetrating slightly. When interpenetration is resolved, what is the maximum angle we can rotate the box before introducing new interpenetration? What does this result tell us about applying a limit to the amount of rotation that we use to resolve interpenetration?

15

RESTING CONTACTS
AND FRICTION

So far I've used the terms *contacts* and *collisions* interchangeably. The collision detector finds pairs of objects that are touching (i.e., in contact) or interpenetrating. The collision resolution algorithm manipulates these objects in physically believable ways.

From this point on, I will make a distinction between the two terms: a *contact* is any location in which objects are touching or interpenetrating, whereas a *collision* is a type of contact in which the objects are moving together at speed (this is also called an *impact* in some physics systems). This chapter will introduce another type, the *resting contact*. This is a contact where the objects involved are neither moving apart nor are they together.

For the sake of completeness, there is a third type of contact—the separating contact, where the objects involved are already moving apart. There is no need to perform any kind of velocity resolution on a separating contact, so it is often ignored.

The collisions we've seen up to this point are relatively easy to handle: the two objects collide briefly and then go on their own way again. At the point of contact, we calculate an impulse that causes the contact to turn from a collision into a separating contact (if the coefficient of restitution is greater than zero) or a resting contact (if it is exactly zero).

When two objects are in contact for a longer period of time (i.e., longer than a single physics update), they are said to have resting contact. In this case, they need to be kept apart, while making sure that each object behaves correctly.

Copyright © 2010, Elsevier Inc. All rights reserved.
DOI: 10.1016/B978-0-12-381976-5.00015-2

15.1 RESTING FORCES

When an object is resting on another, Newton's third and final law of motion comes into play. Newton's third law of motion (Newton-3) follows:

3. For every action there is an equal and opposite reaction.

We already used this law in the last chapter. For collisions involving two objects, when we calculated the impulse on one object, we applied the same impulse in the opposite direction to the second object. Collisions between objects and the immovable environment used the assumption that any movement of the environment would be so small that it could be safely ignored. In reality, when an object bounces on the ground, the entire Earth is also bouncing, that is, the same impulse is being applied to the Earth. Of course, the Earth is so massive that if we tried to work out the amount of motion that the Earth undergoes, it would be vanishingly small, so we ignore it.

When we come to resting contacts, a similar process happens. If an object is resting on the ground, then the force of gravity is trying to pull it through the ground. We feel this force as weight: the force that gravity is applying on a heavy object is great. What isn't as obvious is that there is an equal and opposite force keeping the object on the ground. This is called the reaction force, and Newton-3 tells us that it is exactly the same as its weight. If this reaction force were not there, then the object would accelerate down through the ground. Figure 15.1 shows the reaction force.

Whenever two objects are in resting contact and not accelerating, there will be a balance of forces at the point of contact. Any force that one object applies to the other will be met with an equal reaction force. If this balance of forces isn't present, then both objects will be accelerating. We can work out the acceleration using Newton's second law of motion, after working out the total force (including reaction forces) on each object.

There is something of a circluar process here, and it gives a taste of some issues to come. If reaction forces can be as large as neccesary (we're assuming rigid bodies will

FIGURE 15.1 A reaction force at a resting contact.

never crumble or compress), and acceleration depends on the total forces applied, how do we calculate how big the reaction forces actually are at any time? For simple situations such as in Figure 15.1, this isn't a problem, and in most high school and undergraduate mathematics, the problem is never mentioned. For complex scenarios with lots of interacting objects and especially friction, it is significant, as we will see.

Note that the reaction force between the ground and an object is a real force. It isn't an impulse, as there is no change in velocity. So far in our collision resolution system, we've only applied impulses. This reaction force can't be represented in the same way. We need to consider it more fully.

15.1.1 FORCE CALCULATIONS

The most obvious approach to resting contacts is to calculate the reaction forces. That way we can add the forces into the equations of motion of our rigid bodies (using D'Alembert's principle, as in Section 10.3). With the reaction forces working alongside the regular forces we apply, the body will behave correctly.

Many physics systems do exactly this. Given a set of contacts, they try to generate a set of reaction forces that will keep the objects from accelerating together. For colliding contacts, they use one of two methods: they either use the same impulse method seen in the last chapter, or they use the fact that an impulse is simply a force applied over a small moment of time. If we know the time (i.e., the duration of the physics update), then the impulse can be turned into a one-off force and resolved in the same way as other forces.

This approach is okay if you can accurately calculate the reaction forces every time. For simple situations, such as an object resting on the ground, this is very easy. But it rapidly gets more complex. Figure 15.2 shows a stack of objects. There are many internal reaction forces in this stack. The reaction forces at the bottom of the stack depend on the reaction forces at the top of the stack. The forces that need to be applied at a contact may depend on contacts at a completely different location in the simulation, with no common objects between them.

To calculate reaction forces, we cannot use an iterative algorithm like those in the last chapter. We have to take a more global view, representing all the force interactions in a single mathematical structure, and creating a one-for-all solution. In most cases this can be done, and it is the mathematical core of most commercial physics middleware packages. We'll look at the techniques in Chapter 20.

In some cases, especially when there is friction at resting contacts, there is *no* solution. The combination of reaction forces cannot be solved; the simulation can get into a state that could not occur in physical reality. The computer is trying to solve a problem that is literally impossible.

This problem occurs for many reasons, such as numerical calculation errors, because we miss the exact moment of contact by stepping through time, because we are assuming perfectly rigid bodies, where in reality all objects can be compressed to some degree, and finally, when what appears to be a resting contact would in reality

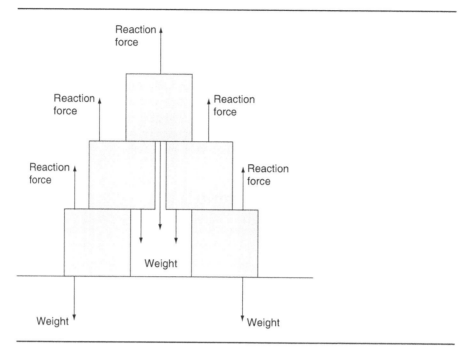

FIGURE 15.2 The long-distance dependence of reaction forces.

be a collision. You can see the latter case in the real world: if you slide an object along a rough surface, you may be able to get it to suddenly leap into the air a little. This occurs because a contact that appears to be a resting contact with the ground may in reality be a collision against a patch of high friction.

Each of these situations leads to problems solving the mathematics to get a set of reaction forces. Special-case code or tailored solving algorithms are needed to detect impossibilities and react differently to them (typically by introducing an impulse of some kind).

If this is sounding complex, it's because it is. Fortunately, there is a much simpler (though less accurate) solution. Rather than resolving all contacts using forces (i.e., converting collision impulses into forces), we can do the opposite and treat resting contacts as if they were collisions.

15.2 MICROCOLLISIONS

Microcollisions replace reaction forces by a series of impulses—one per update. In the same way that an impulse can be thought of as a force applied in a single moment of time, a force can be thought of as an entire series of impulses. Applying a force of 10 N to an object over 10 updates is equivalent to applying impulses of 1 N at each update.

Velocity = 0 Velocity = −1 m/s Velocity = 0

Microcollision
imparts 1 m/s
of velocity

FIGURE 15.3 Microcollisions replace reaction forces.

Rather than calculate a set of reaction forces at each time step, we allow our impulse resolution system to apply impulses. Figure 15.2 shows this in practice. The block should be resting on the ground. At each frame (ignoring interpenetration for a while), the block accelerates so that it has a velocity into the ground. The velocity resolution system calculates the impulse needed to remove that velocity.

These little impulses are sometimes called *microcollisions*. It is a well-known technique for generating reaction forces, but suffers from an undeserved reputation for producing unstable simulations.

If you run the physics engine from Chapter 14, you will see that objects don't sink into one another, even though there is no reaction force at work. Microcollisions are already at work: at each update objects are building up velocity, only to have the velocity resolution algorithm treat contacts as collisions and remove the velocity.

There are two significant problems with treating resting contacts as collisions. The first has to do with the way collisions bounce. Recall that the separation speed at a contact point is calculated as a fixed ratio of the closing speed, in the opposite direction. This ratio is the coefficient of restitution.

If we have a contact such as that shown in Figure 15.3, after the rigid-body update, the velocity into the ground will have built up. During the velocity resolution process, this velocity will be removed. The desired final velocity will be

$$v'_s = -cv_s$$

where v_s is the velocity before the collision is processed, v'_s is the same velocity after processing, and c is the coefficient of restitution.

So whatever velocity built up over the course of the interval between updates will cause a little bounce to occur. If our sphere on the ground had a high c value, the downward velocity would generate an upward velocity.

But in reality, the downward velocity never gets a chance to build up. The sphere can't really accelerate into the ground. The velocity that it accumulates is physically impossible.

This has the effect of making resting contacts appear to vibrate. The objects accelerate together, building up velocity that then causes the collision algorithm to give them a separating velocity. The sphere on the ground bounces up until gravity brings

it back down, whereupon it bounces again. It will never settle to rest, but will appear to vibrate.

Setting a lower coefficient of restitution will help, but limits the kinds of situations that can be modeled. A more useful solution involves making two changes:

1. We remove any velocity that has been built up from acceleration in the previous rigid-body update.

2. We artificially decrease the coefficient of restitution for collisions involving very low speeds.

Independently, both of these can solve the vibration problem for some simulations, but still show problems in others. Together they are about as good as we can get.

15.2.1 REMOVING ACCELERATED VELOCITY

To remove the velocity due to the previous frame's acceleration, we need to keep track of the acceleration at each rigid-body update. We can do this with a new data member for the rigid-body, `accelerationAtUpdate`, which stores the calculated linear acceleration. The rigid-body update routine is then modified to keep a record in this variable of the acceleration generated by all forces and gravity:

```
——————— Excerpt from file include/cyclone/body.h ———————
class RigidBody
{
    // ... Other RigidBody code as before ...

    /**
     * Holds the linear acceleration of the rigid body, for the
     * previous frame.
     */
    Vector3 lastFrameAcceleration;
};
```

```
——————— Excerpt from file src/body.cpp ———————
// Calculate linear acceleration from force inputs.
lastFrameAcceleration = acceleration;
lastFrameAcceleration.addScaledVector(forceAccum, inverseMass);
```

We could extend this to keep a record of both linear and angular acceleration. This would make it more accurate, but since most reaction forces are generated by gravity (which never has an angular component), the extra calculations don't normally give

any visible benefit. In fact, some developers choose to ignore any force except gravity when calculating the velocity added in the last frame. This makes the calculation simpler still, as we can read the acceleration due to gravity from the acceleration data member directly.

When we calculate the desired change in velocity for a contact, we subtract the acceleration-induced velocity in the direction of the contact normal:

$$\Delta v = -v_{\text{acc}} - (1 + c)(v_s - v_{\text{acc}})$$

The desired change in velocity is modified from

```
deltaVelocity = -(1+restitution) * contactVelocity;
```

to

```
real velocityFromAcc = body[0]->accelerationAtUpdate *
                       contactNormal;

if (body[1])
{
    velocityFromAcc -= body[1]->accelerationAtUpdate *
                       contactNormal;
}

real deltaVelocity = - contactVelocity.x - restitution *
                     (contactVelocity.x - velocityFromAcc);
```

Making this simple adjustment reduces the amount of visual vibration for objects resting on the ground. When objects are in tight groups, such as stacks, the vibration can return. To solve that problem we'll perform the second step: reducing the coefficient of restitution.

We'll return to the velocity caused by acceleration later in the chapter. We will need another calculation of this kind to solve a problem with friction at resting contacts.

15.2.2 LOWERING THE RESTITUTION

The change we made in the last section effectively reduces the restitution at contacts. Before reducing the velocity, we have collisions with greater separating velocity than closing velocity, as the objects are pushed apart even when they begin resting. This occurs when there is a coefficient of restitution above 1. The smaller the coefficient, the less bounce there will be.

When the acceleration compensation alone doesn't work, we can manually lower the coefficient of restitution to discourage vibration. This can be done in a very simple way:

```
real appliedRestitution = restitution;
if (contactVelocity.magnitude() < velocityLimit)
{
    appliedRestitution = (real)0.0f;
}
```

We could use a more sophisticated method where the restitution is scaled so that it is smaller for smaller velocities, but the version above works quite well in practice. If you see visible transitions between bouncing and sticking as objects slow down, try reducing the velocity limit (I use a value of around 0.1 in my engine). If this introduces vibration, then the scaling approach may be useful to you:

```
real appliedRestitution = restitution;
real speed = contactVelocity.magnitude();
if (speed < velocityLimit)
{
    appliedRestitution = restitution * (speed / velocityLimit);
}
```

15.2.3 THE NEW VELOCITY CALCULATION

Combining both techniques for resting contacts, we end up with the following code in our adjustVelocities method:

```
void calculateDesiredDeltaVelocity(real duration)
{
    const static real velocityLimit = (real)0.25f;

    // Calculate the acceleration-induced velocity accumulated in
        this frame.
    Vector3 scaledContact = duration * contactNormal;

    real velocityFromAcc =
        body[0]->getLastFrameAcceleration() * scaledContact;

    if (body[1])
```

```
    {
        velocityFromAcc -=
            body[1]->getLastFrameAcceleration() * scaledContact;
    }

    // If the velocity is very slow, limit the restitution.
    real thisRestitution = restitution;
    if (real_abs(contactVelocity.x) < velocityLimit)
    {
        thisRestitution = (real)0.0f;
    }

    // Combine the bounce velocity with the removed
    // acceleration velocity.
    desiredDeltaVelocity =
        -contactVelocity.x
        -thisRestitution * (contactVelocity.x - velocityFromAcc);
}
```

I have placed this series of operations in its own method: calculateDesiredDeltaVelocity that is called as part of the calculateInternals method, rather than have the calculations performed every time that the velocity resolver tries to find the most severe collision.

This approach removed almost all the visible vibrations in the cyclone physics engine. One of the optimization techniques discussed in Chapter 16 removes the rest.

15.3 TYPES OF FRICTION

I've mentioned friction several times throughout the book, and now it's time to tackle it head-on. Friction is the force generated when one object moves or tries to move in contact with another. No matter how smooth two objects look, microscopically they are rough, and these small protrusions catch one another, causing a retardation of their motion or a resistance to motion beginning.

Friction is also responsible for a small part of drag, when air molecules try to move across the surface of an object (the rest of drag has a number of different factors, such as turbulence, induced pressure, and collisions between the object and air molecules).

The two forms of friction, static and dynamic, behave slightly differently.

15.3.1 STATIC AND DYNAMIC FRICTION

Static friction is a force that stops an object moving when it is stationary. Consider a block that is resting on the ground. If the block is given some force, friction between

the block and the ground will resist this force. This is a kind of reaction force: the more you push, the more friction pushes back. At some point, however, the pushing force is too much for the friction and the object begins moving.

Because static friction keeps objects from moving, it is sometimes called *stiction*. The static friction depends on the materials at the point of contact and the reaction force:

$$|f_{\text{static}}| \leqslant \mu_{\text{static}} |r|$$

where r is the reaction force in the direction of the contact normal, f_{static} is the friction force generated, and μ_{static} is the coefficient of static friction.

The coefficient of friction encapsulates all the material properties at the contact in a single number. The value depends on both objects: it cannot be generated by simply adding a coefficient for one object to one for another. In fact, it is an empirical quantity. It is discovered by experiment and cannot be reliably calculated.

In physics reference books, you will often find tables of friction coefficients for various pairs of materials. In game development, setting the coefficient for a particular contact is more often the result of guesswork or trial and error. I have included a table of friction coefficients that I find useful in Appendix B.

Note that the formula above is an inequality—it uses the \leqslant symbol. This means that the magnitude of the friction force can be anything up to and including $\mu|r|$. In fact, up to this limit, it will be exactly the same as the force exerted on the object. So the overall expression for the static friction force is

$$f_{\text{static}} = \begin{cases} -f_{\text{planar}} \\ \widehat{f}_{\text{planar}} - \mu_{\text{static}} |r| \end{cases}, \text{ whichever is smaller in magnitude,}$$

where f_{planar} is the total force on the object in the plane of the contact only. The force is only in this plane, because any resulting force in the direction of the contact normal is generating the reaction force. The reaction force and the planar force can be calculated from the total force applied:

$$r = -f \cdot \widehat{d}$$

where \widehat{d} is the contact normal and f is the total force exerted, and

$$f_{\text{planar}} = f + r$$

In other words, the resulting planar force is the total force with the component in the direction of the contact normal removed. In the equation, this component is removed by adding the reaction force, which is equal and opposite to the force in the direction of the contact, and therefore cancels it out.

The dependence of static friction on the normal reaction force is an important result. It allows rock climbers to walk up a vertical chimney by pushing against a wall at their back, forcing their boots into the wall ahead. This means the wall pushes back with an equal reaction force, and that increase in reaction force means increased friction. Push hard enough, and there will be enough friction to overcome your weight and keep you from falling.

Another important feature of the equations above is that friction doesn't depend on the area that is in contact with the ground. A rock climber with bigger feet doesn't stick better.

Despite being slightly counterintuitive (for me at least), this is fortunate, because nowhere in our engine have we considered the size of the contact area. Contact area does become important in some cases where the objects can deform at the point of contact (tire models in accurate engineering simulations, for example), but they are very complex and well beyond the scope of this book, so we'll stick with the basic formula.

Returning to our block on the ground, as we exert more force, friction pushes back until we reach $\mu_{static}|r|$, the limit of static friction. If we increase the force input a fraction, the friction force drops suddenly and we enter the world of dynamic friction.

Dynamic Friction

Dynamic friction, also called *kinetic friction*, behaves in a similar way to static friction, but has a different coefficient.

When objects at the contact are moving relative to one another, they are typically leaving contact at the microscopic level. Figure 15.4 shows static and dynamic friction magnified many times. Once the object is in motion, the roughness on each object isn't meshing as closely, so dynamic friction provides less resistance.

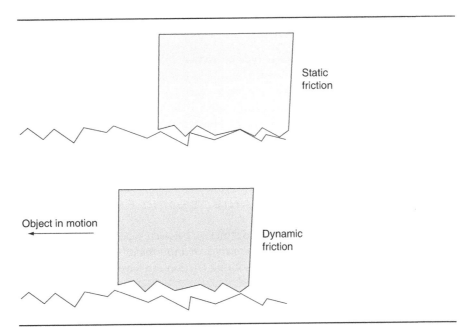

FIGURE 15.4 A microscopic view of dynamic and static friction.

Dynamic friction obeys the equation

$$f_{\text{dynamic}} = -\widehat{v}_{\text{planar}}\, \mu_{\text{dynamic}}\, |r|$$

where μ_{dynamic} is the coefficient of dynamic friction. Note that the direction of friction has changed. Rather than acting in the opposite direction to the planar force (as it did for static friction), it now acts in the opposite direction to the velocity of the object. This is significant: if you stop exerting a force on a stationary object, then the friction force will instantly stop as well. If you stop exerting a force on a moving object, friction will not stop—the object will be slowed to a halt by dynamic friction. Like static friction, dynamic friction coefficients can be found in some physics reference books for various combinations of materials.

It is rare in game physics engines to distinguish between static and dynamic friction in an implementation. They tend to be rolled together into a generic friction value. When the object is stationary, the friction acts as static friction, acting against any force exerted. When the object is moving, the friction acts as dynamic friction, acting against the direction of motion. In practice, this single value provides behavior that is believable for a game.

The friction model we'll develop in this chapter will follow this model, and combine both types of friction into a single value. I will point out below where we are using static friction and where it is dynamic, so you can replace the single value with two values if you need to. Using two values is left as an exercise for this chapter.

Rolling Friction

There is another type of friction that is important in dynamic simulation. Rolling friction occurs when one object is rolling along another. It is most commonly used for high-quality tire models for racing simulation (meaning the simulations performed by motor-racing teams, rather than those found in racing games).

I have not come across physics engines for games with a comprehensive tire model that includes rolling friction. Because we are focusing on game applications, I will ignore rolling friction for the rest of the book.

15.3.2 ISOTROPIC AND ANISOTROPIC FRICTION

There is one further distinction between types of friction that we need to be aware of: friction can be either *isotropic* or *anisotropic*. Isotropic friction has the same coefficient in all directions. Anisotropic friction can have different coefficients in different directions.

Figure 15.5 shows our block on the ground from above. If it is pushed in the first direction, then the friction force will have a coefficient of μ_a; if it is pushed in the second direction, then the friction force will have a coefficient of μ_b. If $\mu_a = \mu_b$, then the friction is isotropic; otherwise, it is anisotropic.

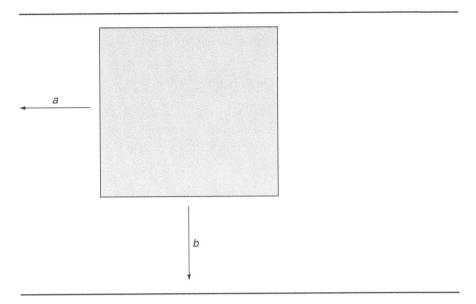

FIGURE 15.5 Anisotropic friction.

The vast majority of game simulations only need to cope with isotropic friction. In fact, most engines I've used are either purely isotropic, or make the programmer jump through extra hoops to get anisotropic friction. Even then, the anisotropic friction model is highly simplified. We'll stick with isotropic friction in this book.

15.4 IMPLEMENTING FRICTION

Introducing friction into a physics simulation depends on how the existing physics is implemented. In our case, we have an impulse-based engine with microcollisions for resting contacts. This means we have no calculated normal reaction forces at resting contacts. In addition, we introduce impulses and not forces at contacts to generate believable behavior.

This makes it difficult to directly carry across the friction equations we have seen so far: we have no calculation of the reaction force, and we have no easy way of applying forces at the contact point (remember that in our engine the forces for the current physics update are applied before collision detection begins).

If you are working with a force-based engine, especially one that calculates the reaction forces for all contacts, then friction can become another force in the calculation and the equations we have seen can be applied directly. Although this sounds simpler, there are knock-on effects that make it even more difficult to calculate the required forces. I'll return to friction-specific force calculation in Chapter 20. At this stage, it is simply worth being aware that despite the modifications we'll have to make

to convert friction into impulses, if we had gone through the force-only route initially, it wouldn't have made friction any easier.

15.4.1 FRICTION AS IMPULSES

The first stage in handling friction in our simulation is to understand what friction is doing in terms of impulses and velocity. Static friction stops a body from moving, when a force is applied to it. It acts to keep the velocity of the object at zero in the contact plane.

In our simulation we allow velocity to build up and remove it with a mirco-collision; we can simulate static friction by removing sliding velocity along with collision velocity. We already adjust the velocity of the object in the direction of the contact normal. We could do something similar in the other two contact directions (i.e., the directions that are in the plane of the contact). If we went through the same process for each direction as we did for the normal, we could ensure that the velocity in these directions is zero. This would give the effect of static friction.

Rather than having a single value for the change in velocity, we now have a vector, expressed in contact coordinates:

```
real deltaVelocity; // ... Calculate this as before ..

Vector3 deltaVelocityVector(deltaVelocity,
                            -contactVelocity.y,
                            -contactVelocity.z);
```

I'll return to the changes needed in the resolution algorithm to cope with this later.

This approach would remove all sliding. But static friction has a limit: it can only prevent objects from sliding up to a maximum force. When dealing with the collision, we don't have any forces, only velocities. How do we decide the maximum amount of velocity that can be removed?

Recall that velocity is related to impulse:

$$\Delta \dot{p} = m^{-1} g$$

where g is impulse, m is mass, and \dot{p} is velocity. So, if we know the amount of velocity that we need to remove, we can calculate the impulse required to remove it.

In the same way, impulse is a force exerted over a short period of time:

$$g = ft$$

where f is force and t is time. Given the impulse required to remove the velocity and the duration of the update, we can calculate the force required to remove the velocity.

The equation still requires a normal reaction force. This can be calculated in the same way, by looking at the contact normal. The normal reaction force can be

approximately calculated from the amount of velocity removed in the direction of the contact normal.

If the desired change in velocity at the contact normal is v, then the reaction force can be approximated as:

$$f = \Delta v m t$$

The velocity resolution algorithm we already have involves calculating the impulse needed to achieve the desired change in velocity. This impulse is initially found in contact coordinates. Since we will be working in impulses, we can combine the equations above with the friction equations to end up with the result

$$g_{\max} = \Delta g_{\text{normal}}\, \mu$$

where Δg_{normal} is the impulse in the direction of the contact normal (i.e., the impulse we are currently calculating in our velocity resultion algorithm). Note that these impulse values are scalar: this tells us the total impulse we can apply with static friction. In code this looks like the following:

```
Vector3 impulseContact;

// ... Find the impulse required to remove all three components of
// velocity (we'll return to this algorithm later) ...

real planarImpulse = real_sqrt(impulseContact.y*impulseContact.y +
                               impulseContact.z*impulseContact.z);

// Check that we're within the limit of static friction.
if (planarImpulse > impulseContact.x * friction)
{
    // Handle as dynamic friction.
}
```

Dynamic friction can be handled by scaling the Y and Z component of the impulse so that their combined size is exactly μ times the size of the X impulse:

```
impulseContact.y /= planarImpulse;
impulseContact.z /= planarImpulse;

impulseContact.y *= friction * impulseContact.x;
impulseContact.z *= friction * impulseContact.x;
```

Dividing by `planarImpulse` scales the Y and Z components so they have a unit size—this is done to preserve their direction while removing their size. Their size is given by the friction equation, `friction * impulseContact.x`. Multiplying the direction by the size gives the new values for each component.

15.4.2 MODIFYING THE VELOCITY RESOLUTION ALGORITHM

In the previous section, I glossed over how we might calculate the impulses needed to remove velocity in the plane of the contact. We already have code that does this for the contact normal, and we could simply duplicate this for the other directions.

Unfortunately, as well as being very long-winded, this wouldn't work very well. An impulse in one direction can cause an object to spin, and its contact point can begin moving in a completely different direction. As long as we were only interested in velocity in the direction of the the contact normal, this didn't matter. Now we need to handle all three directions at the same time, and we need to take into account that an impulse in one direction can increase the velocity of the contact in a different direction. To resolve the three velocities, we need to simultaneously work through the resolution algorithm for each.

The resolution algorithm has the following steps, as before:

1. We work in a set of coordinates that are relative to the contact, which makes lots of the math much simpler. We create a transform matrix to convert into and out of this new set of coordinates.

2. We work out the change in velocity of the contact point on each object per unit impulse. Because the impulse will cause linear and angular motion, this value needs to take account of both components.

3. We will know the velocity change we want to see (in the next step), so we invert the result of the last stage to find the impulse needed to generate any given velocity change.

4. We work out what the separating velocity at the contact point should be, what the closing velocity currently is, and the difference between the two. This is the desired change in velocity.

5. From the change in velocity, we can calculate the impulse that must be generated.

6. We split the impulse into its linear and angular components and apply them to each object.

We have inserted a new step between Steps 5 and 6, to check whether the impulse respects the static friction equation and use dynamic friction if it doesn't.

Step 2 requires modification. Currently, it works out the change in velocity given a unit impulse in the direction of the contact normal. We are now dealing with all three contact directions. We need to calculate the change in velocity given any combination

of impulses in the three contact directions. The impulse can be expressed as a vector in contact coordinates:

```
Vector3 contactImpulse;
```

The X component represents the impulse in the direction of the contact normal, and the Y and Z components represent the impulse in the plane of the contact.

The result of Step 2 will be a matrix: it will transform a vector (the impulse) into another vector (the resulting velocity). With this matrix, the rest of the algorithm is simple. In Step 3, we will find the inverse of the matrix (i.e., the matrix that transforms desired change in velocity into required impulse), and in Step 5 we will transform the desired velocity vector to get the `contactImpulse` vector.

So how do we calculate the matrix? We follow through with the same steps seen in Section 14.2.2. We calculate the velocity change as a result of angular motion, and the velocity change as a result of linear motion.

Velocity from Angular Motion

In Section 14.2.2, we saw the algorithm for calculating rotation-derived velocity from a unit impulse:

```
Vector3 torquePerUnitImpulse =
    relativeContactPosition % contactNormal;

Vector3 rotationPerUnitImpulse =
    inverseInertiaTensor.transform(torquePerUnitImpulse);

Vector3 velocityPerUnitImpulse =
    rotationPerUnitImpulse % relativeContactPosition;

Vector3 velocityPerUnitImpulseContact =
    contactToWorld.transformTranspose(velocityPerUnitImpulse);
```

The first stage calculates the amount of torque for a unit impulse in the direction of the contact normal. The second stage converts this torque into a velocity using the inertia tensor. The third stage calculates the linear velocity of the contact point from the resulting rotation. And the final stage converts the velocity back into contact coordinates.

Rather than use the contact normal in the first stage, we need to use all three directions of the contact: the basis matrix. But if the contact normal is replaced by a matrix, how do we perform the cross-product?

The answer lies in an alternative formation of the cross-product. Remember that transforming a vector by a matrix gives a vector. The cross-product of a vector also gives a vector. It turns out that we can create a matrix form of the vector product.

For a vector,

$$v = \begin{bmatrix} a \\ b \\ c \end{bmatrix}$$

the vector product

$$v \times x$$

is equivalent to the matrix-by-vector multiplication,

$$\begin{bmatrix} 0 & -c & b \\ c & 0 & -a \\ -b & a & 0 \end{bmatrix} x$$

This matrix is called *skew-symmetric*. Its relationship to the cross-product is important—any cross-product is equivalent to multiplication by the corresponding skew-symmetric matrix.

Because, as we have seen, $v \times x = -x \times v$, if we already have the skew-symmetric version of v, we can calculate $x \times v$ without building the matrix form of x; it is simply:

$$x \times v = - \begin{bmatrix} 0 & -c & b \\ c & 0 & -a \\ -b & a & 0 \end{bmatrix} x$$

In fact, we can think of the cross-product in the first stage of our algorithm as turning an impulse into a torque. We know from Equation 10.1 that a force vector can be turned into a torque vector by taking its cross-product with the point of contact,

$$\tau = p_f \times f$$

which is just Equation 10.1 again. The skew-symmetric matrix can be thought of as this transformation, turning force into torque.

It is useful to have the ability to set a matrix's components from a vector, so we add a convenience function to the Matrix3 class:

```
───────────────── Excerpt from file include/cyclone/core.h ─────────────────
class Matrix3
{
    // ... Other Matrix3 code as before ...

    /**
     * Sets the matrix to be a skew-symmetric matrix based on
     * the given vector. The skew-symmetric matrix is the equivalent
     * of the vector product. So if a,b are vectors, a x b = A_s b
```

```
    * where A_s is the skew-symmetric form of a.
    */
    void setSkewSymmetric(const Vector3 vector)
    {
        data[0] = data[4] = data[8] = 0;
        data[1] = -vector.z;
        data[2] = vector.y;
        data[3] = vector.z;
        data[5] = -vector.x;
        data[6] = -vector.y;
        data[7] = vector.x;
    }
};
```

Now we can work the entire basis matrix through the same series of steps:

```
// Create the skew symmetric form of the cross-product.
Matrix3 impulseToTorque;
impulseToTorque.setSkewSymmetric(relativeContactPosition);

// This was a cross-product.
Matrix3 torquePerUnitImpulse = impulseToTorque * contactToWorld;

// This was a vector transformed by the tensor matrix; now it's
// just plain matrix multiplication.
Matrix3 rotationPerUnitImpulse =
    inverseInertiaTensor * torquePerUnitImpulse;

// This was the reverse cross-product, so we'll need to multiply the
// result by -1.
Matrix3 velocityPerUnitImpulse = rotationPerUnitImpulse * impulseToTorque;
velocityPerUnitImpulse *= -1;

// Finally, convert the result into contact coordinates.
Matrix3 velocityPerUnitImpulseContact =
    contactToWorld.transpose() * velocityPerUnitImpulse;
```

The resulting matrix, velocityPerUnitImpulseContact can be used to transform an impulse in contact coordinates into a velocity in contact coordinates. This is exactly what we need for this stage of the algorithm.

In practice, there may be two objects involved in the contact. We can follow the same process through each time and combine the results. The most efficient way to do

this is to note that only the impulseToTorque and inverseInertiaTensor matrices will change for each body. The contactToWorld matrices are the same in each case. We can therefore separate them out and multiply them after the two objects have been processed independently. The code looks like this:

```cpp
//────────── Excerpt from file src/contacts.cpp ──────────
// The equivalent of a cross-product in matrices is multiplication
// by a skew-symmetric matrix. We build the matrix for converting
// between linear and angular quantities.
Matrix3 impulseToTorque;
impulseToTorque.setSkewSymmetric(relativeContactPosition[0]);

// Build the matrix to convert contact impulse to change in velocity
// in world coordinates.
Matrix3 deltaVelWorld = impulseToTorque;
deltaVelWorld *= inverseInertiaTensor[0];
deltaVelWorld *= impulseToTorque;
deltaVelWorld *= -1;

// Check to see if we need to add body two's data.
if (body[1])
{
    // Set the cross-product matrix.
    impulseToTorque.setSkewSymmetric(relativeContactPosition[1]);

    // Calculate the velocity change matrix.
    Matrix3 deltaVelWorld2 = impulseToTorque;
    deltaVelWorld2 *= inverseInertiaTensor[1];
    deltaVelWorld2 *= impulseToTorque;
    deltaVelWorld2 *= -1;

    // Add to the total delta velocity.
    deltaVelWorld += deltaVelWorld2;

    // Add to the inverse mass.
    inverseMass += body[1]->getInverseMass();
}

// Perform a change of basis to convert into contact coordinates.
Matrix3 deltaVelocity = contactToWorld.transpose();
deltaVelocity *= deltaVelWorld;
deltaVelocity *= contactToWorld;
```

The same matrix is reused for intermediate stages of the calculation, as in Chapter 14.

What we are effectively doing here is performing all the calculations in world coordinates (i.e., we end up with a matrix that transforms impulse into velocity, both in world coordinates) for each body. Adding the two results together and then changing the basis of this matrix transforms impulse into velocity in contact coordinates. Recall from Section 9.4.6 that we change the basis of a matrix by

$$BMB^{-1}$$

where B is the basis matrix and M is the matrix being transformed. This is equivalent to BMB^\top when B is a rotation matrix only (as it is for the contactToWorld matrix), hence the last three lines of the code snippet.

Velocity from Linear Motion

So far we only have the change in velocity caused by rotation. We also need to include the change in linear velocity from the impulse. As before, this is simply given by the inverse mass:

$$\Delta \dot{p} = m^{-1} g$$

This again is a transformation from a vector (impulse) into another vector (velocity). Because we are trying to end up with one matrix combining linear and angular components of velocity, it would be useful to express inverse mass as a matrix, so that it can be added to the angular matrix we already have.

This can be done simply. Multiplying a vector by a scalar quantity k is equivalent to transforming it by the following matrix:

$$\begin{bmatrix} k & 0 & 0 \\ 0 & k & 0 \\ 0 & 0 & k \end{bmatrix}$$

You can perform a manual check by trying a vector multiplication.

So to combine the linear motion with the angular motion we already have, we need only add the inverse mass to the diagonal entries of the matrix:

```
deltaVelocity.data[0] += inverseMass;
deltaVelocity.data[4] += inverseMass;
deltaVelocity.data[8] += inverseMass;
```

15.4.3 PUTTING IT ALL TOGETHER

We are now ready to put together all the modifications we need to support isotropic friction. These modifications are only made to the applyVelocityChange method of

the contact: they are all handled as a microcollision. The final code looks like the following:

```
———————— Excerpt from file include/cyclone/contacts.h ————————
class Contact
{
    // ... Other data as before ...

    /**
     * Calculates the impulse needed to resolve this contact,
     * given that the contact has a non-zero coefficient of
     * friction. A pair of inertia tensors-one for each contact
     * object-is specified to save calculation time. The calling
     * function has access to these anyway.
     */
    Vector3 calculateFrictionImpulse(Matrix3 *inverseInertiaTensor);
};
```

```
———————— Excerpt from file src/contacts.cpp ————————
Vector3 Contact::calculateFrictionImpulse(Matrix3 * inverseInertiaTensor)
{
    real inverseMass = body[0]->getInverseMass();

    // The equivalent of a cross-product in matrices is multiplication
    // by a skew-symmetric matrix. We build the matrix for converting
    // between linear and angular quantities.
    Matrix3 impulseToTorque;
    impulseToTorque.setSkewSymmetric(relativeContactPosition[0]);

    // Build the matrix to convert contact impulse to change in velocity
    // in world coordinates.
    Matrix3 deltaVelWorld = impulseToTorque;
    deltaVelWorld *= inverseInertiaTensor[0];
    deltaVelWorld *= impulseToTorque;
    deltaVelWorld *= -1;

    // Check to see if we need to add body two's data.
    if (body[1])
    {
        // Set the cross-product matrix.
        impulseToTorque.setSkewSymmetric(relativeContactPosition[1]);

        // Calculate the velocity change matrix.
```

```
        Matrix3 deltaVelWorld2 = impulseToTorque;
        deltaVelWorld2 *= inverseInertiaTensor[1];
        deltaVelWorld2 *= impulseToTorque;
        deltaVelWorld2 *= -1;

        // Add to the total delta velocity.
        deltaVelWorld += deltaVelWorld2;

        // Add to the inverse mass.
        inverseMass += body[1]->getInverseMass();
    }

    // Perform a change of basis to convert into contact coordinates.
    Matrix3 deltaVelocity = contactToWorld.transpose();
    deltaVelocity *= deltaVelWorld;
    deltaVelocity *= contactToWorld;

    // Add in the linear velocity change.
    deltaVelocity.data[0] += inverseMass;
    deltaVelocity.data[4] += inverseMass;
    deltaVelocity.data[8] += inverseMass;

    // Invert to get the impulse needed per unit velocity.
    Matrix3 impulseMatrix = deltaVelocity.inverse();

    // Find the target velocities to kill.
    Vector3 velKill(desiredDeltaVelocity,
        -contactVelocity.y,
        -contactVelocity.z);

    // Find the impulse to kill target velocities.
    Vector3 impulseContact = impulseMatrix.transform(velKill);

    // Check for exceeding friction.
    real planarImpulse = real_sqrt(
        impulseContact.y*impulseContact.y +
        impulseContact.z*impulseContact.z
        );
    if (planarImpulse > impulseContact.x * friction)
    {
        // We need to use dynamic friction.
        impulseContact.y /= planarImpulse;
        impulseContact.z /= planarImpulse;
```

```
            impulseContact.x = deltaVelocity.data[0] +
                deltaVelocity.data[1]*friction*impulseContact.y +
                deltaVelocity.data[2]*friction*impulseContact.z;
            impulseContact.x = desiredDeltaVelocity / impulseContact.x;
            impulseContact.y *= friction * impulseContact.x;
            impulseContact.z *= friction * impulseContact.x;
        }
    return impulseContact;
}
```

The impulse is then applied in exactly the same way as for the nonfriction case.

15.5 FRICTION AND SEQUENTIAL CONTACT RESOLUTION

With the modifications in this chapter, our physics engine has taken a huge leap forward. It is now capable of modeling rigid bodies with all kinds of contacts and isotropic friction.

There are still some lingering stability issues that we can look at, along with a huge expected increase in performance. Both will be discussed in Chapter 16.

At this stage we can also see the main unavoidable limitation of the microcollision approach to physics. And no amount of tweaking will completely make this go away. Figure 15.6 shows a typical situation in which two boxes are in contact with one another. Neither of the boxes are moving and all contacts have very high friction (let's say it is infinite, i.e., the static friction can never be overcome). The boxes are interpenetrating slightly.

The second part of Figure 15.6 shows what happens after the penetration is resolved. Note that the boxes have moved apart a little. The third part of the figure shows the situation after the rigid bodies have been updated. There is a little interpenetration again. And the final figure shows the situation after the second round of collision resolution.

Over time it is clear that the boxes are moving apart. They are appearing to slide, even though they have an infinite friction.

This is caused by the sequential contact resolution scheme. While the resolution algorithm is considering contact A, it cannot be considering contact B. But when we have friction, the coefficient of friction at B has an effect on how contact A should be resolved. No amount of minor adjustment will solve this problem: to get around it we would need to process contacts simultaneously or create a good deal of special-case code to perform contact-sensitive penetration resolution.

In practice, this isn't a major problem unless you are building stacks of blocks. Even in this case, the sleeping system that we will build in the next chapter ensures

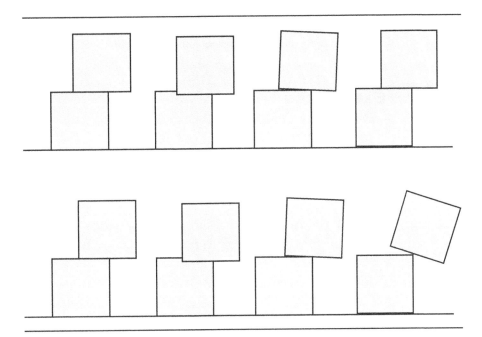

FIGURE 15.6 The problem with sequential contact resolution.

that the sliding will only occur after the player disturbs the stack. If you need to build large stacks of objects that are stable to slight knocks, you can either use one of the simultaneous resolution approaches in Chapter 20 or use fracture physics, found in Chapter 17.

15.6 SUMMARY

Resting contacts can be dealt with as if they were tiny little bouncing contacts: the contact interpenetration is resolved, and the closing velocity is killed by applying a small impulse.

By reducing the resting forces over the entire duration of a simulation frame into just an instant of impulse, we were able to simply add friction to the engine. The effects of friction modify the impulse before it is applied to the objects in contact. This is a simple and powerful approach to friction, but it isn't without its problems. It is much harder to show the difference between static and dynamic friction using microcollisions (in fact, we've avoided the problem by combining the coefficients into a single value).

Another problem with contacts simulated using microcollisions is that they can appear to vibrate slightly. This is one of a set of stability problems that our current engine implementation faces. In Chapter 16, we'll look at stability as a whole, and

improve our engine's realism. Then we'll discuss how to improve its performance by optimizing the code to do less unnecessary work.

15.7 EXERCISES

Exercise 15.1
Two blocks of mass 1 kg sit on top of one another. The bottom block is resting on the ground.

(a) Calculate the reaction force that is keeping the bottom block from sinking into the ground.

(b) Calculate the reaction force keeping the top block from sinking into the bottom block. For this question, assume gravity is $10 \, \text{ms}^{-2}$.

Exercise 15.2
Modify the code given in this chapter to support separate coefficients for static and dynamic friction.

Exercise 15.3
For this practical exercise you will need a selection of objects, some large and relatively heavy, some small to act as weights, a piece of string, and some scales (kitchen scales are fine, and better if they are digital). Weigh the objects. Take each large object in turn and place it on a table. Tie a piece of string around it, as near as possible to the point of contact with the table. Pass the other end of the string over the edge of the table. Tie and suspend the dangling edge to the lightest of your small objects. If the large object does not move, replace the small object with the next lightest, and so on, until the object is heavy enough to break the static friction.

(a) Record the weight that was needed to break the static friction for each large object.

(b) Assuming that gravity is $10 \, \text{ms}^{-2}$, you should be able to calculate both the normal reaction force (from the mass of the large object) and the pulling force (from the mass of the small object). Use these values to calculate the coefficient of friction for each large object.

16

STABILITY AND OPTIMIZATION

The physics engine we've built so far is perfectly usable. As it stands, however, there are two criticisms that can be leveled:

- Occasionally, strange effects are visible, such as objects appearing to be squashed or skewed, or objects sliding down hills despite gravity, and fast-moving objects may not behave believably.
- For very large numbers of objects, the simulation can be slow.

We can address these problems to arrive at our final physics engine implementation that will be powerful and robust enough to be used in a wide range of games. The remaining chapters in the book will focus on ways of applying or extending the engine, but in this chapter we'll aim to polish our implementation into a stable and efficient whole.

16.1 STABILITY

Stability problems in our engine, as in all game software, arise from several directions:

- Unpleasant interaction between different bits of the software that individually behave reasonably.

Copyright © 2010, Elsevier Inc. All rights reserved.
DOI: 10.1016/B978-0-12-381976-5.00016-4

- Inaccuracies of the equations used or the effects of assumptions that we've made.

- The inherent inaccuracy of the mathematics performed by the computer.

These stability problems can become evident through visually odd behavior, algorithms occasionally not working, or even sudden crashes.

For physics engines in particular, there are a couple of common bugbears that you are almost guaranteed to see during development: sudden, unexpected motion, such as when an object leaps off the ground, and an object's disappearance. The accompanying source code shouldn't display either of these critical problems, but chances are that you'll see both of them before long if you make changes and tweaks.

The stability problems we are left with should be even more minor, but their causes fall in all three categories. By carefully testing the engine, I identified five problems that have relatively easy stability fixes:

- Transform matrices for objects performing skews in addition to rotations and translations.

- Fast-moving objects can sometimes respond oddly to collisions (this is independent of whether the collisions are actually detected; a fast-moving object can pass right through an object without a collision being detected).

- Objects resting on an inclined plane (or resting on another object with a sloping surface) tend to slowly slide down.

- Objects experiencing a pair of high-speed collisions in rapid succession can suddenly interpenetrate the ground.

- The simulation can look unrealistic when large and small quantities are mixed: large and small masses, large and small velocities, large and small rotations, and so on.

Together these stability fixes solved the odd behavior I could generate. Of course, no test is ever going to be exhaustive. I have used physics systems for years before noticing some new issue or error.

As with all software maintenance, you never know when some change will need to be made. By the same token, it is a good idea to keep a copy of the test scenarios you run on your engine, so that you can go back and check that your new enhancement hasn't broken anything else.

16.1.1 Quaternion Drift

Transform matrices are generated from the position vector and orientation quaternion of rigid bodies. Both position and orientation (in fact, all values that take part in mathematical manipulation) suffer numerical errors while being processed.

Errors in the position vector put an object in the wrong place. This is usually such a small error that it isn't noticeable over any short period of time. If the position changes slowly enough, the viewer will not notice any errors occurring.

The same is true of the orientation vector to some extent. But there is an extra problem: we have an additional degree of freedom in the quaternion. If the four quaternion components get out of sync (i.e., if the quaternion is no longer normalized), then it may not correspond to any valid orientation. None of the code in our engine is particularly sensitive to this, but left for long enough it can cause objects to visibly become squashed. The solution, as seen in Chapter 9, is to renormalize the quaternion. We don't want to do this when it's not necessary (such as after every quaternion operation) because that's just a waste of time.

I have added a quaternion normalization step in the rigid-body update routine just after the quaternion is updated by the velocity and before the transform matrix is created. This ensures that the transform matrix has a valid rotation component.

I admit that this "stability fix" is a bit contrived. It seemed obvious to me when I first wrote the integration routine that it was a good spot for the quaternion normalization, and so I added it.

I have included it here more by way of illustration. The normal size of the quaternion is an assumption we made early on in the development of the engine; it is easily forgotten and has returned to cause strange effects only after we have a completed engine running for long periods of time. Problems may show up only during quality assurance (QA) and they can be very subtle. Checking and enforcing your assumptions in a way that doesn't massacre performance is key to stabilizing and optimizing the engine.

16.1.2 Interpenetration on Slopes

The next issue is more significant. Figure 16.1 shows a block resting on a slope. The slope could be an angled plane or the surface of another object. Gravity is acting down.

After one update of the rigid bodies, and before collision resolution is performed, the object drops into the plane slightly. This is shown in the second part of the figure. Because the plane contact is in a different direction to the movement of the object, the interpenetration resolution moves the block out to the position shown in the third part of the figure. Over time and despite high friction, the block will slowly drift down the slope.

This is a similar problem to the one we saw at the end of the previous chapter. In that case, the drifting was caused by the interaction between different contacts. In this case, there is no interaction—the same thing would occur for objects with only one contact. It is therefore much easier to find a solution.

The solution lies in the calculation of the relative velocity of the contact. We'd like to remove any velocity that has built up due to forces in the contact plane. This would allow the object to move into the slope in the direction of the contact normal, but not along it.

To accomplish this we add a calculation of the velocity due to acceleration to the `calculateLocalVelocity` method:

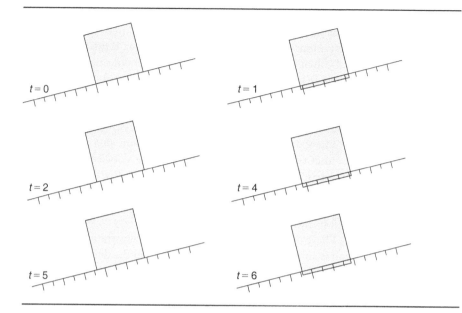

FIGURE 16.1 Objects drift down angled planes.

```
                                    ─────── Excerpt from file src/contacts.cpp ───────
Vector3 Contact::calculateLocalVelocity(unsigned bodyIndex, real duration)
{
    RigidBody *thisBody = body[bodyIndex];

    // Work out the velocity of the contact point.
    Vector3 velocity =
        thisBody->getRotation() % relativeContactPosition[bodyIndex];
    velocity += thisBody->getVelocity();

    // Turn the velocity into contact coordinates.
    Vector3 contactVelocity = contactToWorld.transformTranspose(velocity);

    // Calculate the amount of velocity that is due to forces without
    // reactions.
    Vector3 accVelocity = thisBody->getLastFrameAcceleration() * duration;

    // Calculate the velocity in contact coordinates.
    accVelocity = contactToWorld.transformTranspose(accVelocity);

    // We ignore any component of acceleration in the contact normal
    // direction; we are only interested in planar acceleration.
    accVelocity.x = 0;
```

```
    // Add the planar velocities. If there's enough friction they will
    // be removed during velocity resolution.
    contactVelocity += accVelocity;

    // And return it.
    return contactVelocity;
}
```

The code finds the acceleration, and multiplies it by the duration to find the velocity introduced at the rigid-body integration step. It converts this into contact coordinates, and removes the component in the direction of the contact normal. The resulting velocity is added to the contact velocity, to be removed in the velocity resolution step, as long as there is sufficient friction to do so. If there isn't sufficient friction, then the object will slide down the slope, exactly as it should.

16.1.3 INTEGRATION STABILITY

This enhancement needs some background explanation, so we'll return to the integration algorithm from Chapters 3 and 10.

For both particles and rigid bodies, I have used a similar integration algorithm: it calculates the linear and angular acceleration and applies these to the velocity and rotation, which are in turn applied to the position and orientation. This integration algorithm is called Newton-Euler. Newton refers to the linear component (which is based on Newton's laws of motion) and Euler refers the angular component (Euler was a mathematician who was instrumental in our understanding of rotation).

Our integrator uses the equations

$$\dot{p}' = \dot{p} + \ddot{p}t$$

and

$$p' = p + \dot{p}t$$

along with their rotational equivalents. Each of them only depends on the first differential. They are therefore termed first order. The overall method is more fully called *first-order Newton-Euler* or *Newton-Euler 1*.

Newton-Euler 2

As seen in Chapter 3, Newton-Euler 1 is an approximation. In high school physics, the equation:

$$p' = p + \dot{p}t + \frac{1}{2}\ddot{p}t^2$$

is taught. This depends on the second differential. With the equivalent equation for angular updates, we would have a second-order Newton-Euler integrator (Newton-Euler 2).

Newton-Euler 2 is more accurate than Newton-Euler 1. It takes into account acceleration when determining the updated position. As seen in Chapter 3, however, the t^2 term is so small for high frame rates that we may as well ignore the acceleration term altogether. This is not the case when acceleration is very large, however. In this case, the term may be significant, and moving to Newton-Euler 2 could be beneficial.

Runga-Kutta 4

Both Newton-Euler integrators assume that acceleration will remain constant throughout the update duration. As seen in Chapter 6 when we discussed springs, the way acceleration changes over the course of an update can be very significant. In fact, by assuming acceleration does not change, we can run into dramatic instabilities and the complete breakdown of the simulation.

Springs aren't the only thing that can change acceleration quickly. Some patterns of resting contacts (particularly when a simultaneous velocity resolution algorithm is used) can have similar effects, leading to vibration or dramatic explosion of object stacks.

For both problems a partial solution lies in working out the accelerations needed at mid-step. The fourth-order Runga-Kutta algorithm[1] (RK4) does just this.

If you study physics engines, you'll see a lot of mention of Runga-Kutta integration. I know that some developers have used it quite successfully. Personally, I have never had the need. It is much slower than Newton-Euler, and the benefits are marginal. It is most useful when dealing with very stiff springs, but as seen in Chapter 6, there are simpler ways to fake the same behavior.

The biggest problem with RK4, however, is that it requires a full set of forces midway through the step. When combined with a collision resolution system, this can get very messy. In our case, we do not directly determine the forces due to contacts, and we do not want to run a full collision detection routine mid-step, so RK4 is of limited use. Even for force-based engines, the extra overhead of calculating mid-update forces gives a huge performance hit.

I have seen developers use RK4 for the rigid-body update, and then a separate collision resolution step at the end. This could be easily implemented in our engine by replacing the `integrate` function of the rigid body. Unfortunately, with the collision resolution not taking part, RK4 loses most of its power, and I feel that the result is only useful if you have stubborn spring problems.

1. Unlike Newton-Euler, it is fourth order because it takes four samples, not because it uses a fourth-order differential.

16.1.4 THE BENEFIT OF PESSIMISTIC COLLISION DETECTION

Our algorithm for collision resolution sometimes misses collisions altogether. Figure 16.2 shows a situation with one collision. The object shown has a low moment of inertia, so the resolution of this collision will leave the object as shown. Since there was only one collision detected, this new interpenetration can't be resolved at this time step. The player will see the object interpenetrated until the following frame when it can be resolved. Single-frame interpenetration isn't normally visible, but if two or more contacts end up in a cycle, then the object can appear to be vibrating into the surface.

The only way to deal with this situation is to make collision detection more pessimistic. In other words, collision detection should return contacts that are close, but not actually touching. This can be achieved by expanding the collision geometry around an object, and then using an offset for the penetration value. If the collision geometry is one unit larger than the visual representation of the object, then 1 is subtracted from the penetration value of detected collisions.

In practice, it is rare to see any effects of this. The times when I have needed this kind of modification (which crops up in all physics systems, regardless of the method of collision resolution), it has been most noticeable in collisions between long light objects (such as poles) and the ground. It is a trivial change to move the ground slightly higher for collision detection, and subtract a small amount from generated ground collisions.

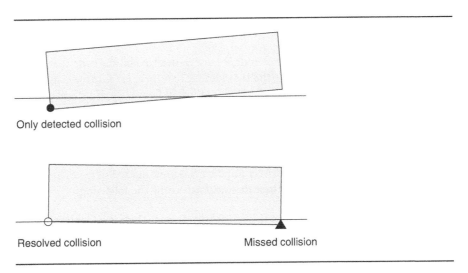

FIGURE **16.2** Collisions can be missed if they are not initially in contact.

16.1.5 CHANGING MATHEMATICAL ACCURACY

All the mathematics in our engine is being performed with limited mathematical precision. Floating-point numbers are stored in two parts: a series of significant digits (called the *mantissa*), and an indication of where the decimal point goes (called the *exponent*). This means that numbers with very different scales have very different accuracies.

For 32-bit, floating-point numbers on a 32-bit machine (i.e., a float data type), adding 0.00001 to 1 will probably give you the correct answer; but adding 0.0001 to 10,000,000,000 will not. When you have calculations that involve numbers of very different scales, the results can be very poor. For example, if you move an object a small distance and it is close to the origin (i.e., its coordinates are close to zero), the object will be moved correctly; if you move the same object the same distance, but it is far from the origin, then you may end up with no movement, or too large a movement, depending on the order of your mathematical operations.

When you are using the physics engine with a broad range of masses, velocities, or positions, this can be a problem. Visually, it can range from objects sinking into the ground and collisions having no effect, to suddenly disappearing bodies and collisions occurring in completely the wrong direction. It is a common problem in collision detection algorithms, too, where objects can be reported as touching when they are separate or vice versa.

There is no definitive solution to this problem, but you can increase the accuracy of the mathematics being performed. In C or C++, you can switch from floats to doubles as your numeric data type. As the name suggestions, doubles take up twice the amount of memory in a 32-bit system (in most 64-bit systems a double will still take 64 bits, and will therefore be identical to a float). On 32-bit system, a double takes a little less than twice the amount of time to process, but has millions of times the accuracy.

In the source code, I have centralized all the code that deals with the accuracy of the engine into the include/cyclone/precision.h file. This defines the real type alias (a C typedef), which is used for all floating-point numbers. The real data type can be defined as a float or as a double. As well as the data type, I have given aliases for various mathematical functions provided by the standard C library and used in the source code. These need to be set so that the code can call the correct precision version without being edited.

The single precision code has been quoted so far. When compiling in double precision mode, these definitions become the following:

```
———————————— Excerpt from include/cyclone/precision.h ————————————
#define DOUBLE_PRECISION
typedef double real;
#define REAL_MAX DBL_MAX
#define real_sqrt sqrt
#define real_abs fabs
```

```
#define real_sin sin
#define real_cos cos
#define real_exp exp
#define real_pow pow
#define real_fmod fmod
#define R_PI 3.14159265358979
```

You can see this code in the precision header, along with an `ifdef` to select the definitions you need.

I tend to compile with double precision by default; on a PC the performance hit is relatively minor. On some consoles that are very strongly 32-bit, the 64-bit mathematics is very slow (they perform the mathematics in software, rather than hardware, and so are much more than twice as slow in most cases), so single precision is crucial. For objects with similar masses, low velocities, and positions near the origin, single precision is perfectly fine. On 64-bit machines, both versions are likely to be the same, so there will be no performance difference.

16.2 OPTIMIZATIONS

Having stabilized the major problems out of our engine, we can turn our attention to optimization. There is a wise programming adage: always avoid premature optimization. Nowhere is this more important than in games.

As game developers, we have a pressing need for fast and efficient code, and this can spur you into optimizing code as you write. This is important to some extent, but I've seen many cases where it consumes vast quantities of programming time, and ends up making negligible difference to code performance. With all code optimization, it is crucial to have a profiler and check what is slow and why. Then you can focus in on issues that will improve performance, rather than burning time.

The engine that I've presented in this book contains many opportunities for optimization. There are quantities that are calculated several times, data storage that is wasteful, and extraneous calculations that can be abbreviated and optimized. I built the version of the engine for this book to be as clear and concise as possible, rather than for optimum performance.

At the end of this section, I will focus briefly on some of the areas that could be improved for speed or memory layout. I will not work through the more complex of them in detail, but leave them as an exercise if your profiler is telling you that it would help.

There is one key optimization we can make first that has such a dramatic effect on the overall performance that it is worth looking at in detail. This isn't a code optimization (in the sense that it doesn't do the same thing in a more efficient way), but rather a global optimization that reduces the physics engine's workload.

16.2.1 Sleep

There is a saying in graphics engine programming that the fastest polygons are those you don't draw. Quickly determining which objects the user can see and only spending time rendering them is a key part of rendering technology. There are tens of common techniques used to this end (including some we've seen in this book, such as BSP-trees and quad-trees).

We can't do exactly the same thing in physics: otherwise, if the player looked away and then looked back, objects would be exactly as they were when last seen, even if that was mid-fall. The equivalent optimization for physics engines is to not simulate objects that are stable and not moving. In fact, this encompasses the majority of objects in a typical simulation. Objects will tend to settle into a stable configuration—resting on the ground or with their springs at an equilibrium point. Because of drag, only systems that have a consistent input of force will fail to settle down (the force may be gravity; however, a ball rolling down an infinitely long slope will never stop, for example).

Stopping the simulation of objects at rest is called putting them to "sleep." A powerful sleep system can improve the performance of a physics simulation by many orders of magnitude for an average game level.

There are two components to the sleep system: one algorithm to put objects to sleep, and another to wake them up again. We will look at both, after putting in place some basic structure to support them.

Adding Sleep State

To support sleep, we need to add three data members to the `RigidBody` class:

- `isAwake` is a Boolean variable that tells us whether the body is currently asleep, and therefore whether it needs processing.
- `canSleep` is a Boolean variable that tells us whether the object is capable of being put to sleep. Objects that are under the constant control of the user (i.e., the user can add forces to them at any time) should probably be prevented from sleeping, for visual rather than performance reasons.
- `motion` will keep track of the current movement speed (both linear and angular) of the object. This will be crucial to deciding whether the object should be put to sleep.

In the `RigidBody` class, this is implemented as follows:

```
——————————— Excerpt from file include/cyclone/body.h ———————————
class RigidBody
{
    // ... Other RigidBody code as before ...
```

```
    /**
     * Holds the amount of motion of the body. This is a recency
     * weighted mean that can be used to put a body to sleep.
     */
    real motion;

    /**
     * A body can be put to sleep to avoid it being updated
     * by the integration functions or affected by collisions
     * with the world.
     */
    bool isAwake;

    /**
     * Some bodies may never be allowed to fall asleep.
     * User-controlled bodies, for example, should be
     * always awake.
     */
    bool canSleep;
};
```

When we perform the rigid-body update, we check the body and return without processing if it is asleep:

```
void RigidBody::integrate(real duration)
{
    if (!isAwake) return;

    // ... Remainder of the integration as before ...
}
```

The collision detector should still return contacts between objects that are asleep. As we'll see later in this section, these dormant collisions are important when one object in a stack receives a knock from an awake body.

Despite collisions being generated, when two objects are asleep they have no velocity or rotation, so their contact velocity will be zero and they will be omitted from the velocity resolution algorithm. The same thing happens with interpenetration. This provides the speed-up in the collision response system.

We need to add a method to the `RigidBody` class that can change the current state of an object's `isAwake` member. The method looks like this:

```
———————————————— Excerpt from file include/cyclone/body.h ————————————
class RigidBody
{
    // ... Other RigidBody code as before ...

    /**
     * Sets the awake state of the body. If the body is set to be
     * not awake, then its velocities are also canceled, since
     * a moving body that is not awake can cause problems in the
     * simulation.
     */
    void setAwake(const bool awake=true);
};
```

```
———————————————————— Excerpt from file src/body.cpp ————————————————
void RigidBody::setAwake(const bool awake)
{
    if (awake) {
        isAwake= true;

        // Add a bit of motion to avoid it falling asleep immediately.
        motion = sleepEpsilon*2.0f;
    } else {
        isAwake = false;
        velocity.clear();
        rotation.clear();
    }
}
```

This code toggles the current value of `isAwake`. If the body is being put to sleep, it makes sure that it has no motion by setting both linear and angular velocity to zero. This ensures that collisions (as we saw above) have no closing velocity, which improves performance for sleeping bodies in contact.

If the body is being awakened, then the `motion` variable is given a value. As we'll see in the next section, an object is put to sleep when the value of this drops below a certain threshold. If the value of this variable is below the threshold, and the object is awakened, it will fall asleep again immediately. Giving it a value of twice the threshold prevents this and ensures that it is awake long enough to do something interesting (presumably, the `setAwake` method is being called so the object can be awakened to do something interesting, not to fall right back asleep).

Finally, we add functions to check whether an object is asleep, and to set and check the value of canSleep. These are implemented in the source code, and none of them are interesting enough to need analysis here.

Putting Objects to Sleep

The algorithm for putting objects to sleep is simple: in each frame we monitor their motion. When their motion stabilizes over several frames, and their velocity is near zero, we put them to sleep.

The "near zero" is controlled by a parameter called sleepEpsilon.[2] When the value of the motion data member drops below this threshold, the body is put to sleep:

```
if (motion < sleepEpsilon)
{
    setAwake(false);
}
```

In the source code, the sleep epsilon value is shared by the entire simulation. It is a global variable accessed through a pair of functions—setSleepEpsilon and getSleepEpsilon. You can fine-tune the value by using body-specific thresholds if you like.

Setting sleep epsilon is a trial-and-error process. The collision handling system introduces motion into objects at each frame. If you set sleep epsilon too low, objects may never fall asleep. Even if you use a resolution system that doesn't have these problems, too low a value may take a long time to reach, meaning that your engine is still doing more processing than you need. If you set the value too high, then objects that are obviously in motion can be sent to sleep, and that can look odd. I set my sleep threshold as high as possible before strange mid-motion freezes become apparent.

This algorithm is simple, but it relies on calculating the value of motion. The motion value needs to encapsulate the linear and angular velocity of the object in a single scalar. To do this, we use the total kinetic energy of the object. In Chapter 3 we saw that the kinetic energy of a particle is given by

$$E_k = \frac{1}{2} m |\dot{p}|^2$$

where m is the body's mass and \dot{p} is its linear velocity. A similar expression holds for the kinetic energy of a rotating rigid body:

$$E_k = \frac{1}{2} (m|\dot{p}|^2 + i_m |\dot{\theta}|^2)$$

where i_m is the moment of inertia about the axis of rotation of the body (i.e., it is a scalar quantity) and $\dot{\theta}$ is its angular velocity.

We could use the kinetic energy as the value for motion, but that would leave us with a problem with different masses: two identical objects would fall asleep at

2. The Greek letter epsilon (ϵ) is used in engineering to mean a very small quantity of any kind.

different times, depending on their mass. To avoid this, we remove the masses from the expression to get the following:

$$\text{motion} = |\dot{p}|^2 + |\dot{\theta}|^2$$

In code, this looks like:

```
currentMotion = velocity.squareMagnitude() + rotation.squareMagnitude();
```

Some developers use variations on this: they either add the two components together without squaring them, or they calculate the full kinetic energy and then divide by the mass. In either case, this gives us a value for the motion of the object. The final stage is to check whether this value is stable. We do this by keeping a record of the current motion over several frames and seeing how much it changes. This can be neatly tracked by a *recency weighted average* (RWA), a simple numerical tool that I find very useful in many situations.

An RWA is updated as follows:

```
rwa = bias*rwa + (1-bias)*newValue;
```

It keeps an average of the last few values, with more recent values being more significant. The bias parameter controls how much significance is given to previous values. A bias of zero makes the RWA equal to the new value each time it is updated (i.e., there is no averaging at all). A bias of 1 ignores the new value altogether.

The RWA is an excellent device for smoothing input, or for checking that an input has stabilized. In our case, we have:

```
motion = bias*motion + (1-bias)*currentMotion;
```

If currentMotion drops below the sleep epsilon value, but in the previous few frames the object has been moving a great deal, then the overall motion value will still be high. Only when an object has spent time not moving will the recency weighted average drop below the epsilon value.

Because objects can move at very high speeds (and because we are working with the square of these speeds), a brief burst of speed can send the RWA sky-high, and it will take a long time to get back down to reasonable levels. To prevent this, and to allow objects to fall asleep faster, I have added code to limit the value of the RWA:

```
if (motion > 10*sleepEpsilon) motion = 10*sleepEpsilon;
```

The bias of the RWA should be dependent on the duration of the frame. Longer frames should allow the current value to affect the RWA more than short frames. Otherwise, objects will fall asleep faster at faster frame rates.

We can accomplish this in the same way as for damping:

```
real bias = real_pow(baseBias, duration);
```

where baseBias is the bias we'd expect for 1-s frames. I've typically used values around 0.5 to 0.8 here, but again some experimentation is needed.

Waking Objects Up

We have already seen that objects can be awakened manually. We also need to wake objects up when they need to respond to new collisions. Collisions between sleeping objects, as we have seen, are generated and automatically ignored by the collision resolution system.

When a new object comes along (the player, for example, or a projectile) and collides with a sleeping object, we want all objects that could be affected by the collision to wake up. For any particular collision, this means that if one body involved is asleep and the other is awake, then the asleep body needs to be awakened. We add a method to the Contact class to accomplish this:

```
———————— Excerpt from file include/cyclone/contacts.h ————————
class Contact
{
    // ... Other data as before ...

    /**
     * Updates the awake state of rigid bodies that are taking
     * place in the given contact. A body will be made awake if it
     * is in contact with a body that is awake.
     */
    void matchAwakeState();
};
```

```
———————————— Excerpt from file src/contacts.cpp ————————————
void Contact::matchAwakeState()
{
    // Collisions with the world never cause a body to wake up.
    if (!body[1]) return;

    bool body0awake = body[0]->getAwake();
```

```
    bool body1awake = body[1]->getAwake();

    // Wake up only the sleeping one.
    if (body0awake ^ body1awake) {
        if (body0awake) body[1]->setAwake();
        else body[0]->setAwake();
    }
}
```

This method is called whenever we are about to resolve a collision. Collisions between a sleeping object and an awake object, but which are not considered (because they don't have any velocity or penetration to resolve), don't need to have the sleeping object awakened. If the contact isn't severe enough to need resolving, we can assume that it isn't severe enough to wake the sleeping object.

If we have a series of collisions in a chain, as shown in Figure 16.3, the first collision will be handled waking up object B, and then the velocity update algorithm will determine that the second contact needs resolving, waking up object C, and so on. Eventually, all the objects that needed a velocity or position change will be awakened, as required.

The adjustPositions and adjustVelocities methods of the contact resolver have the call added just before they perform the resolution on a single contact. Here is the abbreviated code for penetration resolution:

```
for (unsigned i = 0; i < positionIterations; i++)
{
    // Find worstContact (as before) ...

    if (!worstContact) break;

    worstContact->matchAwakeState();
    worstContact->applyPositionChange();

    updatePenetrations();
}
```

There is a second situation in which we need to wake up a rigid body. That is when a force is applied to it (excluding forces that are always present, like gravity). This can be done manually, adding a setAwake call each time a force is applied. This is difficult to remember, however, so I have elected to wake the object automatically whenever a force or torque is applied. Each of the addForce, addForceAtPoint, and addTorque functions in the RigidBody class automatically calls setAwake.

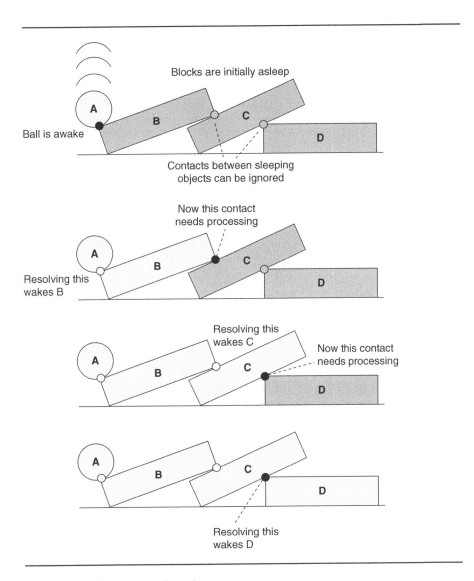

FIGURE 16.3 A chain of collisions is awakened.

We now have a fully functional sleep system, capable of dramatically improving the performance of the engine.

Typically, when the game level is loaded, all rigid bodies are placed so that they are in their rest position. They can then all be set to sleep when the game begins. This makes the physics simulation code very fast indeed; objects will only require physical simulation once they have been collided with. Even then, hopefully, they will reach another equilibrium position and be sent back to sleep quickly.

16.2.2 MARGINS OF ERROR FOR PENETRATION AND VELOCITY

Another optimization that is worth making speeds up the penetration and velocity resolution algorithms dramatically. Figure 16.4 shows our now familiar block in a plane situation. If we run this simulation, and look at the resolutions being performed, we see that the two contacts (four in a 3D simulation) are repeatedly considered. Taking just penetration, if we look at the penetration depths at each iteration, we see (as shown in the figure) that the first penetration resolutions get us almost there, and then subsequent resolutions make such tiny adjustments that they could never be seen by a player. This kind of subvisual adjustment is a pure waste of time.

To avoid this situation, we can add a tolerance limit to both velocity and penetration collisions. Only collisions that are more severe than this limit will be considered. That way the first time a contact is resolved it should be brought within the limit, and then never reconsidered unless the resolution of another contact disturbs it greatly.

This limit can be simply implemented when we search for the most severe contact to consider. Rather than starting with a worstPenetration value of zero, as in the following (which is the code from Chapter 14):

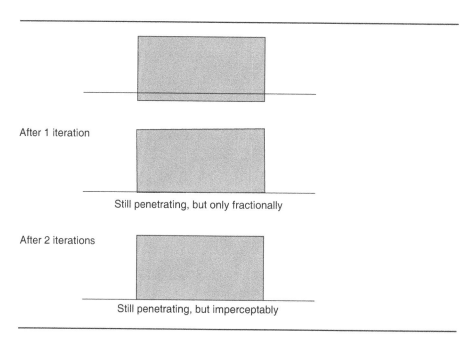

After 1 iteration

Still penetrating, but only fractionally

After 2 iterations

Still penetrating, but imperceptably

FIGURE 16.4 Iterative resolution makes microscopic changes.

```
Contact* lastContact = contacts + numContacts;
for (unsigned i = 0; i < positionIterations; i++)
{
    Contact* worstContact = NULL;
    real worstPenetration = 0;
    for(Contact* contact = contacts; contact < lastContact; contact++)
    {
        if (contact->penetration > worstPenetration)
        {
            worstContact = contact;
            worstPenetration = contact->penetration;
        }
    }
    if (worstContact) worstContact->applyPositionChange();
    else break;
}
```

we start with a value equal to the tolerance we are allowing:

```
Contact* lastContact = contacts + numContacts;
for (unsigned i = 0; i < positionIterations; i++)
{
    Contact* worstContact = NULL;
    real worstPenetration = penetrationEpsilon;
    for(Contact* contact = contacts; contact < lastContact; contact++)
    {
        if (contact->penetration > worstPenetration)
        {
            worstContact = contact;
            worstPenetration = contact->penetration;
        }
    }
    if (worstContact) worstContact->applyPositionChange();
    else break;
}
```

with a similar situation for the velocity. Now no contact will be selected that has a penetration below this epsilon value. This value should be small enough so that it is not easily noticeably by the player. The first time that the contact is resolved, the resolution should bring the contact's penetration below this limit, so it will not be considered again. Tuning is, again, a necessity. For the demos, I have used values around

0.01 for each. If your objects are larger or faster, then higher values should be used. If they are smaller or slower, then use lower values.

Both the `velocityEpsilon` and the `penetrationEpsilon` values are properties of the collision resolver class. In the code, I have included methods to set and get their current value.

When I added this simple change to the engine, I found that there was a five times speed-up immediately. For complex stacks of objects, the improvement was even more significant.

Between the sleep system and this pair of tolerances, we have a physics simulation that is fast enough for real production work. Further optimization can be achieved in the physics core by code manipulation, and trading off memory against speed. I'll say a few things briefly about that at the end of this section.

A significant performance problem with the way contacts and collisions are detected and handled, however, remains.

16.2.3 CONTACT GROUPING

In Chapter 14, I mentioned that performance could be improved by batching together groups of contacts. For our engine, this provides a useful speed-up. For engines that do simultaneous resolution, the speed-up can be critical.

Figure 16.5 shows a simple scene. There are several contacts in the scene generated by the collision detector. In the collision resolution system, contacts A, B, and C can all affect one another: resolving contact A can cause problems with contact B, and

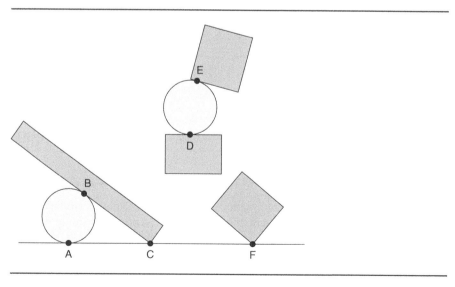

FIGURE 16.5 Sets of independent contacts.

resolving B can affect both A and C. Contacts D and E are likewise related. But note that A, B, and C cannot affect D, E, or F; D and E cannot affect A, B, C, or F; and F cannot affect any of the others.

In fact, two contacts can only affect one another if they are connected through a series of rigid bodies and other contacts. So contacts A and C can affect one another because they are connected through bodies 2 and 3 and contact B.

Our resolution algorithm checks all possible contacts to see if they have been affected by a previous resolution. It also checks through all contacts to find the current most severe contact to resolve. Both of these operations take longer for longer lists of contacts.

A better solution would be to resolve the contacts in groups. Contacts A, B, and C can be sent to the resolver first; then D and E and then F. Used in this way, the contact resolver would have no way of altering contacts D and E based on the results of resolving A, B, and C. But this is okay, since we know those contacts can't possibly interact.

This batching is typically done in one of two places. It can be the job of the collision detector to return groups of contacts. Or the entire set of contacts can be separated by the collision resolution system and processed in batches.

The first approach is the best, if it can be implemented. Typically the collision detector can determine if objects are a long way from one another, and batch them. If it is using a coarse collision detection system, for example, it can produce contact batches for each distinct area of the game level. For sets of nearby objects that aren't touching, however, the collision detector will typically return batches that are too large (i.e., batches that contain contacts that can't affect one another). If the game level has many such situations, it can improve performance further to add a batching processor to the resolver as well as the collision detection batching.

A batching processor separates the entire list of contacts into batches. It does this by starting at one contact and following the combination of contacts and rigid bodies to find all contacts in a single batch. This is then sent for processing. It then finds another contact that has not yet been placed in a batch, and follows the contacts to build another batch. This repeats for as long as there are contacts that have not been processed.

Implementing a batching processor involves being able to quickly find the rigid bodies involved in each contact (we have that already, since the contact data structure stores the rigid bodies involved) and being able to find the contacts on each rigid body. This is difficult with the current state of the engine, since rigid bodies don't keep track of the contacts that affect them. Searching through all possible contacts to find those belonging to a rigid body would take too long and defeat the objective of the optimization.[3]

In Chapter 14, we looked at a set of modifications to contact processing that allowed a sorted list of contacts to be retained, so that they didn't need to be sorted

3. In fact, while this is true of our engine, it is not necessarily true of engines with much more complex resolution algorithms. In either case, however, there is a better way.

each time. In the update part of this algorithm, the effect of one resolution step is propagated through the contacts. This uses the same data structure that we would need to efficiently implement batching: a linked list of contacts belonging to each rigid body.

16.2.4 Code Optimizations

The final optimization phase I want to consider is code optimization. Code optimizations are tweaks that don't change the algorithm, but make processing it more efficient. There are many code optimizations that can be applied to the accompanying source code. I have deliberately avoided making the code more complex by trying to wring additional performance from it.

This section is intended to provide some general pointers. The advice is based on the commercial engine that I developed and on which Cyclone is based. Before embarking on any optimization effort, I would strongly advise you to get a good profiler (I use Intel's VTune for PC work) and only optimize areas of the software that you can prove are causing performance problems.

Caching Contact Data

A relatively simple optimization is to retain the calculations performed during contact resolution as data in the contact class. When resolving one contact several times, we currently recalculate its deltaVelocity and other values. These can instead be stored in the contact data structure and only calculated when first needed.

This is a tradeoff of memory against speed. If you have a large number of contacts that are only likely to be considered once, then it may be better to leave the algorithm as is.

Vectorizing Mathematics

The next optimization takes advantage of the mathematical hardware on PCs and most consoles. This hardware is capable of processing more than one floating-point number at the same time. Rather than performing all our vector and matrix manipulation as a series of floating-point operations, we can have it process an entire vector at a time.

For single-precision builds of the engine (things get considerably more complex for double precision, so we'll ignore that) on a 32-bit PC, we can fit a whole vector into one of the SSE registers. Using SSE mathematics, we can perform a matrix transform of a vector in only four operations. Vector cross-products, additions, and other manipulations are equally accelerated. Most consoles (older hand held consoles being the exception) provide the same facilities.

I'm not going to dive into detail about vectorized mathematics. There is reasonable documentation available with Visual Studio for the Windows PC, and many excellent introductions to the subject online. For serious PC development, I would

recommend the Intel Optimization Cookbook (whether or not you are targeting Intel-branded processors).

Twizzling Rigid-Body Data

The vector mathematics hardware on PCs is optimized to run the same program on multiple bits of data at the same time. Rather than go through one algorithm per rigid body, it would be better to run the same algorithm for a group of bodies at the same time.

The rigid-body integration algorithm is a particular candidate for this. We can speed things up by having it process four objects at the same time. To do this, however, we would need to rearrange how data is held for each rigid body.

For the sake of an object-oriented programming style, we've used a class containing all the data for one rigid body. To take advantage of simultaneous processing we would need to "twizzle" the data, so that it is grouped together—the position for each object in an array, followed by all the velocities, and so on. This could be achieved by using a new data structure that holds four rigid bodies at a time.

Personally, I have never implemented this in a physics engine that I have built. Some of the AI engine development I've been involved with, however, has used this structure, with four characters being updated at once. It provides a modest improvement in speed, but has disadvantages when you want to do various things with different rigid bodies (during collision resolution, for example).

Grouping Data for Areas of the Level

Memory management is a crucial part of optimizing game technologies. There is plenty of memory available on most game machines for physics, but its organization can cause slowdowns.

Processors don't have equal access to all parts of the memory. They load data in chunks from the main memory and keep it in high-speed caches. Accessing data from the cache is fast. If the data needed isn't in the cache, then it needs to be fetched from main memory, which can be very time consuming. Different machines have different sizes of cache and some have several levels of cache.

To avoid constantly fetching new data into the cache, data should be grouped together. For small game levels, all the physics data can be easily kept together. For medium-size game levels, care needs to be taken that the physics data isn't simply added into another data structure, as in the following:

```
class MyObject
{
    AIData ai;
    Geometry geometry;
```

```
    Material material;
    Texture textures[4];
    RigidBody physics;
    CollisionGeometry collisionGeom;
};

MyObject objects[256];
```

This can easily make the rigid-body data for consecutive objects a long distance apart in memory. When resolving collisions between many objects, data could quite easily need fetching to the cache on most resolution steps, causing disastrous performance problems.

A better solution is to keep all the sets of data together in separate arrays:

```
AIData ai[256];
Geometry geometry[256];
Material material[256];
Texture textures[4][256];
RigidBody physics[256];
CollisionGeometry collisionGeom[256];
```

For large game levels this still won't be enough. In this case, it is worth ordering the set of rigid bodies so that objects in different areas of the game level are kept together. That way when contacts are processed, the bodies involved are likely to appear in the cache together. Contacts will not be generated between objects across the level from one another, so they can be separated in the array.

Cache misses are notoriously difficult to diagnose, and they tend to change dramatically when you add debugging code or make seemingly unrelated adjustments. A good profiler is essential.

16.3 Summary

With just sleeping objects and tolerance for near-collisions, you will have a reasonably efficient physics engine. It's time to look at how it can be used in some real game applications. If you are following through this book creating your own engine, it's time to put it through its paces.

If your profiler detects performance problems, you can return to this chapter and try some of the other optimizations.

Chapter 17 reviews what we have, and looks at how the key physics effects seen in many recent games are achieved.

17

PUTTING IT ALL TOGETHER

We have now built a complete physics engine that can simulate any kind of rigid body, detect collisions between objects, and realistically resolve those collisions. It is capable of running the physics for a huge range of games, and it is time to put it through its paces.

Before we work through the demonstration applications, it is worth taking stock of where we are and looking at the physics engine as a whole.

17.1 OVERVIEW OF THE ENGINE

The physics engine we have built has four distinct parts:

- The *force generators* (and *torque generators*) examine the current state of the game and calculate what forces need to be applied to which objects.
- The *rigid-body simulator* processes the movement of rigid bodies in response to those forces.
- The *collision detector* rapidly identifies collisions and other contacts both between objects and between an object and the immovable parts of the level. The collision detector creates a set of contacts to be used by the *collision resolver*.
- The *collision resolver* processes a set of contacts and adjusts the motion of rigid bodies to accurately depict their effects.

Copyright © 2010, Elsevier Inc. All rights reserved.
DOI: 10.1016/B978-0-12-381976-5.00017-6

437

Each of these components has its own internal details and complexities, but we can broadly treat them as separate units. Note that there are two kinds of internal data used in the above stages:

- Forces and torques generated are never represented in an explicit data structure; they are applied directly to the appropriate rigid body as soon as they are calculated.

- Contacts are generated by the collision detector and stored together, before being sent as a group to the collision resolver.

To represent objects in the game, we need three kinds of data:

- *Rendering geometry and materials* are used to display the object on screen. These are normally not used at all by the physics engine, although they can take the place of the collision geometry for very simple objects.

- *Collision geometry* is a simplified set of shapes that represents an object. It is used to speed up collision detection. In some engines, the collision geometry is made up of a polygonal mesh, just like the rendering geometry. In other engines, objects are made up of sets of primitive shapes such as spheres and boxes. In both cases a comprehensive collision detection system will typically need more than one level of collision geometry; the lowest level will be enclosed in one or more bounding volumes.

- *Rigid-body data* contains information about the physical characteristics of the object. It includes things like mass, the inertia tensor, position, and velocity. In our engine, most of this is encapsulated in the `RigidBody` class. In addition, we need to have access to contact data such as the friction between pairs of surfaces and their restitution.

These three kinds of data, along with the four parts of the engine and the two internal lines of communication, work together to provide the physics simulation. Figure 17.1 shows how the data passes through the system.

This is the basic design of most physics engines, although there are some variations possible. In particular, it is possible to add components to the pipeline, such as a grouping algorithm to divide the set of contacts into unconnected batches. Some engines also have another stage of rigid-body update at the end of the pipeline, especially if the result of the collision resolution system is a set of forces to apply.

The whole physics pipeline is typically contained within a single call in the game loop. We could easily create a black-box physics system that keeps track of everything needed to run the physics simulation. In this book, as well as in real game development, I avoid doing this. In real game development, physics isn't happening for its own sake, it is just part of the whole game, and the data that the physics system needs overlaps with data needed elsewhere. Having a black box can easily duplicate work and cause a nightmare trying to make sure that all copies of an object's position (for example) are synchronized.

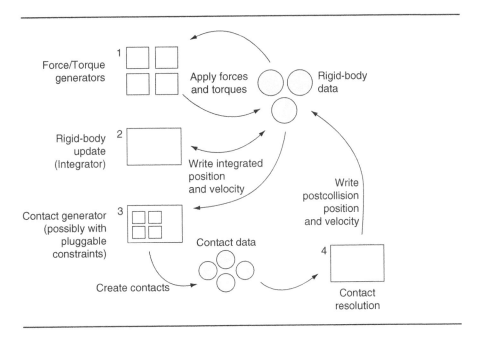

FIGURE 17.1 Data flow through the physics engine.

In a real game, different objects will also need different additional data. Some objects may be active and require data for the AI. Other objects may be player controlled and require network data for synchronization. Any objects can require game-specific data such as hit points or score value. This can cause difficulty ensuring that the physics data is correctly initialized.

Setting up new objects with the correct physics can be a challenge. In my experience, it is invaluable to have a simple environment setup as part of the level design process where the physics of objects can be tested interactively. That way you can be sure as you develop that the object feels right in its environment, and that no crucial data is being left uninitialized. If you have the resources, allowing your physics engine to run live in your level editor is ideal.

17.2 USING THE PHYSICS ENGINE

We can now do almost anything we want with our physics engine. In this chapter, I'll give you a taste of some of the most popular applications for physics: ragdolls, breakable objects, and movie-style explosions. On the way, we'll look at some additional techniques, force generators, and ways to configure the engine.

There is one important caveat to these applications, however. I am going to focus on using our generic engine to power these effects. If all you need is a single-purpose physics system, there may be things we have put in our code that aren't needed. For example, for high-spec racing cars that don't normally leave the ground, you can ignore all the rigid-body physics and build special-case spring code to model how its suspension flexes and how it handles. You might want to keep the physics engine in this book just for when you need a beautiful crash animation when the car leaves the road.

Our approach is to build a physical approximation of the object and simulate it. Sometimes a better approach is to work out the desired behavior and program that in explicitly. Having said that, the general-purpose/special-case dilemma is becoming increasingly moot. Modern games typically need several effects at once: a driving game will model cones and fences, allowing them to break and be scattered realistically, for example. As seen in the opening chapter, in situations where different kinds of physical behavior need to interact, there is little substitute for a complete physics engine.

17.2.1 RAGDOLLS

Ragdolls have become a staple of 3D game development over the last 5 years: they are characters that can be thrown around and generate their own realistic animation using physics. They are part of a wider move toward procedural animation: animation that is generated automatically and without an artist specifying key frames. In practice, the best effects blend both procedural animation and artist-authored animation. The simple ragdolls of 5 years ago are gradually giving way to ragdolls that are partially physics and partially hand-animation. Such hybrids can push their hands out to stop their fall, for example.

A ragdoll is made up of a series of linked rigid bodies. These rigid bodies are called bones (they roughly correspond to the bones used in skeletal animation, although there can be a different number of ragdoll bones and rendering bones). At their most complex, ragdolls can contain tens of bones, essential for getting a flexible spine or tail.

The bones are connected together with joints—constraints very much like those seen in Chapter 7. Finally, in some games, force generators are added to joints to simulate the way a person would move in flight: shielding their faces and trying to brace their hands against the fall.

The accompanying source code contains the **ragdoll** demo (see Figure 17.2). This demo excludes the force generators,[1] but includes the joints to keep the bones together.

The constraints are implemented as contacts. In addition to the regular contact generator, a list of joints is considered and contacts are generated to keep them together. Figure 17.3 shows a detail of one such joint. Note that the contact is keeping

1. I excluded these because there are some important complications in their implementation. These complications arise from the way people move, which is a problem of AI rather than of physics.

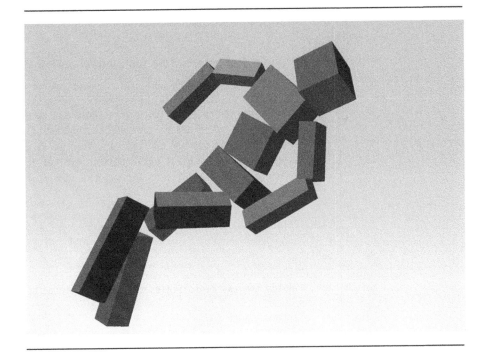

FIGURE 17.2 Screenshot of the **ragdoll** demo.

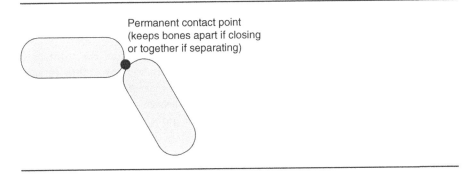

FIGURE 17.3 Closeup of a ragdoll joint.

two points together. The contact will always be between these two points, making sure that they align.

To avoid the contact slipping farther out of alignment, the friction at the joint should be effectively infinite. To avoid the joint bouncing out of alignment, the restitution should be zero.

The structure that holds information on one joint is featured in the following code:

─────────── **Excerpt from file `include/cyclone/joints.h`** ───────────

```
/**
 * Joints link together two rigid bodies and ensure that they do not
 * separate. In a general physics engine there may be many
 * different types of joints that reduce the number of relative
 * degrees of freedom between two objects. This joint is a common
 * position joint--each object has a location (given in
 * body coordinates) that will be kept at the same point in the
 * simulation.
 */
class Joint : public ContactGenerator
{
public:
    /**
     * Holds the two rigid bodies that are connected by this joint.
     */
    RigidBody* body[2];

    /**
     * Holds the relative location of the connection for each
     * body, given in local coordinates.
     */
    Vector3 position[2];

    /**
     * Holds the maximum displacement at the joint before the
     * joint is considered to be violated. This is normally a
     * small epsilon value. It can be larger, however, in which
     * case the joint will behave as if an inelastic cable joined
     * the bodies at their joint locations.
     */
    real error;

    /**
     * Configures the joint in one go.
     */
    void set(
        RigidBody *a, const Vector3& a_pos,
        RigidBody *b, const Vector3& b_pos,
        real error
        );
```

```
/**
 * Generates the contacts required to restore the joint if it
 * has been violated.
 */
unsigned addContact(Contact *contact, unsigned limit) const;
};
```

Within this class there is a checkJoint method that generates contacts based on the current configuration of the joint. In this way, it acts very much like a collision detector, looking at the state of rigid bodies and generating contacts accordingly.

In the demo, the joints are considered in order during the physics update:

──────── **Excerpt from file `src/demos/ragdoll/ragdoll.cpp`** ────────

```
void RagdollDemo::generateContacts()
{
    // Create the ground plane data.
    cyclone::CollisionPlane plane;
    plane.direction = cyclone::Vector3(0,1,0);
    plane.offset = 0;

    // Set up the collision data structure.
    cData.reset(maxContacts);
    cData.friction = (cyclone::real)0.9;
    cData.restitution = (cyclone::real)0.6;
    cData.tolerance = (cyclone::real)0.1;

    // Perform exhaustive collision detection on the ground plane.
    cyclone::Matrix4 transform, otherTransform;
    cyclone::Vector3 position, otherPosition;
    for (Bone *bone = bones; bone < bones+NUM_BONES; bone++)
    {
        // Check for collisions with the ground plane.
        if (!cData.hasMoreContacts()) return;
        cyclone::CollisionDetector::boxAndHalfSpace(*bone, plane, &cData);

        // Check for collisions with each other bone.
        cyclone::CollisionSphere boneSphere = bone->getCollisionSphere();
        for (Bone *other = bone+1; other < bones+NUM_BONES; other++)
        {
            if (!cData.hasMoreContacts()) return;
            cyclone::CollisionSphere otherSphere =
                other->getCollisionSphere();
```

```
                cyclone::CollisionDetector::sphereAndSphere(
                    boneSphere,
                    otherSphere,
                    &cData
                    );
            }
    }

    // Check for joint violation.
    for (cyclone::Joint *joint = joints; joint < joints+NUM_JOINTS;
        joint++)
    {
        if (!cData.hasMoreContacts()) return;
        unsigned added = joint->addContact(cData.contacts,
            cData.contactsLeft);
        cData.addContacts(added);
    }
}
```

This is a fast and effective ragdoll model. It isn't the most stable method, however. For very large ragdolls, a lot of interpenetration resolution iterations are needed to keep the extremities from wandering too far from their correct place.

More Complex Joints

The approach of the **ragdoll** demo is about as simple as possible to get useful joints. Joints are a common feature of physics engines and they can be considerably more complex. Joints are used to remove the freedom of one object to move relative to another.

The joints we have used (called ball-joints) take away the freedom of one object to move linearly with respect to another. There are also joints that restrict movement even more: hinges that restrict the ability of one object to rotate with respect to another, and piston joints that allow relative movement in one direction only.

Implementing these more flexible joints in the engine we have built is, quite frankly, inconvenient. We could do what I have done above and try to represent joints in terms of contacts. This works for ball-joints but becomes very difficult for other kinds of joints.

When I have created joints for this kind of engine, it is by following approximately the same algorithm as for contacts (which are effectively just joints that limit the motion of two objects from overlapping), but using different sets of tests to determine the adjustment needed. A hinge joint, for example, needs to check how twisted the two objects are and do an interpenetration-like resolution to bring them back into alignment.

Force-based engines with simultaneous resolution of contacts often rely on an intermediate mathematical structure that makes it very easy to create a huge range of joints with minimal additional implementation effort. In the next chapter, we'll look at the algorithms that support this. If you are going to make lots of use of joints and need something more comprehensive than the simple contact-based joints in this section, it may be worth biting the bullet and upgrading your contact resolution scheme. For the sake of efficiency, ease of implementation, and programmer sanity, it is worth giving the simple approach a try.

17.2.2 FRACTURE PHYSICS

The trend toward ragdoll physics was closely followed by fracture physics. Particularly in shooters, players want to see objects destroyed in a realistic way: wood should splinter, glass should shatter, and falling crates should crack to reveal their contents.

Fracture physics can be as simple or as complex as you'd like it to be. Early implementations used two sets of rigid bodies—one for the whole object, and another for its components. The whole rigid body has a breaking strain value, that is, the maximum impulse it can suffer before being destroyed. During the velocity phase of the resolution algorithm, the impulse applied to the object is compared against its breaking strain. If the impulse is too great, the whole rigid body is replaced by its component objects.

This is a very quick, efficient, and easy way to implement fracture physics. Unfortunately, two identical objects will always be destroyed in exactly the same way, and the pattern of destruction will not bear any relationship to the location of the impulse. Figure 17.4 illustrates this problem with a glass window.

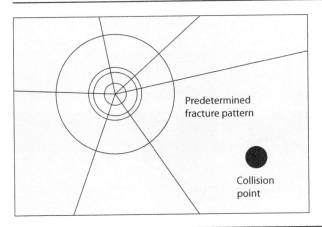

FIGURE 17.4 Precreated fractures can look very strange for large objects.

This problem can be mitigated to some extent by using several possible decompositions for an object and determining which to use when the fracture is initiated. Players are good at spotting patterns, however, and most developers want a more flexible approach.

More complex fracture physics uses the same basic principle of breaking strains, but adds two more algorithms. The first is a geometric algorithm to construct the components of the fractured object on the fly. The decomposition method depends on the type of material. Decomposing wood needs long splintered components, glass cracks into panes, safety glass shatters into smalls nuts, and so on. Typically, this is achieved either by decomposing the object into differently sized tetrahedrons, and keeping groups of these together, or by using a set of fracture patterns, and 3D Boolean operations to separate components. The specifics of this decomposition are highly geometric and depend on geometric algorithms beyond the scope of this book.

The second part of fracture physics needs to assign correct physical characteristics to the component objects. In particular, assigning a correct inertia tensor for a general fractured shape is a nontrivial process. Appendix A provides equations and algorithms for calculating the inertia tensor of various regular objects. For a general shape, however, these are complex and can be inefficient. Most developers opt for a simplification and approximate shattered pieces with geometry that has easy inertia tensors: boxes are a firm favorite.

Figure 17.5 shows the **fracture** demo from the accompanying code. It contains a single large block, made of a relatively dense brittle material, such as concrete. You can move to aim and then fire a ball at the block. The block will shatter on impact,

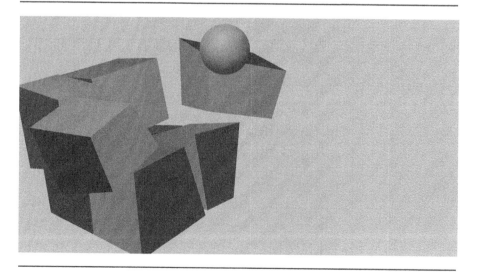

FIGURE 17.5 Screenshot of the **fracture** demo.

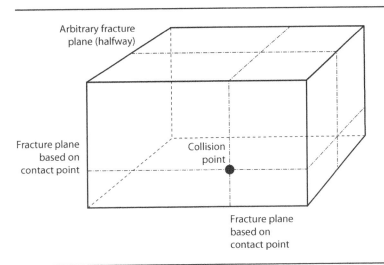

FIGURE 17.6 The fractures of a concrete block.

depending on where the ball strikes. The decomposition scheme splits the block into eight components by dividing it in each direction. The collision point is used as the center of two collisions, and the other direction is split in half, as shown in Figure 17.6. To make the results look more realistic, the splits are angled randomly.

The geometric division algorithm looks like this:

```
—————— Excerpt from file src/demos/fracture/fracture.cpp ——————
/**
 * Performs the division of the given block into four, writing the
 * eight new blocks into the given blocks array. The blocks array
 * can be a pointer to the same location as the target pointer;
 * since the original block is always deleted, this effectively
 * reuses its storage. The algorithm is structured to allow this
 * reuse.
 */
void divideBlock(const cyclone::Contact& contact,
                 Block* target,
                 Block* blocks)
{
    // Find out if we're at block one or two in the contact
    // structure, and therefore what the contact normal is.
    cyclone::Vector3 normal = contact.contactNormal;
    cyclone::RigidBody *body = contact.body[0];
    if (body != target->body)
    {
```

```
        normal.invert();
        body = contact.body[1];
}

// Work out where on the body (in body coordinates) the
// contact is and its direction.
cyclone::Vector3 point =
    body->getPointInLocalSpace(contact.contactPoint);
normal = body->getDirectionInLocalSpace(normal);

// Work out the center of the split: these are the point
// coordinates for each of the axes perpendicular to the
// normal, and 0 for the axis along the normal.
point = point - normal * (point * normal);

// Take a copy of the half-size, so that we can create the new
// blocks.
cyclone::Vector3 size = target->halfSize;

// Take a copy also of the body's other data.
cyclone::RigidBody tempBody;
tempBody.setPosition(body->getPosition());
tempBody.setOrientation(body->getOrientation());
tempBody.setVelocity(body->getVelocity());
tempBody.setRotation(body->getRotation());
tempBody.setLinearDamping(body->getLinearDamping());
tempBody.setAngularDamping(body->getAngularDamping());
tempBody.setInverseInertiaTensor(body->getInverseInertiaTensor());
tempBody.calculateDerivedData();

// Remove the old block.
target->exists = false;

// Work out the inverse density of the old block.
cyclone::real invDensity =
    halfSize.magnitude()*8 * body->getInverseMass();

// Now split the block into eight.
for (unsigned i = 0; i < 8; i++)
{
    // Find the minimum and maximum extents of the new block
    // in old-block coordinates.
    cyclone::Vector3 min, max;
    if ((i & 1) == 0) {
```

```
            min.x = -size.x;
            max.x = point.x;
        } else {
            min.x = point.x;
            max.x = size.x;
        }
        if ((i & 2) == 0) {
            min.y = -size.y;
            max.y = point.y;
        } else {
            min.y = point.y;
            max.y = size.y;
        }
        if ((i & 4) == 0) {
            min.z = -size.z;
            max.z = point.z;
        } else {
            min.z = point.z;
            max.z = size.z;
        }

        // Get the origin and half-size of the block, in old-body
        // local coordinates.
        cyclone::Vector3 halfSize = (max - min) * 0.5f;
        cyclone::Vector3 newPos = halfSize + min;

        // Convert the origin to world coordinates.
        newPos = tempBody.getPointInWorldSpace(newPos);

        // Work out the direction to the impact.
        cyclone::Vector3 direction = newPos - contact.contactPoint;
        direction.normalize();

        // Set the body's properties (we assume the block has a body
        // already that we're going to overwrite).
        blocks[i].body->setPosition(newPos);
        blocks[i].body->setVelocity(
            // Add a separating velocity to burst the fracture open.
            tempBody.getVelocity() + direction * 10.0f
            );
        blocks[i].body->setOrientation(tempBody.getOrientation());
        blocks[i].body->setRotation(tempBody.getRotation());
        blocks[i].body->setLinearDamping(tempBody.getLinearDamping());
        blocks[i].body->setAngularDamping(tempBody.getAngularDamping());
```

```
        blocks[i].body->setAwake(true);
        blocks[i].body->setAcceleration(cyclone::Vector3::GRAVITY);
        blocks[i].body->clearAccumulators();
        blocks[i].body->calculateDerivedData();
        blocks[i].offset = cyclone::Matrix4();
        blocks[i].exists = true;
        blocks[i].halfSize = halfSize;

        // Finally, calculate the mass and inertia tensor of the new
            block.
        blocks[i].calculateMassProperties(invDensity);
    }
}
```

The previous code blocks assume that the collision will occur on the YZ plane of the block (which it must in our demo). More complete code would have similar algorithms for the other possible collision planes.

Because the resulting pieces are roughly rectangular, they are treated like rectangular blocks for calculating their inertia tensors. This is done simply as follows:

```
──────── Excerpt from file src/demos/fracture/fracture.cpp ────────

/**
 * Calculates and sets the mass and inertia tensor of this block,
 * assuming it has the given constant density.
 */
void calculateMassProperties(cyclone::real invDensity)
{
    // Check for infinite mass.
    if (invDensity <= 0)
    {
        // Just set zeros for both mass and inertia tensor.
        body->setInverseMass(0);
        body->setInverseInertiaTensor(cyclone::Matrix3());
    }
    else
    {
        // Otherwise, we need to calculate the mass.
        cyclone::real volume = halfSize.magnitude() * 2.0;
        cyclone::real mass = volume / invDensity;

        body->setMass(mass);

        // And calculate the inertia tensor from the mass and size.
```

```
        mass *= 0.333f;
        cyclone::Matrix3 tensor;
        tensor.setInertiaTensorCoeffs(
            mass * halfSize.y*halfSize.y + halfSize.z*halfSize.z,
            mass * halfSize.y*halfSize.x + halfSize.z*halfSize.z,
            mass * halfSize.y*halfSize.x + halfSize.z*halfSize.y
            );
        body->setInertiaTensor(tensor);
    }

}
```

Creating a general-purpose, fracture physics system involves more geometric processing than physics knowledge. Some developers have gone this route, and there are a couple of middleware vendors with similar technologies, but to trap all useful scenarios is a considerable task, and certainly as complex as the contact resolution or rigid-body algorithms we have created.

17.2.3 EXPLOSIVE PHYSICS

Explosions have been around since the earliest days of gaming, and were the application of the first physics engines, such as particle engines creating smoke and debris. They are a whole lot more fun with proper physics—there's something gratifying about watching debris scattered around the level.

Explosions are easy to create with a custom force generator. We could just create a force generator that imparts a force to objects near the blast point. This would send objects cascading, but would be ultimately dull to look at. It has two problems: first, the explosion effect is quite tedious, as objects just fly out; and second, applying forces alone doesn't cause objects to spin.

A movie-quality explosion effect has three components: an initial implosion, a spherical explosion with expanding concussion wave, and a convection chimney. Each of these components has slightly different behavior.

Implosion

When the explosion first occurs, the heat in the explosion consumes the oxygen in a ball around the explosion point and can ionize the air (this is also responsible for the flash). This causes a sudden dramatic drop in pressure and nearby air rushes into the gap. This is the implosion stage, and it is the same process that occurs in a lightning strike, causing the thunder clap.

There is a military technology called thermobaric weaponry that does its damage in this way, using very high temperatures to cause a huge pressure change and a

powerful compression wave (see the next section) that can destroy buildings and devastate life.

In a real explosion of modest size, this effect is barely noticeable and can even be completely lost in the concussion phase. For games and movies, however, it looks good and gives the explosion an added sense of power. A longer implosion, particularly associated with a geometry-stretching graphical effect, can add tension to the explosion.

The implosion stage of the force generator applies a force to all objects within a given threshold radius in the direction of the point of explosion. We'll put all three stages of the explosion into a single force generator. So far it looks like the following:

—————— **Excerpt from file include/cyclone/fgen.h** ——————

```
/**
 * A force generator showing a three-component explosion effect.
 * This force generator is intended to represent a single
 * explosion effect for multiple rigid bodies. The force generator
 * can also act as a particle force generator.
 */
class Explosion : public ForceGenerator,
                  public ParticleForceGenerator
{
    /**
     * The location of the detonation of the weapon.
     */
    Vector3 detonation;

    /**
     * The radius up to which objects implode in the first stage
     * of the explosion.
     */
    real implosionMaxRadius;

    /**
     * The radius within which objects don't feel the implosion
     * force. Objects near the detonation aren't sucked in by
     * the air implosion.
     */
    real implosionMinRadius;

    /**
     * The length of time that objects spend imploding before the
     * concussion phase kicks in.
     */
    real implosionDuration;
```

```
/**
 * The maximal force that the implosion can apply. This should
 * be relatively small to avoid the implosion pulling objects
 * through the detonation point and out the other side before
 * the concussion wave kicks in.
 */
real implosionForce;
/**
 * Calculates and applies the force that the explosion
 * has on the given rigid body.
 */
virtual void updateForce(RigidBody * body, real duration);
};
```

The implosion can impose only a linear force; because it is so short, we don't need to set objects spinning.

Concussion Wave

The concussion wave (also called the *shock wave*) is triggered by the initial implosion; air rushes into the vacuum, creating an expanding wavefront. This may be combined, near the explosion site, with shrapnel and munition fuel expanding from the weapon. For very high-temperature devices, the wavefront may be one of burning air, known as a fireball (characteristic in atomic and nuclear devices).

The concussion wave throws objects outward from the explosion. In movies and games, it is responsible for cars flying through the air and characters being knocked off their feet.

The characteristic of a concussion wave is its propagation. It spreads out from the point of explosion, getting weaker as it goes. Just like a surfer always on the outside edge of a water wave, light objects can ride the outside edge of the concussion wave and be accelerated to very high speeds. But like a surfer who doesn't catch the wave, most objects will receive an initial boost at the wave boundary, but will fall behind the wave and behave normally when inside the wavefront.

We can implement this in our force generator by applying forces to objects within an expanding interval from the blast point. The interval should be wide enough so that no objects are missed. Its width depends on the frame rate and the speed of the wavefront according to the formula

$$w \geqslant \frac{s}{\text{fps}}$$

where s is the speed of the wavefront, w is the width of the interval, and fps is the number of frames per second. In other words, w is the distance the wave travels in

one frame. In practice objects on either side of this peak should also get some force, but to a lesser extent. The force equation,

$$f_a = \begin{cases} f_b(1 - (st - d)/kw) & \text{when } st - kw \leqslant d < st \\ f_b & \text{when } st \leqslant d < st + w \\ f_b(d - st - w)/kw & \text{when } st + w \leqslant d < st + (k+1)w \\ 0 & \text{otherwise} \end{cases}$$

has proved useful for me. In it st is the position of the back of the wavefront (i.e., the speed times the time), k is the width of the tail-off on either side of the wave, d is the distance of an object from the center of the blast, f_a is the applied force, and f_b is the peak blast force, which we'll calculate in a moment. The equation simply provides a linear fall-off of force on either side of the wave. The force cross-section is shown in Figure 17.7. Note that the force is always acting outward from the center of the blast.

We need to calculate the peak force for this equation. The force applied to an object depends on both its aerodynamic drag (since the compression wave is primarily a moving-air effect) and its current velocity. We could do this by simply using the aerodynamic effects from Chapter 11, but if you aren't using that already, it is probably overkill.

We can approximate the force effect by applying a force that depends on the difference between the object's velocity and the wavefront. To get exploding objects to spin as they are moved, we apply the force off center. This can be as simple as selecting a random, off-center point for each object when the force generator is created. The same point should be used from frame to frame to avoid objects looking like they are

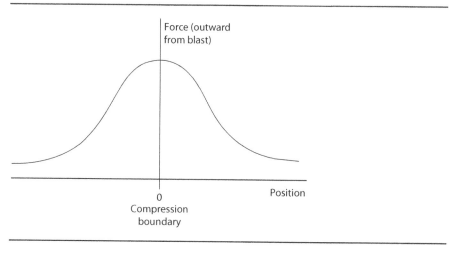

FIGURE 17.7 The force cross-section across a compression wave.

jiggling in mid-air. It also means that once the point is pushed so that it is in line with the force vector, the object stops rotating. Otherwise, objects could rotate faster and faster under the influence of the explosion, and that looks odd.

With the concussion wave implemented, the explosion force generator looks like this:

```
────── Excerpt from file include/cyclone/fgen.h ──────
class Explosion : public ForceGenerator,
                  public ParticleForceGenerator
{
    // ... Other Explosion code as before ...

    /**
     * The speed that the shock wave is traveling, which is related
     * to the thickness below in the relationship:
     *
     * thickness >= speed * minimum frame duration
     */
    real shockwaveSpeed;

    /**
     * The shock wave applies its force over a range of distances, which
     * controls thickness. Faster waves require larger
     * thicknesses.
     */
    real shockwaveThickness;

    /**
     * This is the force that is applied at the very center of the
     * concussion wave on an object that is stationary. Objects
     * that are in front of or behind the wavefront, or that are
     * already moving outward, get proportionally less
     * force. Objects moving in toward the center get
     * proportionally more force.
     */
    real peakConcussionForce;

    /**
     * The length of time that the concussion wave is active.
     * As the wave nears this, the forces it applies are reduced.
     */
    real concussionDuration;
};
```

Convection Chimney

The final part of the explosion is another Hollywood exaggeration of a real explosion. As well as the pressure effects from the initial explosion, the heat generated will set up a convection current above the blast point. In most conventional weapons this is a minor effect, and isn't very noticeable. It is significant and iconic in atomic and nuclear weapons, and the mushroom cloud has become a potent indicator of explosive violence.

While it should be used sparingly (big mushroom clouds after a grenade goes off look odd), it can be a great way to indicate a superior weapon.

Convection chimneys provide a very small amount of upward force for a long time after the explosion. It is not enough to lift all but the lightest objects off the ground. Because light objects are unlikely to be around the blast point after the concussion wave, developers typically introduce extra particles that only respond to the convection. These particles are light enough to be carried upwards.

The convection chimney has an equation similar to that of the concussion wave, but it doesn't move outward. The linear fall-off works fine:

$$f_a = \begin{cases} f_b d_{xz}/w & \text{when } d_{xz} < w \text{ and } d_y < h \\ 0 & \text{otherwise} \end{cases}$$

where w is the width of the chimney, h is the maximum height of the chimney, d_{xz} is the distance of the object from the blast center in the XZ plane only (because we want the chimney to be a cylinder shape), and d_y is the height of the object above the blast point.

The force again should be applied in a line from the blast center. If we apply the force in just the up direction, then objects will rise up the chimney and bob at the top with the force angled outward, and the characteristic mushroom cloud shape is formed. The peak force is calculated in the same way as for the concussion wave, as it is another moving-air phenomenon.

The code to produce this effect looks like this:

```
             ──────────── Excerpt from file include/cyclone/fgen.h ─────────
class Explosion : public ForceGenerator,
                  public ParticleForceGenerator
{
    // ... Other Explosion code as before ...

    /**
     * This is the peak force for stationary objects in
     * the center of the convection chimney. Force calculations
     * for this value are the same as for peakConcussionForce.
     */
    real peakConvectionForce;
```

```
    /**
     * The radius of the chimney cylinder in the xz plane.
     */
    real chimneyRadius;

    /**
     * The maximum height of the chimney.
     */
    real chimneyHeight;

    /**
     * The length of time the convection chimney is active. Typically
     * this is the longest effect to be in operation, as the heat
     * from the explosion outlives the shock wave and implosion
     * itself.
     */
    real convectionDuration;
};
```

Altogether the explosion looks quite good. The **explosion** demo shows the three components in action (see Figure 17.8). There are no lighting or fire particle effects, which would normally be used in a real game explosion (neither of which are typically driven by the explosion force generator but, as particle effects, will be driven by the

FIGURE 17.8 Screenshot of the **explosion** demo.

physics engine). For a huge explosion, a neat effect is to set fire to objects as they first come into the range of the concussion wave (i.e., add fire particles to the surface of the object). This gives the effect of a consuming fireball.

17.3 LIMITATIONS OF THE ENGINE

So we have built a usable physics engine and had some fun putting it through its paces in various game situations. This is about as far as we'll be going in detailed code. The rest of the book addresses in a more general way other issues and approaches.

As I've said from the beginning, the approach we've taken is a sound one, with a good blend of implementation ease and simulation power. Ultimately, however, any approach has limitations. While I have tried to be clear about the limitations as we have gone along, before looking at the benefits of other approaches, it is worth recapping what our engine finds difficult.

17.3.1 STACKS

Stacks of objects may not be too stable in our engine. Of course, we can set the stack up and put it to sleep, and have it fall when knocked, but a slight touch is likely to set it jiggling. At its worst it can cause blocks at the top of the stack to move visibly and vibrate their way off the edge.

This is caused by the iterative penetration resolution algorithm. The algorithm doesn't perfectly position objects after resolving the resolution. For one object (or even a small number of stacked objects) this isn't a problem. For large stacks, the errors can mount until at the top they are very noticeable.

Judicious use of putting objects to sleep means that stacks can be made to appear stable. If you need a brick wall to be blown apart, this is a good strategy, and won't show the engine's limits.

17.3.2 REACTION FORCE FRICTION

As we saw in the last chapter, reaction force friction is accommodated when a contact is being resolved, but not when a the contact is moved as a side effect of another resolution. This makes it difficult for one movable object leaning against another to stay in place. The objects will appear to slide off one another, regardless of the frictions imposed. The best that can be hoped for is that the sleep system kicks in to stop them from sliding apart.

This is another side effect of the interpenetration resolution algorithm: it doesn't accommodate the friction of one contact when considering the penetration resolution of another.

17.3.3 Joint Assemblies

The same cumulative errors that cause stacks to become unstable can also lead to noticeable artifacts when long strings of rigid bodies are connected by joints. In addition to making a full range of joints a burden to program, our engine considers each joint in series. Joints at one end of a chain can be dramatically affected by adjustments at the other.

This can be as mild as a slight stretching of some of the joints, through slow-down in the processing (where all the available iterations are used up) to vibration, and at the most extreme, catastrophic failure.

Iterative resolution isn't the best option for highly constrained assemblies of rigid bodies (although it can cope with modest groupings like our ragdoll). If this is your primary application, then it is best to go for a simultaneous solver.

17.3.4 Stiff Springs

And finally the bugbear from Part II of the book: stiff springs are as much a problem for our full rigid-body engine as they were for the particle engine, and for exactly the same reason. While it is possible to use fake force generators, as we did in Chapter 6, the problem can't be properly solved.

17.4 Summary

Almost anything that can be done with a game physics engine can be done with the physics engine we've built in this book. As we seen in this chapter, it can be used to provide the sophisticated state-of-the-art effects associated with game physics.

But no physics engine is perfect. We've built a system that is very fast indeed, but we've sacrificed some accuracy, particularly when it comes to how contacts are resolved.

In the final chapter of this book, we'll look at other ways to approach building a physics engine. You can use these either as inspiration for building your second physics engine, or to extend the engine we've built with some extra features.

17.5 Projects

Mini-Project 17.1
Extend the **fracture** demo, so that impacts on any side of the cube also cause a believable fracture.

Mini-Project 17.2
Extend the **explosion** demo to include the kind of particle effects we saw in the **fireworks** demo. When the explosion occurs, have the fireworks particle system generate a cascade of sparkes.

Mini-Project 17.3

Implement the contact grouping algorithm described in Chapter 16. The approach is described in Section 16.2.3, but the implementation is not given there.

Project 17.1

This project assumes that you have access to a game engine or animation system that supports skeletal animation. Using the animation system as a basis, integrate a ragdoll so that any bones in the animation can be controlled by physics, rather than following the preset animation. Build the basis of a hybrid animation system for a zombie shooter. Find a walk-cycle animation that is vaguely undead. Allow the player to aim and fire at the animated character. When a limb is hit, that limb, and all limbs below it in the skeletal hierarchy, will be handed over to the physics system for animation.

Project 17.2

Create a 10-pin bowling game. The pins can be cuboid (you'll need to use a more advanced collision detection approach to model the concave curved forms of real pins). Players should be able to set the initial trajectory and spin of their ball, and the physics engine should model the results. To count the number of pins knocked down, you will have to examine the quaternions of each pin after the simulation has settled down (i.e., after all objects have been put to sleep).

PART VI

Further Topics in Physics

18

PHYSICS IN TWO DIMENSIONS

The physics engine we've built over the course of this book was designed to be as general as possible. It can be used for all kinds of game genres, but is focused on the kinds of physics seen in state-of-the-art games.

Over the 5 years since I started working on the first edition of this book, however, the landscape of game development has changed significantly. Motivated by a new generation of Internet-connected consoles, players have been able to select from lower-budget, independently created games that hark back to the best game-play experiences of previous decades. This has meant a sudden renaissance in commercial 2D games, years after it looked like 3D would be ubiquitous.

These games are not simple retro-remakes, however, as they use state-of-the-art technologies, including, inevitably, physics. Physics-based game play has, if anything, been better developed in 2D than 3D and so a question I have often been asked about the first edition of this book is, how do I build a 2D physics engine, rather than the 3D engine the book focuses on? If a 2D game is where you're heading, then this chapter is for you too.

18.1 2D OR 3D?

But before we get into the discussion, it would be worth thinking about whether you really need a 3D engine in your game. There are some things to realize about 3D physics for a 2D game.

Copyright © 2010, Elsevier Inc. All rights reserved.
DOI: 10.1016/B978-0-12-381976-5.00018-8

463

1. It is possible to do everything you want with a 3D physics engine. 3D is a super set of the functionality in a 2D engine, so you'll lose nothing keeping a 3D engine. To use a 3D engine, you need to constrain objects so they only move and spin in a 2D plane. This can be done using the kinds of constraints we saw in Chapter 15.

2. You may, at some point, want 3D movement in your game. One very powerful effect used in several games that are essentially 2D, is to allow some objects to move in 3D. While the player's actions are limited to 2D, you may want to create an illusion of depth, so allowing objects to fall into and out of the player's 2D plane is a good strategy. This has been used successfully in the Trials series of games for the PC and XBox Live, for example. In these games, your motorbike is fixed in a 2D plane (at least until you crash—crash animations use ragdolls in full 3D), but crates and pipes and other game objects can move into and out of the game plane.

3. Even if you're not expecting game-play elements to move in 3D, you may need 3D to simulate particles believably. It is pretty common to have a 3D particle engine on top of 2D physics. This hybrid engine can be very powerful, but it might be simpler to just stay in 3D.

4. The reason you build a physics engine in the first place is reuse. If you just need a single physical effect here or there, you may be better off coding it directly (we discussed this tradeoff in Chapter 1). If you're going to spend the time building, optimizing, and learning to use a physics engine, then it is better to build a 3D engine, because that will give you the most flexibility for the kinds of games you can create later on.

5. Which direction is gravity in your game? 3D engines don't really care, as gravity can be acting along any direction. (In our engine you simply set each object's acceleration vector in any direction you choose.) But 2D games are representations of a 3D world, and so they typically come in two groups: those where gravity acts in the 2D plane, and those where it acts perpendicular to the game plane. You can think of these as side-view and top-down games. 2D physics engines are designed primarily for side-view games. If you're developing a top-down game, then the majority of the forces in your physics system (because gravity is almost always the dominant force in game physics) won't be simulated. And this can look odd; or worse, it can make your physics pretty much redundant. If you're going to put all that hard work in, it should be noticeable!

Having said all that, if you build an engine for 2D use, it will have some important advantages.

1. It will be faster, and often considerably faster. There's no need to perform a huge number of calculations that you won't be needing. Using a 3D engine involves adding new constraints to remove the extra degrees of freedom. Better to not introduce them.

2. Collision detection is much simpler. 3D collision detection is an order of magnitude more difficult (and therefore slower) than in 2D. An interesting consequence of this is that 2D physics engines often implement more complex collision detection schemes, including support for convex objects.

3. The simplicity allows you to experiment more with alternative algorithms, to add new constraints, and to build more options for force and torque generators. This in turn can provide a more interesting and varied physics experience for your players.

4. Typically, 2D engines are more accurate at representing 2D physics. This is because when we remove extra degrees of freedom from a 3D engine, we are removing some of its accuracy. Consider the work we did on resolving interpenetration or other constraints. When we move objects back into place so they don't violate their constraints, we have to use rules of thumb (such as having a portion of the movement angular and a portion linear, although not too much angular). Those rules of thumb left us in situations that weren't physically accurate. The same thing happens when we process the 2D constraint in a 3D engine—we have to approximate, using rules of thumb, and that means slightly less accurate and slightly less believable physics.

The remainder of this chapter will go back through the engines we've built, chapter by chapter in this book, and discuss the changes that would be needed to implement a pure 2D engine. I will not describe the process of building the engine from scratch, so this chapter isn't designed to be read on its own if you just need a 2D engine. It builds on the content in the rest of the book, and should be read afterward.

18.2 Vector Mathematics

The changes needed to cope with mathematics in 2D are relatively minor. Recall that a vector in 3D consists of three independent quantities:

$$a = \begin{bmatrix} x \\ y \\ z \end{bmatrix}$$

In a 2D engine, we'd simply lose one of these quantities:

$$a = \begin{bmatrix} x \\ y \end{bmatrix}$$

We would want to implement a Vector2D class with just these two degrees of freedom. If you followed my implementation in Chapter 2, you noted that I slipped in

an extra member to make sure that the size of the vector sat nicely in the computer's memory. You'd want to do something similar again. You could have:

```
class Vector2D
{
    real x;
    real y;
};
```

and have it sit in memory with two vector objects per 16-byte range. This would perform far better than if we had three `real` variables in the structure, because for three we'd inevitably get some vectors that straddle the 16-byte boundary. But it would still perform better as:

```
class Vector2D
{
    real x;
    real y;
    real _pad[2];
};
```

It is worth profiling the memory use and cache performance of both approaches, to see if the tradeoff for reduced memory usage is worth it.

Of the methods we implemented for our vector class, most require pretty obvious modifications. Scalar product looks like this, for example:

```
class Vector2D
{
    // ... Other Vector2D code as before ...

    real scalarProduct(const Vector2D &vector) const
    {
        return x*vector.x + y*vector.y;
    }
}
```

The only method we will not have is the vector product. Vector products are not defined for 2D vectors, as there is simply no way to calculate them. One useful

application of the vector product in 3D, however, is the construction of vectors at right angles to one another. Recall that for two vectors, *a* and *b*, the vector *a* × *b* will be at right angles to both.

In 2D it is useful to be able to do the same thing—to generate a vector at right angles to another. In 2D, things are simpler. For any given vector, there will be only one other direction that is perpendicular. There are an infinite number of vectors in that direction, however, so we need to choose one. The following code chooses the vector made by turning the original vector through 90 degrees counterclockwise:

```
Vector2D perpendicular() const
{
    return Vector2D(-y, x);
}
```

18.3 Particle and Mass Aggregate Physics

The remainder of the particle and mass aggregate engines require only trivial modifications to our previous code. We simply replace Vector3D calls with Vector2D calls. The force accumulators, collision response, our constraints, the integration step, and the particle data structure need no other modifications.

After making these simplifications, you should be able to run equivalent 2D versions of the demos in Chapters 4 and 8.

18.4 The Mathematics of Rotation

Handling rotation is the first stage at which our 2D engine will significantly diverge from the 3D system.

18.4.1 Representing Rotation

Recall that in Chapter 9 we looked at a number of different ways to represent rotation. All of them had their weaknesses, but we settled on quaternions, because the were easy to implement in code.

A similar discussion could be had for 2D rotations. The situation isn't as tricky, however, because a rotation in 2D only has one degree of freedom.

We could get away with using just a single scalar value for our orientation, as long as we took steps to make sure that it was always in the correct range. So if our orientation became 540 degrees, for example, we might want to correct it back to

180 degrees. We could also use a 2 × 2 matrix, although (as in the 3D case) this would have a lot of extra degrees of freedom we don't need.

A better approach would follow the 3D logic and use complex numbers to represent orientations. This is sometimes called the *spinor* representation of rotation.[1] The complex number encoding represents a rotation angle, θ, as the complex number,

$$z = \cos\theta + \sin\theta\, i$$

Note that, unlike the quaternion representation, this is given in terms of cos and sin of θ, rather than of $\frac{\theta}{2}$. We can also write the same expression as

$$\theta = \cos\theta + \sin\theta\, i = e^{i\theta} \qquad [18.1]$$

which will be important to us shortly.

Just like quaternions, these complex numbers are of length 1, and to make sure our rotation is still a rotation (as opposed to some other kind of transformation), we'll need to keep it unit length by occasionally normalizing it.

As before, I will write complex numbers representing rotations as a vector:

$$\begin{bmatrix} \cos\theta \\ \sin\theta \end{bmatrix}$$

To combine two rotations, we use complex multiplication:

$$\begin{bmatrix} a \\ b \end{bmatrix} \cdot \begin{bmatrix} c \\ d \end{bmatrix} = \begin{bmatrix} ac - bd \\ ad + cb \end{bmatrix}$$

The only remaining operation to take on 2D rotations is the calculation to add a scaled version of a rotation value. We use this calculation to integrate the orientation by the angular velocity. In 2D, because we only have one degree of freedom, angular velocity will be a scalar quantity, $\dot{\theta}$. The math for this update follows:

$$\theta' = \theta + t\dot{\theta}$$

In terms of complex numbers, it is:

$$\theta' = e^{i(\theta + t\dot{\theta})}$$

$$= e^{i\theta} \cdot e^{i\dot{\theta}}$$

$$= \theta \cdot \begin{bmatrix} \cos\dot{\theta} \\ \sin\dot{\theta} \end{bmatrix}$$

1. Strictly speaking, this is a general term; quaternions are also the spinor representation for rotations in 3D. The mathematics can be generalized further, and becomes the geometric algebra (GA). See Dorst et al. [2007] for more details on GA.

which involves the calculation of sin and cos of the angular velocity for each update. This is a worse situation than our equivalent quaternion update, because trigonometric calculations are less efficient than addition, subtraction, or multiplication.

18.4.2 MATRICES

To support our 2D vectors, we'll need two kinds of matrices. The first, not surprisingly, will be a 2×2 matrix. This can represent rotations, but not translations. The second is the equivalent of the 2×3 matrix from Chapter 9, and, as there, it uses the extra column to allow it to represent translation.

The 2×3 matrix transforms a vector by assuming that the vector has a third entry, which is always 1:

$$\begin{bmatrix} a & b & c \\ e & f & g \end{bmatrix} \begin{bmatrix} x \\ y \\ 1 \end{bmatrix} = \begin{bmatrix} ax + by + c \\ ex + fy + g \end{bmatrix} \qquad [18.2]$$

This is the same as the 3D case.

If you are modifying your existing physics engine to work in 2D, you could simply reuse your existing `Matrix3` class. You will need to add a new method to transform `Vector2` objects, however, by assuming that they have a third entry equal to 1.

Other matrix operations are exactly the same, but the loss of one row and column makes many of them far simpler.

18.5 RIGID-BODY DYNAMICS

When we considered torque in 3D, we made use of the vector product to calculate the torque from a force and position of application. We no longer have a vector product, so we need an explicit method for calculating torque from corresponding force. If we have a force,

$$f = \begin{bmatrix} f_x \\ f_y \end{bmatrix}$$

which applies to a rigid body at a position

$$p = \begin{bmatrix} p_x \\ p_y \end{bmatrix}$$

relative to its center of mass, then the torque associated with that force will be

$$\tau = p_x f_y - p_y f_x$$

There are a couple of ways to derive this result. The simplest, given what we have already covered in this book, is to think of the 2D case as something that is happening in 3D, where everything occurs in the $z = 0$ plane. So we could then calculate the vector product,

$$\boldsymbol{\tau} = \boldsymbol{p} \times \boldsymbol{f} = \begin{bmatrix} p_x \\ p_y \\ 0 \end{bmatrix} \times \begin{bmatrix} f_x \\ f_y \\ 0 \end{bmatrix} = \begin{bmatrix} 0 \\ 0 \\ p_x f_y - p_y f_x \end{bmatrix}$$

which gives our result as the z component, the others being zero. So this represents a torque that is only about the z axis, as we'd expect.

2D rigid bodies have another dramatic simplification: they do not require tensors to represent their rotational inertia. Instead, the angular inertia of a 2D rigid body about its center of mass is a scalar value. It is usually simply called the *moment of inertia*, I. The equation for angular motion is simply

$$\ddot{\theta} = \frac{1}{I}\tau$$

where all the terms are now scalars.

We're now at the point where we can perform a rigid-body integration. The integration is simple compared to the 3D case. It can be implemented as follows:

```
void RigidBody2D::integrate(real duration)
{
    // Calculate linear acceleration from forces and gravity.
    lastFrameAcceleration = acceleration;
    lastFrameAcceleration.addScaledVector(forceAccum, inverseMass);

    // Calculate angular acceleration (a scalar).
    real angularAcceleration = torqueAccum * inverseMomentOfIntertia;

    // Update the linear and angular velocities.
    velocity.addScaledVector(lastFrameAcceleration, duration);
    rotation += angularAcceleration * duration;

    // Apply damping to both components.
    velocity *= real_pow(linearDamping, duration);
    rotation *= real_pow(angularDamping, duration);

    // Update the linear and angular positions.
    position.addScaledVector(velocity, duration);
    orientation.addRotation(rotation, duration);

    // Perform end-of-update bookkeeping.
```

```
        orientation.normalize();
        clearAccumulators();
}
```

`calculateDerivedData` now only needs to normalize the orientation and calculate a transform matrix. It doesn't need to update the inertia tensor matrix, because we have replaced that.

18.6 COLLISION DETECTION

Collision detection, specifically narrow-phase collision detection, is a second area where the code is dramatically simplified in 2D. Broad-phase collision detection is left almost entirely unchanged. We have bounding circles rather than spheres, and bounding rectangles rather than boxes, but the math is largely the same. Of the broad-phase techniques we covered in Chapter 12, we can use all of them except oct-trees, which assume a third dimension. The 2D equivalent is the quad-tree, which is also covered in that chapter.

For narrow-phase collision detection, the methods are largely the same, but the cases we have to consider are simpler. In 2D, there are three types of contact, as shown in Figure 18.1.

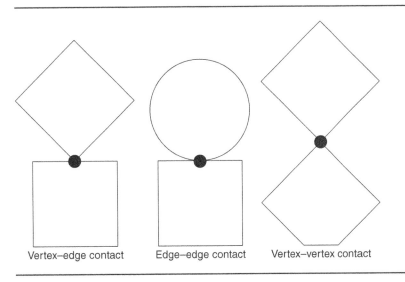

Vertex–edge contact Edge–edge contact Vertex–vertex contact

FIGURE 18.1 The three types of contact in 2D.

1. Vertex–edge

2. Edge–edge

3. Vertex–vertex

As in Section 13.2.1, I have ordered these according to their importance. As before, if we find contacts higher up this list, we don't need to generate the contacts lower down. And, as before, we will not look for the contact at the bottom of the list at all: vertex–vertex contacts can be safely ignored.

The properties of contact are unchanged. Our methods for generating the contacts are discussed in the next section.

18.6.1 VERTEX–EDGE CONTACTS

This is the most important type of contact in 2D. The edge may be straight or curved. This is the equivalent of the vertex–face contact in 3D.

The contact normal is given by the tangent of the edge at the point of contact. For straight edges (which are common) this is the direction of the edge. We can use our `perpendicular` method from the start of this chapter to generate the contact normal. For collisions involving curved surfaces, this normal might be available directly.

The contact point is normally given as the vertex involved in the contact.

18.6.2 EDGE–EDGE CONTACTS

This is the equivalent to the face–face contact in 3D, and like that contact there is some ambiguity about the contact normal to use. We typically use the edge normal (calculated in the same way as we saw for vertex–edge contacts) of either object. Often we just pick the first object. In reality, edges can only meet when they have a common normal, but inaccuracies in our simulation mean this is not always the case. Choosing one or the other (as long as we're consistent) is usually not noticeable.

18.6.3 CONTACT GENERATION

In 2D, our key primitives are the circle, a line (actually a half-space again, as in 3D), and a rectangle. The detection code for circle–circle and circle–half-space primitives is as for 3D. Depending on how you've implemented your 2D vector class, you might be able to use it unchanged, as the operator and method implementations hide the differences in the arithmetic. Both these pairs can only generate an edge–edge contact. It is normal to generate the contact normal based on the line, in the circle–half-space case.

The rectangle–circle case is also very similar to the 3D case, only we have one fewer dimension to check, so the code becomes a little simpler.

The SAT works as well for 2D as 3D. In the 2D case, however, the only axes we need to check are those that are normal to each edge in the model. This is an important result. In the 3D case, we had to check each face normal and the direction given by the cross-product of each *pair* of edges. So the work we needed to do grew with the *square* of the number of edges. This made the SAT slow for complex geometry.

In the 3D case, the number of axes to test depends only on the number of edges in each model; there is no squared term. This makes SAT tractable for much more complex geometries. To collide two rectangles, we need to check just four axes (again assuming opposite edges in a box are parallel, so there are only two distinct axes to check per box). This is nearly a fourfold reduction to the 3D case.

The actual performance of an SAT for a given axis is the same as the 3D case, and the method used to generate the contact information is also analogous.

18.7 Collision Response

Collision response is similar to the 3D case. It benefits from the demise of the inertia tensor, however. At several points in the collision response algorithm we need to work with the inertia tensor in various coordinate schemes (local, where it is constant; world, where it changes each frame; and contact, which is calculated per contact). This is a lot of conversion and bookkeeping work. In 2D the moment of inertia doesn't depend on the rotation axis, since there is only ever one rotation axis. Therefore, we don't have to perform the conversions. Anytime the inverse inertia tensor (in any coordinates) is needed, we can simply use the inverse moment of inertia, $1/I$. This goes for all aspects of the contact resolver: collisions, microcollisions for resting contacts, interpenetration resolution, and friction. In 2D, there is no distinction between isotropic and anisotropic friction.

In fact, the only reason we constructed the contact coordinates in the first place was so we could manipulate the inverse inertia tensor in those coordinates. We can therefore do away with contact coordinates entirely and work in world coordinates throughout.

The iterative algorithms for collision and interpenetration resolution were independent of the number of dimensions in the simulation, and will therefore be unchanged.

18.8 Summary

In this chapter, we have seen that the vast majority of the code in a 3D physics engine is shared with a 2D engine. When there are differences, they are caused by having only one degree of rotational freedom in 2D, rather than the three in 3D. This makes any calculations involving rotation simpler, but particularly makes calculations involving the moment of inertia almost trivial. Add to this the speed improvements that 2D

makes to our collision detection, and we get performance improvements that are at least an order of magnitude in size. This seems to be a slam-dunk argument for 2D physics. But we saw that the lower flexibility in a 2D engine isn't ideal in many games. A large number of 2D games still use a 3D physics engine.

18.9 PROJECTS

Mini-Project 18.1
Modify the **fireworks** demo from Chapter 4 so that it operates in 2D. You will need to change the underlying physics engine to make this work, so it would be wise to make a separate copy or branch of the source code.

Mini-Project 18.2
Modify the **platform** demo from Chapter 8 so that it operates in 2D. As in the previous exercise, you will need to make modifications to the Cyclone engine to do this. You should make a copy of the source.

Mini-Project 18.3
Create a 2D version of the aerodynamic tensor from Chapter 11, and use it to implement a simple 2D gliding model. For a given launch altitude and velocity, the game should see how far the player can fly before touching the ground plane.

Project 18.1
Create a simple two-player dog-fighting game with a simple aerodynamic model for the aircraft. Each player should be able to rotate her or his aircraft using the aerodynamics only (i.e., don't apply torques directly) and should be able to shoot in the direction she or he is facing. The game will be quite tricky: it will be as much of a challenge to keep the plane in the air as to avoid being shot down.

Project 18.2
Create a game where the player controls a pogo stick. The player's stick is a rigid body to which she can apply a small amount of torque. The center of mass should be almost at one end of the stick, and it should have a relatively high moment of inertia (this isn't physically realistic, if the center of mass is concentrated at one end, but it improves playability). Add a selection of half-spaces or fixed rectangles to form a level. If the heavy end of the stick hits a surface, the player loses. If the other end of the stick hits the ground use a spring force generator to push it back out again. The player will have to move down the level to keep bouncing (because of damping), but bouncing too far will cause the stick to spin and the top will hit.

Implementing this game will involve having to think hard about how to mix the spring force generator with regular collision detection. There are at least two good and valid approaches to this.

19

OTHER
PROGRAMMING
LANGUAGES

The source code for the Cyclone engine is written in C++. Although C++ is still the most common language for game development, the recent surge in interest in other game platforms, particularly mobile and browser-based games, has meant that more developers are using alternative languages.

This chapter looks at some of those languages, and gives general advice for implementation strategies. I won't give complete implementations here, however, because the overwhelming majority of the implementation task is the same, no matter what language you use. Different languages make it more or less complex to achieve the same thing, however, so it is worth understanding the pitfalls before you start.

In the first edition of this book, this chapter was placed in an appendix. I dealt with porting to C, Java, .NET platforms, and Lua. In the 5 years since I wrote that appendix, Flash has become a more significant tool for serious game development than I imagined. I get requests from users about Flash implementation more often than any other.

19.1 ACTIONSCRIPT 3

With the release of Flash version 9, and a free SDK, Adobe opened up Flash development to more serious game developers. Prior to that point Flash was clearly aimed

Copyright © 2010, Elsevier Inc. All rights reserved.
DOI: 10.1016/B978-0-12-381976-5.00019-X

at graphic artists and designers who wanted to add interactivity to their designs. Amazing things had been done by developers even so, but the tools weren't optimized for software engineering. ActionScript 3 was a significant step forward in the language and tool support. In the wake of its release, a series of physics technologies began to gain prominence, including full 2D physics engines. These are now increasingly being used in browser-based Flash games. Visit any of the major Flash game portals and a significant proportion of the titles will have some form of physics engine.

ActionScript 3 is also important in another way. It is a dialect of ECMAScript, the international standard for scripting languages. As such it shares significant similarities with JavaScript, the browser scripting language, and JScript, Microsoft's implementation for Internet Explorer. JavaScript, through open-source implementations such as SpiderMonkey and V8, and through the .NET system and its open-source version, Mono, has seen an increasing amount of use as a general-purpose scripting language in games. Mono runs the scripting virtual machine for the Unity 3D game development platform, for example. I haven't seen a physics engine developed in JavaScript, yet, and it is still better to develop your engine in C++, even if you have a Mono or JavaScript virtual machine running. But clearly ECMAScript languages are here to stay, and as their implementations become more efficient there will be an increasing opportunity for using them to code physics. As the HTML 5 specification for direct drawing on a web page from JavaScript matures, I expect to see a new raft of games developed directly in client-side JavaScript. But these hypothetical games of the future will have many similarities with the Flash games of the present.

Implementing physics in ActionScript is tricky because, compared to some other development tools, Flash is slow. Unlike other comparable languages (such as Java, as we'll see below), Flash does not provide language bindings to allow you to implement performance-critical code in C or C++. Everything has to be built in ActionScript.

The ActionScript 3 interpreter in Flash 9 and 10 is much faster than previous versions, and a lot of work has been done on the compiler to produce better byte code. But still, every operation you code has to go through a series of error checking, security sandbox, and interpretation phases before it can be executed. It is therefore more important to keep your code optimized, and to profile it regularly (the professional version of Flex Builder, Adobe's ActionScript IDE, has a full profiling system; the free SDK and regular Flex Builder does not).

A key performance bottleneck to be aware of is objects. In C++, objects are relatively lightweight entities. They take very little additional memory (over and above their data, that is), and they are intrinsically quick to create and destroy. In ActionScript, however, there is a fair bit of management data associated with each object. This is quite common in systems that manage memory and provide automated garbage collection. In developing you can unwind data types into their parents. You could, for example, expand the `Vector3` instances in a `Particle` into their class as follows:

```
public class Particle {
    public var x:Number;
    public var y:Number;
    public var z:Number;

    public var dx:Number;
    public var dy:Number;
    public var dz:Number;

    public var ddx:Number;
    public var ddy:Number;
    public var ddz:Number;

    public var gravity:Number;

    public var inverseMass:Number;

    public function update(duration:Number):void {
        dx += ddx * duration;
        dy += ddy * duration;
        dz += ddz * duration;

        x += dx * duration;
        y += dy * duration;
        z += dz * duration;

        // Zero the accumulator.
        ddx = 0;
        ddy = -gravity;
        ddz = 0;
    }

    public function addForce(fx:Number, fy:Number, fz:Number):void {
        ddx += fx * inverseMass;
        ddy += fy * inverseMass;
        ddz += fz * inverseMass;
    }
}
```

This will perform better than our previous implementation that separates the Particle and Vector3 classes.

This is efficient and relatively straightforward for particles, but implementing the rigid body or contact objects in this way rapidly becomes an exercise in long-winded algorithms and copy-and-paste code. There is a tradeoff to make.

When you implement mathematical data types as classes, you will face a minor stylistic problem caused by ECMAScript's historical links to Java: it does not support operator overloading. So, whereas you could do

```
class Vector3 {
    Vector3 operator*(float k) const
    {
      return Vector3(x*k, y*k, z*k);
    }
    void operator+=(const Vector3& other)
    {
        x += other.x;
        y += other.y;
        z += other.z;
    }
};
```

in C++, and then

```
accumulatedAcc += force * inverseMass;
```

you would have to write

```
public class Vector3 {
    public function multiply(by:Number):Vector3 {
        return Vector3(x*by, y*by, z*by);
    }
    public function add(other:Vector3):void {
        x += other.x;
        y += other.y;
        z += other.z;
    }
}
```

in ActionScript and then

```
accumulatedAcc.add(force.multiply(inverseMass));
```

which tends to make code much more verbose and less clear (particularly in some of the very complex collision response algorithms where we saw many operators in a single line).

On the other hand, in ActionScript, once you've decided to make a method call, there is no additional penalty for having virtual methods. That means structures such as the polymorphic `ContactGenerator` and `ForceGenerator` could be replicated in various kinds of `RigidBody`, `Particle`, or even `Contact`—classes for which I did not use virtual methods in C++. This makes some kinds of programming much clearer. The **fireworks** demo, for example, is more cleanly expressed using subclasses for each firework type and overloaded methods for their behavior (such as their spawning pattern when they reach maximum age).

Since most people wanting to develop physics engines in ActionScript are intending to use them for 2D games, it is worth referring to Chapter 18 for a guide on the other modifications you'll need to make to the engine.

19.2 C

Among some parts of the game development community, C is still the gold standard for implementing performance-critical code. It has the added advantage of begin easily compilable, with excellent optimizing compilers. When you're writing code once to run on multiple platforms, this translates into increased confidence that you won't find good C++ code turned into terrible-performance machine code because of a poor C++ compiler. With the advent of the iPhone as a gaming powerhouse, particularly in the independent development community, C has also seen a renaissance. It is a common sublanguage behind both C++ and Apple's Objective-C languages, and so can easily cross-compile into iPhone libraries and code for other consoles.

Most of the source code in this book can be translated into C fairly easily. Classes are replaced with structures, and all methods in classes are replaced by functions.

Operator overloading isn't supported in plain C (although some dialects do backport it from C++). The places we've used overloaded operators to represent vector and matrix operations are replaced by plain functions. This has the same verbosity issue as with ActionScript, discussed previously.

C doesn't support virtual functions and the kinds of polymorphism that I used to implement contact generators and force generators in this book. You can do a similar thing in C, however, by using a fixed-function signature of the form,

```
(void)(*forceGenerator)(void* inData,
                        RigidBody* inOutBody);
```

where `RigidBody` is a `typedef` of a structure.

The additional data parameter is used to pass data to the force generator function (in C++ this isn't needed because the implicit `this` pointer contains the generator's data). You can then define any number of such functions, and even hold them as function pointers in other data structures.

I have used the C++ standard template library at a number of points in the source code to represent a variable-length array. Most other languages have native equivalents, but C does not. To implement these structures (the list of force generators and the list of rigid bodies, for example), you can use singly or doubly linked lists:

```c
typedef struct rigidbody_t {
    // ... Other RigidBody data as for C++ ...

    struct rigidbody_t *previous;
    struct rigidbody_t *next;
} RigidBody;
```

In each of the cases where I've used an STL vector, it has been to make the algorithm clearer. I don't rely on its performance characteristics, and I only ever traverse it in a forward direction. If you are adding and removing objects from the list at runtime, however, there will be a larger difference in performance.

19.3 Java

Lots of the caveats around implementing in Java are the same as we've seen for Action-Script. Although Java has dramatically improved in terms of its just-in-time compilation efficiency, it is still usually better to implement highly localized, time-critical parts of the code in C++. Unlike ActionScript, Java has a native language binding that allows us to write in C++ and compile down as a native library.

Java still holds significant pull for developing games on mobile handsets (although this seems to be waning), which often cannot run native code. Of the remaining Java-developed games, the majority are distributed as the clients for web-based games, so they should be capable of being run through Java WebStart. This makes it much more inconvenient to distribute native libraries, and so all coding for Java-based games is normally done in Java.

If you decide to implement the engine in Java, then it is worth reading through the previous discussion related to ActionScript, since many of the issues will be the same. One key thing to be aware of is the overhead of objects in Java. This is significantly higher than it is for other VM-based, byte-code languages, and so you could find yourself having memory issues sooner if you split all your data structures into smaller components.

If you have each vector in your simulation as a separate instance, for example, then on some Java platforms this can cause a huge bloat in the amount of memory required.

Java, like ActionScript, has interfaces as a characteristic component of its syntax. In the case of force and torque generators, for example, we can replace the pure-virtual classes of our C++ implementation with interfaces. Classes such as GravityForceGenerator can then implement these interfaces. This also allows a single class to be both a force generator and a contact generator, if required (this would be useful when implementing a spring with hard limits, for example).

19.4 c#

C# has gained popularity among game developers as a Java-like managed language for targeting Microsoft's gaming properties, Windows PCs and XBox 360 consoles, particularly as part of their XNA strategy to engage hobbyist and independent developers.

Once again, implementing in C# involves the same concerns and strategies as ActionScript and Java. Like those languages, it is compiled down to an intermediate byte code that has security and error-checking facilities built in. And once more it uses a good deal of extra per-object data to help it manage memory in your game.

Unlike Java and ActionScript, C# supports operator overloading, so you can create math classes that are intuitive to use and produce readable code.

Because C# programs run on a specific set of hardware, it is far more feasible to implement your physics engine in another language, and one that compiles down more efficiently to native code. Microsoft's common language runtime (the byte code that C# compiles to) allows elements written in different languages to communicate efficiently. This is simplest when the components are all "managed" (broadly this means they have their life cycles, and therefore their memory, managed), but unmanaged C or C++ is faster than managed code, and can also be integrated with C# components.

The .NET common language runtime supports a number of other languages as well as C#. Microsoft's stalwart Visual Basic language is also a common choice, although there are cross-compilers for a wide range of languages, including Ruby (IronRuby), Python (IronPython), and JavaScript. Be careful using these languages, however. Because the change in language doesn't change the underlying assumptions of the virtual machine, some facilities of the language may not be supported, and some semantics of the language may be different.

The common language runtime has an open-source implementation: Mono. This is seeing considerable traction as an in-game scripting platform. Because of the language-independent work that has gone into it, the VM runs byte code very efficiently. Because it has bindings for several languages, it allows mixed teams to work together, each developing subsystems in a language that they are most comfortable with. I am aware of some readers of the first edition of this book implementing their physics in C# so that it can be run on the Mono platform.

19.5 OTHER SCRIPTING LANGUAGES

Lua makes an excellent language for implementing game logic and anything beyond the low-level routines used to run the game. At the risk of sounding like a stuck record, the physics can be one of these low-level routines implemented in C++ and called when needed from Lua.

Another option I've used, however, is to mix Lua into the physics engine. It is relatively easy to expose Lua code as a force or torque generator into the physics engine (this is particularly useful in my experience to create controllers for player characters).

To set this up, create a LuaForceGenerator in C++ that can call Lua code. The RigidBody class will need its addForce and addTorque methods exposed via a table to Lua so that the code can then affect the rigid body when it has completed its calculation.

Lua is remarkably quick for an embedded scripting language. It has been designed to interface with native code with as little overhead as possible. This makes it easily fast enough to be called a few times for each frame in this way.

I have also seen implementations where routines written in Scheme (via the Gnu Guile project) have been created as scripts in a level editor that is called by the physics engine to generate custom effects. Python rounds out the catalog of languages I'm aware of that are being used commercially (or that readers have told me they are using). Once more, Python is not suitable for coding the main physics engine, but is very powerful as an embedded language for extending the capabilities of your game, including implementing force generators.

20

OTHER TYPES OF PHYSICS

We've developed our physics engine as far as we will. There are things you can add to it, such as more force generators, more joints, and so on. You can use it in a wide variety of game genres as long as you understand its limitations and are willing to work around them.

I've referred to this chapter more than any other in this book. As we've built the engine, I've made decisions about approximations, assumptions, and implementation options that I would use. In each case, there were other alternatives. The engine I've built is good and useful, but there are a couple of other approaches that would have been equally good, and would have had a different set of limitations.

This chapter looks at the main differences between our physics engine and those other approaches. It will not give a step-by-step guide to building those engines, nor any detailed implementation advice. Building an engine involves a whole series of interdependent decisions, so this chapter would be twice the length of the book if we worked through each approach. Instead, I hope it will give you enough information to understand the alternatives and to get you started if you want to go that way too.

20.1 SIMULTANEOUS CONTACT RESOLUTION

In our engine, we resolve contacts one at a time. This is fast, but as we've seen, it has limitations. In particular, we have no way of knowing whether the action we take

Copyright © 2010, Elsevier Inc. All rights reserved.
DOI: 10.1016/B978-0-12-381976-5.00020-6

to resolve one contact might cause other contacts to move in an unrealistic way. In our engine, this is seen when a set of connected contacts with friction appear to slide against one another or when stacks of objects vibrate.

The alternative is to resolve a set of contacts at the same time. Rather than calculating the impulse of each in turn, we need to find the impulses of all simultaneously.

Most physics engines that perform this simultaneous calculation are based on force calculations rather than impulse. In other words, two objects in resting contact are kept apart by a constant force, not by a series of single-frame impulses as we have done. So the resolution calculation tries to find the forces and impulses to apply at each contact, taking the interaction of all contacts into account.

The most common approach to doing this is called the linear-complementarity problem. It involves building a mathematical structure called a Jacobian, which encodes the interactions between different contacts. This can then (usually) be turned into a single set of forces to apply.

Because this is such a common and important approach, we'll look at it from a high level in this chapter. I won't go into the finer points of implementation, however, because getting the algorithms to work in a stable way involves numerous special-case problems and unusual complications.

20.1.1 THE JACOBIAN

The Jacobian is a mathematical construct that says how one contact affects another. It is used to determine the right balance of adjustments to make with the full knowledge of the side effects of any tweak. The Jacobian is a matrix, and may be of any size.

All the forces and torques for all objects are combined into a single very long vector. There will be three force entries and three torque entries for each rigid body, so the vector will have $6n$ entries, where n is the number of rigid bodies. In the same way, all the accelerations (linear and angular) for all objects are treated as one long vector (again having $6n$ entries).

The entries in the Jacobian matrix relate the two together. The value of row a, column b in the matrix tells us the amount of acceleration that would be experienced by component a given a unit of force or torque in direction b. Some of the entries in the matrix are very simple—they are the equations we've used throughout the book to determine the movement of objects. For example, a force in the X direction causes an acceleration of magnitude m^{-1} (from $F = ma$); so in the Jacobian, the value that relates X-direction force to X-direction acceleration will be m^{-1}.

While many of the values in the Jacobian are based on the simple laws of motion, some are due to interaction of objects at contact points. Each value in the matrix gives the change that will occur in the row's component given a unit change in the column's component. Calculating the entries in the Jacobian involves working out the forces at each contact given a unit force at each other contact. The process is similar to the one we used in our engine to calculate the effects of one contact resolution on others.

Entries in the Jacobian don't only exist because one contact affects another. It is also possible for one axis of one contact to affect another. For a contact with friction, the friction force generated will depend on the normal reaction force. As the reaction force increases in one direction, the friction force will also increase. There will therefore be an entry in the Jacobian to represent this connection.

The flexibility of the Jacobian to represent interactions between objects, as well as the basic motion of the object itself, allows it to be used to create a much wider range of joints. In our engine, joints are explicitly specified and handled with their own special-case code. The Jacobian provides a mechanism to link the movement of any two objects in the simulation. In fact, it can link various elements of the same object; for example, the motion of one object along one axis can be fixed (i.e., any force that tries to break this joint is resisted by an equal and opposite reaction force). In addition, motors can be implemented by adding elements to the Jacobian that generate forces regardless of anything else going on. If you look at a physics engine such as the Open Dynamics Engine (ODE), an open-source physics engine, and several commercial middleware packages, they allow very flexible joints and motors to be created by adding entries directly into the Jacobian.

Most force components will not directly interact with one another at all, so the Jacobian will have zeros at the corresponding locations. In fact, most of the matrix will be filled with zeros. The Jacobian is therefore a sparse matrix for this reason. The mathematics of sparse matrices can be dramatically simpler than for regular matrices, but the algorithms are often more complex.

You may come across books or papers on game physics that talk about Lagrange multipliers, the Lagrange method, or Featherstone's algorithm. Each of these is related to the method shown here. In fact, the Lagrange method works with more complex equations than ours, where the Jacobian is decomposed into several parts, one of which specifies the connections between objects, and another (the so-called Lagrange multipliers) of which specifies the amount of interaction.[1] Most game physics engines use the raw Jacobian as shown, but it can be useful to read up on the Lagrange method. Root mathematical physics textbooks and other resources were not written with games in mind, so be careful when seeking to use the Lagrange formulation.

20.1.2 THE LINEAR-COMPLEMENTARITY PROBLEM

Armed with the Jacobian, we can formulate the mathematical problem of resolving all contacts at the same time. It has the basic form of

$$Jf = \ddot{p}$$

1. Note that the Lagrange formulation isn't just an expanded Jacobian with all the bits extracted; it can be used in other ways and with variations on the equation I have introduced in this chapter. But all this is well beyond the scope of this book, and it is stuff I've never needed and never invested the time to implement; it is also not for the mathematically faint hearted.

where f is a vector of force and torque components for all rigid bodies, and \ddot{p} is the resulting accelerations. But f is made up of two components,

$$f = f_{\text{contacts}} + f_{\text{known}}$$

where f_{known} is the set of forces and torques that we know we are applying (forces due to gravity or due to other force generators), and f_{contacts} is the set of forces that are generated in the contacts, which is what we're trying to find out.

Most often you see the equation written as follows:

$$Jf_{\text{contacts}} + \ddot{p}_{\text{known}} = \ddot{p} \qquad [20.1]$$

(although it is often given with different symbols such as $Jf + b = a$). In other words, the Jacobian is multiplied by the known force vector to get a known acceleration. This relies on a fact of matrix multiplication that I haven't explicitly stated before, namely, that it is distributive: for any valid matrix multiplication, $A \times (B + C) = A \times B + A \times C$.

Calculating \ddot{p}_{known} is performed as a step before contact resolution, because this value will not change as we try to work out the contact forces.

On its own, Equation 20.1 could be solved by working out the inverse of the Jacobian (a time-consuming problem, and one often without a solution). But to make things worse, we have an additional constraint:

$$0 \geqslant f_{\text{contacts}} \geqslant r$$

where r is a vector of limits on how big the forces can be. Normal reaction forces can be as large as they need to be, but friction forces are limited. A particular entry in the force vector may represent a friction force and will therefore need to be limited.

The final calculation, finding f so that it fulfills both equations, is called the linear-complementarity problem (or LCP for short). An alternative approach tries to find the smallest possible values for the components in f contacts; this becomes an optimization problem called quadratic programming (or QP). Some physics systems build and solve the QP, but it is more common to work with the LCP.

A commonly used algorithm for solving the LCP is called the pivot algorithm. It works by making guesses for components in f and checking the results. The errors from one set of guesses can be used to modify components one at a time and converge at a solution. Under some assumptions that are commonly met in rigid-body simulations, the guesses will always converge toward the solution. The pivot algorithm (based on an algorithm called the Lemke pivot) was popularized in rigid-body simulation by David Baraff (see Baraff and Witkin [1997] for a step-by-step introduction to the approach).

Complications arise because of numerical instability and the approximation of fixed-length time steps. It is possible (and not uncommon) for a rigid-body simulation to end up in a physically impossible situation where there is no solution to the LCP. In this case, the pivot algorithm can loop endlessly. A robust implementation needs to take account of these kinds of problems and provide alternatives. A common alternative is to impose impulses when there is no valid force solution. But getting it

right while remaining efficient can be very difficult. In my experience (I have created two LCP-based engines, one of some significant complexity), it is easy to get something working, but takes months to end up with a general and robust engine.

How It Is Used

The force-based LCP algorithm works in a different way from the engine we've been building in this book. In our engine, forces are accumulated and applied, and then collision detection and response occur.

The Jacobian includes the calculations for applying forces, so that everything is done in one go: contact forces are calculated and applied along with the rest of the forces. This procedure raises three problems, however: When do we do collision detection? How do we handle interpenetration? What about non-resting contacts?

The architecture of different physics engines handles these steps in different ways. The second two are often applied in much the same way as in our engine (but removing microcollisions—if two objects are determined to be in resting contact, then they are handled by the force system). The collision and interpenetration steps are solved independently of the force calculations. In some engines, the collision response is performed first, and its results are embedded in the known force vector and incorporated into the force calculations above. This relies on the fact that if we know the length of time for one update frame t, then we can convert an impulse g into a force f using the formula

$$f = gt$$

which allows us to represent the calculated collision impulse as if it were just another force applied to the rigid body.

The first problem is more sticky: when do we perform collision detection? If we perform collision detection at the start of the frame before the force calculations, then the result of applying the forces may cause new collisions that will still be visible when the objects are next drawn.

If we perform collision detection after the force calculation, then we can remove all interpenetration before the user sees the frame. But how do we determine the contacts we need to fill the Jacobian at the start of the frame?

We could do both, but that would be very time consuming.

In effect, the second solution is what is normally used. Collision detection is performed before interpenetration is resolved, and the user sees no interpenetrating bodies. The same collision data is then stored until the next update, and it is used to fill the Jacobian. This affords a good compromise between efficiency (extra data is stored between frames) and removing visible interpenetration (which is typically very obvious to the viewer).

As I mentioned in Chapter 13, many systems improve efficiency further by using frame coherence: keeping track of the last frame's collisions to speed up collision checks this frame. If the collision detector does this, then the data is already being stored and can be made available to the physics engine.

20.2 REDUCED COORDINATE APPROACHES

Another technique sometimes mentioned in game development circles (although very rarely implemented) is the reduced coordinate approach.

In our physics engine we've given each rigid body 12 degrees of freedom—three each for position, orientation, velocity, and rotation. The orientation uses four values but has only three degrees of freedom; the fourth value can always be determined from the other three (because the size of the quaternion must be 1).

When objects are in contact, or have joints between them, they are constrained. They can no longer have any value for each of the 12 degrees of freedom. For example: if a nonliftable block is placed on the flat ground, it can only be pushed in two directions, and can only be oriented along one axis. It has only six actual degrees of freedom (two for position, one for orientation, two for velocity, and one for rotation).

The physics system we've built in this book allows all objects to move with 12 degrees of freedom; then it uses impulses and nonpenetration code to make sure they behave properly. Effectively, this code is used to remove or correct certain degrees of freedom after they have been updated.

An alternative is to work out exactly how many degrees of freedom the object has, and allow only those to change. For the block on the ground, this is simple. An example is fully worked through in Eberly [2010], the other physics book in this series.

The approach involves working out the equations of motion, using Newton's laws of motion, but only in terms of the degrees of freedom that are left. For anything beyond a block on a plane, this can become quite involved. When the constraints represent joints, then degrees of freedom can be a combination of rotation and position. Finding the equations of motion can be very difficult indeed. Once the equations of motion are calculated, they can often be solved very rapidly. It is therefore a useful approach when the degrees of freedom don't change, and the equations can be hardcoded beforehand and solved quickly (as is the case for the example in Eberly [2010]).

For some assemblies of bodies connected by joints (such as a ragdoll where there is a branching tree of bones and joints with no loops), there are well-known methods for calculating the degrees of freedom and the corresponding equations of motion. There have been a couple of single-purpose ragdoll simulators that I've seen using this approach, but only running as technical demos rather than in production games. For general sets of joints, the procedure is tougher, and for all intents and purposes, impractical, especially since in a game the constraints may appear and disappear at different times (this is particularly the case with contact constraints).

It is also more difficult to introduce general force generators using this technique. Having the ragdoll float on water or be buffeted by wind, for example, introduces major complications into calculating the equations of motion for each degree of freedom.

For this reason, I'm not aware of any general-purpose game physics engines that are based on reduced coordinate approaches. You may like to look at reduced coordinate approaches to get specific effects, but they are unlikely to be a general solution.

20.3 SUMMARY

The purpose of this whirlwind tour of other approaches is to give you a basic vocabulary and understanding. When looking through the bewildering array of physics and simulation resources available on the Internet, you can, I hope, understand how they fit into the whole picture and how our engine relates to them.

There are a couple of open-source physics systems online that you can compare with the one we've built. ODE, in particular, is widely used in hobby projects. It is a solid implementation, using a Jacobian LCP approach. It therefore allows you to create complex joints simply. In my experience, it can be difficult to determine how the code works. The performance of the engine is also not optimal.

An open-source engine that has gained some traction in the hobbyist community, and has been used in several production games, is Bullet. Bullet is the physics engine that also drives physical simulation effects in several graphics- and level-editing systems.

For a more comprehensive mathematical survey of various physics techniques that are useful in games, I recommend Eberly [2010]. His work assumes more mathematical knowledge than this book, but if you've followed this book through, you're probably ready to get started. Eberly's book doesn't cover how to build a complete general-purpose engine, but looks at a massive range of techniques and tricks that can be used on their own or incorporated into our engine. David Baraff has done more for disseminating information on Jacobian-based approaches to physics. A good introduction to his work is Baraff and Witkin [1997].

USEFUL INERTIA
TENSORS

This appendix provides formulas for calculating the inertia tensor for a range of physical primitives. They can be used to generate an inertia tensor for almost any game object.

Inertia tensors are featured in Chapter 10. As discussed in that chapter, an inertia tensor is a matrix whose diagonals represent the moment of inertia about each of the three principal axes, and whose off-diagonal components represent the tendency of an object to spin in an axis different from that of the torque.

For any given object, you can always select a set of principal axes, such that the off-diagonal terms are zero.[1] This is the simplest form of the inertia tensor. Most common shapes, when they have uniform mass density, have these principal axes coinciding with features of the shape. A rectangular box, for example, has principal axes coinciding with its face directions, a cone has a principal axis coinciding with the direction of its point, and so on.

In the first part of this appendix, I will revisit the formulas for general-purpose inertia tensors, made up of any set of discrete or continuous masses. The bulk of the appendix, however, is comprised of these kinds of common shapes. You will notice, in these cases, that the off-diagonal elements are zero.

1. This result is proved by way of the spectral theorem, or spectral decomposition, for symmetric matrices.

Copyright © 2010, Elsevier Inc. All rights reserved.
DOI: 10.1016/B978-0-12-381976-5.00021-8

A.1 DISCRETE MASSES

The inertia tensor of any set of masses connected together to form a rigid body follows:

$$I = \begin{bmatrix} I_x & -I_{xy} & -I_{xz} \\ -I_{xy} & I_y & -I_{yz} \\ -I_{xz} & -I_{yz} & I_z \end{bmatrix} \qquad [A.1]$$

where

$$I_a = \sum_{i=1}^{n} m_i a_{p_i}^2$$

and

$$I_{ab} = \sum_{i=1}^{n} m_i a_{p_i} b_{p_i}$$

In each case, a_{p_i} is the distance of particle i from the center of mass of the whole structure, in the direction of axis a. m_i is the mass of particle i, and there are n particles in the set.

A.2 CONTINUOUS MASSES

We can do the same for a general rigid body by splitting it into infinitesimal masses. This requires an integral over the entire body, which is considerably more difficult than the rest of the mathematics in this book. The formula is included here for purposes of completeness:

$$I = \begin{bmatrix} I_x & -I_{xy} & -I_{xz} \\ -I_{xy} & I_y & -I_{yz} \\ -I_{xz} & -I_{yz} & I_z \end{bmatrix} \qquad [A.2]$$

as before, where

$$I_a = \int_m a_{p_i}^2 \, dm$$

and

$$I_a = \int_m a_{p_i} b_{p_i} \, dm$$

The components of both are as before. The integrals are definite integrals over the entire mass of the rigid body.

A.3 COMMON SHAPES

This section gives some inertia tensors of common objects. All of the inertia tensors are given about the center of mass. You may find alternative formulations in other references that differ from these; check whether other sources use the center of mass as the reference point.

A.3.1 CUBOID

This includes any rectangular six-sided object, where the object has constant density:

$$I = \begin{bmatrix} \frac{1}{12}m(d_y^2 + d_z^2) & 0 & 0 \\ 0 & \frac{1}{12}m(d_x^2 + d_z^2) & 0 \\ 0 & 0 & \frac{1}{12}m(d_x^2 + d_y^2) \end{bmatrix}$$

where m is the mass and d_x, d_y, and d_z are the extent of the cuboid along each axis.

A.3.2 SPHERE

This inertia tensor corresponds to a sphere with constant density:

$$I = \begin{bmatrix} \frac{2}{5}mr^2 & 0 & 0 \\ 0 & \frac{2}{5}mr^2 & 0 \\ 0 & 0 & \frac{2}{5}mr^2 \end{bmatrix}$$

where m is the mass and r is the radius of the sphere.

The same sphere that is just a shell (i.e., has all its mass around the surface of the sphere) has an inertia tensor:

$$I = \begin{bmatrix} \frac{2}{3}mr^2 & 0 & 0 \\ 0 & \frac{2}{3}mr^2 & 0 \\ 0 & 0 & \frac{2}{3}mr^2 \end{bmatrix}$$

An ellipsoid is the spherical equivalent of a general cuboid: it can have different radii in each of its three principal axes. An ellipsoid has the inertia tensor

$$I = \begin{bmatrix} \frac{1}{5}m(r_y^2 + r_z^2) & 0 & 0 \\ 0 & \frac{1}{5}m(r_x^2 + r_z^2) & 0 \\ 0 & 0 & \frac{1}{5}m(r_x^2 + r_y^2) \end{bmatrix}$$

where r_x, r_y, and r_z are the radii along respective axes. You can see by inspection that this reduces to the sphere inertia tensor when the radii are all equal.

A.3.3 CYLINDER

A cylinder of uniform density, whose principal axis is along the y-axis, has an inertia tensor of

$$I = \begin{bmatrix} \frac{1}{12}mh^2 + \frac{1}{4}mr^2 & 0 & 0 \\ 0 & \frac{1}{2}mr^2 & 0 \\ 0 & 0 & \frac{1}{12}mh^2 + \frac{1}{4}mr^2 \end{bmatrix}$$

where m is the mass, r is the radius, and h is the height. If the cylinder is not solid, but is instead a cylindrical tube (such as a length of pipe), its inertia tensor is:

$$I = \begin{bmatrix} \frac{1}{12}mh^2 + \frac{1}{4}m(r_o^2 + r_i^2) & 0 & 0 \\ 0 & \frac{1}{2}m(r_o^2 + r_i^2) & 0 \\ 0 & 0 & \frac{1}{12}mh^2 + \frac{1}{4}m(r_o^2 + r_i^2) \end{bmatrix}$$

where r_o is the outer radius and r_i is the inner radius.

A.3.4 CONE

A cone is a slightly more complex shape than those above, since it only has symmetries along one axis. A cone has a center of mass one-quarter of the way from the center of its base to its tip. If the cone is oriented so that its tip points along the positive y direction (i.e., it is pointing "up" in normal game usage), then it will have the following inertia tensor:

$$I = \begin{bmatrix} \frac{3}{80}mh^2 + \frac{3}{20}mr^2 & 0 & 0 \\ 0 & \frac{3}{10}mr^2 & 0 \\ 0 & 0 & \frac{3}{5}mh^2 + \frac{3}{20}mr^2 \end{bmatrix}$$

where m is the mass and r is the radius of the base of the cone, and h is its height. The center of the base of the cone will be at

$$\begin{bmatrix} 0 \\ -\frac{1}{4} \\ 0 \end{bmatrix}$$

You may also see the cone's inertia tensor about either its apex or the center of its base, and the coefficients will be different in each case.

A.3.5 Hemisphere

A hemisphere is similar to a cone, in that it has symmetries along only one axis. Its center of mass is three-eights of the way from the center of its base to its radius perpendicular to that base. Placed with its flat surface on an x-z plane, its inertia tensor about its center of mass follows:

$$I = \begin{bmatrix} \frac{83}{320}mr^2 & 0 & 0 \\ 0 & \frac{2}{5}mr^2 & 0 \\ 0 & 0 & \frac{83}{320}mr^2 \end{bmatrix}$$

A.4 Moments of Inertia in 2D

In 2D, shapes have only a single value for their moment of inertia about their center of mass. It can be calculated for a set of discrete masses as

$$I = \sum_{i=1}^{n} m_i d_i^2$$

where d_i is the distance of mass i from the center of mass, and m_i is its mass.

Continuous masses have a moment of inertia,

$$I = \int_m d_i^2 \, dm$$

where we are integrating over the masses, with d_i as the distance from the center of mass, as before.

A.4.1 Common 2D Shapes

The moment of inertia of a disk is

$$I = \frac{1}{2}mr^2$$

where r is the radius of the disk. This can also be seen by inspection from the y component of the inertia tensor of the cylinder above. Since that term had no h component, it would not change for a flat (i.e., 2D) disk.

Similarly, a ring has the moment of inertia

$$I = \frac{1}{2}m(r_o^2 + r_i^2)$$

where r_o and r_i are the outer and inner radii, respectively.

A rectangle has the moment of inertia

$$I = \frac{1}{12} m(d_x^2 + d_y^2)$$

where d_x and d_y are the dimensions of the box. Again, this can be seen by inspection from the cuboid inertia tensor.

Finally, a shape that we have not seen in 3D form, a thin rod (i.e., a line segment in 2D), spins about its center with a moment of inertia,

$$I = \frac{1}{12} ml^2$$

where l is its length.

A P P E N D I X **B**

USEFUL FRICTION
COEFFICIENTS

his appendix provides a table of useful static and dynamic friction values for
materials used in games. Both static and dynamic values are given for complete-
ness; if you are using only one friction coefficient, then you can average these, or use
the dynamic value for both. Friction is discussed in Chapter 15.

Materials	Static Friction	Dynamic Friction
Wooden crate on concrete	0.5	0.4
Wooden crate on ice	0.2	0.1
Glass on ice	0.1	0.03
Glass on glass	0.95	0.4
Metal on metal	0.6	0.4
Lubricated metal on metal	0.1	0.05
Rubber on concrete	1.0	0.8
Wet rubber on concrete	0.7	0.5
Performance race tire on concrete	1.5	1.0
Velcro on velcro	6	4.0

Copyright © 2010, Elsevier Inc. All rights reserved.
DOI: 10.1016/B978-0-12-381976-5.00022-X

MATHEMATICS SUMMARY

This appendix summarizes the mathematics used in the book. It serves as a quick look-up for the appropriate formulas and equations needed when implementing physics.

C.1 VECTORS

Vector a multiplied by a scalar k:

$$k\boldsymbol{a} = k \begin{bmatrix} x \\ y \\ z \end{bmatrix} = \begin{bmatrix} kx \\ ky \\ kz \end{bmatrix}$$

Vector addition:

$$\boldsymbol{a} + \boldsymbol{b} = \begin{bmatrix} a_x \\ a_y \\ a_z \end{bmatrix} + \begin{bmatrix} b_x \\ b_y \\ b_z \end{bmatrix} = \begin{bmatrix} a_x + b_x \\ a_y + b_y \\ a_z + b_z \end{bmatrix}$$

Copyright © 2010, Elsevier Inc. All rights reserved.
DOI: 10.1016/B978-0-12-381976-5.00023-1

and subtraction:

$$a - b = \begin{bmatrix} a_x \\ a_y \\ a_z \end{bmatrix} - \begin{bmatrix} b_x \\ b_y \\ b_z \end{bmatrix} = \begin{bmatrix} a_x - b_x \\ a_y - b_y \\ a_z - b_z \end{bmatrix}$$

Vectors can be multiplied in several ways. The component product has no geometric correlate:

$$a \circ b = \begin{bmatrix} a_x \\ a_y \\ a_z \end{bmatrix} \circ \begin{bmatrix} b_x \\ b_y \\ b_z \end{bmatrix} = \begin{bmatrix} a_x b_x \\ a_y b_y \\ a_z b_z \end{bmatrix}$$

and the symbol shown is a personal convention.

The scalar product,

$$a \cdot b = \begin{bmatrix} a_x \\ a_y \\ a_z \end{bmatrix} \cdot \begin{bmatrix} b_x \\ b_y \\ b_z \end{bmatrix} = a_x b_x + a_y b_y + a_z b_z$$

has the trigonometric form,

$$a \cdot b = a_x b_x + a_y b_y + a_z b_z = |a||b| \cos \theta$$

where θ is the angle between the two vectors.

The vector product,

$$a \times b = \begin{bmatrix} a_x \\ a_y \\ a_z \end{bmatrix} \times \begin{bmatrix} b_x \\ b_y \\ b_z \end{bmatrix} = \begin{bmatrix} a_y b_z - a_z b_y \\ a_z b_x - a_x b_z \\ a_x b_y - a_y b_x \end{bmatrix}$$

has the trigonometric form,

$$|a \times b| = |a||b| \sin \theta$$

and is noncommutative:

$$a \times b = -b \times a$$

C.2 QUATERNIONS

A quaternion,

$$\begin{bmatrix} \cos \frac{\theta}{2} \\ x \sin \frac{\theta}{2} \\ y \sin \frac{\theta}{2} \\ z \sin \frac{\theta}{2} \end{bmatrix}$$

represents an orientation of θ about the axis:

$$\begin{bmatrix} x \\ y \\ z \end{bmatrix}$$

Two quaternions can be multiplied together:

$$\begin{bmatrix} w_1 \\ x_1 \\ y_1 \\ z_1 \end{bmatrix} \begin{bmatrix} w_2 \\ x_2 \\ y_2 \\ z_2 \end{bmatrix} = \begin{bmatrix} w_1 w_2 - x_1 x_2 - y_1 y_2 - z_1 z_2 \\ w_1 x_2 + x_1 w_2 - y_1 z_2 - z_1 y_2 \\ w_1 y_2 - x_1 z_2 + y_1 w_2 - z_1 x_2 \\ w_1 z_2 + x_1 y_2 - y_1 x_2 + z_1 w_2 \end{bmatrix}$$

A quaternion representing orientation can be adjusted by a vector representing the amount of rotation according to

$$\underset{\hat{}}{\theta'} = \underset{\hat{}}{\theta} + \frac{1}{2} \underset{\hat{}}{\Delta\theta} \, \underset{\hat{}}{\theta}$$

where the rotation is converted into a quaternion according to

$$\begin{bmatrix} \Delta\theta_x \, \Delta\theta_y \, \Delta\theta_z \end{bmatrix} \rightarrow \begin{bmatrix} 0 \, \Delta\theta_x \, \Delta\theta_y \, \Delta\theta_z \end{bmatrix}$$

C.3 MATRICES

An $n \times m$ matrix has n rows and m columns.

Matrices can be post-multiplied (we don't use pre-multiplication in this book) by vectors with the same number of elements as the matrix has columns:

$$\begin{bmatrix} a & b & c \\ d & e & f \\ g & h & i \end{bmatrix} \begin{bmatrix} x \\ y \\ z \end{bmatrix} = \begin{bmatrix} ax + by + cz \\ dx + ey + fz \\ gx + hy + iz \end{bmatrix}$$

Matrices can be multiplied together, providing that the number of columns in the first matrix is the same as the number of rows in the second:

$$C_{(i,j)} = \sum_k A_{(i,k)} B_{(k,j)}$$

where $C_{(i,j)}$ is the entry in matrix C at the i-th row and j-th column, and where k ranges up to the number of columns in the first matrix.

A 3×3 matrix,

$$M = \begin{bmatrix} a & b & c \\ d & e & f \\ g & h & i \end{bmatrix}$$

has its inverse given by

$$M^{-1} = \frac{1}{\det M} \begin{bmatrix} ei - fh & ch - bi & bf - ce \\ fg - di & ai - cg & cd - af \\ dh - eg & bg - ah & ae - bd \end{bmatrix}$$

where det A is the determinant of the matrix,

$$\det M = aei + dhc + gbf - ahf - gec - dbi$$

A quaternion,

$$\hat{\theta} = \begin{bmatrix} w \\ x \\ y \\ z \end{bmatrix}$$

represents the same rotation as the following matrix:

$$\Theta = \begin{bmatrix} 1 - (2y^2 + 2z^2) & 2xy + 2zw & 2xz - 2yw \\ 2xy - 2zw & 1 - (2x^2 + 2z^2) & 2yz + 2xw \\ 2xz + 2yw & 2yz - 2xw & 1 - (2x^2 + 2y^2) \end{bmatrix}$$

A transformation matrix M_t can be changed into a new coordinate system, using a transform M_b to the new coordinate system according to

$$M_t' = M_b M_t M_b^{-1}$$

C.4 INTEGRATION

To update an object's position,

$$p' = p + \dot{p}t + \frac{1}{2}\ddot{p}\,t^2$$

is normally replaced by the less accurate

$$p' = p + \dot{p}t$$

Velocity is updated with

$$\dot{p}' = \dot{p} + \ddot{p}t$$

Orientation is updated with

$$\hat{\theta}' = \hat{\theta} + \frac{\delta t}{2}\hat{\omega}\hat{\theta}$$

where $\hat{\omega}$ is the quaternion form of the angular velocity, and t is the duration to update by.

Angular velocity is updated exactly as linear velocity:

$$\dot{\theta}' = \dot{\theta} + \ddot{\theta}t$$

C.5 Physics

Newton's second law of motion gives us

$$f = ma = m\ddot{\boldsymbol{p}}$$

where m is the mass and \boldsymbol{p} is the position of an object, or

$$\ddot{\boldsymbol{p}} = m^{-1}\boldsymbol{f}$$

in terms of position.

Euler's equivalent for rotation is

$$\ddot{\boldsymbol{\theta}} = I^{-1}\tau$$

where I is the inertia tensor and τ is the torque.

The force of gravity is

$$f = mg$$

where g is around 10 m s^{-2} on Earth, but is often replaced by 20 m s^{-2} for added speed in games.

Forces through an object's center of mass can be combined using D'Alembert's principle:

$$f = \sum_i f_i$$

Forces not through the center of mass also have a torque component:

$$\tau = p_f \times f$$

where p_f is the position of application of the force, relative to the center of mass. D'Alembert's principle also applies to rotations:

$$\tau = \sum_i \tau_i$$

which includes the torques generated from off-center forces.

The separating velocity of two colliding objects, v_s, is related to their velocity immediately before the collision v_c by

$$v_s = -c v_c$$

where c is the coefficient of restitution.

C.6 OTHER FORMULAS

Hook's law related the force of a spring f to its length:

$$f = -k(|d| - l_0)\widehat{d}$$

where d is the vector from one end of the spring to another.

Simple fluid flow can be modeled with an aerodynamic tensor:

$$f_a = A v_w$$

where f_a is the resulting force, A is the aerodynamic tensor, and v_w is the velocity of the air.

Glossary

anisotropic friction Friction that differs according to direction. An ice skate on ice, for example, slides more easily in one direction than another.

axis-aligned bounding box A box that encloses an object or collection of objects, where the sides of the box are parallel to the axis.

bounding volume Any shape that is designed to enclose an object or a collection of objects, to speed up collision detection.

bounding volume hierarchy A hierarchy of bounding volumes, such that each node in the hierarchy is large enough to enclose all of its descendants.

broad-phase collision detection The process of quickly excluding as many non-collisions as possible, before a more complex algorithm determines whether any are actually touching.

center of mass The point in or around a rigid body that is the average point of all its mass. The rigid body will balance on any axis through the center of mass.

coefficient of friction The proportion of normal reaction force at a contact that can be withstood by friction. This can take on any value above zero.

coefficient of restitution The proportion of relative speed that is retained after a collision. This can take any value between 0 and 1.

coherence The principle that the set of contacts in a simulation does not change much from frame to frame.

collision A contact between two objects where there is a specific closing velocity before the objects touch. Used in contrast to a **resting contact**.

contact generation The process of analyzing the geometry of a scene and determining the contacts between pairs of objects.

Copyright © 2010, Elsevier Inc. All rights reserved.
DOI: 10.1016/B978-0-12-381976-5.00024-3

dynamic friction A force that acts to slow down objects that are sliding along one another. Also called *kinematic friction.*

force An action that changes the linear acceleration of an object in proportion to its mass.

force-based engine A physics simulation that calculates the forces between objects in resting contact with one another.

half-size Half of the length, width, and depth dimensions of a box.

homogeneous coordinates A coordinate system using four values to represent points in 3D space. The additional coordinate allows matrices to represent translations.

identity matrix Any square matrix whose values are all zero, except for 1's on the leading diagonal. It has the characteristic that multiplying by any matrix M for which multiplication is defined leaves the value M unchanged.

impulse An action that changes the linear velocity of an object, in proportion to the object's mass. It is equivalent to a force applied for some specific duration.

impulse-based engine A physics simulation that models resting contacts by using lots of small impulses, that is, one per frame.

inertia tensor A matrix that determines how a torque turns into an angular acceleration. It contains terms that show how resistant an object is to being rotated about each principal axis, and terms that control how a torque applied in one axis could generate a rotation in another.

isotropic friction Friction that is the same in all directions. In reality, friction is anisotropic, but it in game simulations it is often modeled as isotropic.

iterative constraint solver A method of determining the forces or impulses to apply to objects in a simulation, by repeatedly considering each constraint (such as contacts or joints) individually.

Jacobian constraint solver A method for determining the forces to apply to objects in a simulation by building a matrix that encapsulates the interrelations between physics quantities, and solving an expression to give the forces required.

magnitude of a vector If a vector represents a change in position, then the magnitude is the length of that change. For this reason, it is often also called the "length" of a vector.

mass The property of an object that resists acceleration when a force is applied. Objects of infinite mass would be immovable.

mass aggregate physics engine A physics engine that simulates 3D objects as a network of point masses connected with rods or other constraints.

microcollision A collision that is intended to represent a resting contact.

moment of impulse An action that changes the angular velocity of an object, in proportion to the object's moment of inertia.

moment of inertia The property of an object that resists angular acceleration when torque is applied. Unlike mass, the moment of inertia is only defined about a particular axis; different axes may have different moments of inertia, depending on the shape of the object.

narrow-phase collision detection The process of examining pairs of objects in geometric detail to determine whether they are touching.

normal A vector that is perpendicular to one or more objects or features of objects. A normal to a surface, for example, is a vector pointing out of that surface.

normal reaction force The force that a surface applies to an object that is being pushed against it, to prevent the object sinking into the surface. Up until the surface or object gives way under the strain, the surface will push back with the same force that is applied to it.

normalizing a vector The process of transforming a vector so that it has unit length.

object bounding box A box that encloses an object or collection of objects, where the box can be oriented in whatever way best fits its contents.

orientation The direction in which an object is facing. This is often called *rotation*, but in this book I use *orientation* consistently to avoid ambiguity.

penalty constraint solver A method of determining the forces or impulses to apply to objects in a simulation, by treating each constraint as a spring, and generating spring forces to push the simulation back to a state where the constraints are not violated.

product of inertia The tendency of an object to accelerate about a particular axis when a torque is applied to a different axis. This value depends on the axes chosen. It forms the nondiagonal components of the inertia tensor.

recency weighted average A technique for smoothing a continually changing stream of numbers by blending each new sample with a running total.

resting contact Where two objects are touching but they have no closing or separating velocity at the point of contact.

separating axis An axis along which two objects are projected into non-overlapping ranges. Because the objects are separated along this axis, we can conclude that they cannot be touching in reality.

spatial data structure A data structure that represents a particular space, where the pattern of slots for data is analogous to the space. A grid data structure is an example.

spatial partitioning The process of dividing an entire space into a series of smaller regions so that algorithms can run on small subsets of the entire simulation.

speed The magnitude of an object's velocity. Speed is a scalar value that is always positive and ignores direction.

spring constant The multiplying factor that determines how much force a spring will generate for a certain amount of extension or compression.

static friction The proportion of the normal reaction force that can be applied laterally at a point of contact before the objects begin to slide along each other.

unit vector A vector with a length of 1.

BIBLIOGRAPHY

David Baraff and Andrew Witkin [1997]. *Physically Based Modeling: Principles and Practice.* SIGGRAPH Proceedings '97. ACM Press.

Leo Dorst, Daniel Fontijne, and Stephen Mann [2007]. *Geometric Algebra for Computer Science: An Object-Oriented Approach to Geometry.* Morgan Kaufmann.

David Eberly [2003]. *Conversion of Left-Handed Coordinates to Right-Handed Coordinates.* Geometric Tools, LLC. Available at: www.geometrictools.com/Documentation/Left Handed to Right Handed.pdf.

David H. Eberly [2010]. *Game Physics, 2nd ed.* Morgan Kaufmann.

Christer Ericson [2005]. *Real-Time Collision Detection.* Morgan Kaufmann.

Roger A. Horn and Charles R. Johnson [1990]. *Matrix Analysis.* Cambridge University Press.

Roger A. Horn and Charles R. Johnson [1994]. *Topics in Matrix Analysis.* Cambridge University Press.

Gino van den Bergen [2003]. *Collision Detection in Interactive 3D Environments.* Morgan Kaufmann.

INDEX

Printed and bound by CPI Group (UK) Ltd, Croydon, CR0 4YY

21/10/2024

01777093-0010